TYPOGRAPHY 27

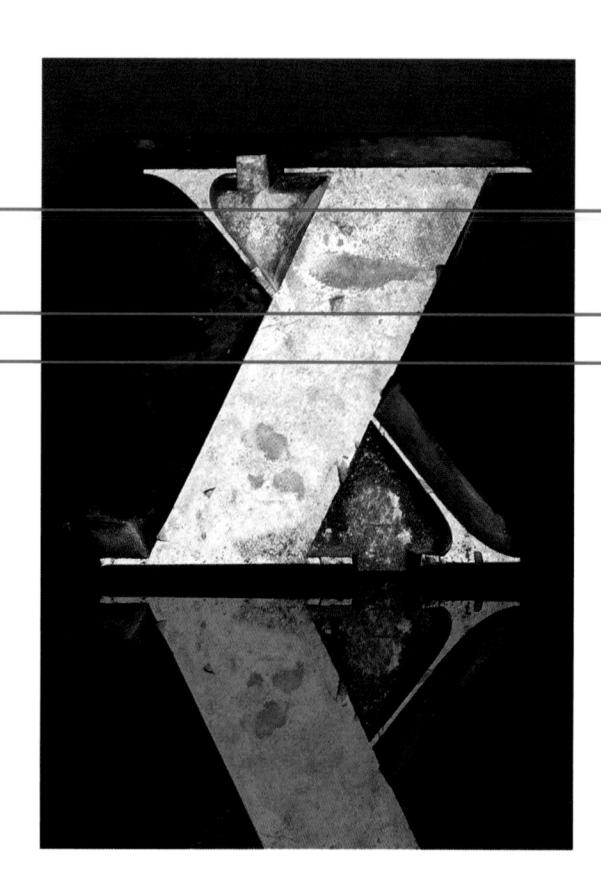

TYPOGRAPHY 27 THE ANNUAL OF THE TYPE DIRECTORS CLUB

TYPOGRAPHY 27

Copyright © 2006 by the Type Directors Club

All rights reserved. No part of this book may be used or reproduced in any manner whatsoever without written permission except in the case of brief quotations embodied in critical articles and reviews. For information, address Collins Design, 10 East 53rd Street, New York, NY 10022.

HarperCollins books may be purchased for educational, business, or sales promotional use. For information, please write: Special Markets Department, HarperCollins Publishers, 10 East 53rd Street, New York, NY 10022.

First Edition

First published in 2006 by:
Collins Design

An Imprint of
HarperCollinsPublishers
10 East 53rd Street
New York, NY 10022
Tel: (212) 207-7000
Fax: (212) 207-7654
collinsdesign@harpercollins.com
www.harpercollins.com

Distributed throughout the world by: HarperCollins*Publishers* 10 East 53rd Street New York, NY 10022 Fax: (212) 207-7654

Library of Congress Control Number: 2006926986

ISBN-10: 0-06-114423-1 ISBN-13: 978-0-06-114423-3

Printed in China First Printing, 2006

ACKNOWLEDGMENTS

The Type Directors Club gratefully acknowledges the following for their support and contributions to the success of TDC52 and TDC² 2006:

Design: Andrew Kner Associate Designer: Michele L. Trombley Cover photographer: Isidore Seltzer Editing: Susan E. Davis

Judging Facilities: Fashion Institute of Technology Exhibition Facilities: The One Club Chairpersons' and Judges' Photos: Christian DiLalla

TDC52 Competition (call for entries):
Design: Andrew Kner
Associate Designer: Michele L. Trombley
Photographer: Isidore Seltzer
Printer: Anderson Lithograph
Paper: Smart Paper
Prepress Services:
A to A Graphic Services, Inc.
TDC2 2006 Competition
(call for entries):
Design: Ilene Strizver

The principal typefaces used in the composition of *Typography 27* are: Futura Light and Futura Book, ITC Garamond Condensed Book, and Latin MT Condensed

Carol Wahler
Executive Director
TYPE DIRECTORS CLUB
127 West 25 Street, 8th Floor
New York, NY 10001

212-633-8943 212-633-8944 fax www.tdc.org director@tdc.org

Produced by Crescent Hill Books

Contents

TDC52 chairman's statement

TDC52 Judges

TDC52 judges' choices and designers' statements

TDC52 entries selected for typographic excellence

TDC2 2006

TDC² 2006 chairman's statement

TDC² 2006 judges

TDC² 2006 judges' choices and designers' statements

 TDC^2 2006 entries selected for excellence in type design

TDC3 - 1956

TDC officers

TDC membership

Typographic index

General index

TDC Chairman's Statement

Diego | Vainesman

Born in Argentina, Diego Vainesman is the senior art director at MJM Creative Services, Inc. in New York City. HIs list of clients ranges from global corporations such as Canon, IBM, Pfizer to nonprofit organizations such as Congregation B'nai Jesburun and PS 158. His work has included logos, corporate identities, promotional materials, collateral materials, signage, videos, books, CDs, and interactive media. Diego is also the New York correspondent for tipoGráfica, the leading typographic magazine in South America, and he has taught at Pratt and Parsons School of Design. Diego is the co-editor/designer of Letterspace, the TDC newsletter, and

was the designer of Typography 25.

As we celebrate the 60th anniversary of the Type Directors Club, the winning pieces featured in this annual represent the highest standards of typographical excellence as established by the TDC over the years.

From hand-set foundry type to machine composition, through photo- and computer-generated images, it is, however, the skills and sensitivity of the typographers/craftspeople/designers that establish the standards by which the aesthetics of these wonderful abstract shapes we call letters are judged.

To the typographers/craftspeople/designers who submitted work to the competition, to the people who contributed their talent and time, to the judges who patiently reviewed the thousands of entries, and to our crew of volunteers: Thank you. To the winners: Congratulations.

TDC52 JUDGES

Andy Altmann

Andy Altmann graduated in graphic design from the Royal College of Art in 1987 and almost immediately formed the multidisciplinary design group Why Not Associates with fellow graduates David Ellis and Howard Greenhalgh. Located in London, Why Not Associates gained an international reputation based on its creative and experimental approach. Over the past 18 years they have worked on projects ranging from exhibition design to postage stamps and done designs for advertising, commercials, corporate identity, publishing, and television titles. Their clients include Channel 4, Malcolm McClaren, Nike, the Royal Academy of Arts, the Royal Mail, Paul Smith, and Virgin Records.

A book was published in 1998 by Booth-Clibborn Editions documenting the first ten years of their work. A second was published in 2004 by Thames and Hudson which documented another five years. Andy, David, and Howard still strive to push the boundaries of graphic design. More recent projects collaborating with artist Gordon Young have moved them into the world of public art.

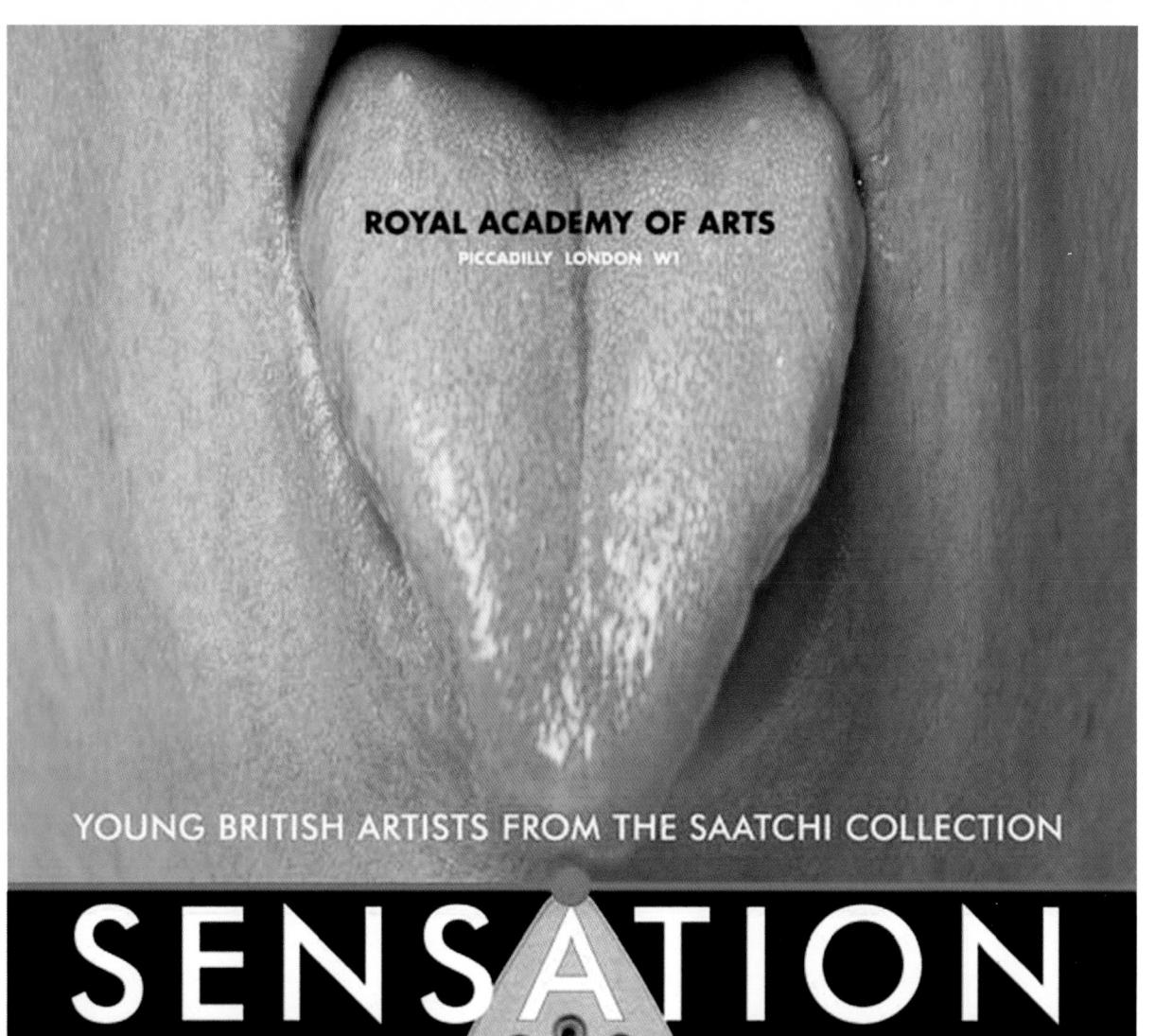

SENSALION SENSALION 18 SEPTEMBER - 28 DECEMBER 1997 CLOSED 25 DECEMBER OPEN DAILY 10 AM-6PM

Mike Joyce

Mike Joyce is the founder of Stereotype Design in New York City and was formerly an art director at MTV Networks. Before that, he was the creative director at Platinum Design. He has designed CD packaging for established artists and upstarts, from Iggy Pop and Natalie Merchant to Fall Out Boy and Robbers on High Street. Mike has also designed countless T-shirts for bands like The All American Rejects, Maroon 5, and The Strokes and has produced books for Tony Hawk and KISS.

Stereotype's work has been featured in such publications as *Communication Arts, Coupe, HOW, IdN, New York Magazine, Plus 81, Print,* and *Rolling Stone*. Mike has designed exhibitions for the AIGA 365, the Art Directors Club's first Young Guns show, the One Show, and the Type Directors Club. His work is included in the Permanent Collection of the Library of Congress. In 2004 Mike was selected to co-chair the Art Directors Club's Young Guns 4. The following year he licensed a line of typographic T-shirts to the design-driven clothing company 2K. Mike also teaches typography and design to third- and fourth-year students at the School of Visual Arts.

Alexa Nosal

Alexa Nosal studied communication design at Parsons School of Design and the Fashion Institute of Technology in New York City after receiving degrees in fine arts and economics. She worked in partnership with Martin Solomon from 1983 to 2006. Together they developed a diverse collection of internationally recognized work, including corporate identities, fine press books, posters, promotional material, and typeface designs. She continues her graphic career as an independent designer.

Alexa currently teaches typography and design at the Fashion Institute of Technology and Parsons School of Design. She was honored to receive the first University Teaching Award presented by New School University.

Alexa presents national and international typography and design workshops, the latest a training session for the U.S. Government Printing Office in 2006. She lectured at Altos de Chavon Design School in the Dominican Republic from 1998 to 2003; was the keynote speaker at Grandestypos, a typographical seminar sponsored by the Instituto Superior Comunicacion Visual in Rosario, Argentina, in 2001; participated in Los Secretos del Diseño Grafico Exitoso, an international conference held in Santo Domingo in 2002; and presented a three-day workshop at the II Encuentro Internacional de Enseñanza del Deseño sponsored by the Instituto Superior Deseño Industial in Havana, Cuba, in 2003.

Alexa writes articles about design and typography, including those published by *a! Diseño, Between, Japan, Mexico*, and the Argentine publications *Suma+* and *tipoGráfica*. She also serves on the *tipoGráfica* advisory board.

Emily Oberman

Emily Oberman, a graduate of Cooper Union, founded Number Seventeen in the summer of 1993 with her partner Bonnie Siegler. The company is a multidisciplinary design firm working in television, film, print, products, and the web.

Some of their recent work includes designing the newly reinvented *Colors* magazine, creating the identity and advertising for Air America Radio, the advertising and design for New York's River-to-River Festival, and the identity and packaging for a new line of modern organic baby food called Homemade Baby. They have also designed books for *In Style Magazine*, "Will & Grace," and "Desperate Housewives." Other clients include Condé Nast, HBO, Hyperion, The Maritime Hotel, The Mercer Hotel, the MGM Grand in Las Vegas, MTV, NBC, Nickelodeon, and "Saturday Night Live."

Before starting Number Seventeen, Emily was a senior designer at Tibor Kalman's wonderful, crazy design studio, M&Co. She recently concluded a two-year stint as president of the New York Chapter of the American Institute of Graphic Arts; before that she served on its national board for three years. In 2004 Emily was chosen for the Augustus St. Gaudens Award for Alumni of the Year by Cooper Union.

In her spare time, Emily teaches design for television at Cooper Union and is a visiting critic for the Yale University Graduate Design Program.

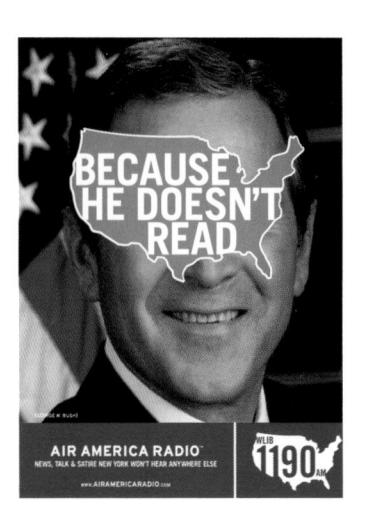

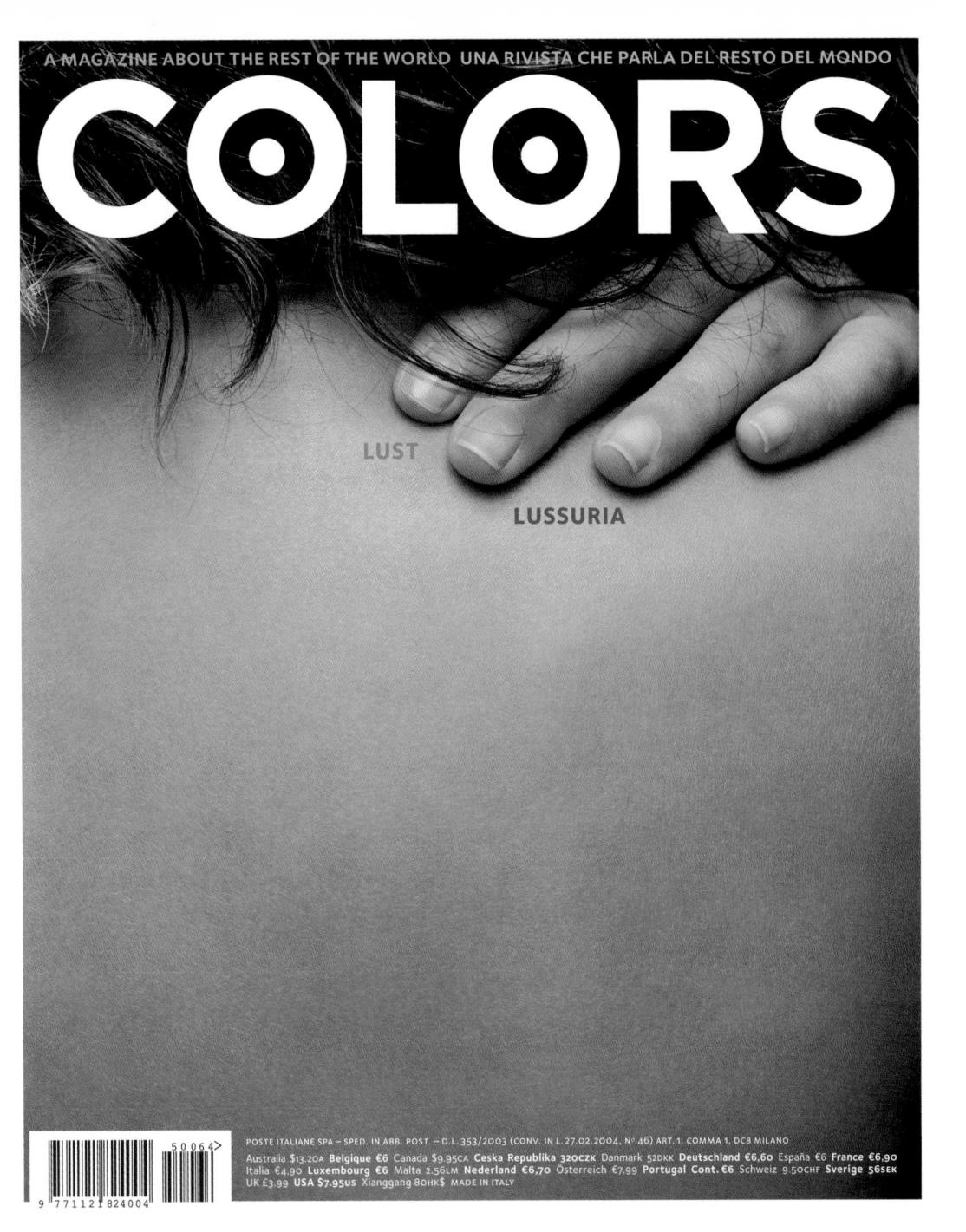

Woody Pirtle

Woody Pirtle established Pirtle Design in Dallas in 1978. Over the next 10 years the firm produced some of the most important and celebrated work of the decade for a broad spectrum of clients. In 1988 Woody merged Pirtle Design with Pentagram, the international design consultancy founded in London in 1972. For nearly 20 years as a partner in Pentagram's New York office, Woody worked on some of the firm's most prestigious projects for many of its A-list clients. In 2005 Woody left Pentagram to re-establish Pirtle Design.

Today, Pirtle Design continues to provide unparalleled design and consulting services that run the gamut of business and cultural endeavors while producing work for a broad range of national and international clients. Because of its simple structure and lean profile, Pirtle Design is able to retain the entrepreneurial spirit and creative freedom necessary for producing fresh, original work, while continuing to receive interdisciplinary support from the partners and staff at Pentagram. The firm's organization assures the best of both worlds for clients: like a small private firm, Woody is intimately involved with the design work and communicates directly with the client; like a large international firm, the office maintains a sophisticated support structure and a wide network of professional resources.

Recent projects include identity and website redevelopment for the international law firm, Wachtel Lipton Rosen & Katz; design development of architectural and graphic components for The William Stafford Center in Portland, Oregon; and identity and/or signage programs for the American Folk Art Museum, Amnesty International, Brooklyn Ballet, Callaway Golf, international publisher Graphis, the Hudson Valley Preservation Commission, Rizzoli International, and the Virginia Museum of Fine Art.

Woody's work has been exhibited worldwide and is in the permanent collections of the Cooper-Hewitt Museum and Museum of Modern Art in New York, the Neue Sammlung Museum in Munich, the Victoria & Albert Museum in London, and the Zurich Poster Museum. Woody has taught at the School of Visual Arts, lectured extensively, is a member of the Alliance Graphique Internationale, and has served on the board of the American Institute of Graphic Arts (AIGA) and *HOW* magazine. In October 2003 he was awarded the prestigious AIGA Medal for his contribution to the design profession.

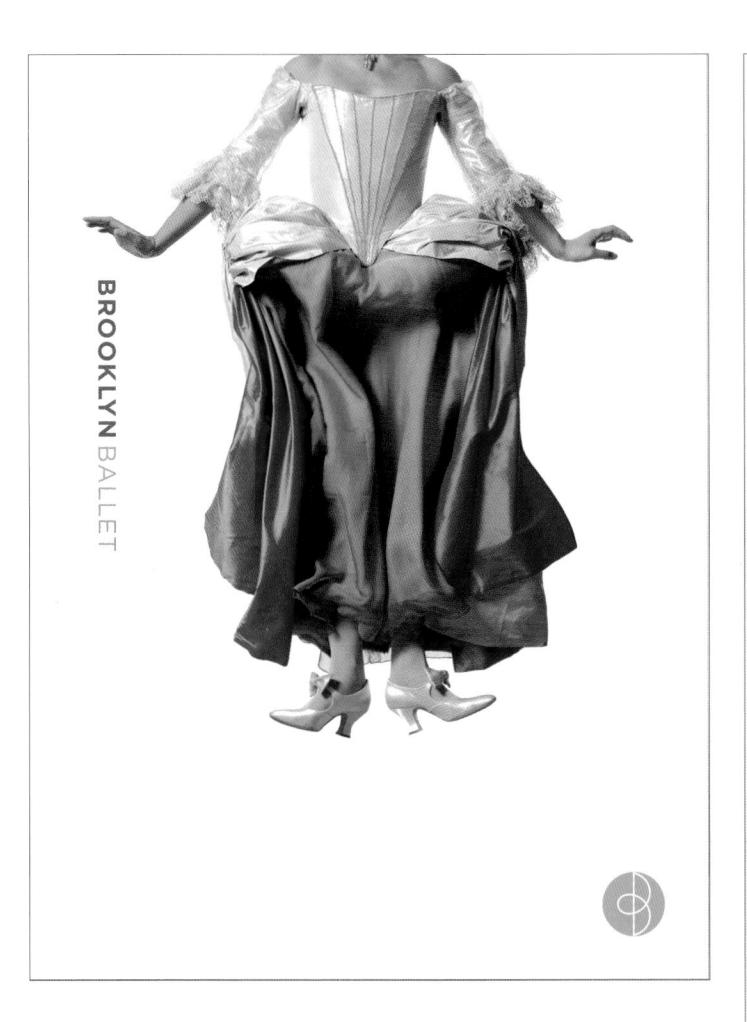

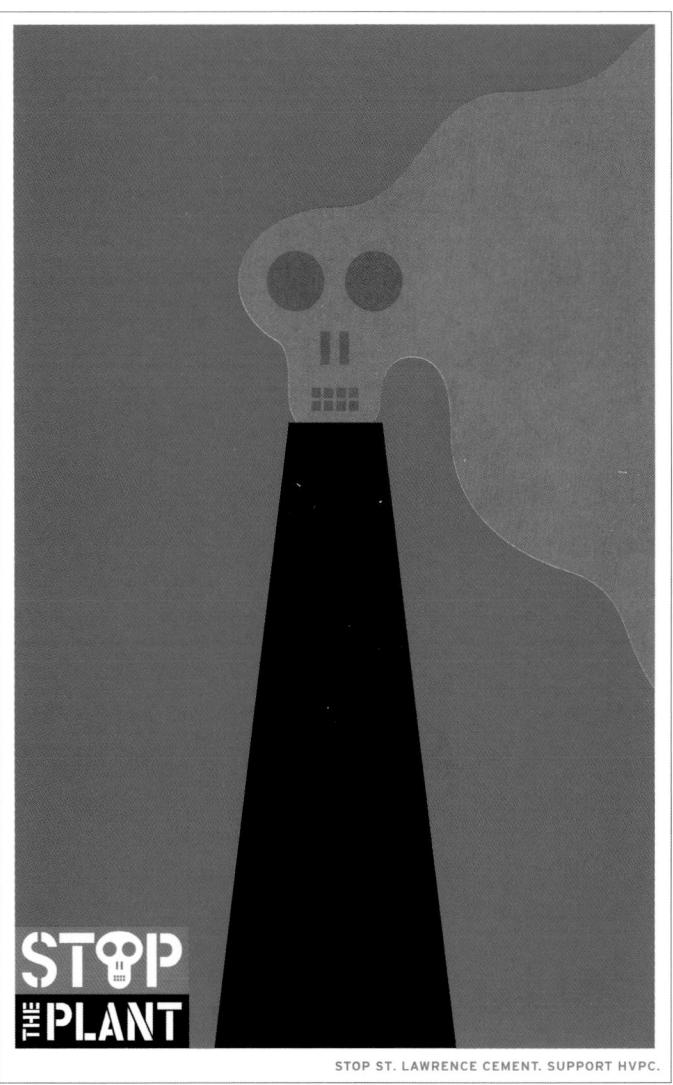

Steve Sandstrom

Steve Sandstrom is creative director and partner of Sandstrom Design in Portland, Oregon. Clients have included Adidas, Converse, Coca-Cola, The Cost Vineyard, ESPN, Fiskars, Full Sail Brewing, Levi Strauss & Co., Marriott, Microsoft, Miller Brewing, Nike, Nissan, Seagrams, Sony Pictures, Steppenwolf Theatre, Tazo Tea, and Virgin Mobile. Advertising agency relationships have included GSD&M, JWT, McKinney, Ogilvy & Mather, Publicis, TBWA/ChiatDay, Wieden-Kennedy, and Young & Rubicam. Prior to founding Sandstrom Design in November 1988, Steve was a senior art director at Nike, responsible for brand image and collateral materials for the apparel division.

Steve's firm has been featured in several publications, including *Adweek*, @*Issue*, *Communication Arts*, *Creativity*, *Critique*, *Grapbis*, *HOW*, *Novum* (Germany) and in numerous books on design, packaging, and corporate identity. Steve was integrally involved with the creation of Tazo, an eclectic premium tea brand, and the development of its brand personality. He was primarily responsible for Tazo's award-winning packaging and general design aesthetic. Tazo is the number one brand in natural foods sales in the United States.

Steve has won numerous design and advertising awards, including Andys, Beldings, Clios, and Kellys, and those given by the American Advertising Federation, *Communication Arts*, D&AD (London), *Graphis* Top Ten in Design, *I.D.* magazine, London International Advertising, the New York Art Directors Club, The One Show, and the Type Directors Club. In 1994 he was the youngest to be honored as Advertising Professional of the Year by the Portland Advertising Federation. He also won a Blue Ribbon at the 1961 Oregon State Fair for a crayon drawing of a cow.

Steve serves on the board of directors for The One Club; is a board member for BodyVox, an acclaimed contemporary dance group; and is currently president of the Portland Advertising Federation—the first designer elected to that position in its 100-year history. Steve also serves on the Board of Visitors for the University of Oregon School of Architecture and Allied Arts.

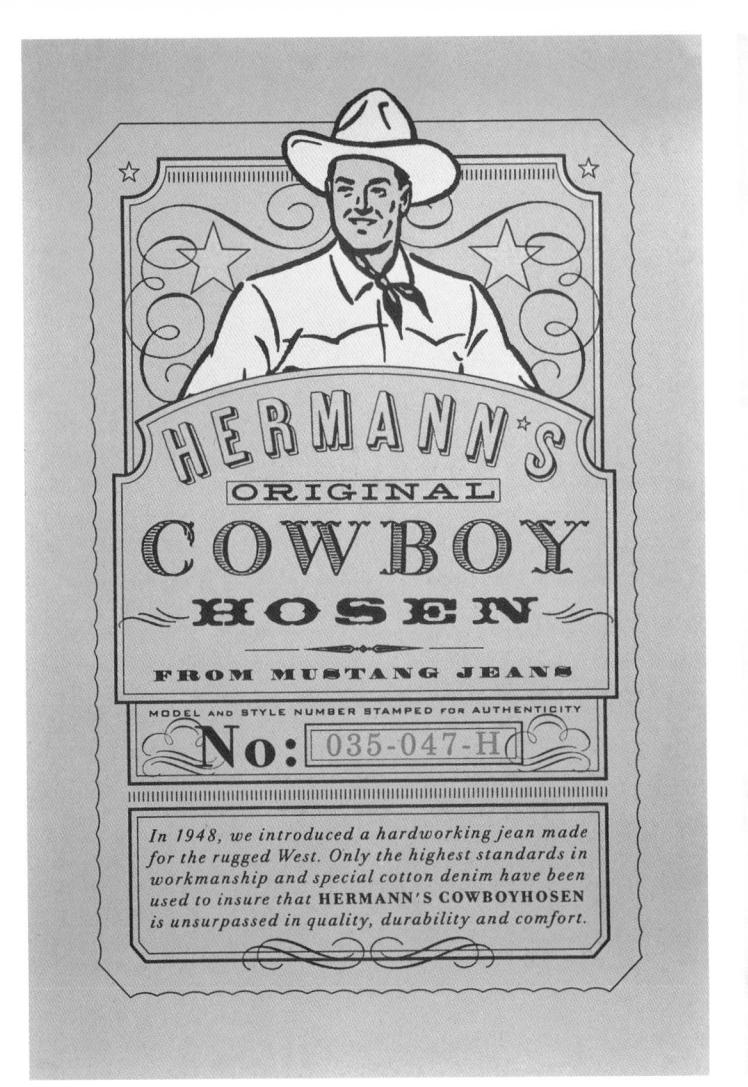

Theory to per to Diffet off

Theory to per to Diffet off

A first to live to the top of the stand of the stand of the stands

Gestart tool of A man et live houseful Diran Jehr Topseh

Louseful Diran Jehr Topseh

Son Ami Muse Desparet

Ist protected grader of Direct

Tabliasco alas et Ferine Hodars

Curs 6: Herensetta Lett of Hegy

The olist varou John setten Go.

The olist varou John setten Do

Nothing Jungo Lenandi Ville

et Pagano Jan francisto me

Lour Tehr toper thuse Girls

Jan Pahrtofper thuse Girls

San Tehrtomon Ch., Inspech

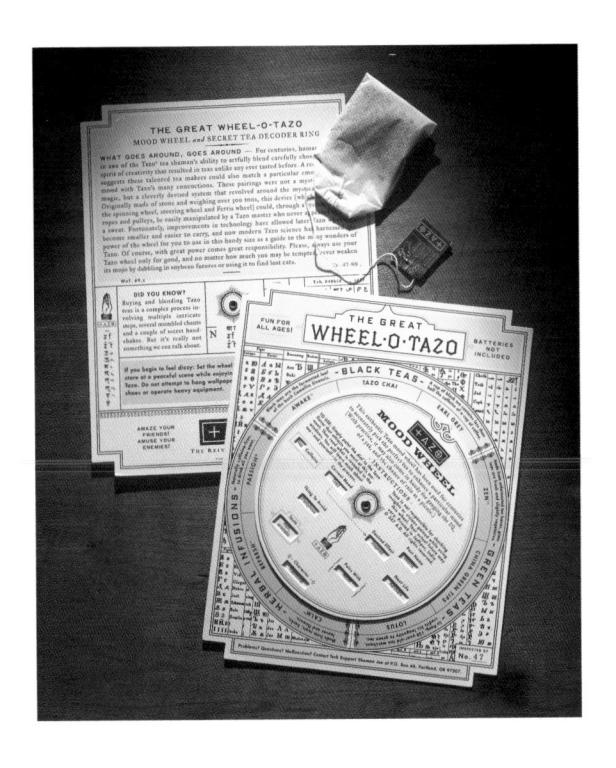

Brady | Vest

Brady Vest is the owner and founder of Hammerpress, a letterpress and design studio located in Kansas City, Missouri. Since graduating from the Kansas City Art Institute with a BFA in printmaking in 1994, Brady Vest and Hammerpress have churned out tons of posters, CD packages, postcards, promotional pieces, books, and many other types of print-candy. From the very first projects for mysteriously legendary rock bands such as Quitters Club and Giants Chair to more recent and strangely varied design and print jobs for clients, ranging from Houlihan's Restaurants and Domino Records to wedding invitations for Kansas City's tasteful newlyweds-to-be, Brady Vest and his Hammerpress robots have continued to create a body of work that has a strong connection to traditional typography and the craft of letterpress while presenting it in a new and unusual way. Top five favorite things are (in no particular order): chocolate, beer, Lindsay Laricks, steel guitars, and run-on sentences.

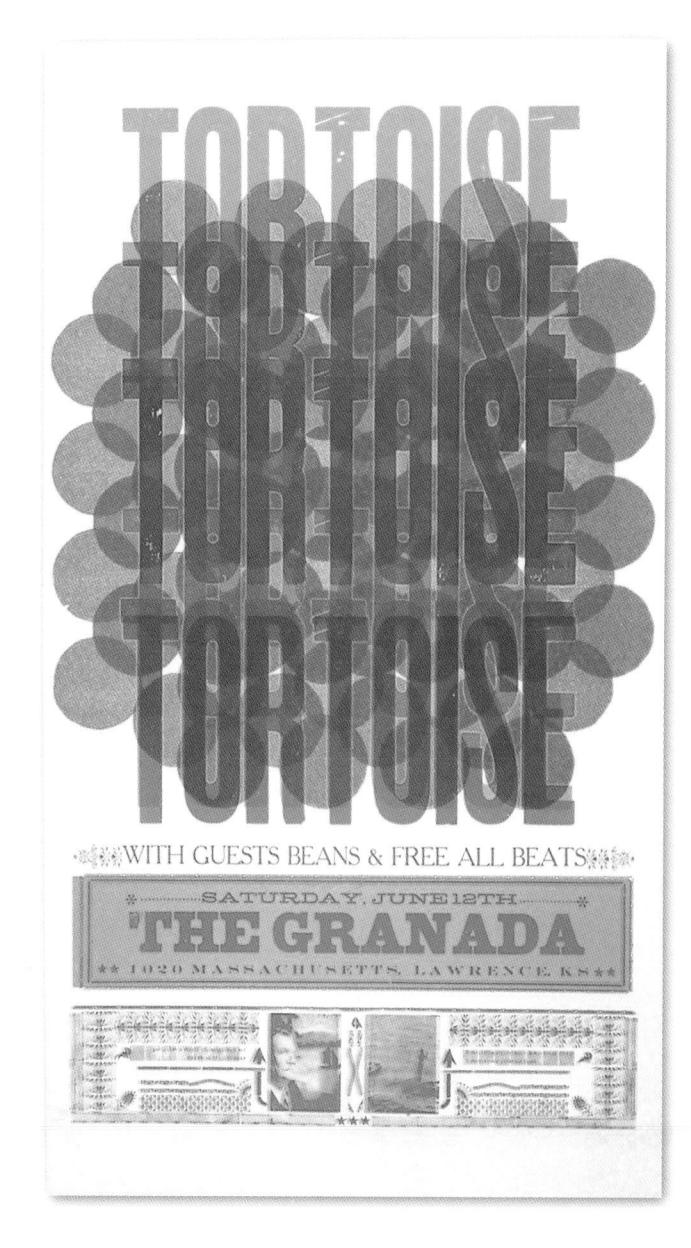

Andy Altmann JUDGE

The first thing that attracted me to these posters was obviously the beautiful, powerful imagery of the distorted roses, not the typography. But on closer observation the letterforms of the verse appeared to be constructed from dots created from the rose imagery. This seemed to be a very sympathetic way of combining the text and the image.

When all the posters were laid out on the floor for us to judge, I then had to go down on my hands and knees to take a closer look. It was at this point that the true subtlety of the typography appeared. The letterforms of the title of the exhibition were again constructed from dots, but this time they were actually punched through the paper. This was fantastic attention to detail, but I am sure that it will be imperceptible when reproduced in this book, so you will just have to take my word for it! But I'm glad I took the time and trouble to crawl around a dusty university floor in the name of typography

Hideki Nakajima DESIGNER

I created this poster for "Seven Exhibition" curated by Benny Au from Hong Kong. The image of roses is based on work I created for the German magazine *032c*. Following creative director Joerg Koch's suggestion, I quoted a verse from "The Inner Rose" by Rainer Maria Rilke. My primary challenge was to express "sensuality and beauty."

Roses have been the motif in so many creators' works in the past and will keep attracting people in the future. It seems that my turn has come, and now I am really into the beauty of roses. I created the font for the verse with dots. I feel honored to receive this prestigious award.

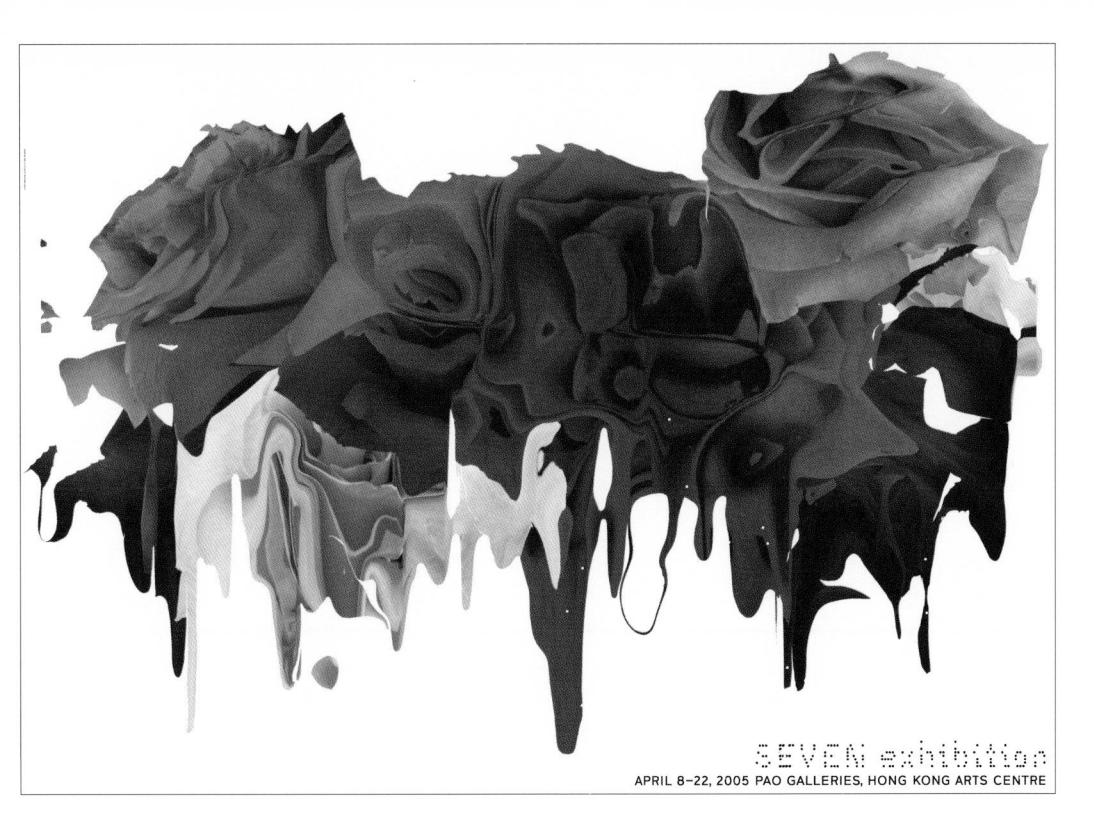

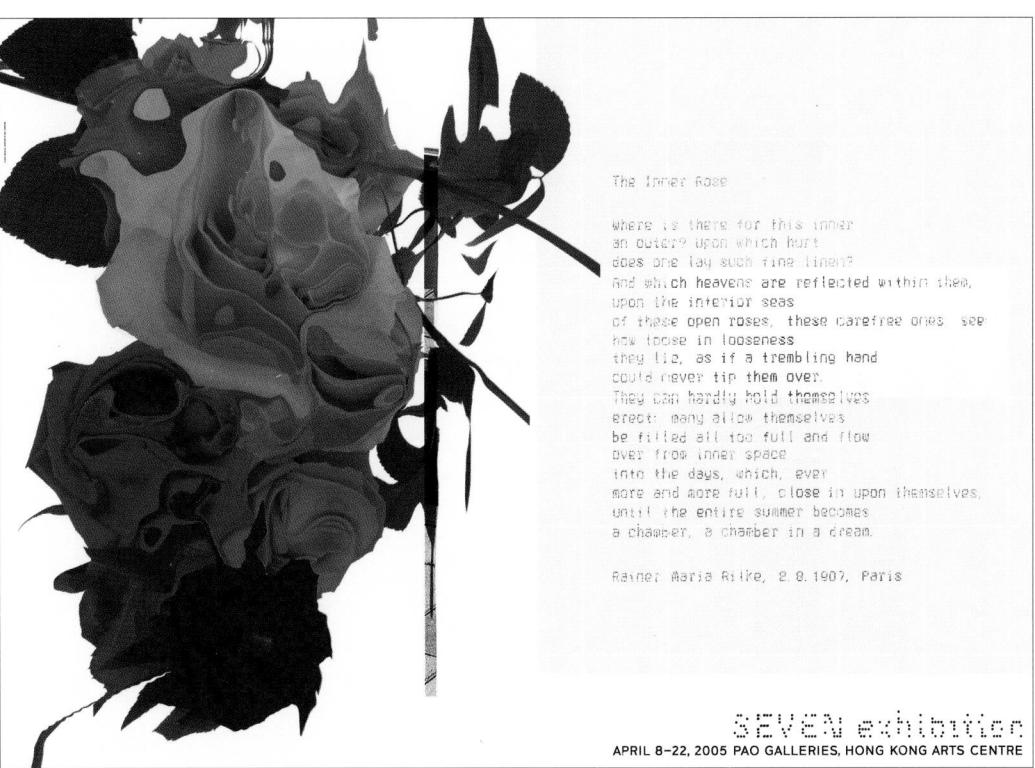

DESIGN Hideki Nakajima Tokyo, Japan

ART DIRECTION

Hideki Nakajima

DESIGN OFFICE

Nakajima Design Ltd.

CLIENT

Hong Kong Art Centre

PRINCIPAL TYPE

Custom

DIMENSIONS 57.3 x 40.6 in. (145.6 x 103 cm)

Mike Joyce JUDGE

For me, this enormous poster is what the TDC Annual is all about—all type! At first glance it's an explosion of fragmented typographic elements, but then you quickly realize it's something more. It's a city street plan and a skyline all in one—a well-constructed, meticulously assembled mass of characters lining up and locking up to create a structure with heart—literally. Fernando Távora would be proud.

Lizá Defossez Ramalho and Artur Rebolo DESIGNERS

We were asked to create an image for an event that paid tribute to the architect Fernando Távora, who died recently. The title "I Love Távora" came from a slogan that he himself used on a T-shirt when he was a teacher at the Oporto Fine Arts School. It reflects the feeling that one has today about the architect and his work.

Without using any photographs of Fernando Távora or any of his designs, we wanted to create a poster that would evoke the modernist and humanist strands that characterize his work. In the project we developed, the text and image blend, forming an organic mass, suggesting an urban plan within which you can "read" a heart.

Ciclo de Video Reposição das "Aulas de Teoria Beral da Organização do Espaço, Fernando Távora, FAUP, 92793" introduzidas por arquitectos e historiadores que com ele partilharam a docência Domingos - 21:30 Mercado Municipal de Santa Maria da Feira 11 Fevereiro Apresentação / 20 Novembro Salão Nobre da Faculdade de Ciências, UP / 21:30 Casa da Covilhã, Guimarães 25 de Fevereiro 2. Obra Pedagógica 08 Jan João Mendes Ribeiro Ciclo de conferências e video projecção de desenhos e fotografias de viagens lectivas 1980—1993 Salão Nobre e átrio da Faculdade de Ciências (Praça dos Leões), 21:30 Casa de Férias no Pinhal de Ofir 11 de Março 20 Nov: "A Aula" 22 Jan Rui Tavares Álvaro Siza Vieira Entrada livre em todos os eventos! 27 Nov António Lousa Pousada de St[#] Marinha, Guimarães / 25 de Março 29 Jan Carlos Machado Ciclo de Conferências 4ª feiras - 21:30 05 Fev Paulo Varela Gomes 23 Nov: "A Viagem" Alexandre Alves Costa, Quinta da Conceição e Quinta de Santiago, Leça da Palmeira 6 de Maio 11 Dez Rui Lobo (a confirmar) 3. Reunião de Obra - Exposição Joaquim Vieira (a confirmar) Palácio do Freixo, Porto (1996 30 Nov: "Viajar / Coleccionar" Eduardo Souto Moura us dos Transporte Alfândega do Porto /15 Dezembro Casa dos 24, Porto 22 de Abril Nuno Tasso de Sousa 07 Dez: "Fernando Távora – Eu sou a Arquitectura Portuguesa" Manuel Mendes iemorações do Ordem dos Arquitectos Secção Regional do Norte dia Mundial da Arquitectura OASRN 20 Nov-06 Maio 2005/06 *

1. Prémio Fernando Távora

прокто

4. Obra Aberta

Visitas guiadas a obras de arquitectura de Fernando Távora,

5 de Fey — 6 Majo (Sábados)

5. A Festa

l Love Távora Quinta da Conceição,

Leca da Palmeira

o6 de Maio, 22 horas

DESIGN

Lizá Defossez Ramalbo and Artur Rebelo

Matosinhos, Portugal

ART DIRECTION Lizá Defossez Ramalho and Artur Rebelo

DESIGN OFFICE R2 Design

CLIENT

Ordem dos Arquitectos -Secção Regional do Norte

PRINCIPAL TYPE. Grotzec Headline Condensed and Rongel Osf

DIMENSIONS 47.2 x 67 in. $(120 \times 170 \text{ cm})$

Alexa Nosal JUDGE

The diverse array of visual directions represented in this TDC competition was an obvious reminder of how dynamic and exciting our graphic world is. Many different design styles got my attention and my vote. Yet, what attracted me to the Max Bill book were qualities akin to my own design philosophy.

One theme that is central to my philosophy is the concept of totality. The strength of this book lies in its conception and execution as a unified product. The front cover with its large, black, singular statement, "bill," aptly begins the book. This visual transforms into a flowing stream of vividly colored words that lead to the table of contents. Here, the reader pauses to recap what proceeded and prepare for what will come. The ensuing text pages are a wonderful contrast of bold and light, large and small typography. The grid structure is classic, yet contemporary, with an aesthetic sensitivity to the period in which Bill worked. Each of the text sections and their corresponding illustrations are linked together by reintroducing the cover's typographical statement. The book then ends as it visually began: cover and contents projecting a cohesive visual direction.

The book's design demonstrates a particular sensitivity to the interplay among the elements. The calculated relationship of space and typography makes the book very readable. The typography, set in Monotype Grotesque, composed in all lowercase, is exact in its details. The design is clean, uncluttered by superficial inclusions. The clear structure of the book supports the verbal and illustrative contents, enabling the reader to concentrate on each element without competition from the other items on the spread. This is extremely appropriate to the book's function, showcasing the work of Max Bill.

The Max Bill book is a successful harmony of aesthetic and function. My compliments to the designers on a job well done.

Sascha Lobe and Ina Bauer DESIGNERS

Max Bill wrote in 1937: "Typography is the design of a space that results from function and matter. The determination of function, the choice of matter, the interconnection with the order of space, are the tasks of the typographer... Typography can be used in very different ways. The simple solution however most closely corresponds to its innermost nature...."

For us, 70 years after his typographical main works, designing a Bill catalog doesn't mean imitating Bill's design concept, but translating it into a contemporary form.

For the differentiation of text pages and picture pages we chose different types of paper, and within the layout we developed a clear, strongly structured typography with distinct contrasts in size and type style. The breadth of Bill's work as painter, designer, sculptor, and architect is expressed in large-sized lines of writing that, in the book introduction, run off the page format and are cited in the individual chapters as introductions or closings.
bill, itekt, desig

HALLE

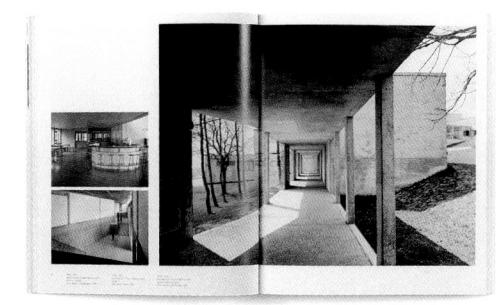

max bill die unendlichkeit als plastisches thema

in der skondinuläthe habe ich versucht, eine seit laugen im mis schwebend eine zu ratigisteren, die Jangen im mis schwebend eine zu ratigisteren, die Jangen im mis schwebend eine zu ratigisteren, die Jangen der Schwebend eine Zeitze bei der Schwebend eine Zeitze bei der Schwebend zu der Schwebe

and in their to officialization years to all their selections are excellent in the subscitciting to the visual administration of their selections are excellent in the subscitcitions are excellent in the subscitcition and their selections are excellent in the subscitcition and their selections are selected as the subscitcition and their selections are selected as the subscitcit of their selections are selected as abministration and their selections are selected as abministration and their selections are selected as a selection and their selections are selected as a selection and their selections are selected as a selection and their selections are selected as the selection and unconflictive selections are selected as a selection and the selection and the selection are selected as a selection and the selection are selected as selections are selected as a selection and are selected as a selection and are selected as all the selections are selected as a selection and are selected as an are selected as a selection and are selected as a selection ar

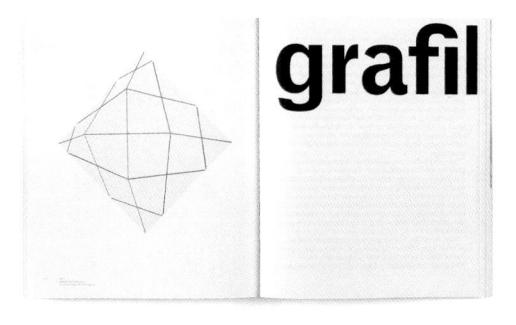

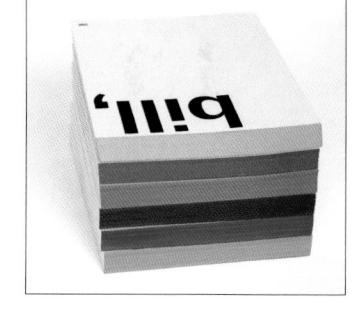

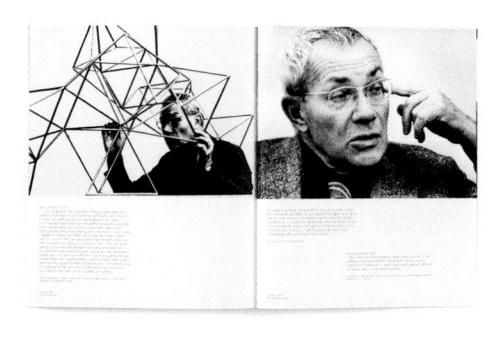

DESIGN

Sascha Lobe and Ina Bauer Stuttgart, Germany

CREATIVE DIRECTION Sascha Lobe

DESIGN OFFICE

L2M3 Kommunikationsdesign GmbH

CLIENT

Institut für Kulturaustausch, Tübingen, Germany

PRINCIPAL TYPE

Monotype Grotesque

DIMENSIONS

9.1 x 10.6 in.

(23 x 27 cm)

Emily Oberman JUDGE

This piece is amazing. As far as I can tell this guy did everything: he designed the fonts, as well as the piece, wrote the copy, and even printed the thing while on an internship at a printer. That's pretty great.

But the real beauty of this piece, to me, was that it is simple and complex at the same time. The fonts are beautiful, smart, funny, and dexterous. They seem timeless and trendy. I love how beautifully they work together. I also love the use of the two colors (plus black) to support the fact that the faces overlap each other in their style and use. It gives the booklet a nearly 3-D quality that implies an animation and a liveliness that leaps off the page at you. The fonts (and the dingbats) feel Germanic and Texan at the same time. Each spread reveals a different aspect of the personality of the face. I especially love the interview with the typeface that actually requires 3-D glasses to read. Oh, and the cover folds out to be a spec sheet of the whole font family. Very nice.

The fact that this is a student piece makes the whole thing even more wonderful and inspiring—though this piece would be award-worthy even outside the student category.

Peter Brugger DESIGNER

The concept of Gringo is a fusion and merging of type cultures to cross borders and create something new. Gringo is presented in a limited edition letter-size brochure printed on a letterpress.

The Gringo typeface family contains 27 different varieties divided into three groups: sans, Slab, and Tuscan. The three styles have different backgrounds, but they're like a journey from Europe to Texas or vice versa. Due to the family's consistent structure, the single groups can be mixed as you wish. Furthermore, every variety comes in light, medium, and bold. There are three widths from narrow to wide. There is also a Dingbats font.

FOULS IN USE

Rifter the tragic user between the states, firmerica turned to the uninting of the Illust. The signified of this era use the building of the trans-continental ratifoads. The advance of the ratifoads used to soom cases, predeting and unecrupations. Whole communities found themselves

₩ SLAB MEDIUM

After the tragic war between the states, fimerica turned to the unioning of the URL. The symbol of this era was the building of the trans-continental railroads. The advance of the railroads was is some cases, predatory and onscruptious. Unlet communities found themselves victimized by an ever-grouing oper – the Iron lorse. It was this uncertain and sauves age that gave to the world, for good or III, its most famous outlaws, the brighter Franks and Jesse James.

+===

TUSCAQ

AFTER THE TRAGIC WAR BETWEEN THE STATES, AMERICA TURNED TO THE WINNING OF THE WEST. THE SYMBOL OF THIS ERA WAS THE BUILDING OF THE TRANS-CONTINENTAL RAILROADS WAS IN SOME CASES, PREDATORY AND UNSCRUPULOUS. WHOLE COMMUNITIES FOUND THEMSELVES VICTIMIZED BY AN EVER-GROWING OGRE - THE IRON HORSE. IT WAS THIS UNCERTAIN AND LAWLESS AGE THAT GAVE TO THE WORLD, FOR GOOD OR ILL, ITS MOST FAMOUS OUTLAWS, THE BRO

ABCDEFGHIJKLMNOPORSTUVWXYZ abcdefghijklmnopqrstuvwxyz • 0123456789 (Sans Light Narrow)

BIUGO

FTER THE TRAGIC WAR BETWEEN THE STATES, AMERICA TURNED TO THE WINNING OF THE WEST. THE SYMBOL OF THIS EAR WAS THE OUTLOING OF THE TRANS-CONTINENTAL RAILAGORDS. THE ADVANCE OF THE RAILAGORDS WAS IN SOME CASES, PREDATORY AND UNSCRUPULOUS. WHOLE COMMUNITIES FOUND THEMSELVES VICTIMIZED BY AN EVER-GROWING OGRE — THE IRON HORSE. IT WAS THIS UNCERTAIN AND LAWLESS AGE THAT GAVE TO THE WORLD, FOR GOOD OR ILL, ITS MOST FRMOUS OUTLAWS, THE

ATTENDED THE STATES, AND ADDRESS OF THE STATES, AND ADDRESS, PREDATORY AND UNSCRUPULOUS. WHOLE, CONDUCTATION BRIEDROSS WAS 11 SOME CASES, PREDATORY AND UNSCRUPULOUS. WHOLE, SOME CASES, PREDATORY AND UNSCRUPULOUS. WHOLE, SOME CASES, PREDATORY AND UNSCRUPULOUS. WHOLE, STATES OF THE IROO THE WORLD, FOR GOOD OR ILL, ITS MOST

Riter the tragic war between the states, fimerica turned to the winning of the West. The symbol of this era was the building of the transcontinental railroads. The advance of the railroads was in some cases, predetory and unscrupulous

SANS MEDIUM &

Whole communities found themselves victimized by an ever-growing ogre—the Iron Horse. It was this uncertain and laudess age that gave to the world, for good or ill, its most famous outlaws, the brother frank and Jesse James.

Otngbab

0

DESIGN PROJECT

Peter Brugger

Karlsruhe, Germany

LETTERING

Peter Brugger

SCHOOL

Hochschule Pforzheim

PROFESSORS

Michael Throm and Lars Harmsen

PRINCIPAL TYPE

Gringo

DIMENSIONS

8.7 x 11.2 in.

 $(22 \times 28.5 \text{ cm})$

Woody Pirtle JUDGE

Circular is the magazine of the London-based Typographic Circle, an organization dedicated to the advancement of, and exposure to, the best of the typographic arts. Published once each year, this eclectic piece is conceived and designed to reflect the organization's goals, aspirations, and continually evolving nature.

The magazine is designed to command the attention of its recipients, keeping them well informed, challenged, and inspired by a collection of essays on a variety of subjects centered on typography. Peter Bain's piece on the evolution of blacklettering is a perfect case in point.

What I love about this particular issue is its refined sense of eclecticism. It is a beautiful example of British restraint, on one hand, and a playful exercise in contrasts of subject matter, papers, and scale, on the other. I particularly like the divider spreads, incorporating clever monograms of each of the featured artists against solid red backgrounds. These function as chapter openers for each of the various subjects, providing pacing and effective exercises in "typographic tinkering."

This piece is a perfect example of letting design take a back seat to content within each article, while bracketing the articles with powerful spreads that are each examples of typographic discovery.

As trade publications go, this is one of the best I've seen recently. Clearly, this designer has exhibited the confidence to use restraint, where others might have misused the opportunity and let design get in the way.

Domenic Lippa DESIGNER

The problem for issue 13 of the Typographic Circle's magazine Circular is the same problem we have with every issue: How to create an eclectic publication that reflects the Circle's aims and aspirations?

Because the magazine is published once a year, we are not under the same continuity issues as other magazines. In fact, our past issues have all had different designs, often based on different formats and binding methods. I suppose the biggest challenge is to produce something that visually excites the most demanding of audiences—designers and typographers!

The solution rested in the interplay among the different personalities' initials, which we turned into typographic monograms. With just black and red as the primary color palette, the magazine was printed on a playful mix of different paper stocks, all left unbound.

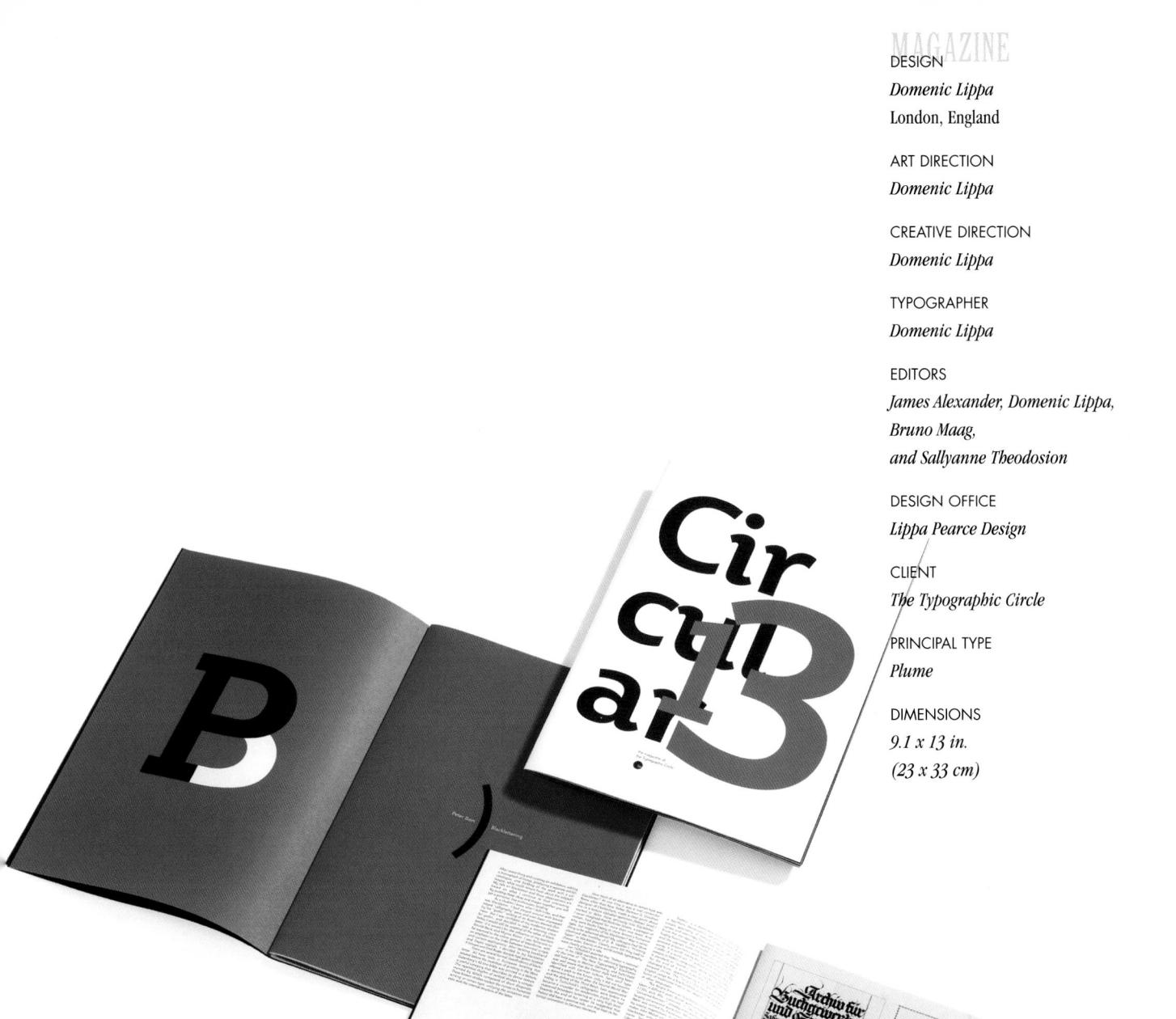

06_07

Steve Sandstrom JUDGE

I selected a piece of work that was a remarkable effort entitled "Trans-Sensing/Seeing Music" by a student named Wen-Hua Hu from California College of the Arts. The piece is a 144-page thesis project, case bound with a cloth cover—a meticulous execution at that. The designer's balance of white space to text and imagery is beautiful. If you don't read a single word, you will still be held captive by the detail, depth, and fascinating graphic quality of the book.

The book is Wen-Hua Hu's attempt to visualize music, which is demonstrated in three phases: (1) semi-empirical mappings, utilizing a grid system based on a timeline; (2) intuitive, based on the designer's own feelings applied to a more complex grid; and (3) emotional/expressive, based on the spirit of the music without any grid or rational analysis. If this sounds complicated, it is. This is not going to make any literary best-seller list.

The typography and layout have both structure and lyrical qualities. There is a sense of the geometry and mathematics of music throughout. Its formality appears to me to represent a symphony of classical music. As a piece of literature, it may be challenged. As a piece of science, it might not be. But as a piece of visual art and as a demonstration of the subject, it succeeds very nicely. It gets a "Wow" from everyone I've shown it to.

Wen-Hua Hu|DESIGNER

This project was my BFA thesis submission at the California College of the Arts. There was no assigned topic. Instead, we were challenged to develop an original, compelling, rich design project that embodied the sum of our training and the statement "great design must communicate."

Inspired by the phenomenon of synaesthesia, a neurological condition where people experience cross-modal sensory perception—hearing colors or tasting shapes—I originally set out to decode the visual arts of the blind by translating colors to sound. I started exploring audio-to-visual mappings using empirical methods and identified three mappings: color to sound, shape to rhythm, and size to beat. In the next phrase I began to introduce more intuitive elements and finally embraced a completely expressive/emotional approach.

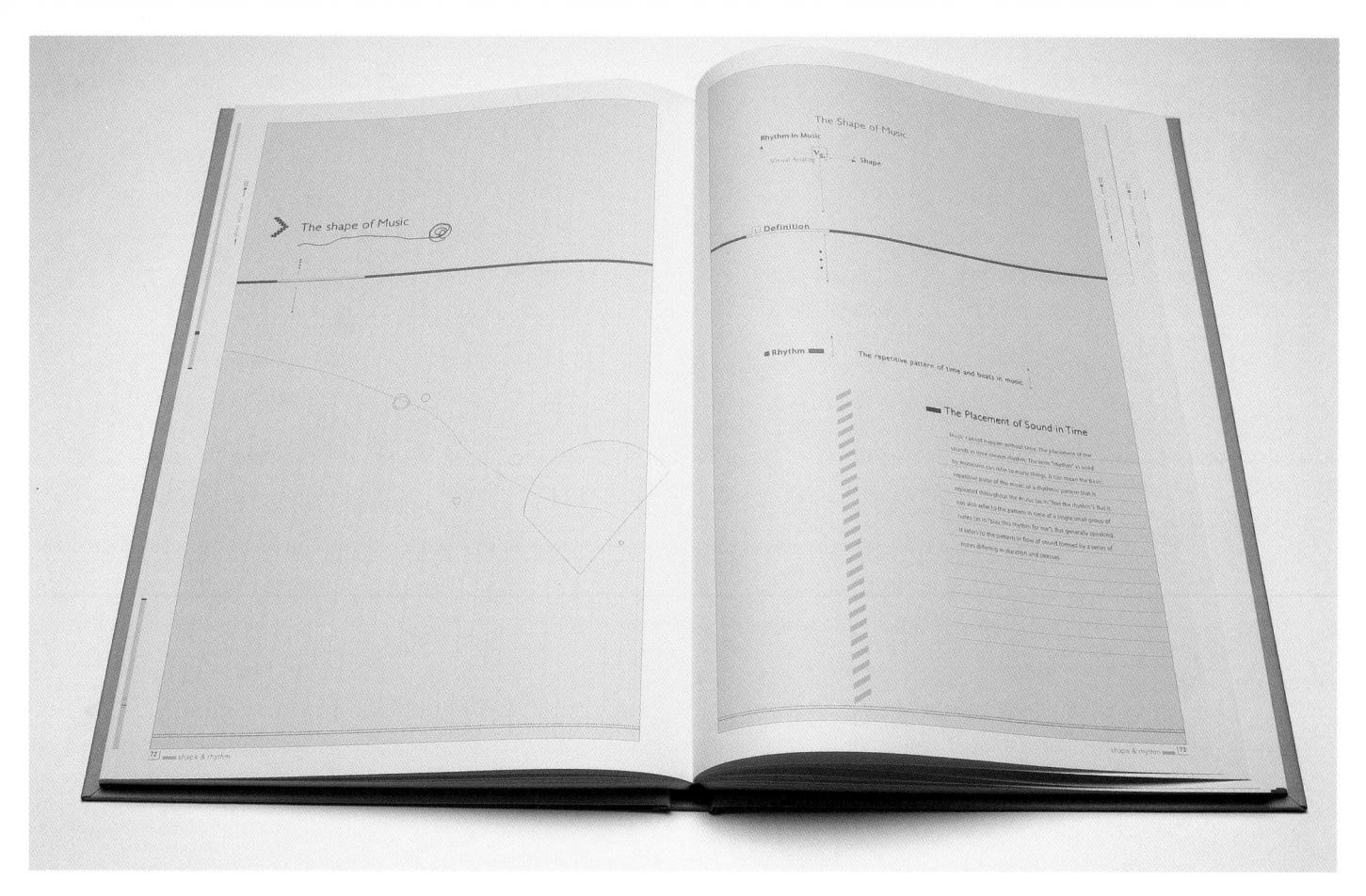

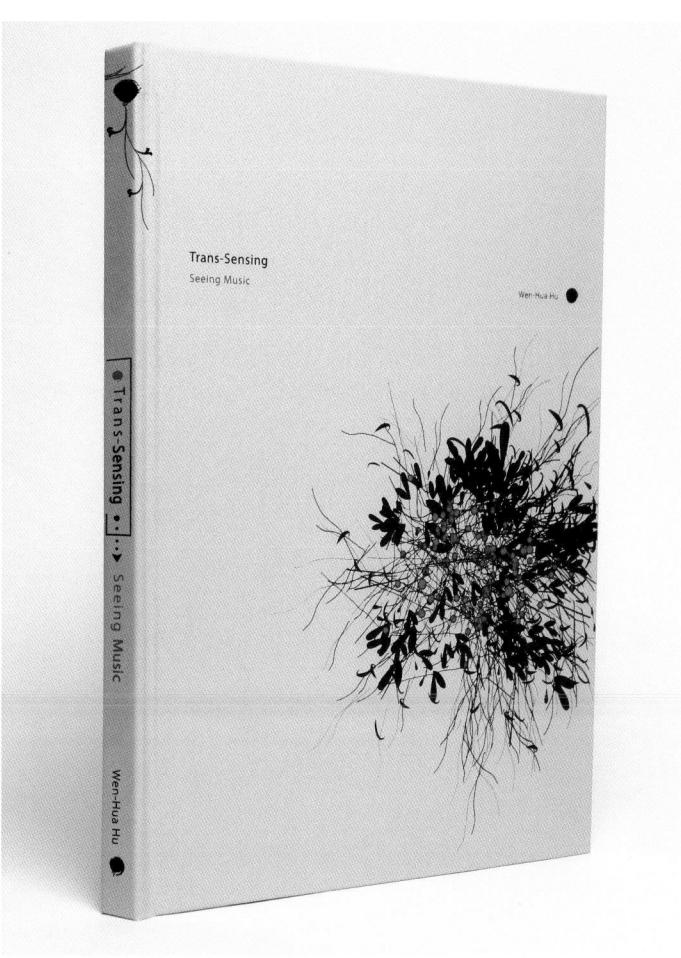

STIDENT PROJECT

*Wen-Hua Hu*San Francisco, California

SCHOOL

California College of the Arts

INSTRUCTORS Leslie Becker, David Karam, and Michael Vanderbyl

PRINCIPAL TYPE

Avenir, Gill Sans, Adobe Jenson,
and Myriad Pro Light

DIMENSIONS 10 x 14 in. (25.4 x 35.6 cm)

Brady Vest JUDGE

OK, it was a lot of work to look through all the submissions, each commanding a different focus or a sensitivity in judging why one was or was not to be given a thumbs-up. But only a few very nearly jumped off the table out of sheer beauty, elegance, punch, and a true sense of craft. This was one of those pieces. I seem to recall every judge flipping over this one—probably because it's a student entry.

This piece did a really nice job of presenting the history of wood type and referencing the history of type specimen books, while, I think, packaging and presenting that in a very non-nostalgic way. With all these really fresh, almost irreverent typographic illustrations sitting next to this amazingly sturdy and well-crafted specimen book and box, the piece looked like it could have come right out of a museum. All these elements went together seamlessly and communicated the project as an investigation into type—specifically wood type—and a personal expression of craft and art. If it wasn't so huge, I would have stolen it.

Daniel Janssen DESIGNER

The publication Wood Type Manufacture Hamburg: History and Future was developed to accompany the exhibition workshop in the graphical crafts department of the Museum of Work in Hamburg. The idea was to give the exhibition workshop a corporate design of wood type manufacture to make the technique and use of the produced letters more illustrative and obvious to the visitor. The material—a type specimen book, examples of use, and a project book—shows the rich variety of the exhibition workshop: It documents its history and builds a bridge between the old technique and innovative uses. The type specimen book shows the historical type models. The examples of use could be a source of inspiration for new typographical work.

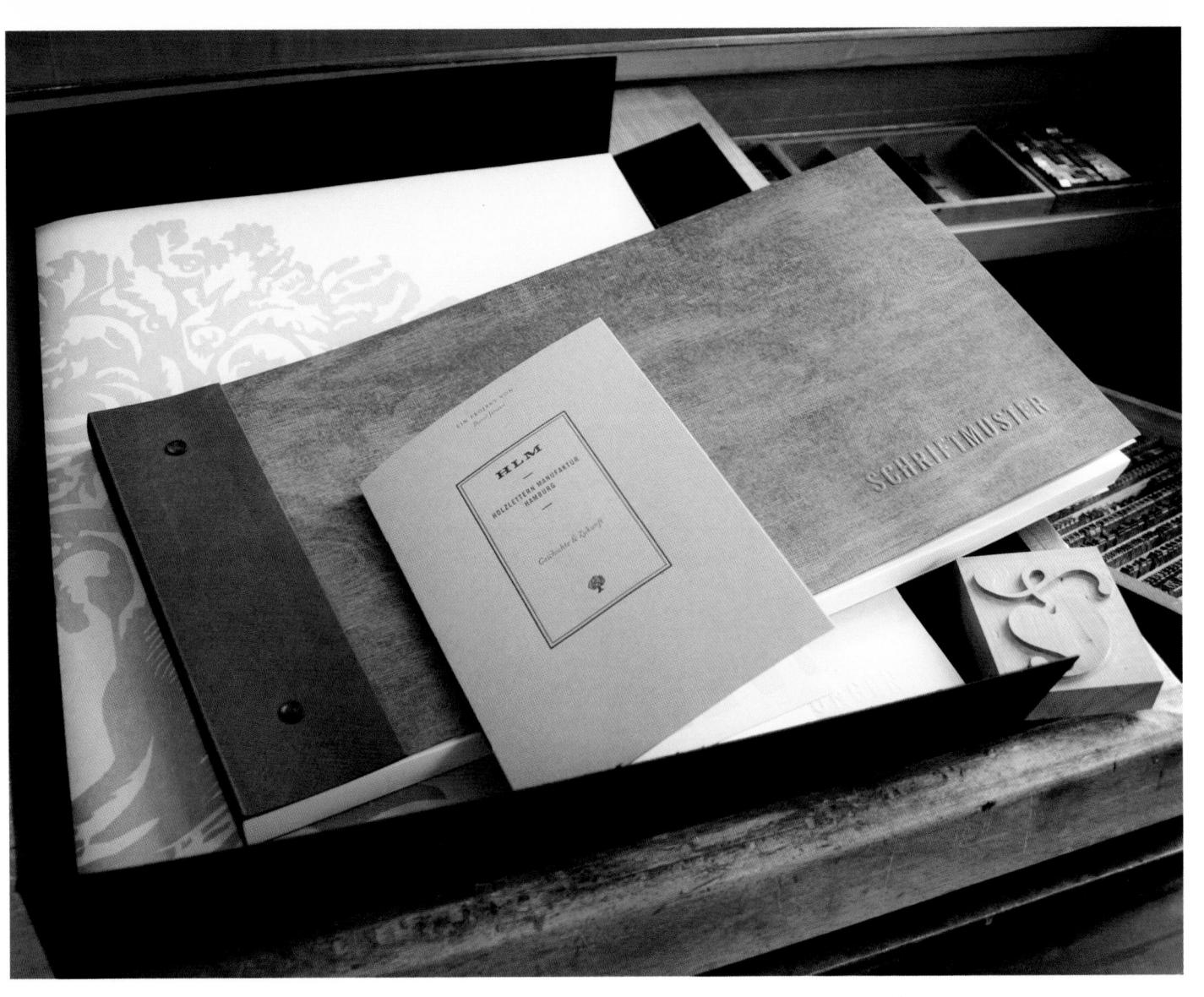

STILDENT PROJECT

Daniel Janssen Hamburg, Germany

SCHOOL University of Applied Sciences Hamburg

PROFESSORS

Jovica Veljovic and Peter Kabel

PRINCIPAL TYPE

Historical wood type

DIMENSIONS 16.5 x 20.5 x 3.5 in. (42 x 52 x 9 cm)

TDC52 ENTRIES SELECTED FOR TYPOGRAPHIC EXCELLENCE

DACK AGING

Liza Butler Napa, California

CREATIVE DIRECTION

David Schuemann

DESIGN OFFICE CF Napa

CLIENT

John Anthony Vineyards

PRINCIPAL TYPE

Centaur and HTF Requiem

DIMENSIONS 4 x 5.25 in. (10.2 x 13.3 cm)

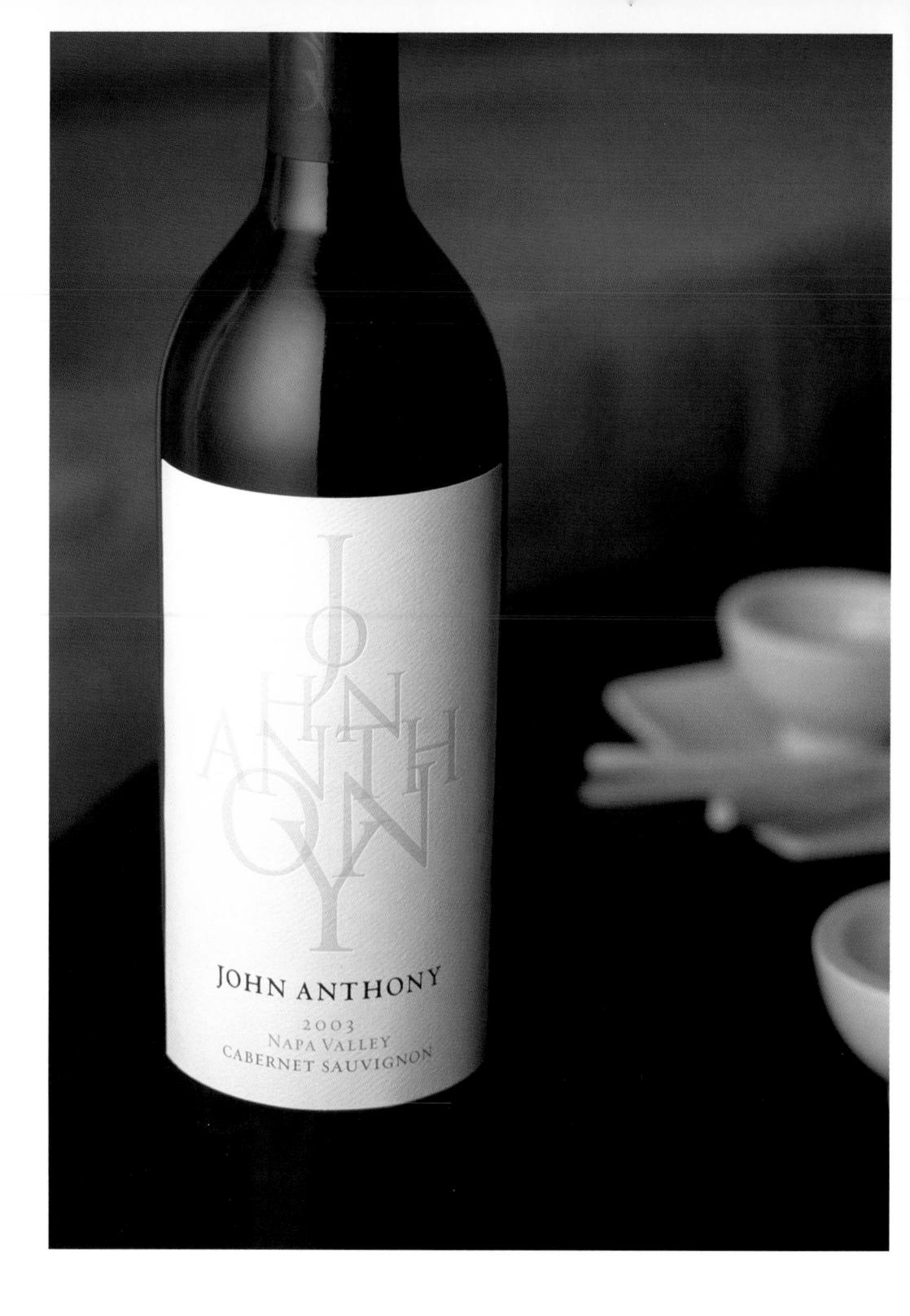

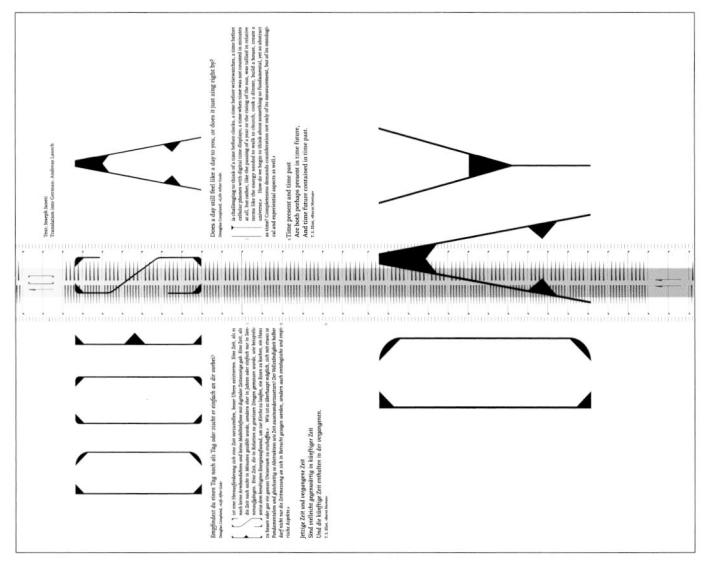

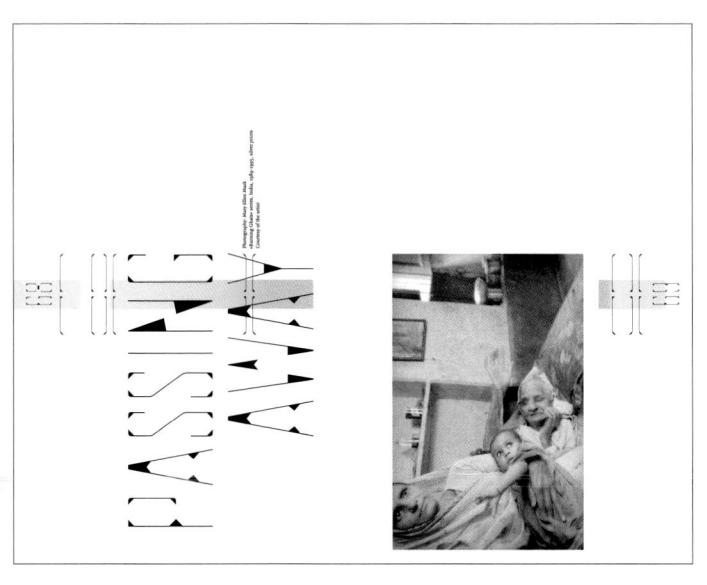

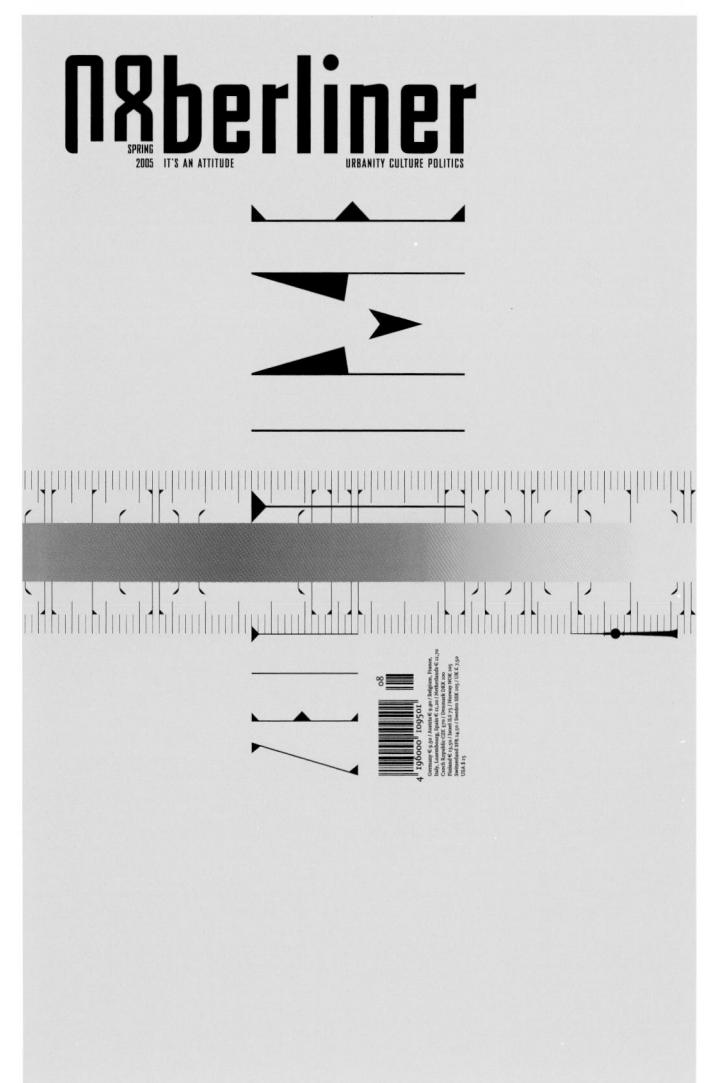

MACAZINE DESIGN

Thees Dohrn, Christina Poth, and Philipp von Robden Berlin, Germany

ART DIRECTION

Thees Dohrn and Philipp von Rohden

CREATIVE DIRECTION

Thees Dohrn and Philipp von Rohden

DESIGN OFFICE

Zitromat

CLIENT

Berliner Magazine

PRINCIPAL TYPE

Timeless Regular and

FF Quadraat Regular

DIMENSIONS

8.5 x 13 in.

(21.5 x 33 cm)

DESIGN
Nadine Nill
Moessingen, Germany
DESIGN OFFICE
Nadine Nill
PRINCIPAL TYPE
Bauer Bodoni

DIMENSIONS *Various*

Nadine Nill T 0049 (0)7473 27 25 46 Lange Straße 45 F 0049 (0)7473 37 07 38 72116 Mössingen E mail@snadinentide

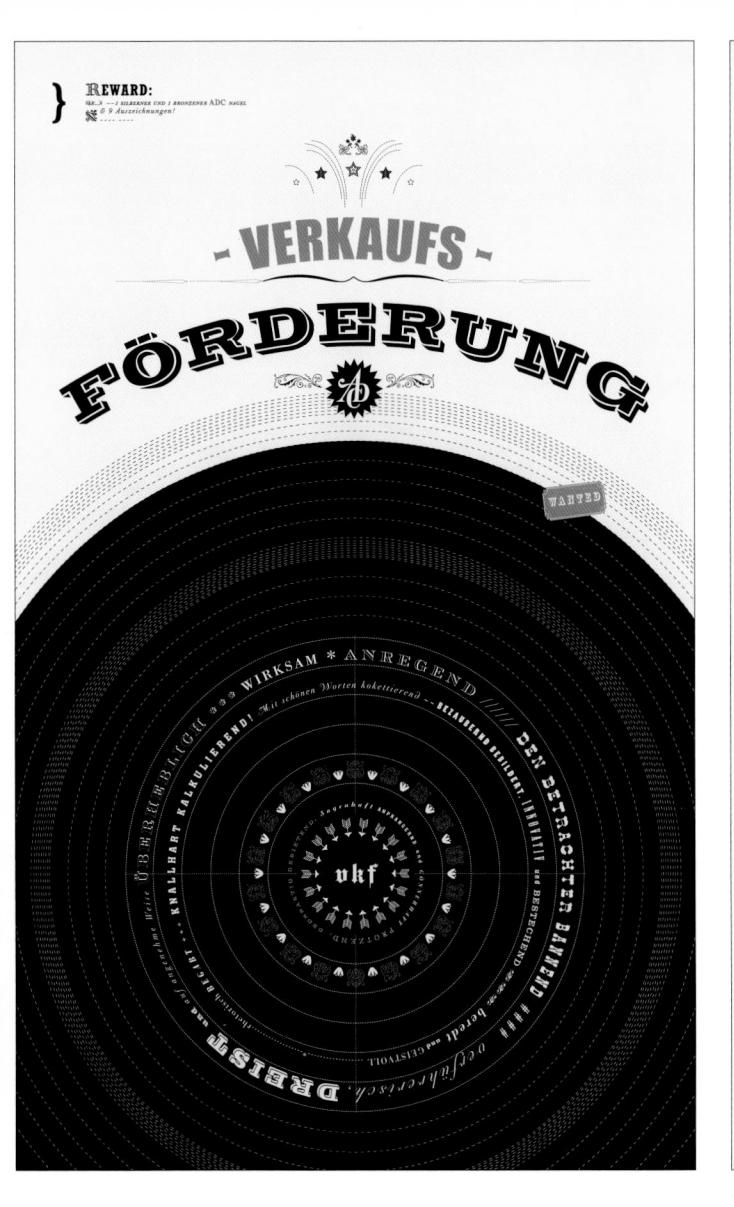

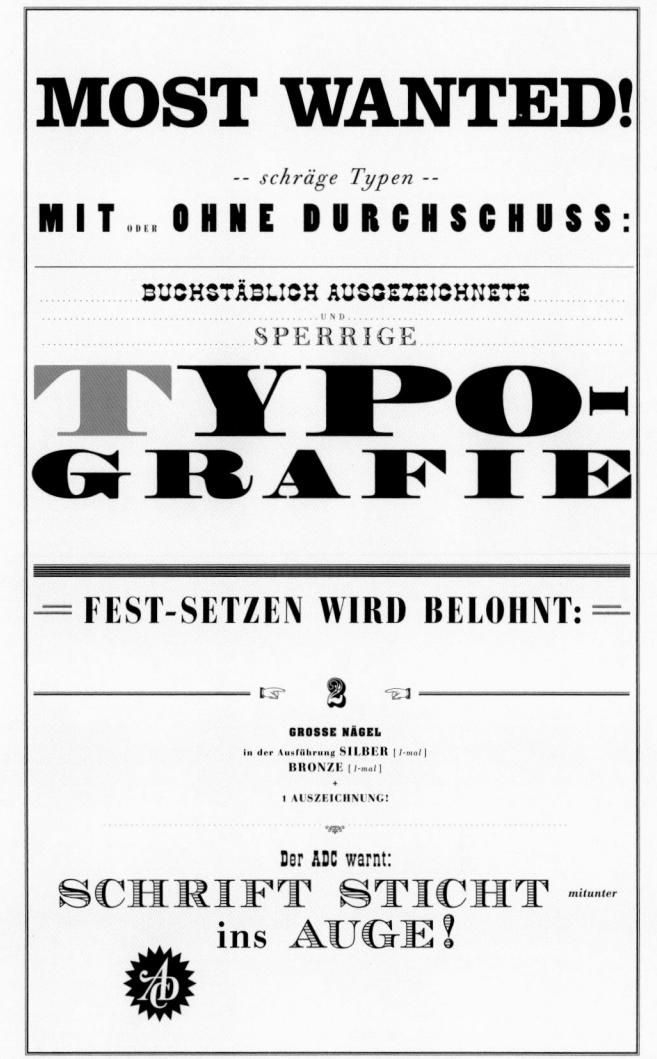

DAGMER

Susanne Hörner

Stuttgart, Germany

ART DIRECTION

Kirsten Dietz

CREATIVE DIRECTION

Jochen Rädeker and Felix Widmaier

LETTERING

Susanne Hörner

AGENCY

strichpunkt

CLIENT

Art Directors Club Deutschland

PRINCIPAL TYPE

Various

DIMENSIONS

27.4 X 44.3 in.

((0.5 .. 110.5 ...

(69.5 x 112.5 cm)

DESIGN
Shinnoske Sugisaki
Osaka, Japan

ART DIRECTION

Shinnoske Sugisaki

DESIGN OFFICE Shinnoske, Inc.

CLIENT
Alliance Graphique
Internationale (AGI)

PRINCIPAL TYPE

Helvetica Neue Black

DIMENSIONS 20.3 x 28.7 in. (51.5 x 72.8 cm)

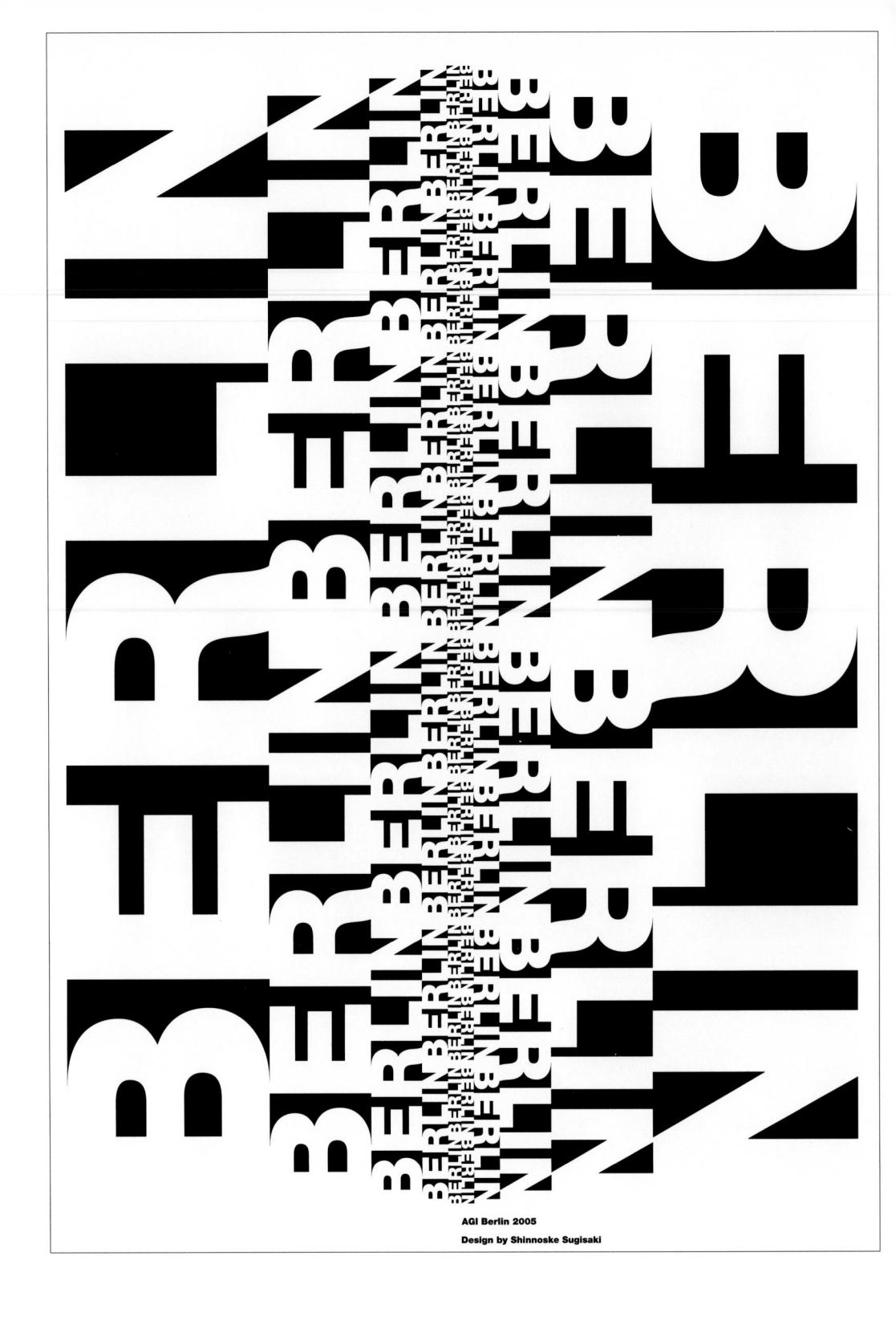

DESIGN

Nedjeljko Spoljar and Kristina Spoljar

Zagreb, Croatia

ART DIRECTION

Nedjeljko Spoljar

CREATIVE DIRECTION

Nedjeljko Spoljar

DESIGN OFFICE

Sensus Design Factory

CLIENT

Croatian Designers' Society

PRINCIPAL TYPE

Fobia Gothic and FF Profile

DIMENSIONS

6.7 x 11.8 in.

 $(17 \times 30 \text{ cm})$

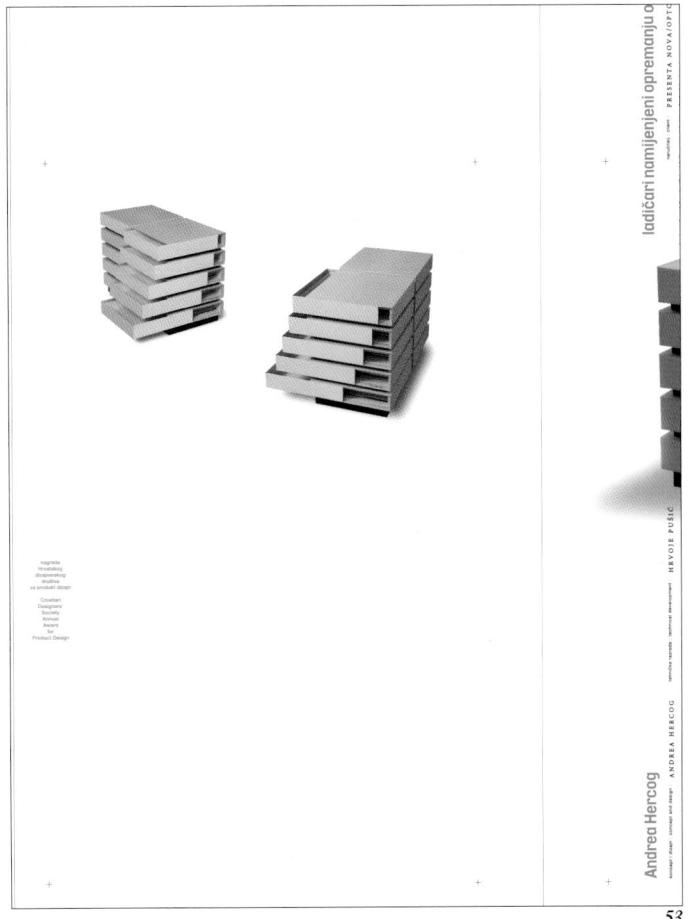

DESIGN

Belinda Bowling, Sonja Max, Tiffany Place, Yuri Shvets, and James Tee Seattle, Washington

ART DIRECTION *James Tee*

CREATIVE DIRECTION

Jack Anderson

DESIGN STUDIO

Hornall Anderson Design Works

CLIENT

Allconnect

allconnect

LOGOTYP

Buck Smith

St. Louis, Missouri

ART DIRECTION

Buck Smith

DESIGN OFFICE

Fleishman-Hillard Creative

CLIENT

The Joy Foundation

PRINCIPAL TYPE

New Century Schoolbook

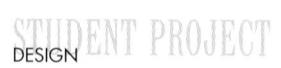

René Siegfried Kiel, Germany

SCHOOL

Muthesius Kunsthochschule Kiel

PROFESSORS

Silke Juchter and Klaus Detjen

PRINCIPAL TYPE

Futura Book, Adobe Garamond, Shelley Andante Script, and Zentenar-Fraktur

DIMENSIONS 6.3 x 8.3 in. (16 x 21 cm)

STUDENT PROJECT

Hsin-Yi Wu

Brooklyn, New York

SCHOOL

Pratt Institute

INSTRUCTOR

Olga de la Roza de Gutierrez

PRINCIPAL TYPE

Garamond

DIMENSIONS

9 x 12 in.

(22.9 x 30.5 cm)

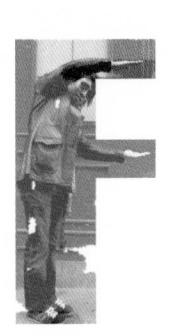

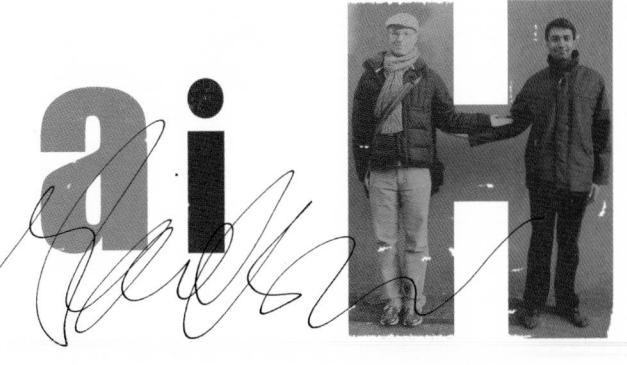

DESIGN

Tivy Davies

London, England

ART DIRECTION

Mark Norcutt and Laurence Quinn

CREATIVE DIRECTION

Nick Bell

AGENCY

JWT London

CLIENT

Diageo-Smirnoff

PRINCIPAL TYPE

Unit 3 Extra

DIMENSIONS

24 x 11 in.

 $(61 \times 27.9 \text{ cm})$

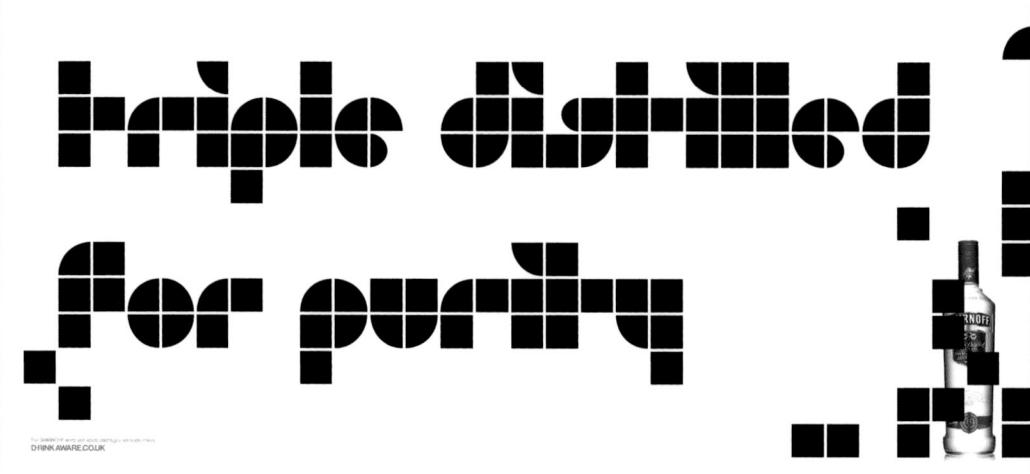

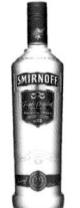

DON'TNUT

Approximately 30% of adolescents ages 12 to 19 in America are overweight and 15% percent are obese. Obesity in adolescents increases their chances of developing asthma, diabetes, high blood pressure, and sleep apnea—conditions likely to persist in adulthood.

Don't succumb to unhealthy food temptations.

American Obesity Association

STILDENT PROJECT

Julyanne Liang San Francisco, California

SCHOOL

California College of the Arts

INSTRUCTOR

Mark Fox

PRINCIPAL TYPE
Frankfurter and Futura

DIMENSIONS 20 x 40 in. (50.8 x 101.6 cm)

Richard Boynton

Minneapolis, Minnesota

ART DIRECTION

Richard Boynton and Scott Thares

CREATIVE DIRECTION

Richard Boynton and Scott Thares

LETTERING

Richard Boynton

DESIGN OFFICE

Wink

CLIENT

Target

CTILDENT PROJECT

Ramon Grendene

Weimar, Germany

SCHOOL

Faculty of Art and Design, Bauhaus University, Weimar

PROFESSOR

Alexander Branczyk

PRINCIPAL TYPE

FF DIN and Chalet Book

DIMENSIONS

Various

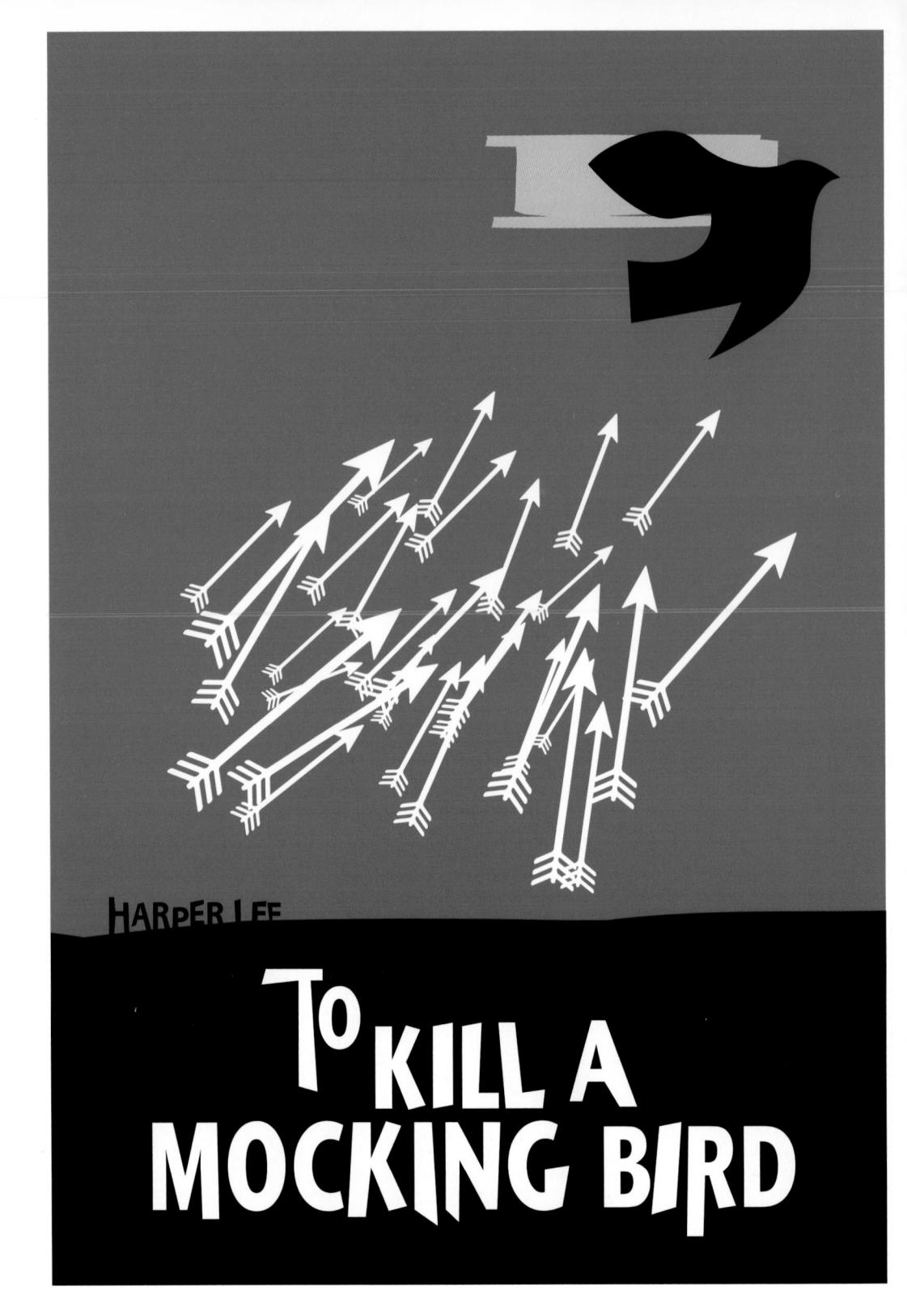

STILDENT PROJECT

Moyeenul Alam Miami, Florida

SCHOOL

Miami Ad School

INSTRUCTOR *Judy Penny*

PRINCIPAL TYPE

ITC Stone Sans modified

DIMENSIONS 10 x 15 in. (25.4 x 38.1 cm)

CORPORATE IDENTITY

Jun Takechi

Tokyo, Japan

ART DIRECTION

Jun Takechi

CLIENT

incell corp.

PRINCIPAL TYPE

Custom

DIMENSIONS

Various

DESIGN

Muy Billy
Winston-Salem, North Carolina

ART DIRECTION

Muy Billy

CREATIVE DIRECTION Hayes Henderson

DESIGN OFFICE
HENDERSONBROMSTEADART

CLIENT
Musicmaker Relief Foundation

PRINCIPAL TYPE

HTF Champion and Brothers Bold

DESIGN

Larry Anderson, Holly Craven, Chris Freed, and Jay Hilburn Seattle, Washington

ART DIRECTION

Larry Anderson

CREATIVE DIRECTION

Jack Anderson

DESIGN STUDIO

Hornall Anderson Design Works

CLIENT Blisscotti

LOLUMEN

LALEH HAAS

0421 ' 33 65 815 · 0421 ' 33 65 816 · 0172 * 44 50 558 · post@lolue.di Richard-Wagner-Straße 31 · 2820g Bremer COLUMN CO

Exhack-Wagner-loody 21 - Aking Brones

FIRE SOUND AND THE REGEN HARDN SPILL ZEE EINEM FLECTIFFEREITH STILL MARTHAUSPIELCHEN SETROTTES, USER OFWINNER DAKE MORGEN DAK WETTER RESTEMMIN, DIE RAFTEN MISCHT LOLUGWISCHMINGER GERTAUEN LEGEN WIRDER DIE SOUND SETHENT, ARER DIE BLUMEN SEILEN SO TRABERD AUS. DER BISSTEEN REGEN WERDE SETEN EIGEN WERDE SETEN EIGEN WERDE SETEN EIGEN WERDE SETEN EIGEN

Richard-Wagner-Straße 31 · 28209 Bremen

CORPORATE IDENTITY

Anne-Lene Proff Berlin, Germany

COPYWRITER

Barbara Kotte

DESIGN OFFICE

scrollan

CLIENT

Lolü — Kids Wear, Laleh Haas

Bremen, Germany

PRINCIPAL TYPE

FF Quadraat Small Caps and

FF Quadraat Italic

DIMENSIONS

Various

LOLU

DEPARTMENT OF MERRIMENT CURO FINANCIAL MANAGEMENT 108 4TH AVE. SOUTH, SUITE FRANKLIN, TENNESSEE 37064

NOTICE NUMBER: EFFECTIVE DATE: TAX YEAR: 2005 EGG NOG: YES

DON.T U LOODOOOVE TH3 HOL1DAY5?

CLAUDE P. HOOT 100 STABLE COURT FRANKLIN, TN 37069-1608

FOR ASSISTANCE CONTACT THE OFFICE OF: Office of S. Clause

Non Toll Free #: 1-615-599-1300

XMA5

OFFICIAL NOTICE

We intend to levy holiday cheer. Please respond NOW.

At the end of Calendar year 2005 all parties receiving this notice will be required to have a magnificently happy Holiday season. If you have already had, or are now having, or are planning to have a magnificently happy Holiday season, you may disregard this notice.

Thank you for your cooperation.

If you have any questions regarding compliance or seek warmest wishes for a happy 2006, please contact: Jason Childress, Noel Hartough, Leslie Tolman or Jennifer Knutson at Curo Financial Management.

DESIGN

Clark Hook

Nashville, Tennessee

AGENCY

Lewis Communications

CHENT

Curo Financial Management

PRINCIPAL TYPE

OCR B

DIMENSIONS

8.5 x 11 in.

 $(21.6 \times 27.9 \text{ cm})$

M3RRY-CHR1STMA5 2 U FROM CURO F1NANC1AL (2005)

BULLY
BULLE ONE A HALF
MORELAN HOUSE, AND A STREAM
BULLE WHO HA STOT TO STONEY
MY SOLVE WHO HAVE A STREAM
HALF WHO HAS SOLVE SOLVE
HAS MADERIAN OF TO SE HIS
HAGINE ALL THOSE COMPOUS
MADERIAN AND ASSENCES AND
MAGNITUM DATE OF THE STREAM
SOMEWELD HAVE SOLVED SOLVED TO SOLVED THE STREAM
SOMEWELD HAVE SOLVED TO SOLVED THE SOLVED THE

CRIMINAL

agentic creativity lives at

BILLY BLUE

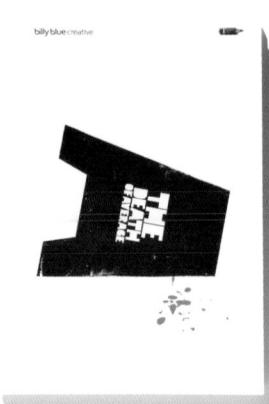

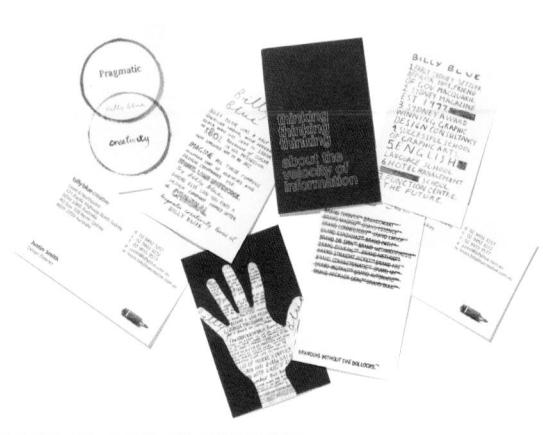

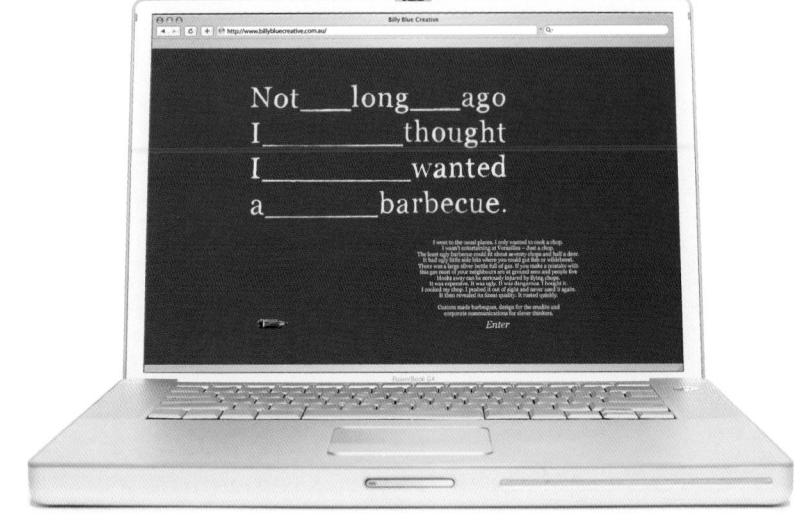

DESIGN DESIGN

Justin Smith

North Sydney, Australia

ART DIRECTION

Justin Smith and Mick Thorp

CREATIVE DIRECTION

Mick Thorp

LETTERING

Justin Smith

DESIGN OFFICE

Billy Blue Creative

PRINCIPAL TYPE

Custom

DIMENSIONS

Brochure: 5.9 x 8.3 in.

 $(15 \times 21 \text{ cm})$

Business Cards: 3.4 x 2.2 in.

 $(8.5 \times 5.5 \text{ cm})$

68

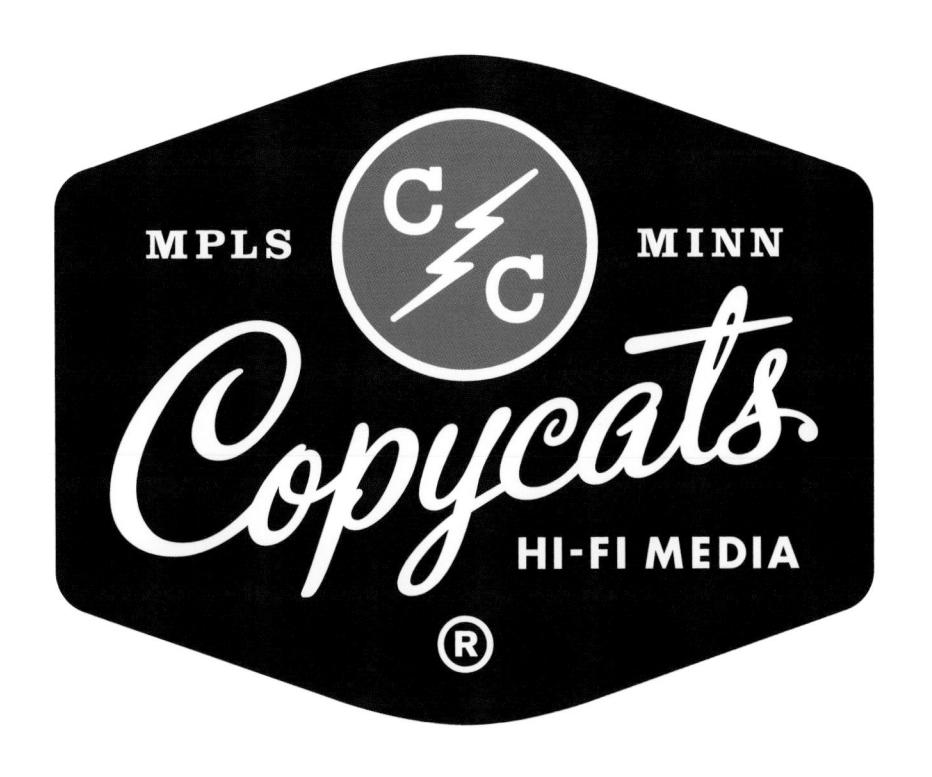

LOGOTYPE

Richard Boynton
Minneapolis, Minnesota

ART DIRECTION

Richard Boynton and Scott Thares

CREATIVE DIRECTION

Richard Boynton and Scott Thares

LETTERING

Richard Boynton

DESIGN OFFICE

Wink

CLIENT Copycats

PRINCIPAL TYPE
Futura, Monterey, and
Trade Gothic Extended

Ed Benguiat

Hasbrouck Heights, New Jersey

ART DIRECTION

Silas Rhodes

CREATIVE DIRECTION

Ed Benguiat

LETTERING

Ed Benguiat

DESIGN OFFICE

Ed Benguiat/Design, Inc.

CLIENT

School of Visual Arts

PRINCIPAL TYPE

Handlettering

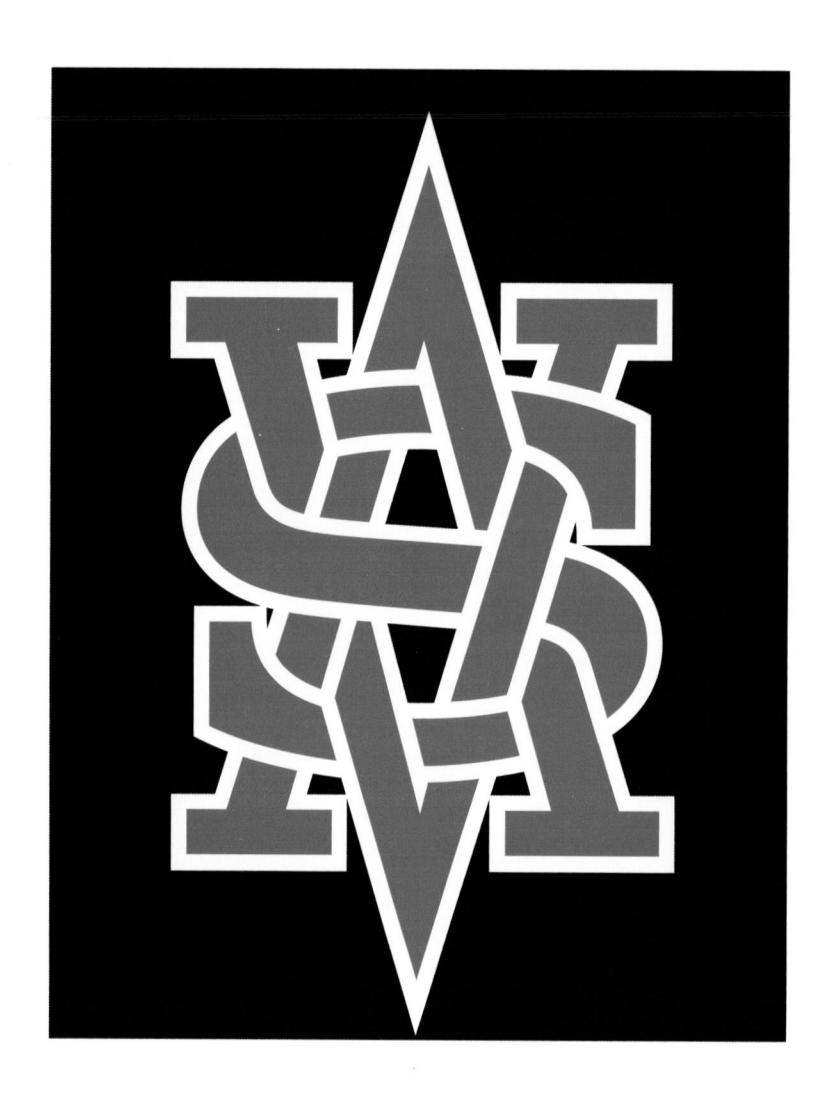
L2M3 KOMMUNIKATIONSDESIGN GMBH HÖLDERLINSTRASSE 57 D-70193 STUTTGART T+49711/9933 91 60 F 9933 9170 ISDN 9933 9180 INFO@L2M3.COM WWW.L2M3.COM

WWW.L2M3.COM

NEUE ADRESSE AB 14.03.2005

L2M3 KQMMUNIKATIONSDESIGN GMBH HÖLDERLINSTRASSE 57 D-70193 STUTTGART T+49711/9933 91 60 F 9933 9170 ISON 9933 9180 INFO@L2M3.COM VWW.L2MS.COM

Sascha Lobe and Ina Bauer Stuttgart, Germany

DESIGN OFFICE

L2M3 Kommunikationsdesign GmbH

PRINCIPAL TYPE

Wilma

DIMENSIONS

Various

CORPORATE IDENTITY

Christian Lenz

Steinfurt, Germany

ART DIRECTION

Christian Lenz

PRINTER

Einblatt-Druck

Kiel, Germany

LASER PERFORATION

Kremo

Mosbach, Germany

STUDIO

Lenz/Typografie & Design

CLIENT

Stöhrmann Fotografie

Hamburg, Germany

PRINCIPAL TYPE

Folio SB Bold Condensed

DIMENSIONS

Various

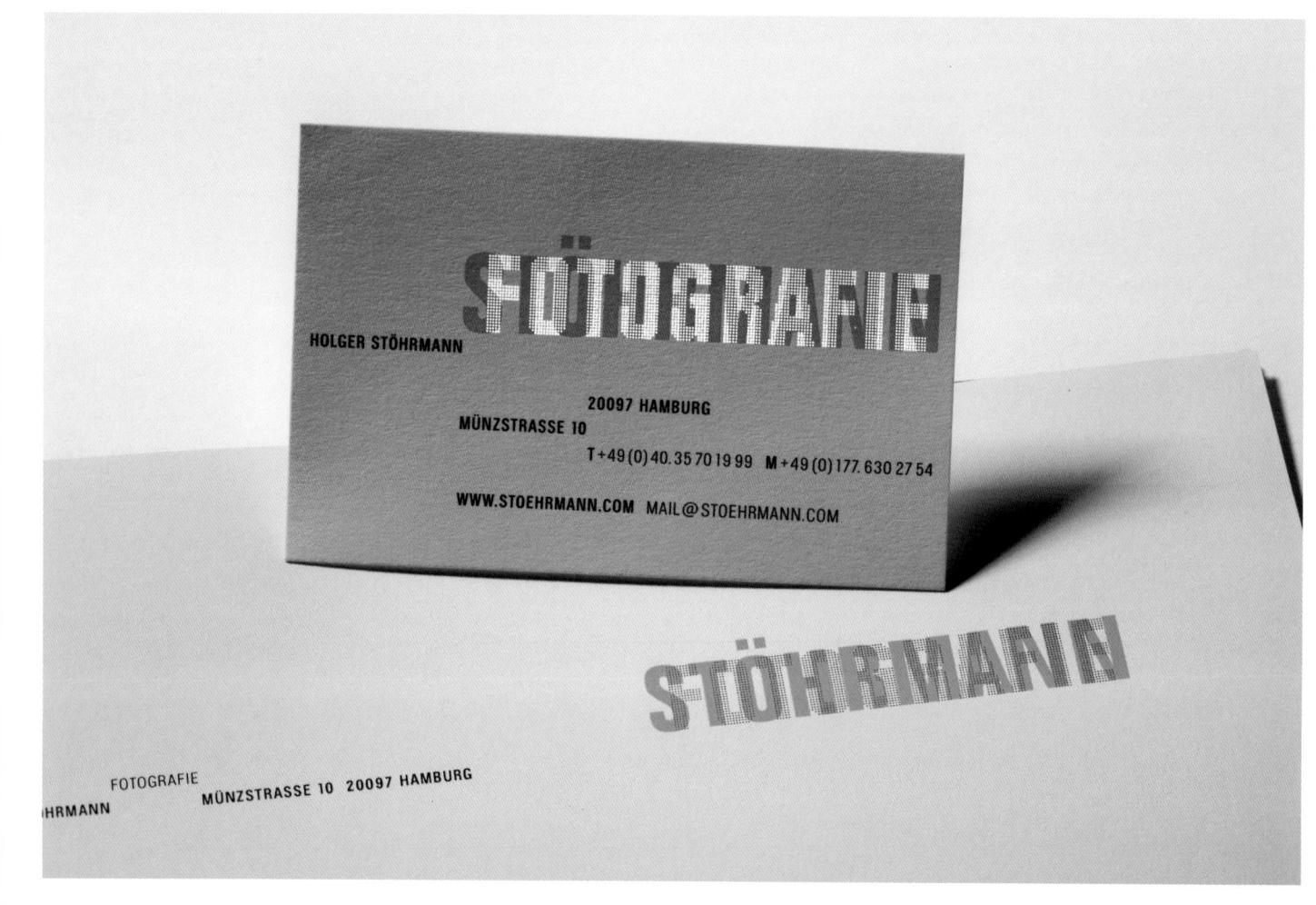

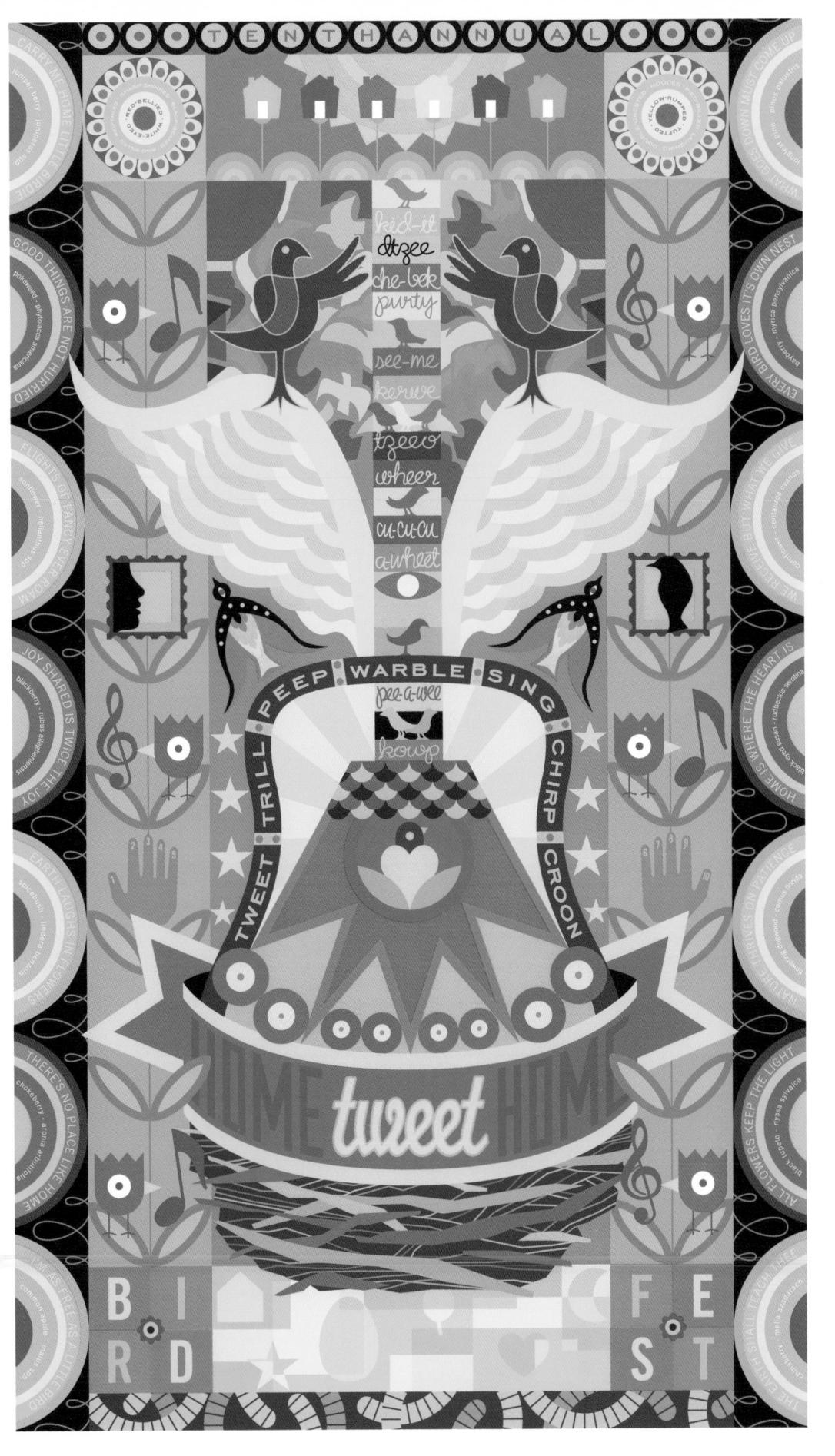

POSTER

*Kris Hendershott*Winston-Salem, North Carolina

ART DIRECTION

Kris Hendershott

CREATIVE DIRECTION Hayes Henderson

DESIGN OFFICE HENDERSONBROMSTEADART

CLIENT

Habitat for Humanity

PRINCIPAL TYPE

Chisel Wide, Radio, Trade Gothic,
and custom

DIMENSIONS 15.5 x 26 in. (39.4 x 66 cm)

CORPORATE IDENTITY

Kirsten Dietz

Stuttgart, Germany

ART DIRECTION

Kirsten Dietz

CREATIVE DIRECTION

Kirsten Dietz

LETTERING

Kirsten Dietz

AGENCY

strichpunkt

PRINCIPAL TYPE

FF DIN

DIMENSIONS

Various

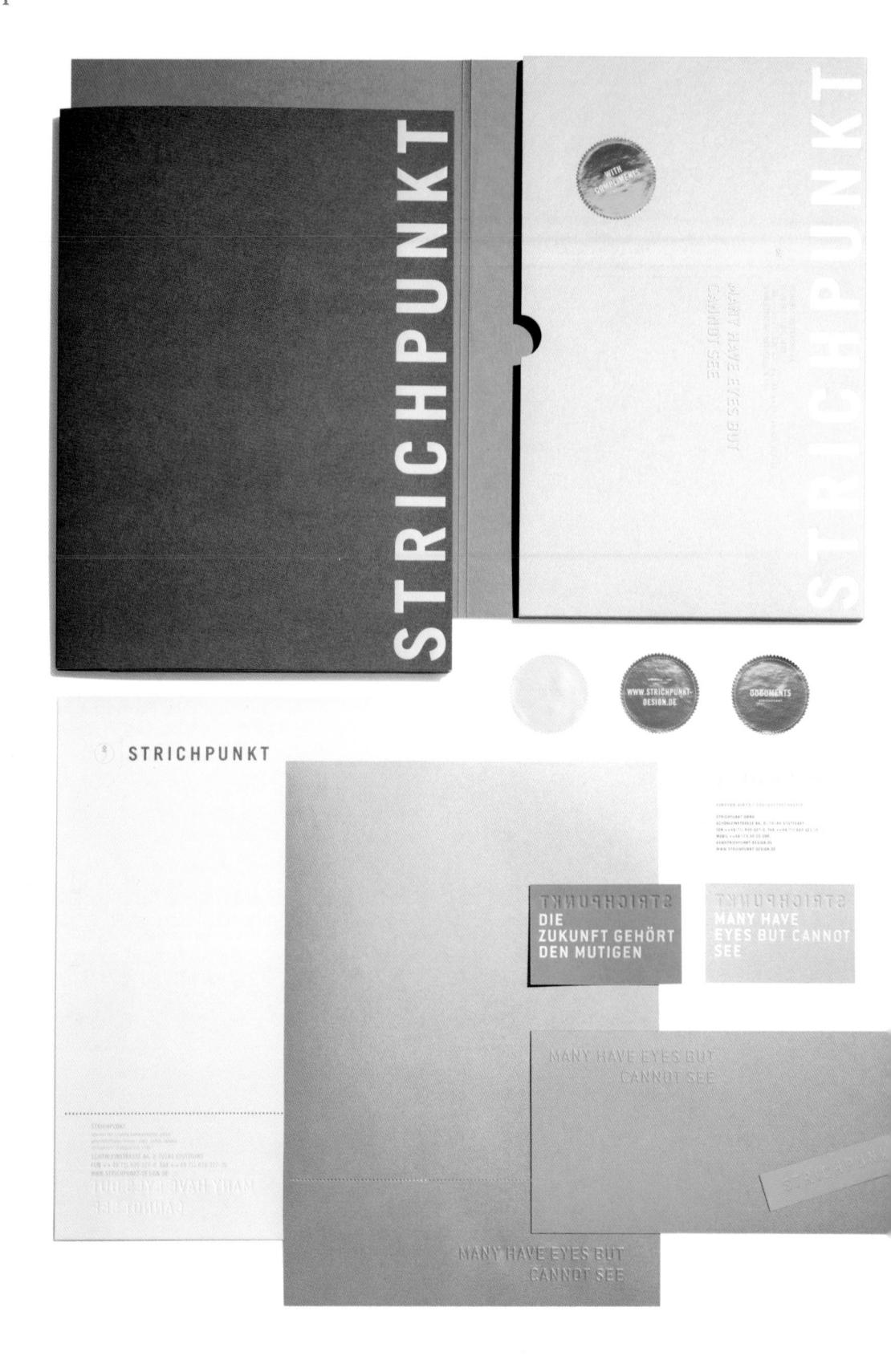

ONE MINUTE. SHE'S THE ARCHANGEL GABRIEL, AND THE NEXT, MARILYN MANSON. TILDA SWINTON, AS LYNN HIRSCHBERG DISCOVERS, IS A WOMAN OF EXTREMES. PROMOTOR HERSCHBERG PROMOT

One of Titlds Swinise's accessors on her very pools, very military Scottish family tree was painted by John Singer Sargent, and it is easy to imagine Swinton, with her albasters kin, otherworldly green eyes and regal 5-foot-11 bearing, exputed in oils. "I do look like all those old paintings," Swinton joked over a midsummer hunh of raw oysters at the Merce hoed. "But I'm afraid my temperament does not conform. At all."

She said this, as she said nearly everything, with a mix of direct authority and engaged enthusians that was both immediately ingratizing and commanding. Swinton, who is 44, was wearing no trace of makeup, point sunderes and flip-floops, and her hart, which is naturally red, was dyed white-blond. "I love the roots," she said, as she titled her scalp forward for impection." That's the best part of being this blond."

Het unique looks, her ease with herself and her voracious interest in the more esoteric worlds of cinema and style have made Swinton as kind of goddess of the avant-garde. In her movies, she has continually transformed Berself — changing class, nationalities, gender. For "Orlando," perhaps her most famous film, she played multiple incarnations of the title character, including a man. In "Inhumbucker," opening in theaters on Sept. 16, she is utterly convincing as a suburban. American mom. The director Jim Jamusch east her as an ex-girlirend of Bill Murray's in the recent "Broken Flowers," which she is territying, her face half-obscured by a foreboding currant of long brown har. For "The Chronicles of Namia The Lion, the Witch and the Wardrobe," a big-budget movie that is due out from Disney at the end of the year, Swinton

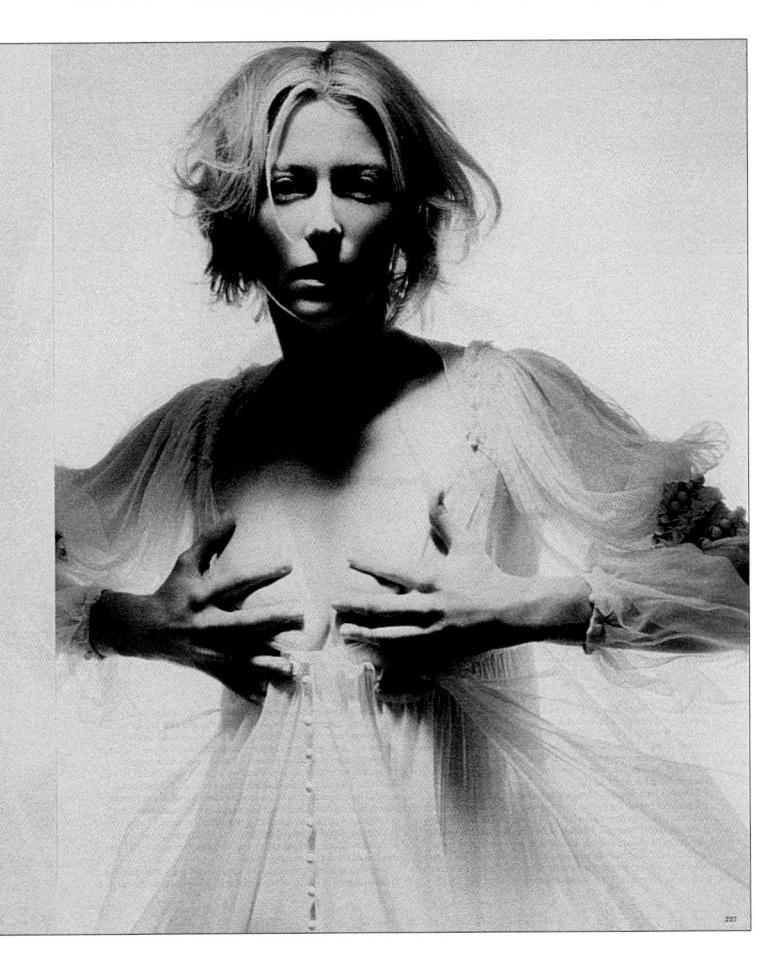

ART DIRECTION

David Sebbah

CREATIVE DIRECTION

Janet Froelich

New York, New York

PHOTOGRAPHY

Raymond Meier

PUBLICATION

The New York Times Style Magazine

PRINCIPAL TYPE

Various

DIMENSIONS

11.5 x 19 in.

(29.2 x 48.3 cm)

POSTER

Obsugi Gaku and Shinozaki Mika Tokyo, Japana

ART DIRECTION

Ohsugi Gaku

DESIGN OFFICE

702 Design Works Inc.

CLIENT

JAGDA and 702 Design Works, Inc.

DIMENSIONS

28.7 x 40.6 in.

(72.8 x 103 cm)

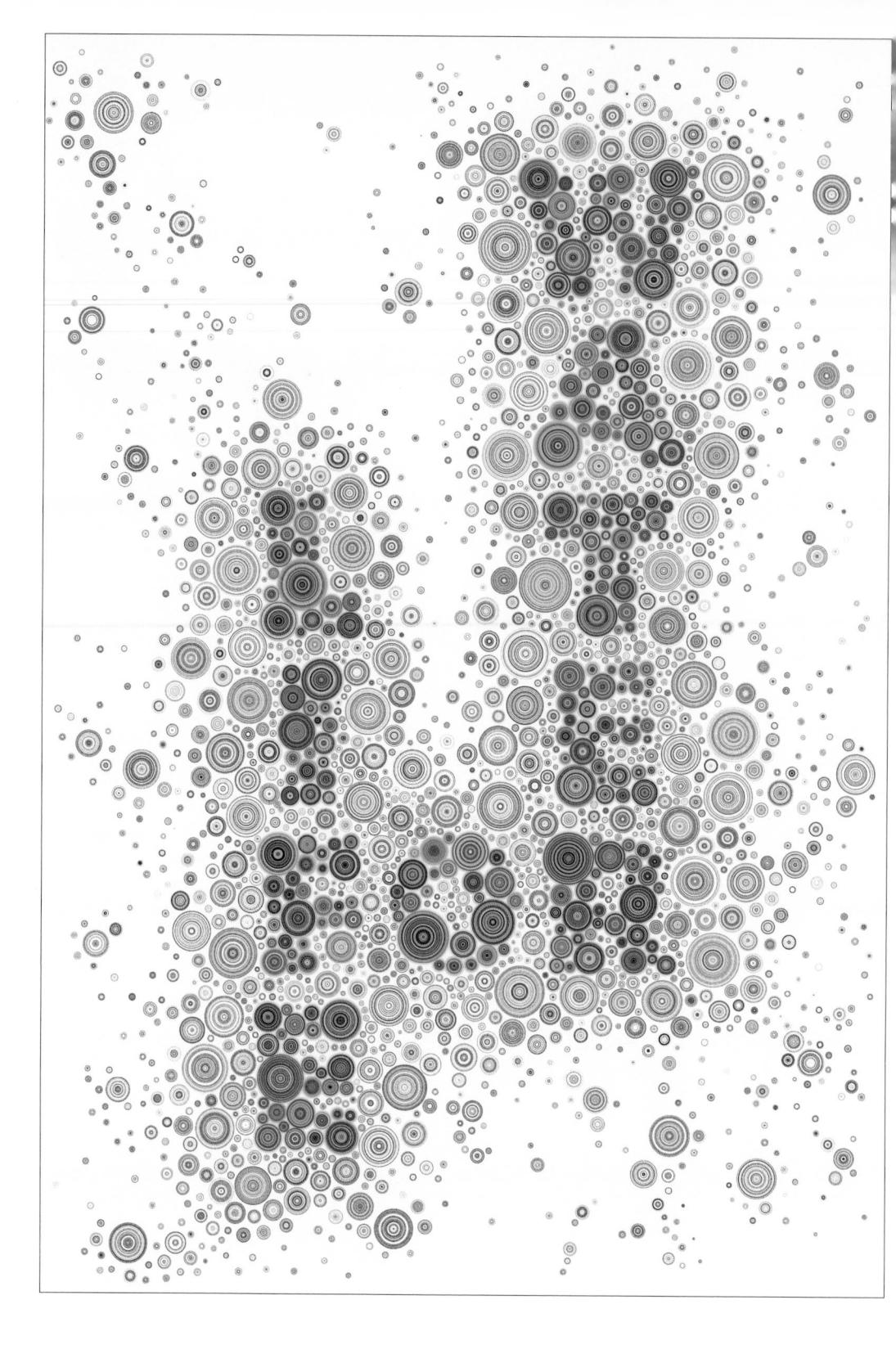

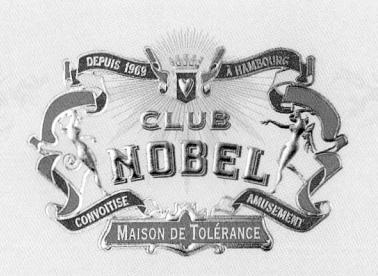

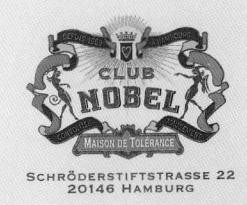

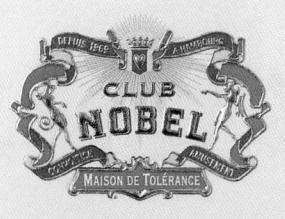

EROTIK ELITÄR

SCHRÖDERSTIFTSTRASSE 22 20146 HAMBURG TELEFON 040/41356095 WWW.CLUBNOBEL.DE

DESIGN

Karsten Kummer Hamburg, Germany

CREATIVE DIRECTION Robert Neumann

LETTERING

Karsten Kummer

DESIGN OFFICE

Delikatessen Agentur für Marken und Design GmbH

CLIENT

Club Nobel

PRINCIPAL TYPE Copperplate modified and bandlettering

DIMENSIONS 8.3 x 11.4 in. $(21 \times 29 \ cm)$ DESIGN ONERY

Ken Sakurai

Minneapolis, Minnesota

CREATIVE DIRECTION

Dan Olson

DESIGN OFFICE

Duffy & Partners

CLIENT

Thymes

PRINCIPAL TYPE

Bryant

DIMENSIONS

Various

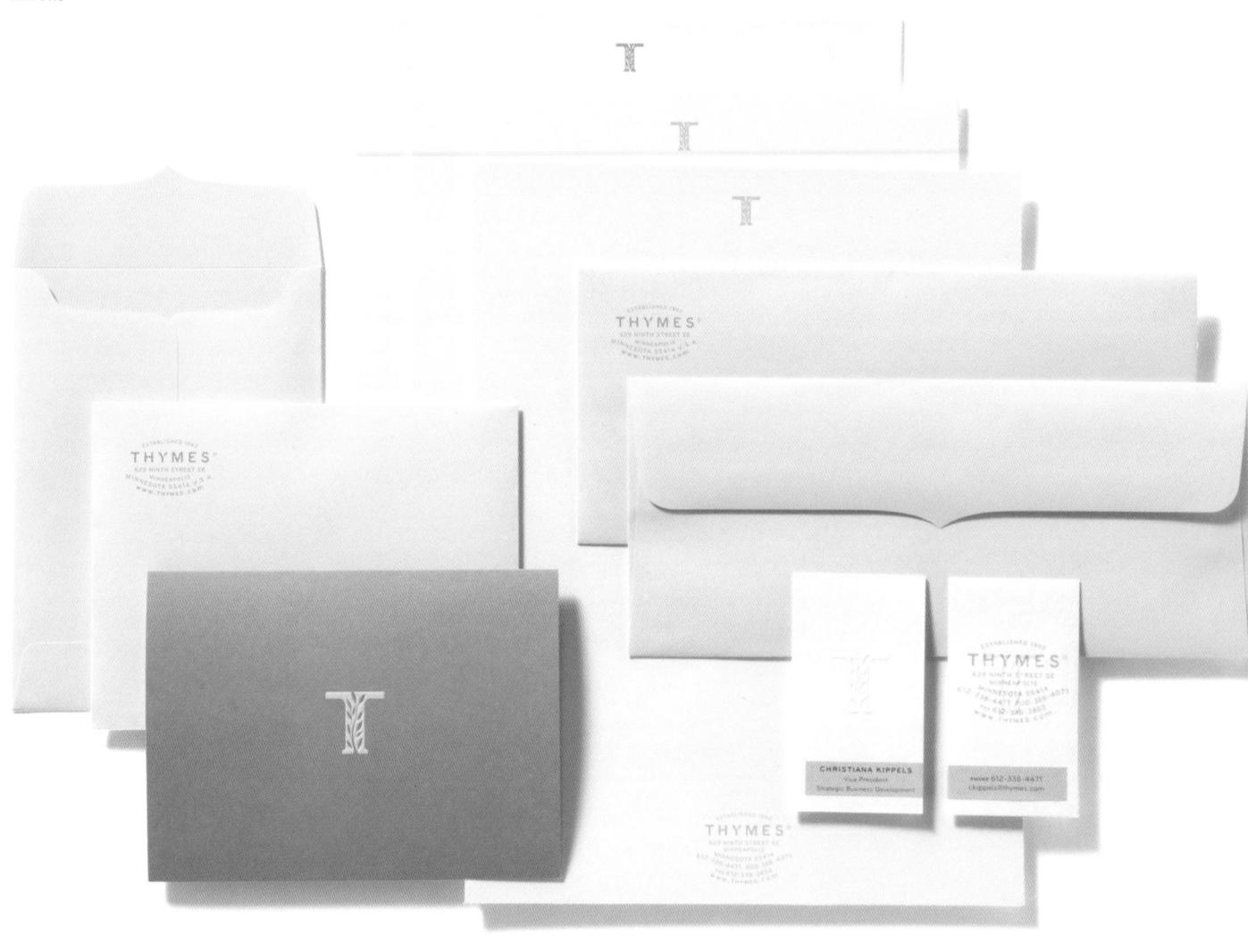

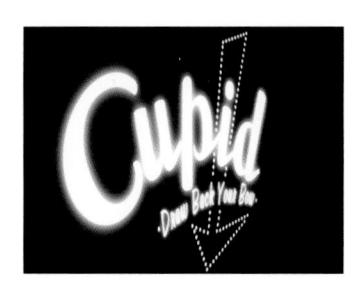

DESIGN

Masood Ahmed Bronx, New York

SCHOOL

School of Visual Arts, MFA Design

INSTRUCTOR

Gail Anderson

PRINCIPAL TYPE

Gravur Condensed, Milk Script, Stereopticon, and Tiki Holiday

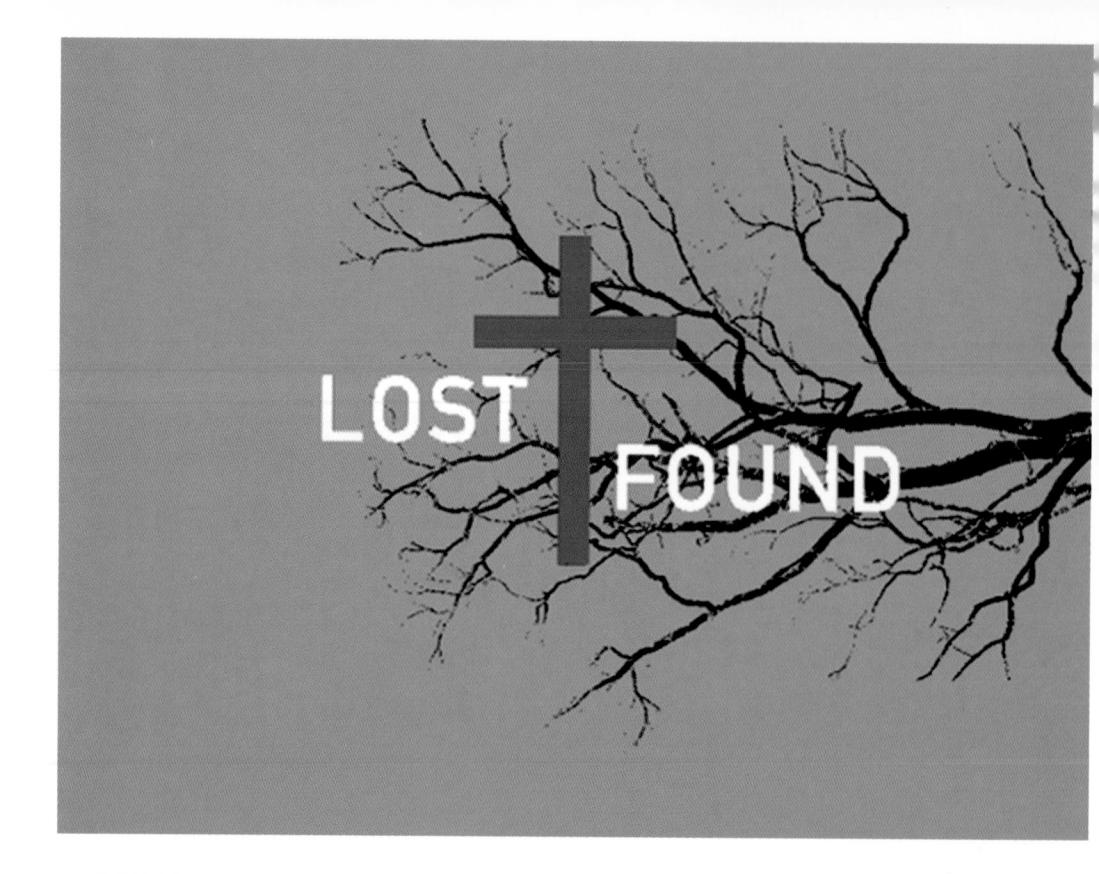

DESIGN ON GRAPHICS

Jeff Miller

Kansas City, Missouri

ART DIRECTION

Jeff Miller

ANIMATOR

Jeff Miller

DESIGN OFFICE

Muller + Company

CLIENT

Church of the Nazarene

PRINCIPAL TYPE

DIN Mittelschrift and MeMimas

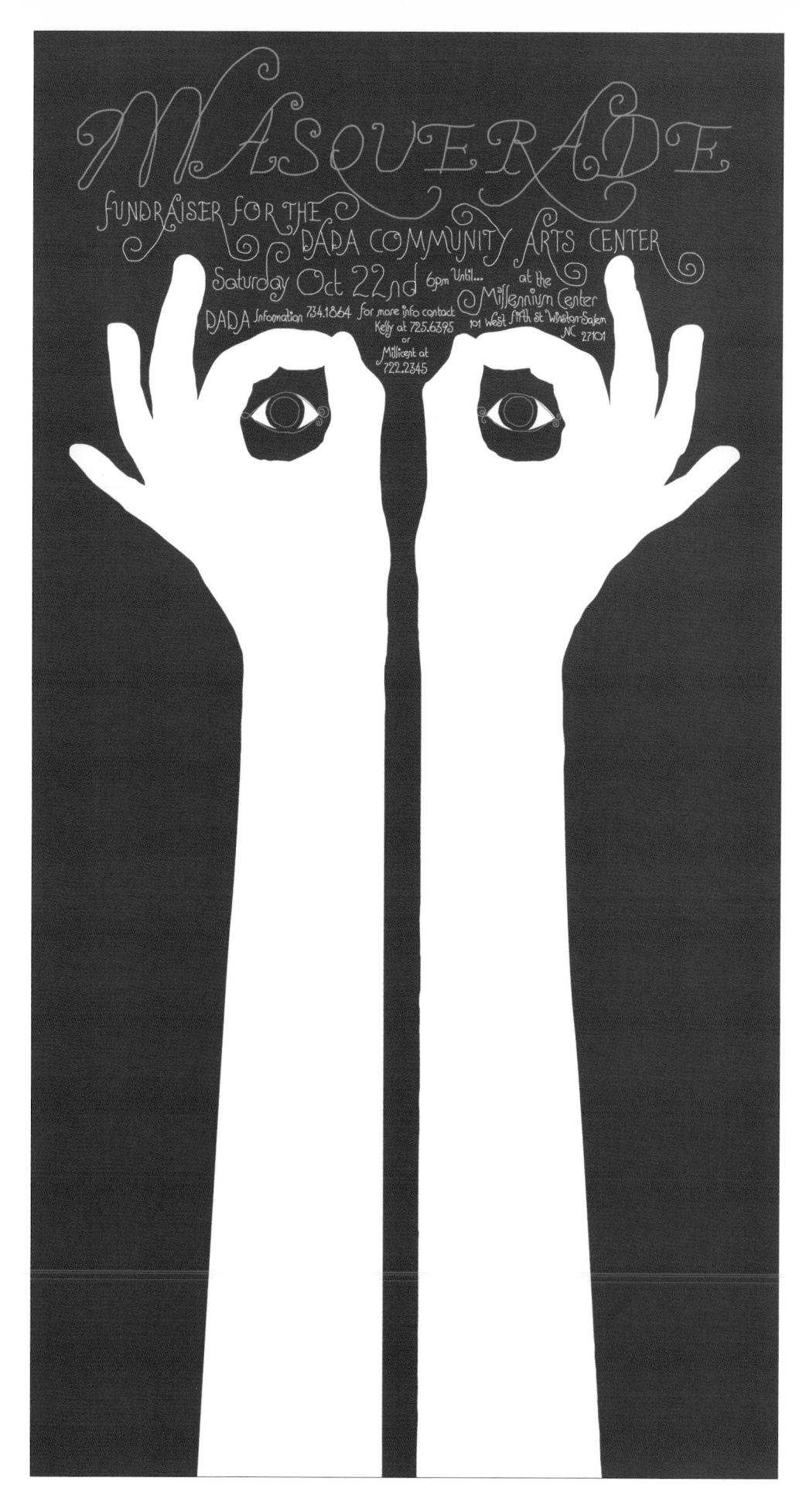

POSTER

Muy Billy

Winston-Salem, North Carolina

ART DIRECTION

Muy Billy

CREATIVE DIRECTION

Hayes Henderson

CALLIGRAPHY

Muy Billy

DESIGN OFFICE

HENDERSONBROMSTEADART

CLIENT

Downtown Arts District Association

PRINCIPAL TYPE

Handlettering

DIMENSIONS

12.5 x 23 in.

(31.8 x 58.4 cm)

MAGAZINES

Todd Richards and Nicholas Davidson San Francisco, California

ART DIRECTION

Bill Caban, Steve Frykholm,
and Todd Richards

CREATIVE DIRECTION

Bill Cahan

DESIGN OFFICE

Cahan & Associates

CLIENT *Herman Miller*

PRINCIPAL TYPE

Helvetica and Sabon

DIMENSIONS 9.25 x 11.75 in. (23.5 x 29.9 cm)

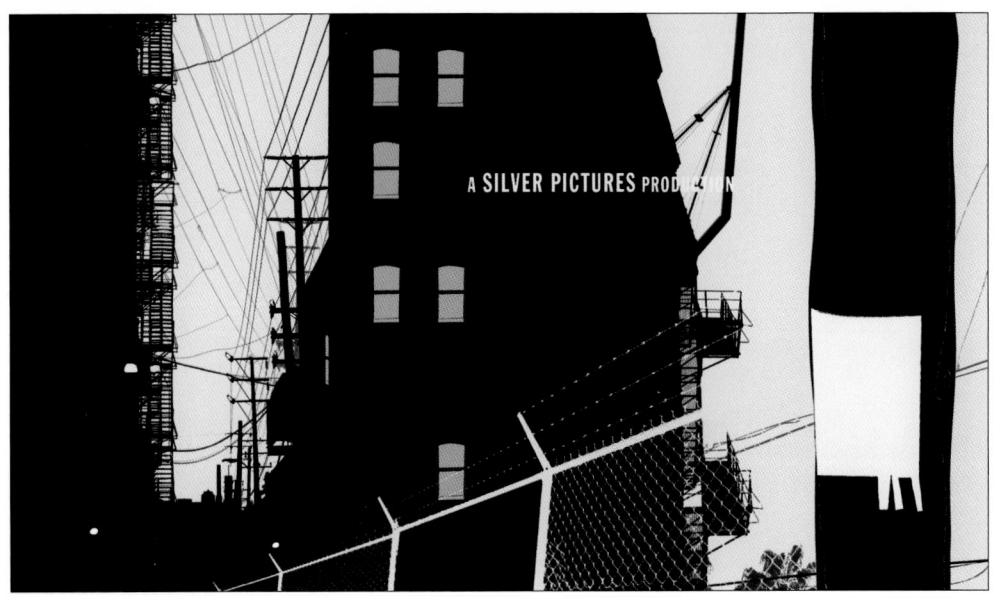

DESIGN

DESIGN

James Choi, Gary Mau, Stephen Schuster, and Danny Yount Malibu, California

CREATIVE DIRECTION

Danny Yount

DESIGN OFFICE

Prologue

CLIENT

Silver Pictures and Warner Bros.

PRINCIPAL TYPE
Franklin Gothic Extra Bold
Condensed

CORPORATE IDENTITY

Matthias Ernstberger New York, New York

CREATIVE DIRECTION

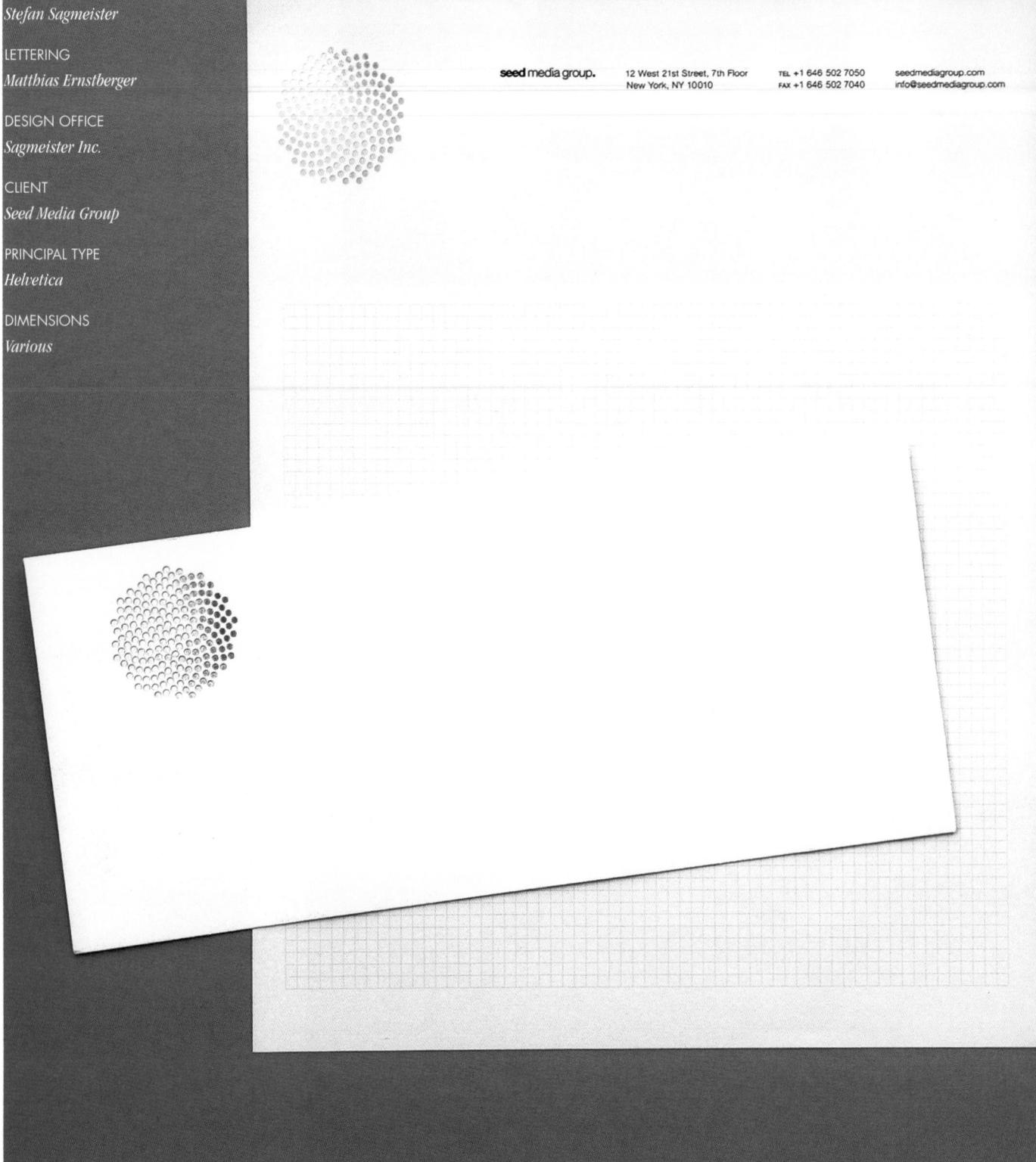

ILENSCAPE -

LENSCAPE

3 March 2005

Mr. James Leung Company Name 25th Floor 1 Des Voeux Road West Hong Kong

Dear James,

This example shows the typing layout for The Lenscape Studio letterhead.

Set the left-hand margin to align on the left 25mm from the edge of the page. The Right-hand margin should also be set so it is 25mm.

The date, name and address should be typed in upper and lower case. The date should be 50mm from the top edge of the page. The name and address should be two line spaces below the date. The salutation is two line spaces below the last line of the typed address. Start the body of the letter two line spaces below the subject title or two line spaces below the salutation if there is no subject title. Use single line spacing throughout the letter. Use double spacing between paragraphs and do not indent paragraphs.

Use single spacing between words, and two spaces between the end of a sentence and the beginning of the next. Do not use right-hand justified margins but try to keep the right margin as even as possible.

Type the closure two line spaces after the end of the body of the letter. Type the name of the signatory five line spaces below the closure. Status or title may included immediately below the name if required.

Sincerely,

Bertha Ma

flat g, 9/f.
pak lee mansion
1 tin hau temple road
tin hau, hong kong

* +852 2528 2523

t +852 2528 2523 f +852 2528 5855 DESIGN

James Wai Mo Leung Hong Kong, China

CREATIVE DIRECTION

James Wai Mo Leung

ART DIRECTION

James Wai Mo Leung

LETTERING

James Wai Mo Leung

DESIGN STUDIO

Genemix

CLIENT

Berth Ma and Helene Tam of The Lenscape Studio

PRINCIPAL TYPE

Didot, Frutiger, and FF Meta

DIMENSIONS Various

bertha ma

helena tam

LENSCAPE

LENSCAPE -

flat g, 9/f. pak lee mansion 1 tin hau temple road tin hau, hong kong

tin hau, hong kong t +852 2528 2523 f +852 2528 5855 e bertha@thelenscape.com flat g, 9/f. pak lee mansion 1 tin hau temple road tin hau, hong kong

t +852 2528 2523 f +852 2528 5855 e helena@thelenscape.com.hk

LENSCAPE

flat g, 9/f. pak lee mansion 1 tin hau temple road tin hau, hong kong ILENSCAPE >

flat g, 9/f. pak lee mansion 1 tin hau temple road tin hau, hong kong Mr. James Leung Company Name 25th Floor 1 Des Voeux Road West Hong Kong

DESIGN

Julia S. Kuon and Florian Pfeffer Bremen, Germany

DESIGN OFFICE

jung und pfeffer: visuelle
kommunikation

CLIENT : out output foundation

PRINCIPAL TYPE

Serifa BQ and Lutz Headline

DIMENSIONS
9.1 x 13 in.
(23 x 33 cm)

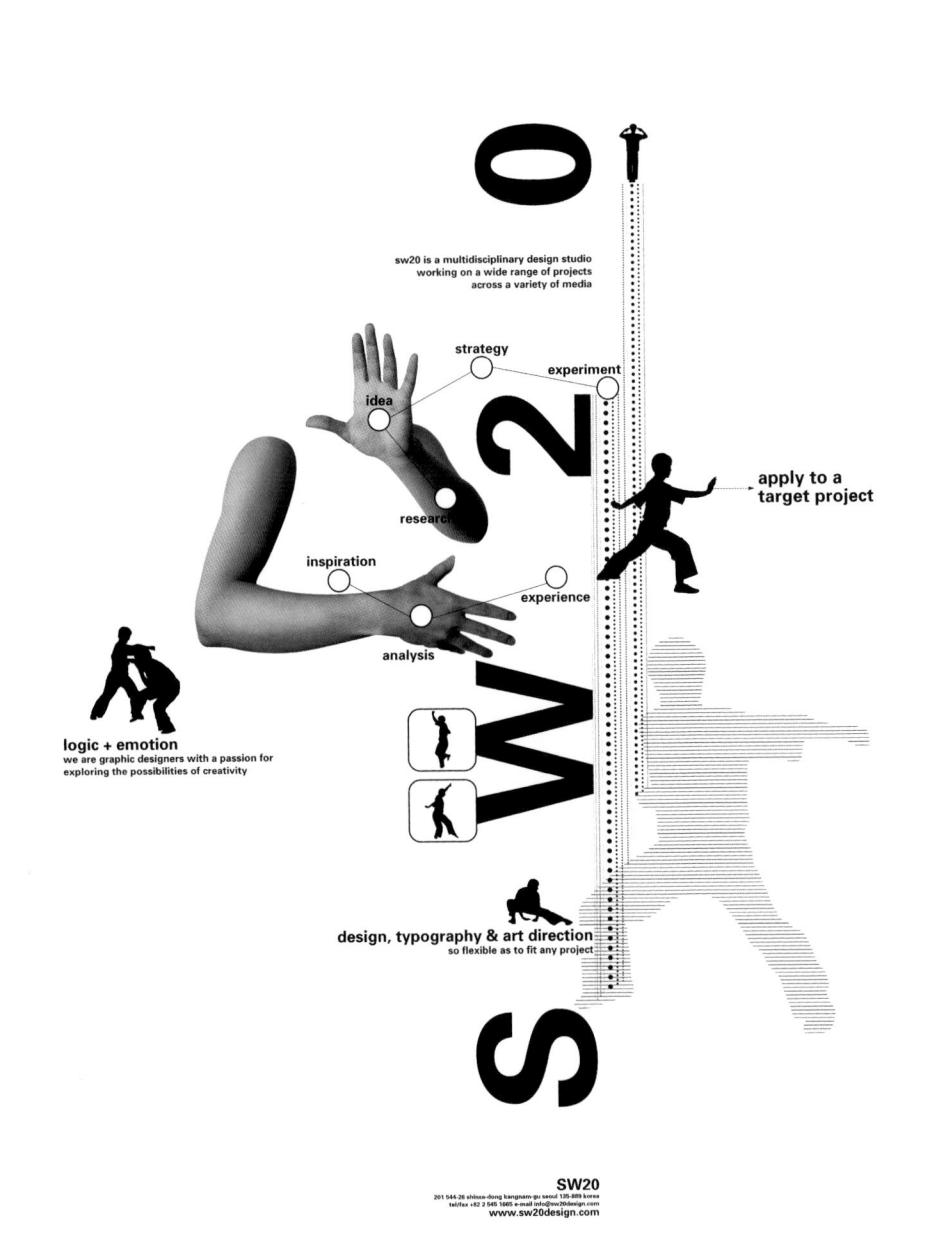

DAGTER DESIGN
Choong Ho Le

Choong Ho Lee Seoul, Korea

ART DIRECTION

Choong Ho Lee

CREATIVE DIRECTION

Choong Ho Lee

design office SW20

PRINCIPAL TYPE Univers

DIMENSIONS 21.3 x 29.5 in. (54 x 75 cm)

CONFERENCE OPENER

Emre Veryeri New York, New York

ART DIRECTION

Garry Waller

CREATIVE DIRECTION

Jakob Trollbäck and Joe Wright

DESIGN OFFICE

Trollbäck + Company

CLIENT
Pop!Tech Conference

PRINCIPAL TYPE *Helvetica*

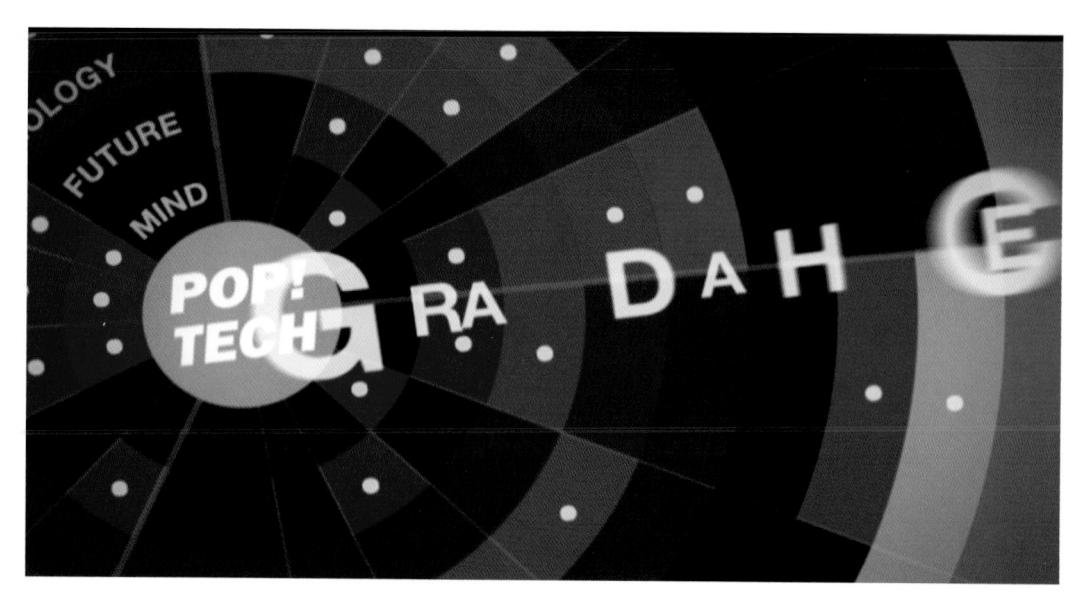

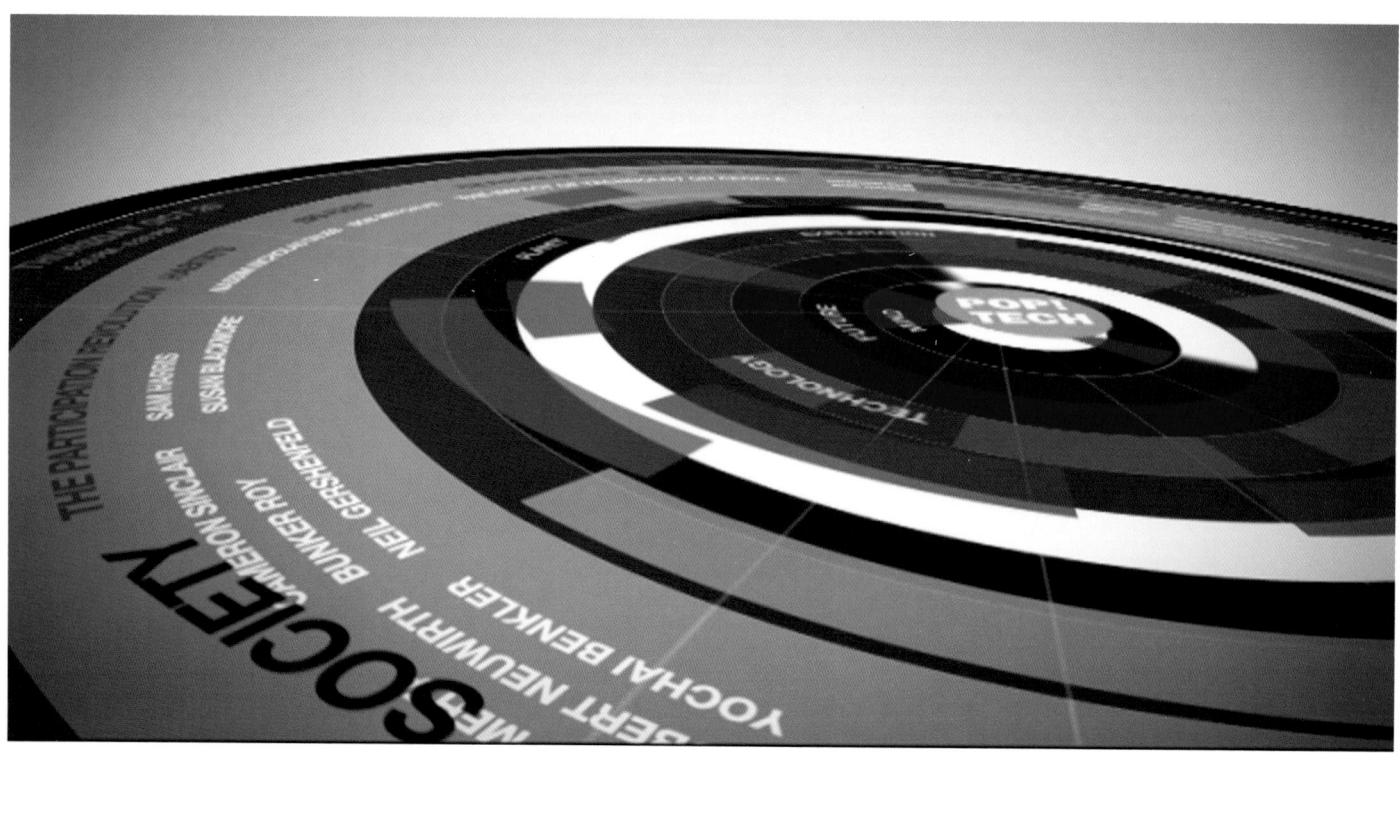

CTUDENT PROJECT

Hana Sedelmayer Hamburg, Germany

SCHOOL

Muthesius Academy of Fine Arts, Kiel

PROFESSOR

Klaus Detjen

PRINCIPAL TYPE

Proforma Medium and Auto 1 Black

DIMENSIONS

7.9 x 10.6 in.

 $(20 \times 27 \ cm)$

David Plunkert Baltimore, Maryland

ILLUSTRATION David Plunkert

STUDIO Spur

CLIENT Theatre Project

PRINCIPAL TYPE Century Schoolbook

DIMENSIONS 14 x 23 in. (35.6 x 58.4 cm)

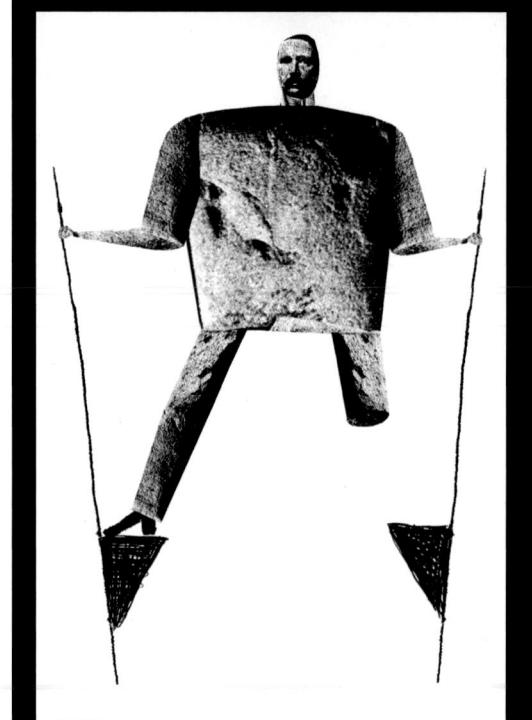

Nov 3-13 Beyond the Mirror

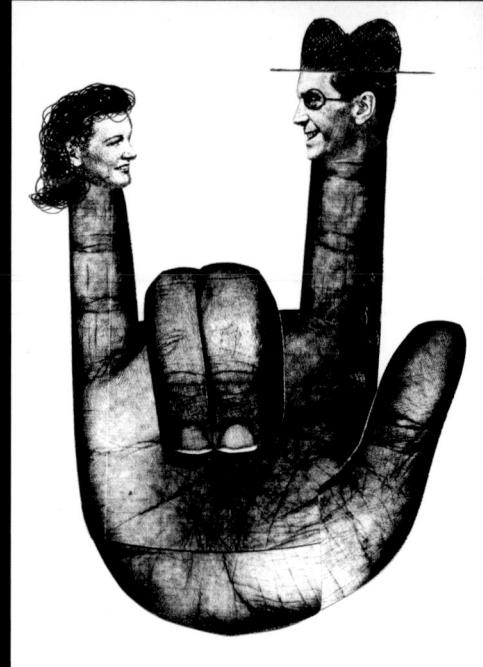

THEATRE PROJECT

Jan 12-22 Blood Makes Noise

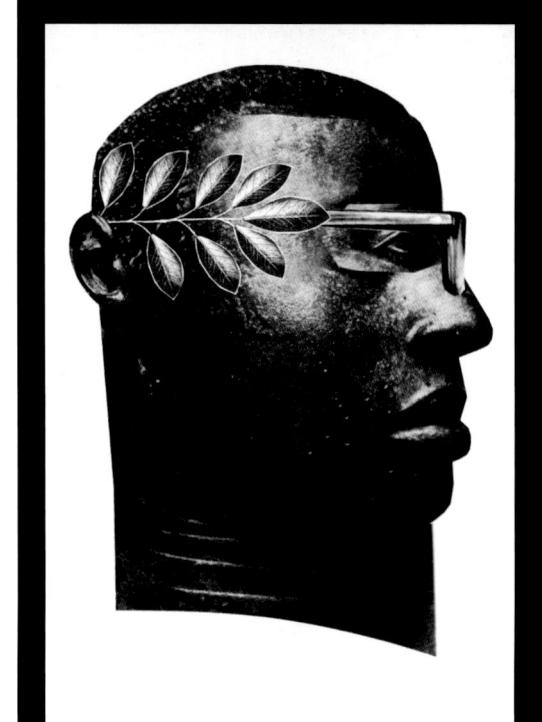

THEATRE PROJECT

 $\stackrel{\text{Feb 9-19}}{\text{Julius X}}$

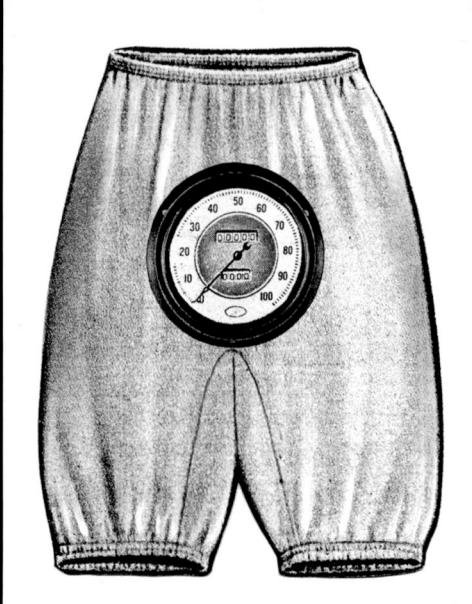

THEATRE PROJECT

May 18-21 Walk a Mile in my Drawers

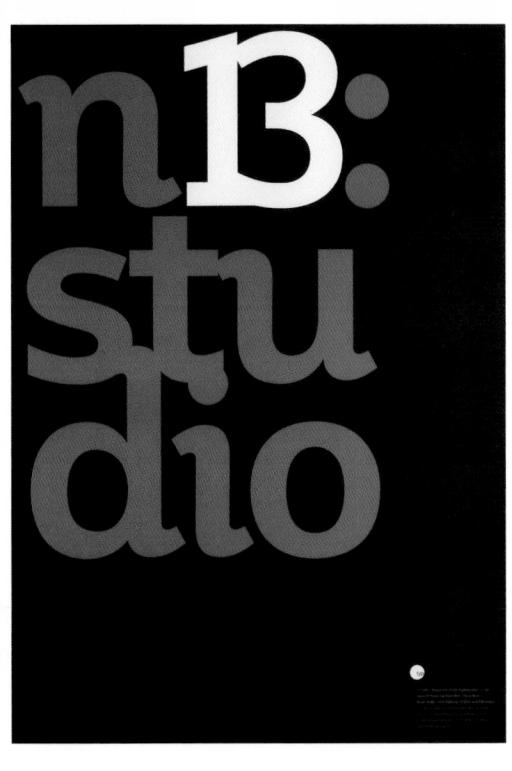

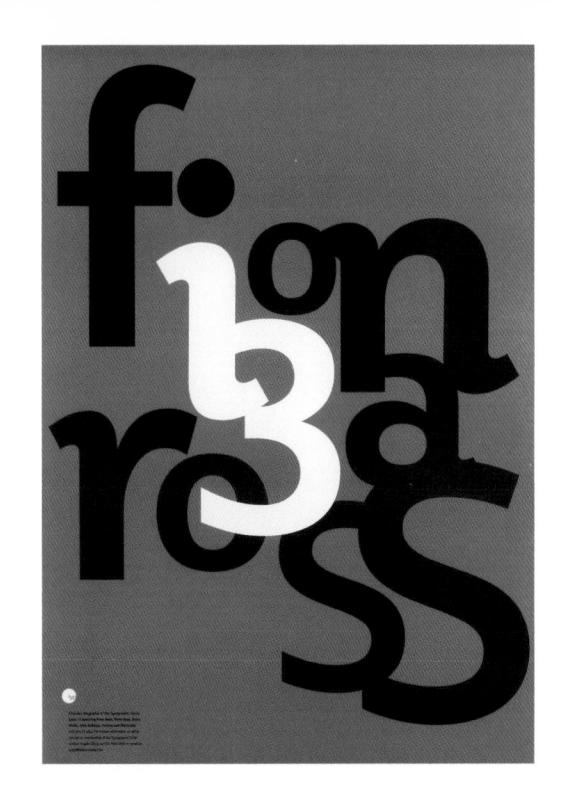

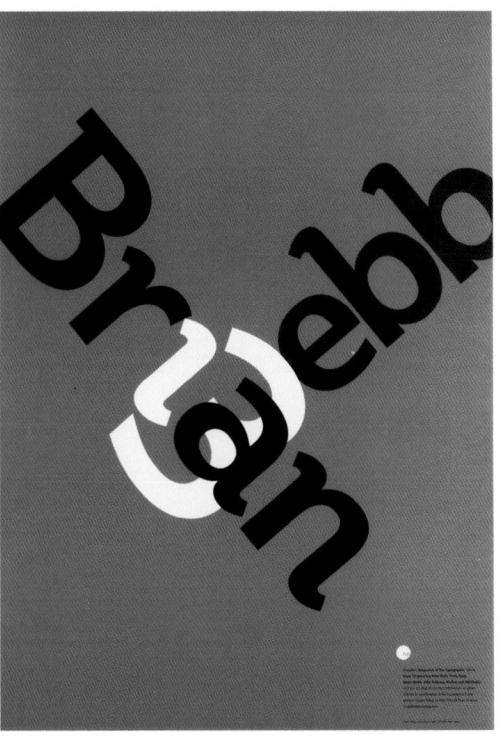

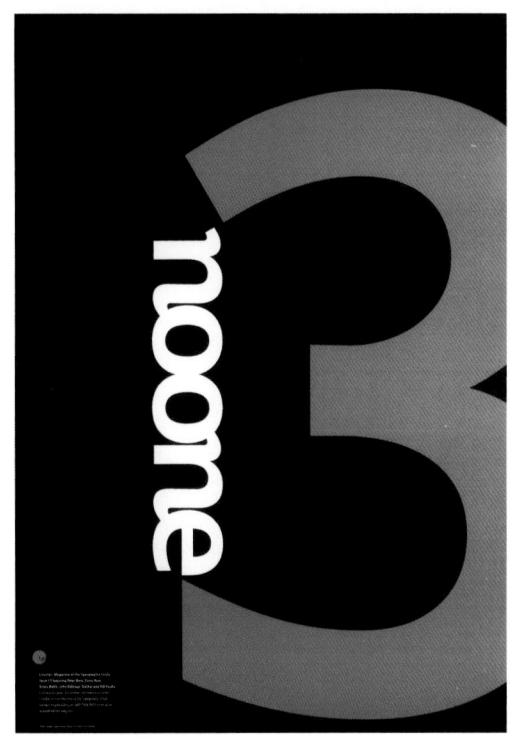

DOCTERS DESIGN

Domenic Lippa London, England

ART DIRECTION

Domenic Lippa

CREATIVE DIRECTION

Domenic Lippa

TYPOGRAPHER

Domenic Lippa

DESIGN OFFICE

Lippa Pearce Design

CLIENT

The Typographic Circle

PRINCIPAL TYPE

Plume

DIMENSIONS 23.6 x 33.1 in. (60 x 84 cm) CORPORATE IDENTITY

Guy Pask and Kerry Argus Christchurch, New Zealand

ART DIRECTION

Guy Pask

CREATIVE DIRECTION

Guy Pask and Douglas Maclean

LETTERING

Guy Pask

STUDIO

Strategy Design & Advertising

CLIENT

Bell Hill Vineyards

PRINCIPAL TYPE

Futura and Indian typeface redrawn

DIMENSIONS

Various

pellhill

pellhill

Bell Hill Vineyard Limited, P O Box 24, Waikari 8276, North Canterbury, New Zeoland
Phone - 00 64 3 379 4374 Fax - 00 64 3 379 4378 Vineyard - 00 64 3 314 2100 Mobile - 027 2031 031 Emoil - info@bellkill.co.nz

pellhill

MARCEL GIESEN & SHERWYN VELDHUIZEN WINEGROWERS

Beil Hill Venyard Limited, F.O. Box 24, Wisskan, North Catterbory, New Zadard Floore - 00. 64.3379.4374. For - 00.64.3379. 4378. Venyard - 00.64.3314.2100. Mobile - Marcel Clience - 027.230.587. Ernal - marcel@belbill.co.nz. Mobile - Shervyn Wolfshuizen - 027.7031.031. Ernal - shervyn@belbill.co.nz.

penhin

Ball Hill Vineward Limited P.O. Rox 24. Waikari 8276. North Canterbury, New Zealan

OORDORATE IDENTITY

Daniel Gneiding

Philadelphia, Pennsylvania

ART DIRECTION

Carol Keer

PRINTER

Medford Printing

Medford, New Jersey

CLIENT

Anthropologie

PRINCIPAL TYPE

Filosofia

DIMENSIONS

Various

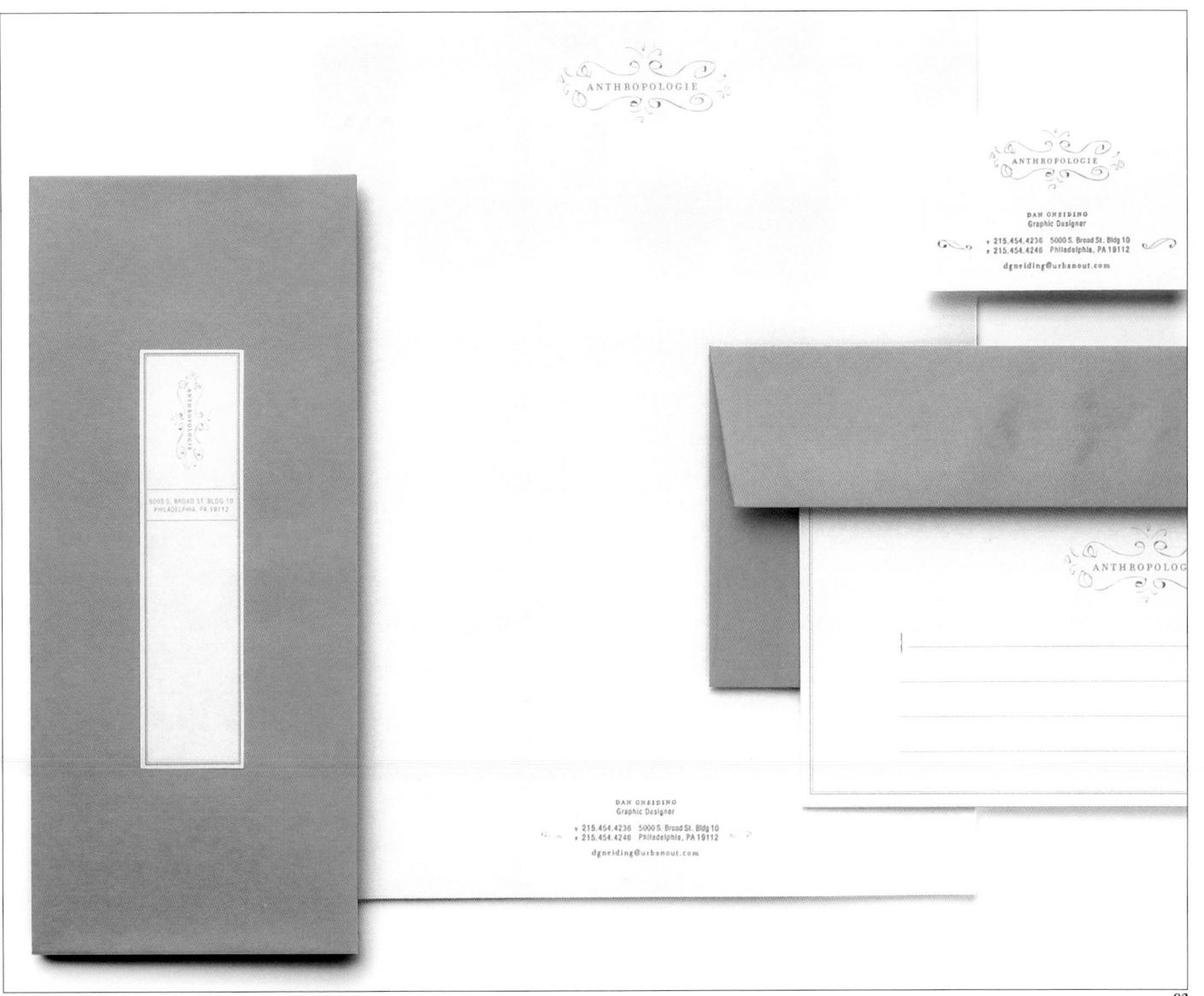

DESIGNER

Kjell Ekhorn and Jon Forss London, England

CREATIVE DIRECTION

Kjell Ekhorn and Jon Forss

STUDIO
Non-Format

CLIENT

The Royal Norwegian Embassy

London

PRINCIPAL TYPE Custom

DIMENSIONS 33.1 x 23.2 in. (84 x 59 cm)

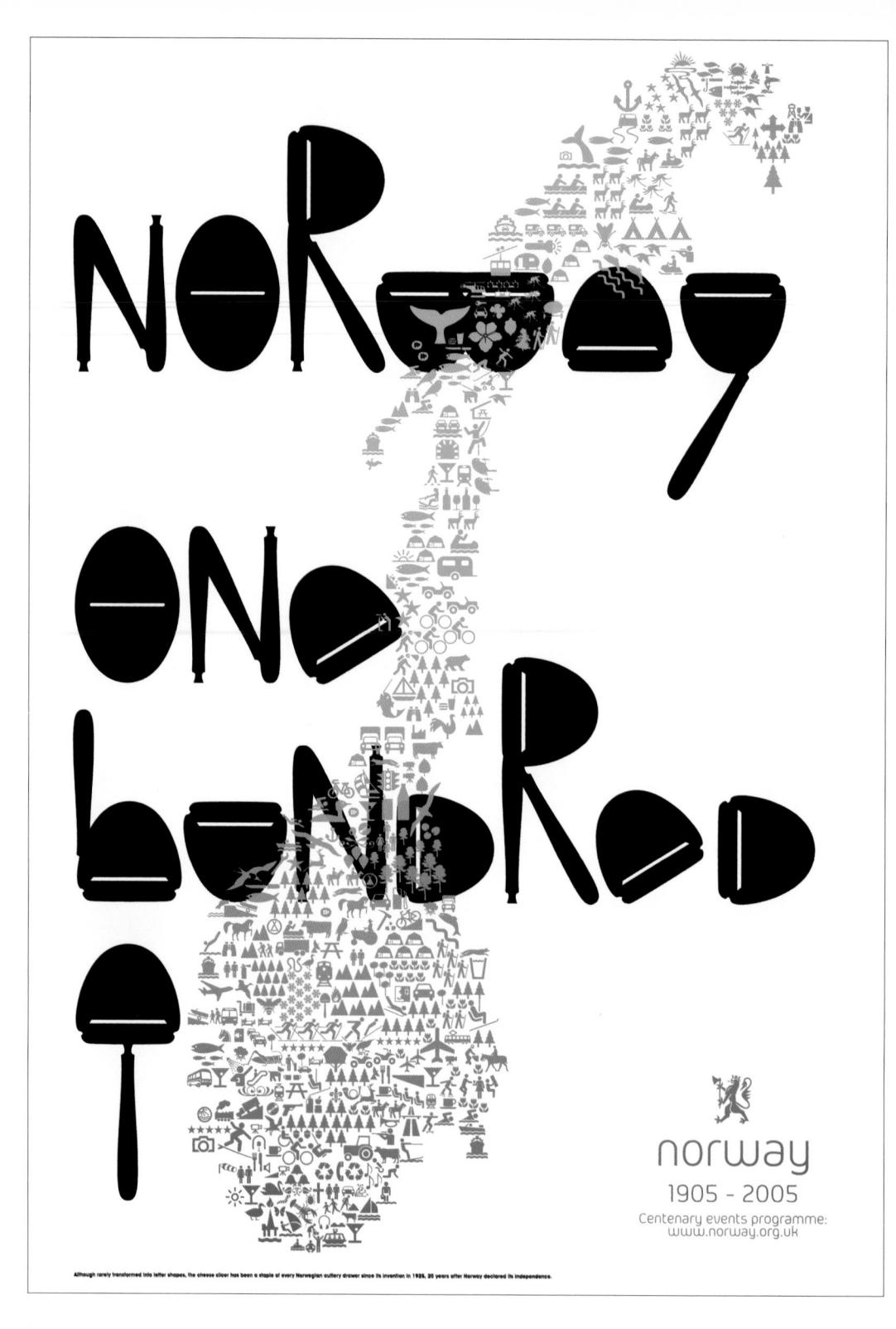

AUSWÄRTIGEN AMTS

INSTITUT FÜR AUSLANDSBEZIEHUNGEN

..DekaBank

DW-TV DEUTSCHE WELLE

ART DIRECTION

Ingo Maak

Wuppertal, Germany

CREATIVE DIRECTION

Christian Boros

AGENCY

Boros CLIENT

Venice Biennale, German Pavilion

PRINCIPAL TYPE

Helvetica Neue

DIMENSIONS

23.4 x 33.1 in.

(59.4 x 84 cm)

CATALOG

Stefan Bargstedt, Philipp Dörrie, and Betie Pankoke Bremen, Germany

SUPPORTER

Professor Bernd Bexte

SCHOOL

Hochschule für Künste, Bremen

PRINCIPAL TYPE

FF Eureka and Lo-Res Teens

DIMENSIONS 5.8 x 7.7 in.

(14.8 x 19.5 cm)

Ibán Ramón and Daniel Requeni Valencia, Spain

ART DIRECTION *Ibán Ramón*

CREATIVE DIRECTION *Ibán Ramón*

STUDIO

Estudio Ibán Ramón

CLIENT

ICEX and Anieme

PRINCIPAL TYPE

FF DIN

DIMENSIONS

Various

DESIGN ENT PROJECT

David Peacock

Seattle, Washington

SCHOOL

University of Washington

INSTRUCTOR

Annabelle Gould

PRINCIPAL TYPE

Stymie

DIMENSIONS

Various

PRESERVE THE CHARACTER OF YOUR NEIGHBORHOOD.

DESIGN AY CARD

Brad Simon

New York, New York

ART DIRECTION

Brad Simon

CREATIVE DIRECTION

John Klotnia and Ron Louie

DESIGN OFFICE

Opto Design

PRINCIPAL TYPE

Akzidenz Grotesk and Le Corbusier

DIMENSIONS

4 x 5 in.

(10.2 x 12.7 cm)

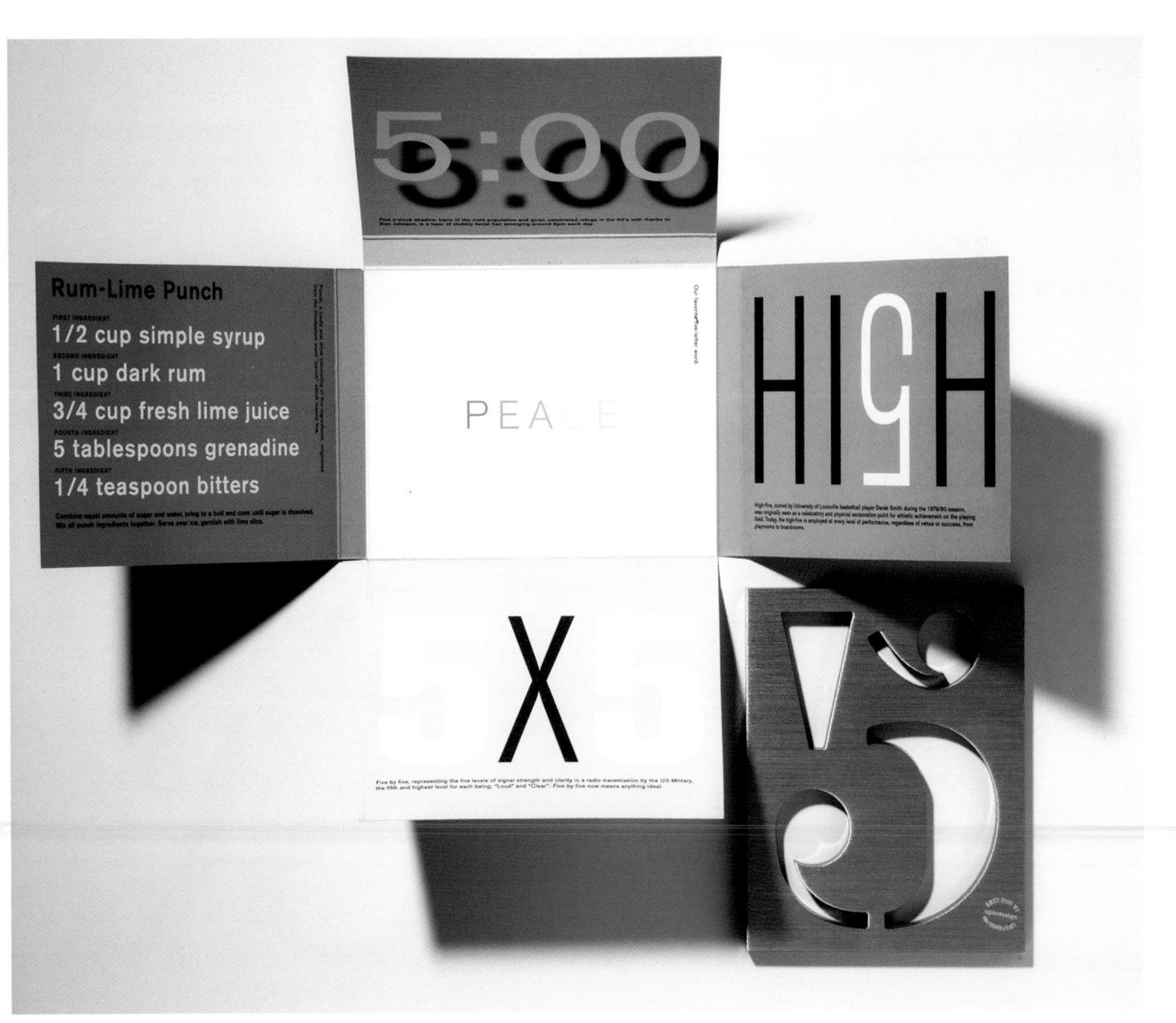

DESIGN ENT PROJECT

Anastasiya Arknipenko, Rachel Bosley, Chase Campbell, Eric Grzeskowiak, Jennifer Neese, and Nick Vandeventer West Lafayette, Indiana

SCHOOL

Purdue University

INSTRUCTOR

Dennis Y. Ichiyama

PRINCIPAL TYPEFACE

Baskerville, Bodoni Roman, Bodoni Italic, Garamond, Times New Roman, and Univers

DIMENSIONS

24 x 36 in.

 $(61 \times 91.4 \text{ cm})$

Anastasiya Arkhipenko

Rachel Bosley

Eric Grzeskowiak

Jennifer Neese

Chase Campbell

Nick Vandeventer

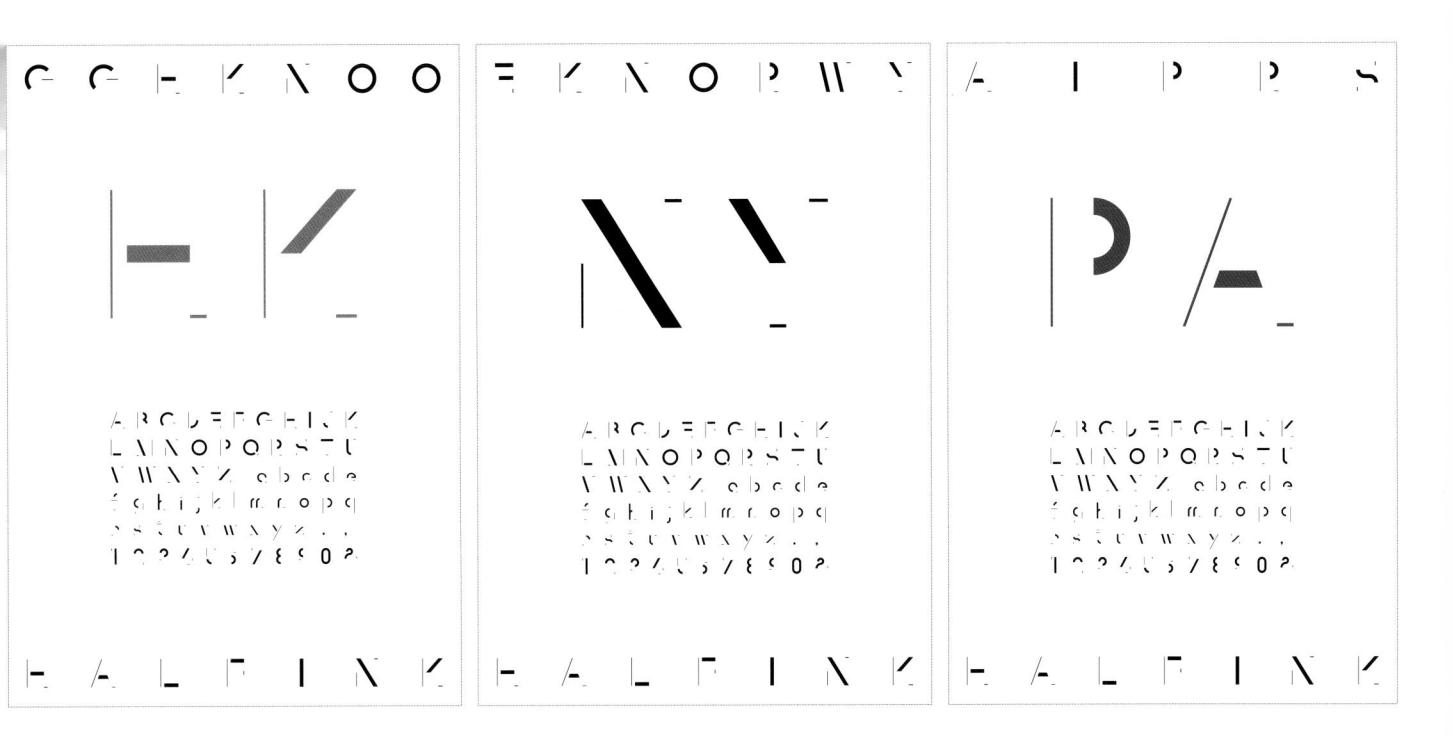

DESIGN ENT PROJECT

Takayoshi Fujimoto Osaka, Japan

SCHOOL

Saito I.M.I. Graduate School

PROFESSOR

Akio Okumura

PRINCIPAL TYPE

Halfink

DIMENSIONS

86 x 40.6 in.

(218.4 x 103 cm)

DESIGN

Martin Summ Munich, Germany

LETTERING

Martin Summ

PRODUCTION

Katja Schmelz

AGENCY

KOCHAN & PARTNER GmbH

CLIENT

designafairs, Munich, and avedition, Ludwigsburg

PRINCIPAL TYPE

FF Seria

DIMENSIONS

4.9 x 7.5 in.

 $(12.5 \times 19 \text{ cm})$

Philipp von Rohden and Thees Dohrn Berlin, Germany

ART DIRECTION

Philipp von Rohden and Thees Dohrn

CREATIVE DIRECTION

Philipp von Rohden and Thees Dohrn

DESIGN OFFICE

Zitromat

CLIENT

T-B A21

PRINCIPAL TYPE

Sabon and custom

DIMENSIONS

6.7 x 9.5 in.

 $(17 \times 24 \text{ cm})$

DESIGN

Clive Piercy and Carol Kono-Noble Santa Monica, California

CREATIVE DIRECTION

Clive Piercy and Michael Hodgson

WRITER *Eric LaBrecque*Lafayette, California

DESIGN OFFICE

Pb.D

PRINCIPAL TYPE

Various

DIMENSIONS 3.75 x 5.5 in. (9.5 x 14 cm)

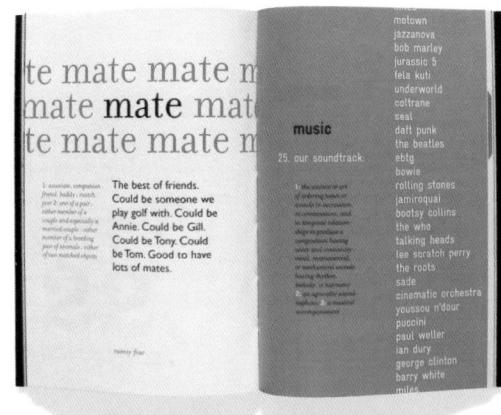

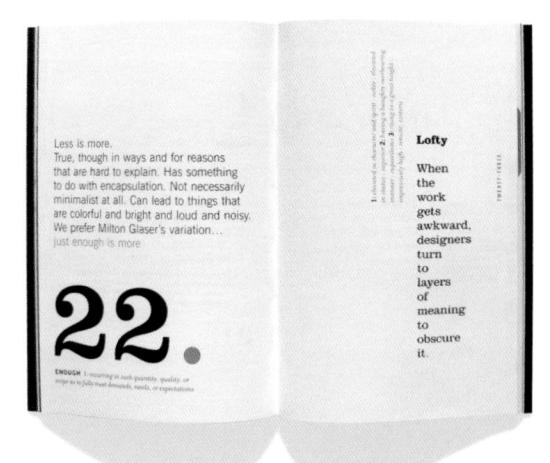

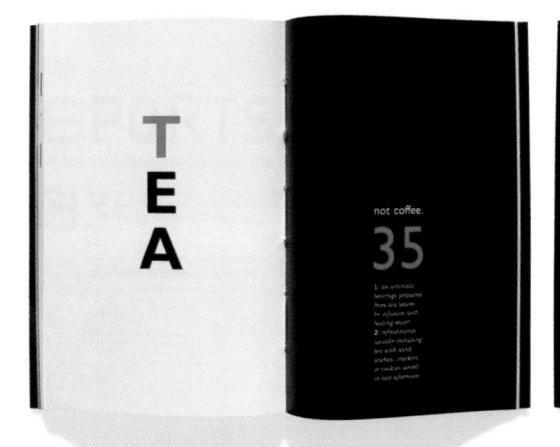

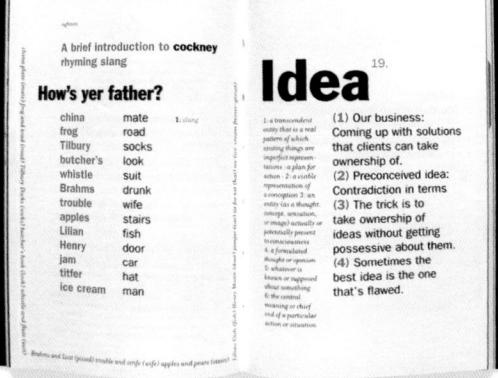

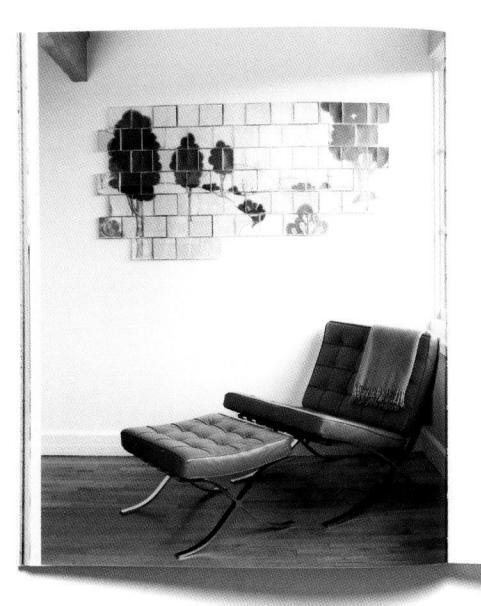

CD WALL

Have you switched to the soft pack of CDs? Are all your empty jewel cases starting to block the way to the kitchen? Time to make something from that mess of plastic brittle. Remember, jewel cases are fabricated from Thermoset, which can't be melted down and turned into two-liter Coke bottles. It's our way or the highway to the dump for these fellers. But look at all they have to offer: protection against the elements; translucency; clean, modern lines. For all those reasons and more, use your empties to make a wall mural. It's yet another step in your march against passive domesticity.

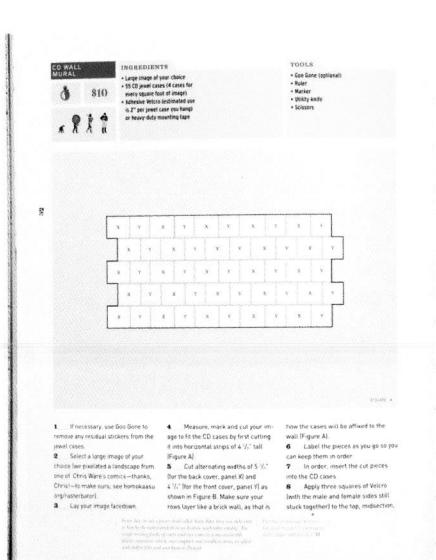

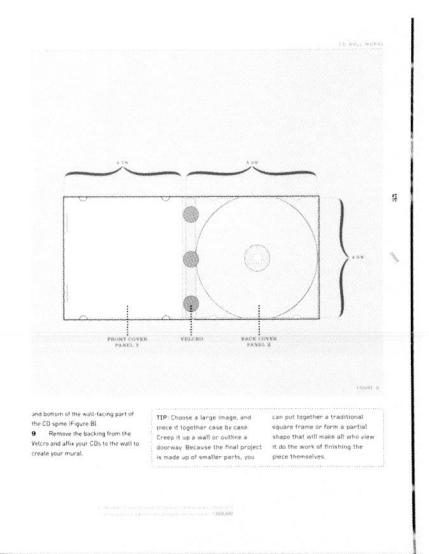

DESIGN

Elizabeth Fitzgibbons, Eric Heiman, and Akiko Ito San Francisco, California

ART DIRECTION

Eric Heiman

CREATIVE DIRECTION

Adam Brodsley and Eric Heiman

PHOTOGRAPHY Jeffery Cross Oakland, California

ILLUSTRATION

Kate Francis

Bermuda

DESIGN OFFICE *Volume, Inc.*

CLIENT ReadyMade

PRINCIPAL TYPE

FF DIN and Foundry Gridnik

DIMENSIONS 7.4 x 9 in. (18.8 x 22.9 cm) DESIGN

Giorgio Pesce and Roberto Muñiz

Lausanne, Switzerland

ART DIRECTION

Giorgio Pesce

CREATIVE DIRECTION

Giorgio Pesce

DESIGN OFFICE

Atelier Poisson

CLIENT

Musée Cantonal de Géologie,

Lausanne

PRINCIPAL TYPE

Gravur Condensed and Bembo

DIMENSIONS

35.2 x 50.4 in.

(89.5 x 128 cm)

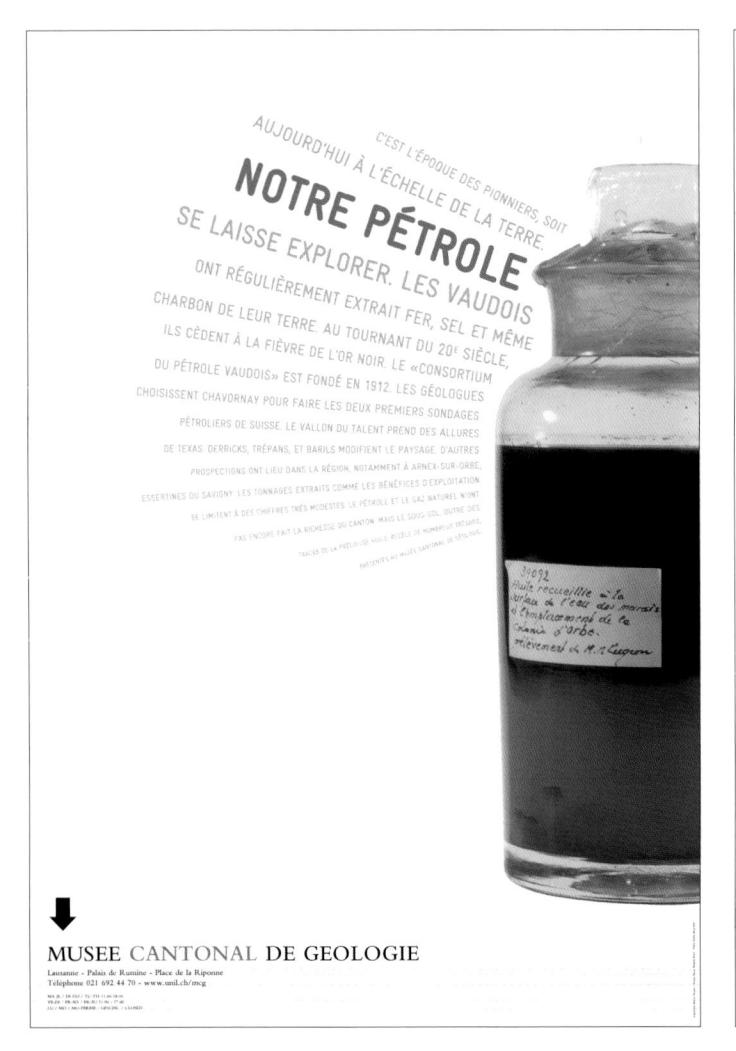

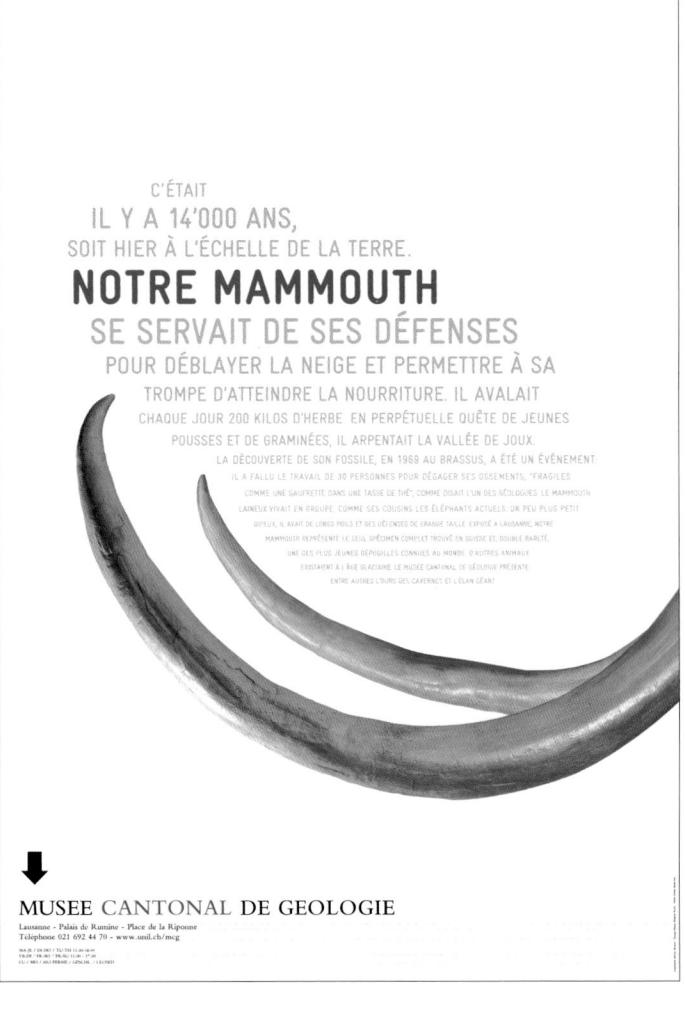
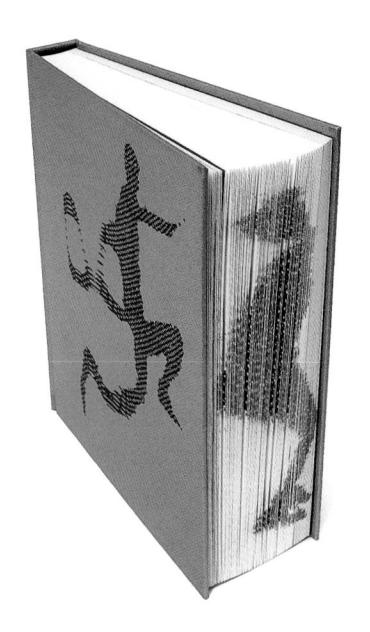

and You Na-Won

Seoul, Korea

ART DIRECTION

Choi Han-Na

Oh Dong-Jun, Park Kum-Jun,

Park Kum-Jun

CREATIVE DIRECTION

Park Kum-Jun

LETTERING

ILLUSTRATION

Park Kum-Jun

Kim Ji-Won, Jung Jong-In, and Nam Seung-Youn

COORDINATORS

IMAGE REVISION

Kang Joong-Gyu

DESIGN OFFICE

601bisang

CLIENT

Visual Information Design

Association of Korea (VIDAK)

PRINCIPAL TYPE

Bembo, FF DIN Bold, FF DIN Light,

and FF DIN Regular

DIMENSIONS

8.9 x 10 in.

 $(22.5 \times 25.5 \text{ cm})$

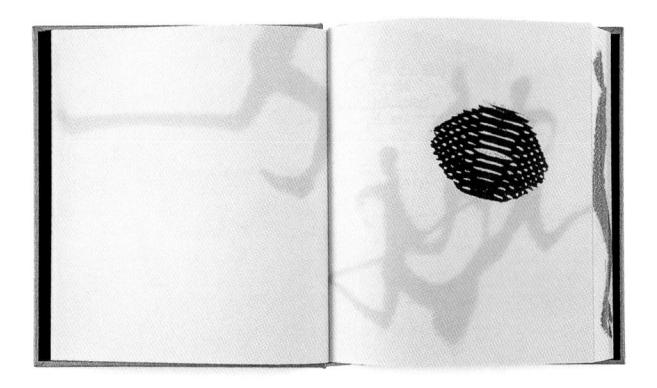

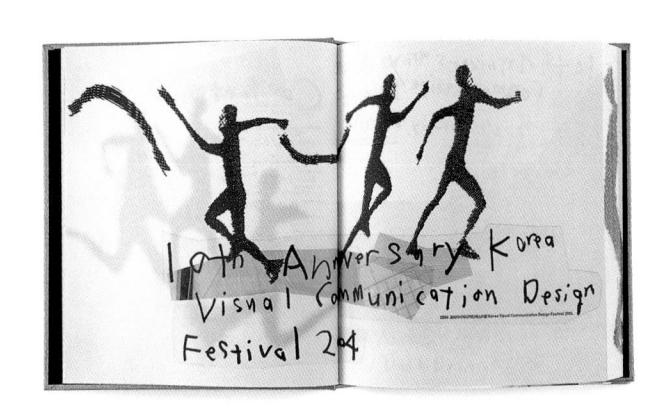

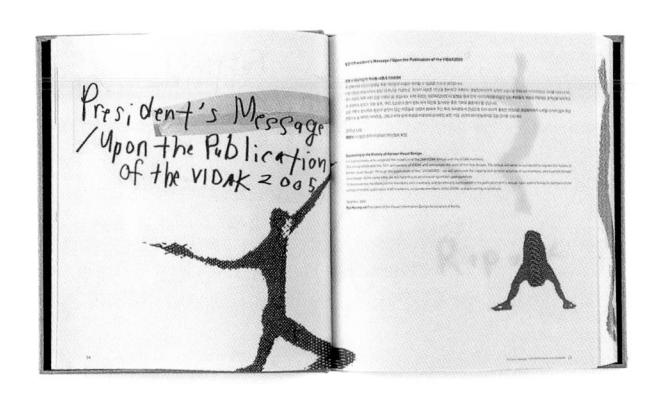

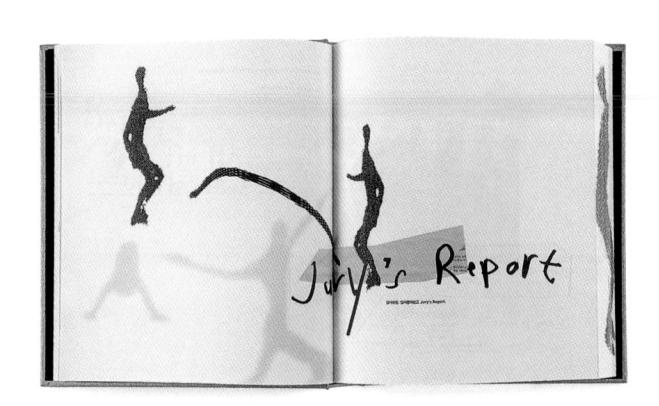

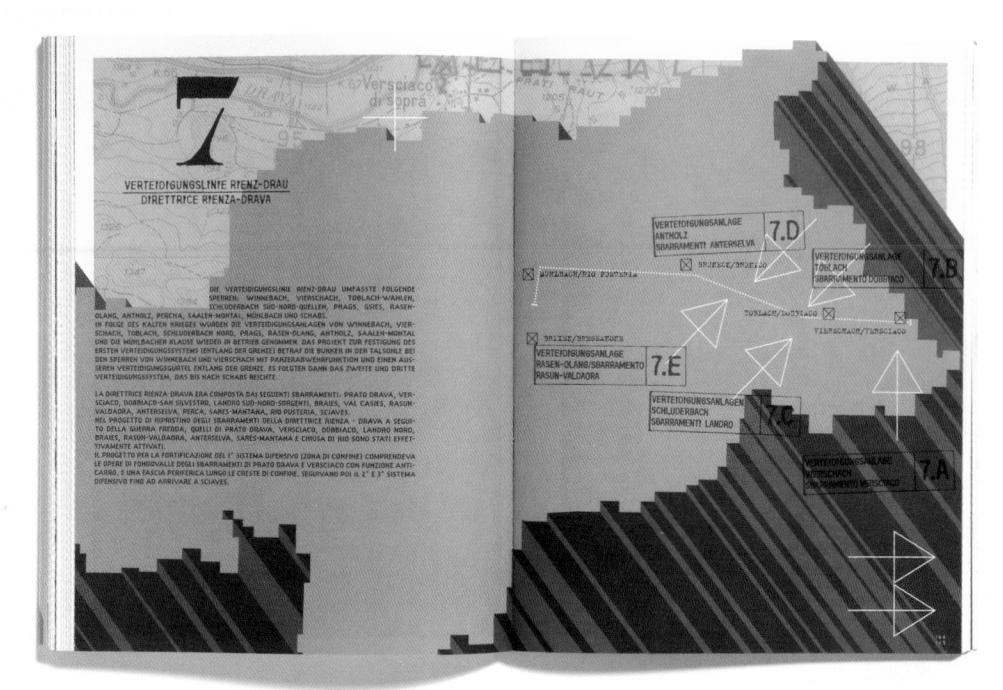

DESIGN

Philipp Putzer

Bolzano, Italy

ART DIRECTION

Uli Prugger

CREATIVE DIRECTION

Alfonso Demetz

DESIGN OFFICE

Gruppe Gut Gestaltung

CLIENT Provincia Autonoma di Bolzano

PRINCIPAL TYPE

Citizen, FF Flightcase, FF Meta,
and FF Trixie Plain

DIMENSIONS 9.2 x 11.8 in. (23.3 x 30 cm)

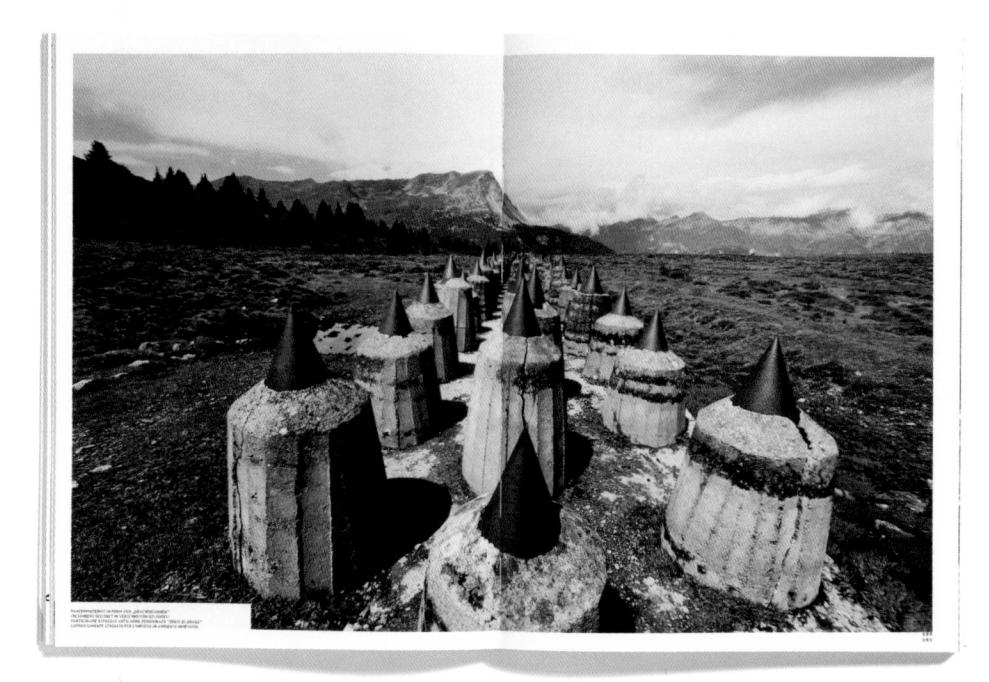

Carin Goldberg Brooklyn, New York

ART DIRECTION

Carin Goldberg and Richard Wilde

CREATIVE DIRECTION

Carin Goldberg and Richard Wilde

Brooklyn, New York, and

New York, New York

PRODUCTION

Adam S. Wahler

DESIGN OFFICE

Carin Goldberg Design

CLIENT School of Visual Arts

PRINCIPAL TYPE

Helvetica and Baskerville

DIMENSIONS 7.5 x 10.75 in. (19.1 x 27.3 cm)

STILL ENT PROJECT

DESIGN

Noémie Darveau Montreal, Canada

SCHOOL

École de Design, UQAM

INSRRUCTOR

Yann Mooney

PRINCIPAL TYPE

Univers Bold Condensed and custom

DIMENSIONS

27 x 39 in.

(68.6 x 99.1 cm)

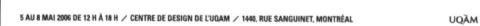

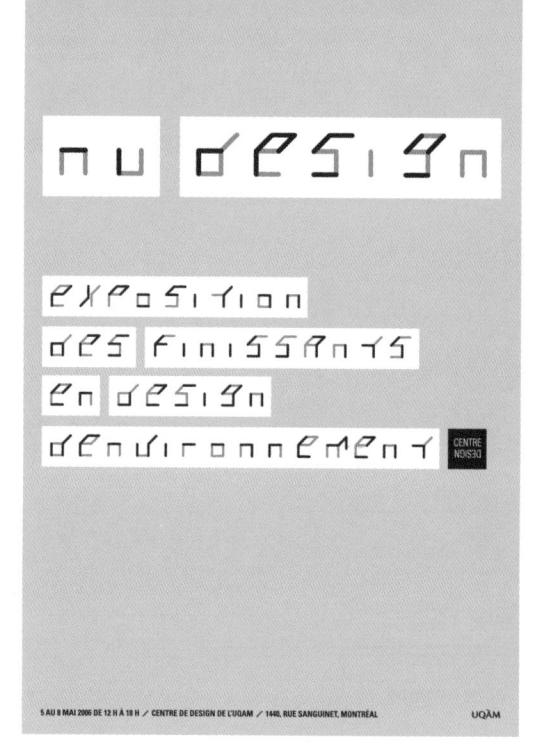

Erin Mayes and DJ Stout Austin, Texas

ART DIRECTION

DJ Stout

DESIGN OFFICE

Pentagram Design Inc.

CLIENT

The Museum of Fine Arts, Houston (MFAH)

PRINCIPAL TYPE

ITC Conduit and Iowan

DIMENSIONS 10.5 x 14 in. (26.7 x 35.6 cm)

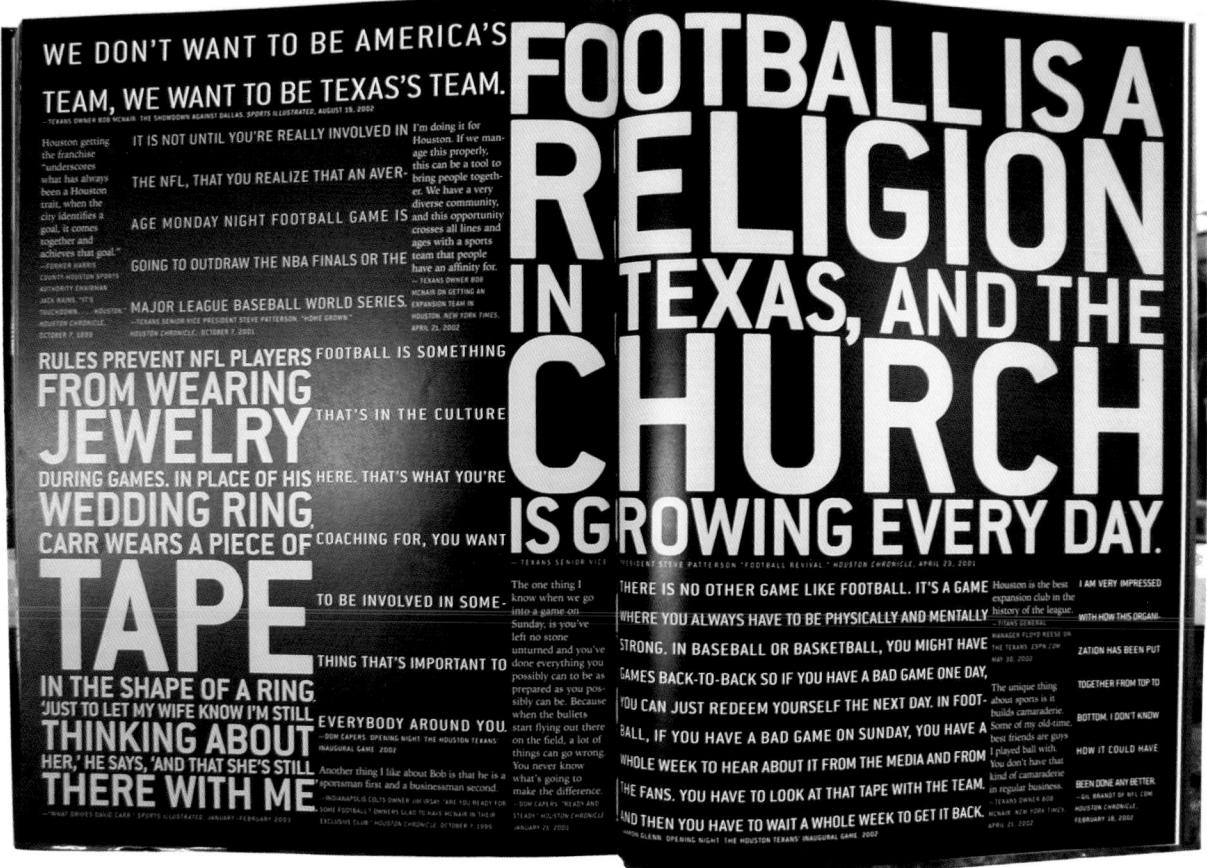

Armin Lindauer

Mannheim, Germany

CLIENT

City of Darmstadt, Germany

PRINCIPAL TYPE

Thesis

DIMENSIONS

6 x 9 in.

 $(15 \times 22.8 \ cm)$

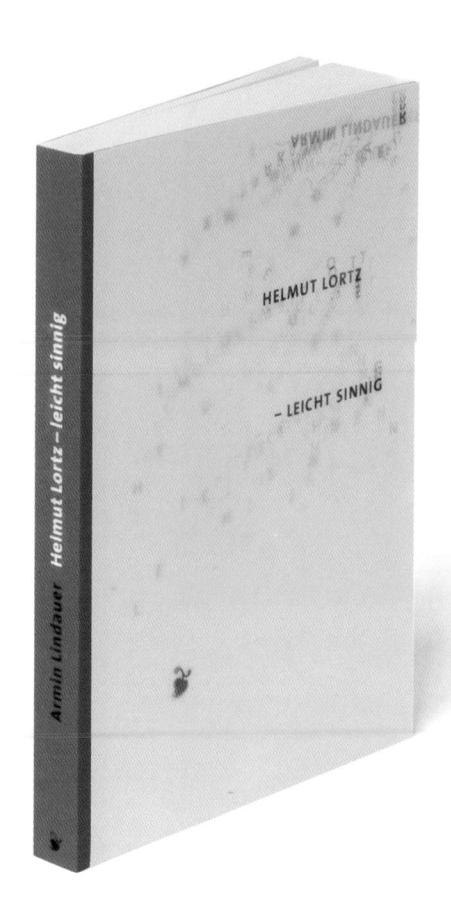

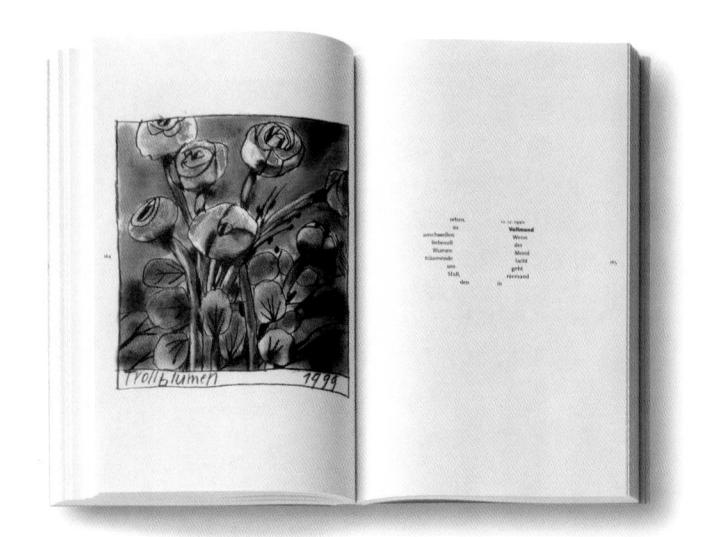

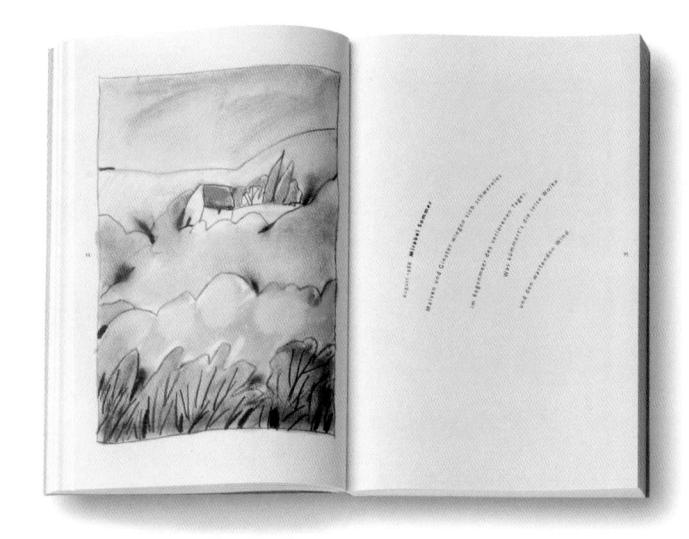

DESIGN

H. P. Becker

Wiesbaden, Germany

ART DIRECTION

H. P. Becker

PHOTOGRAPHY

Peter Poby

COPYWRITER

Cordula Becker

DESIGN OFFICE

New Cat Orange

PRINCIPAL TYPE

Bembo, Fette Fraktur,

and Helvetica Neue

DIMENSIONS

9.25 x 13.4 in.

(23.5 x 34 cm)

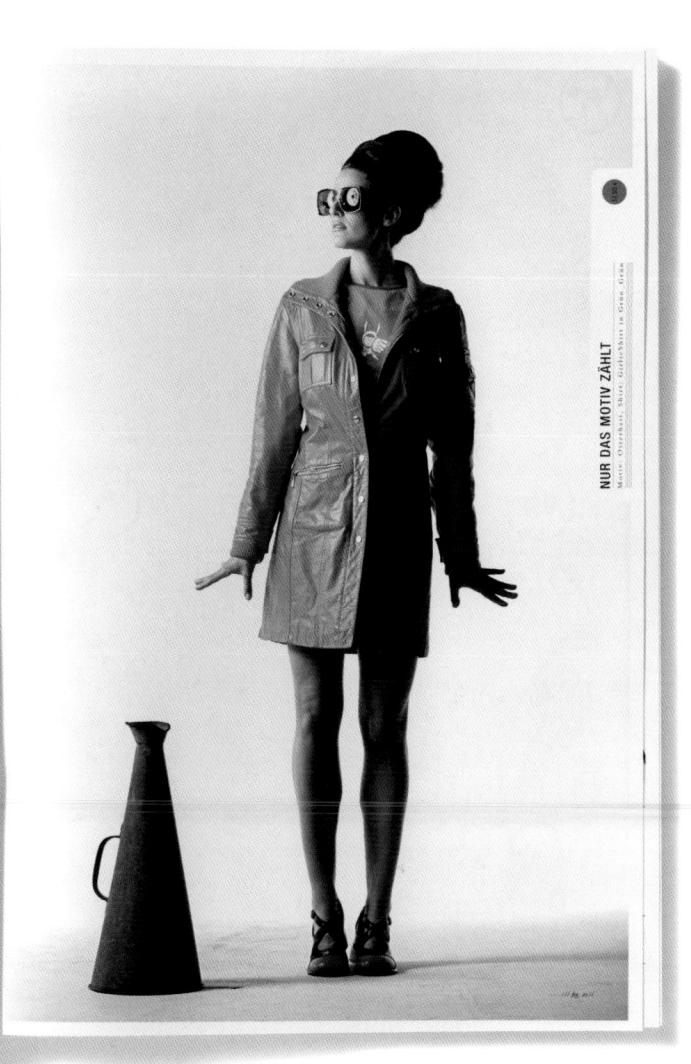

Traian Stanescu

New York, New York

CREATIVE DIRECTION

Stefan Sagmeister

LETTERING

Stefan Sagmeister and

Traian Stanescu

PHOTOGRAPHY

Oliver Meckes and

Nicole Ottawa

DESIGN OFFICE

Sagmeister Inc.

CLIENT

Copy magazine

PRINCIPAL TYPE

Handlettering

DIMENSIONS

11.5 x 9 in.

(29.2 x 22.9 cm)

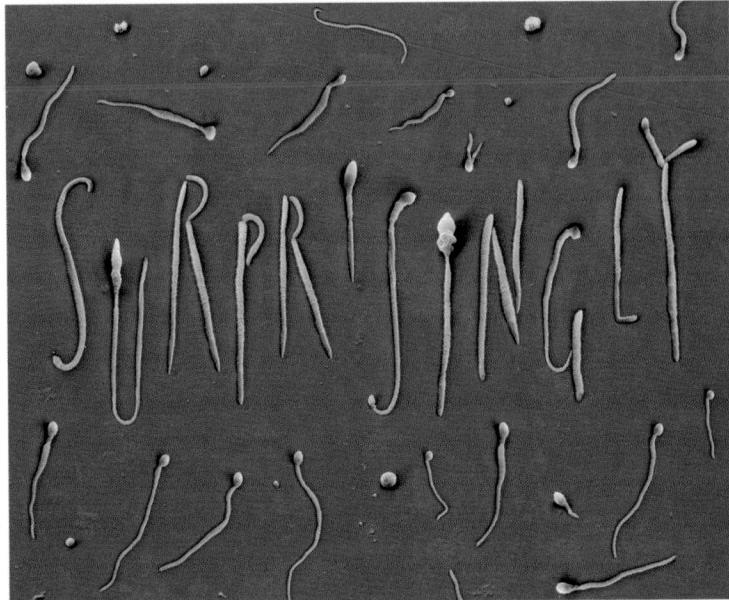

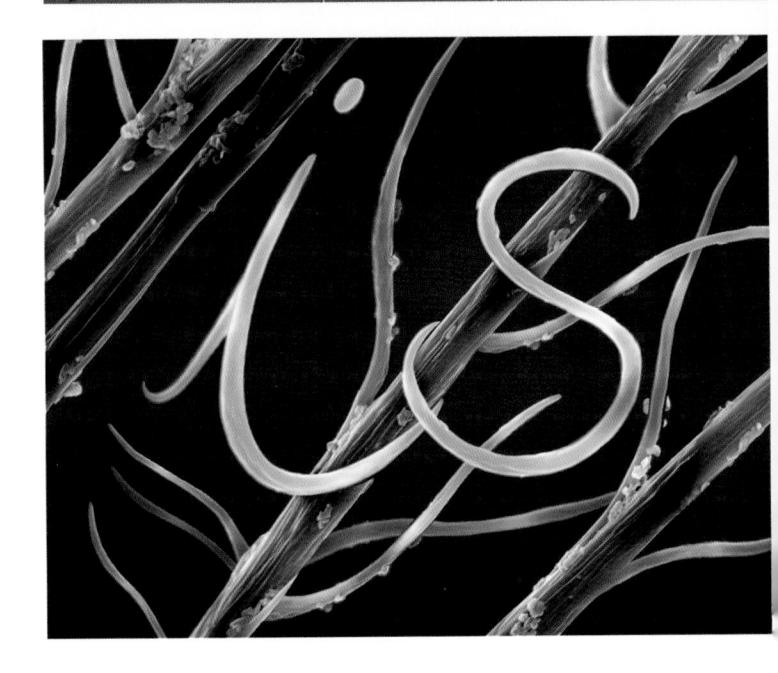

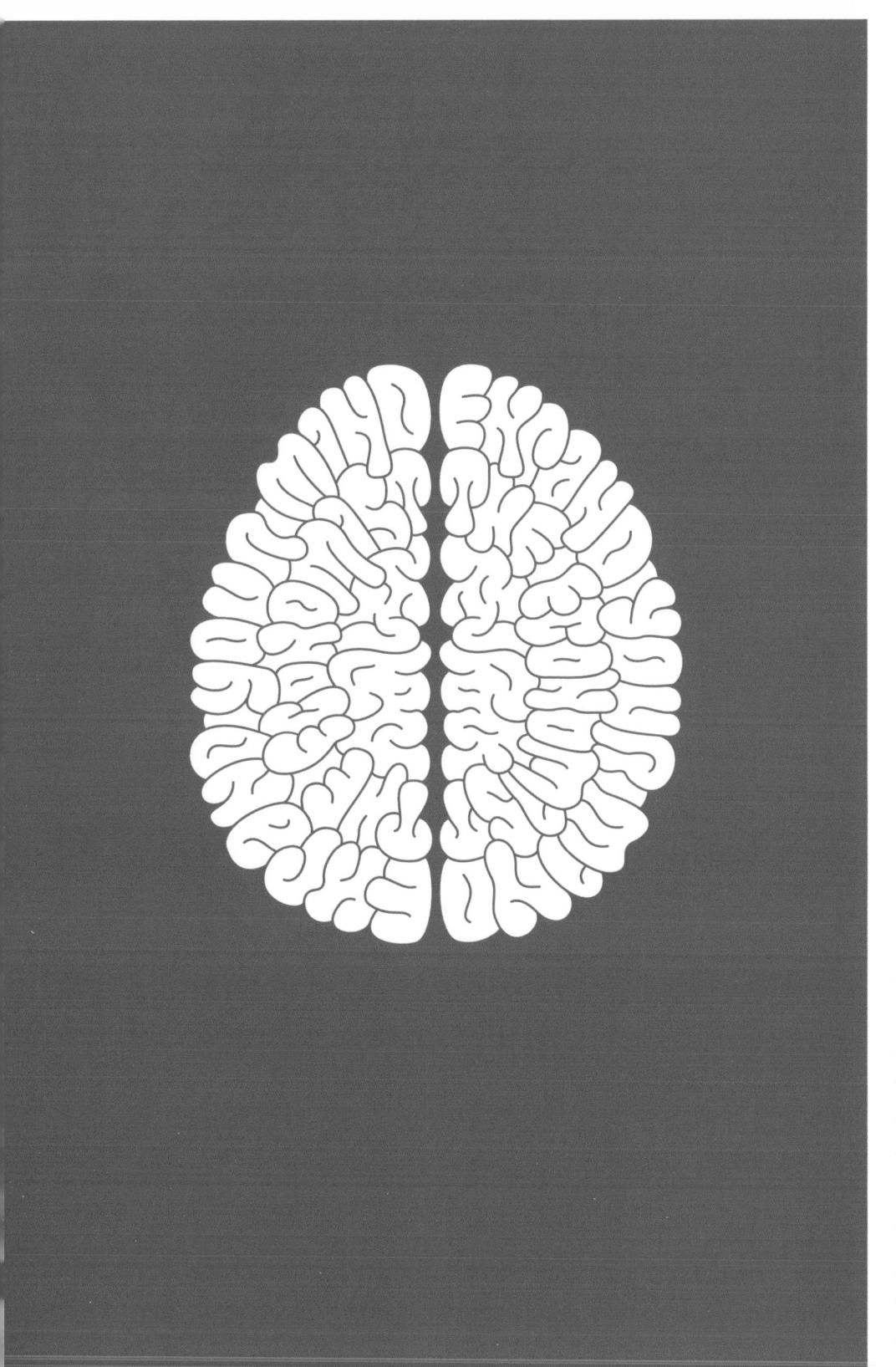

Paul Belford London, England

A DE DIDECTION

ART DIRECTION

Paul Belford

CREATIVE DIRECTION

Paul Belford and Nigel Roberts

LETTERING

Paul Belford

AGENCY

AMV BBDO

CLIENT

The Economist

PRINCIPAL TYPE Handlettering

DIMENSIONS 19.25 x 28.9 in. (48.9 x 73.3 cm)

DESIGN CARD

Jason Godfrey London, England

CREATIVE DIRECTION

Jason Godfrey

DESIGN OFFICE

Godfrey Design

PRINCIPAL TYPE

Caslon and News Gothic

DIMENSIONS 23.4 x 33.1 in. (59.4 x 84 cm)

Kyle Anthony, Eric Haag, and Kendra Inman Kansas City, Missouri

CREATIVE DIRECTION

Robin Knight

ILLUSTRATION

Kyle Anthony, Eric Carver,

Eric Haag, and Kendra Inman

COPYWRITERS

Rick Dunn, James Holden,
and John Lightstone

DESIGN OFFICE

Barkley Evergreen and Partners

CLIENT

Original Juan's

PRINCIPAL TYPE

Courier, House Las Vegas Fabulous, Myriad, Typeka, and handlettering

DIMENSIONS 5.5 x 8.5 in. (14 x 21.6 cm)

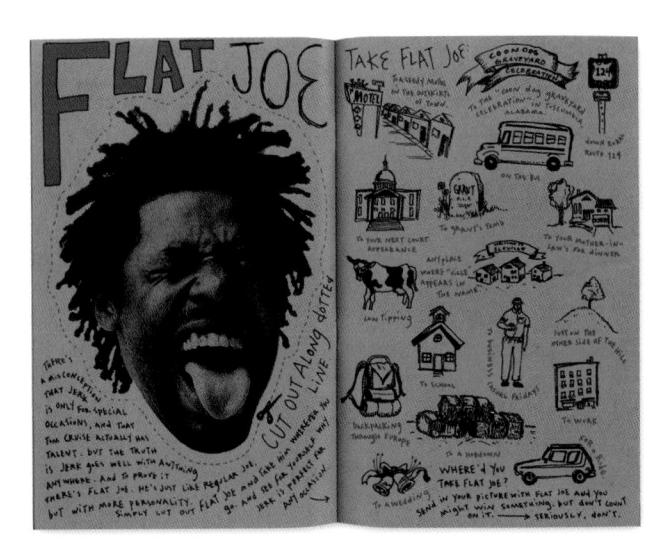

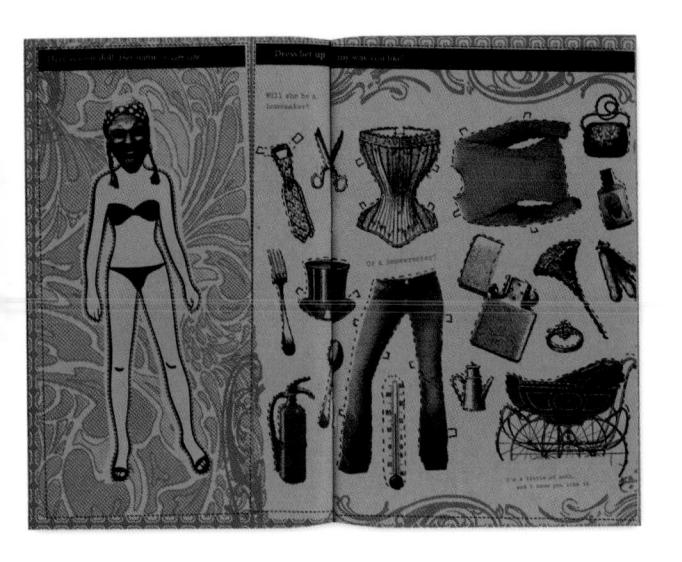

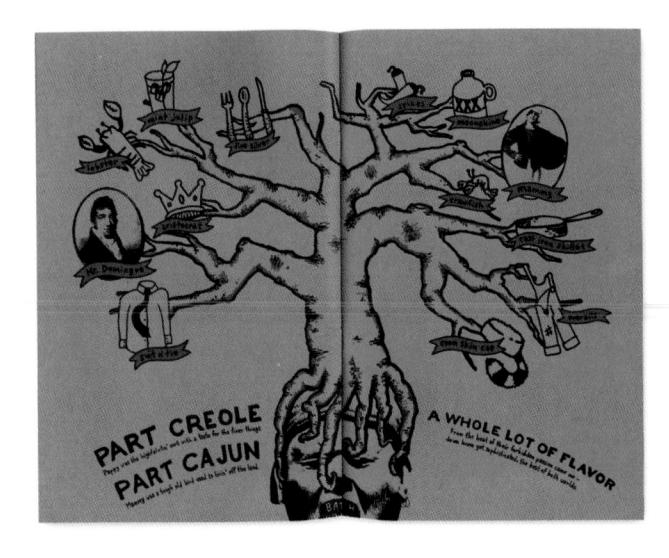

DESIGN HURE

Richard The and Ariane Spiranni Berlin, Germany

CREATIVE DIRECTION

Stefan Sagmeister

New York, New York

LETTERING

Richard The and Ariane Spiranni

PHOTOGRAPHY

Richard The and Ariane Spiranni

ILLUSTRATION

Richard The and Ariane Spiranni

DESIGN OFFICE

Sagmeister Inc.

CLIENT

Anni Kuan Design

PRINCIPAL TYPE

Handlettering

DIMENSIONS

16 x 23 in.

(40.6 x 58.4 cm)

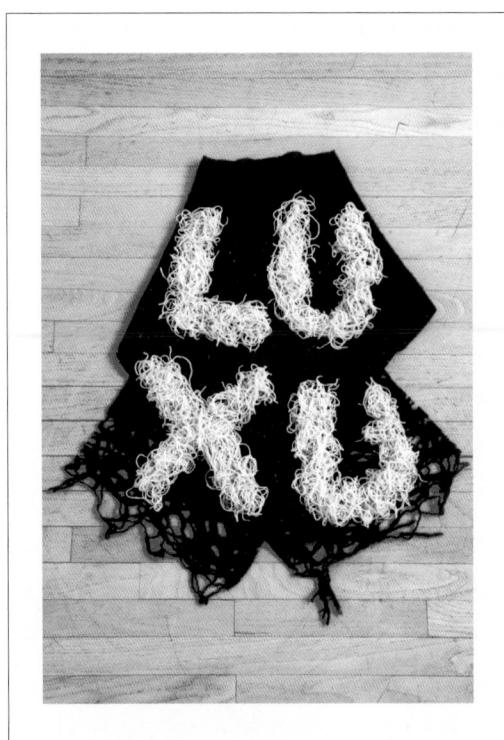

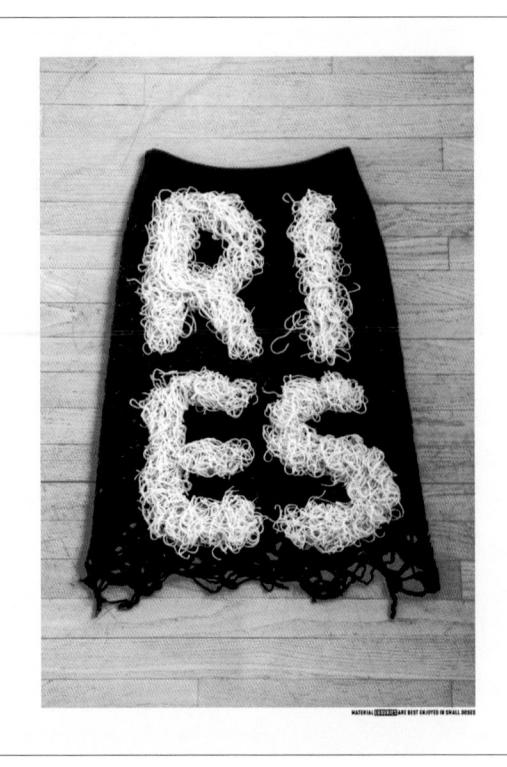

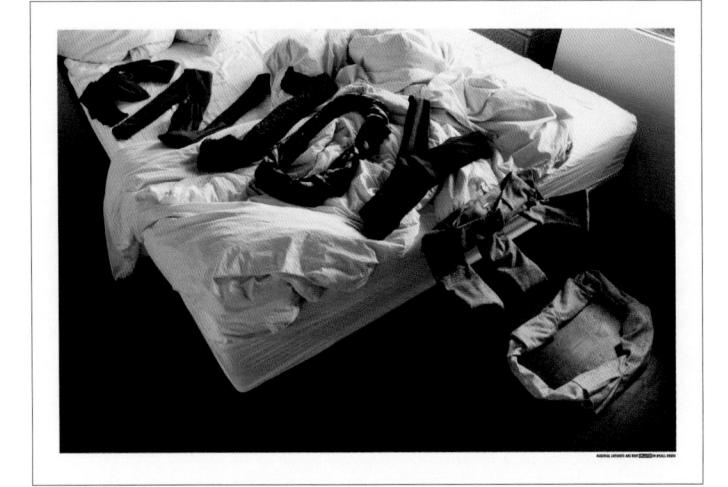

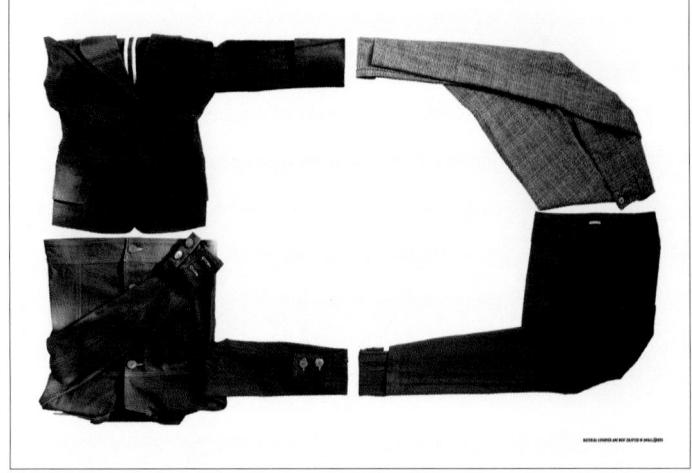

 ${\it Geoff\, Halber}$

Falls Village, Connecticut

ART DIRECTION

William Drenttel and Jessica Helfand

CREATIVE DIRECTION

William Drenttel and Jessica Helfand

STUDIO

Winterbouse Studio

CLIENT

Winterbouse Institute

PRINCIPAL TYPE

Fedra Mono

DIMENSIONS

10.5 x 16 in.

 $(26.7 \times 40.6 \text{ cm})$

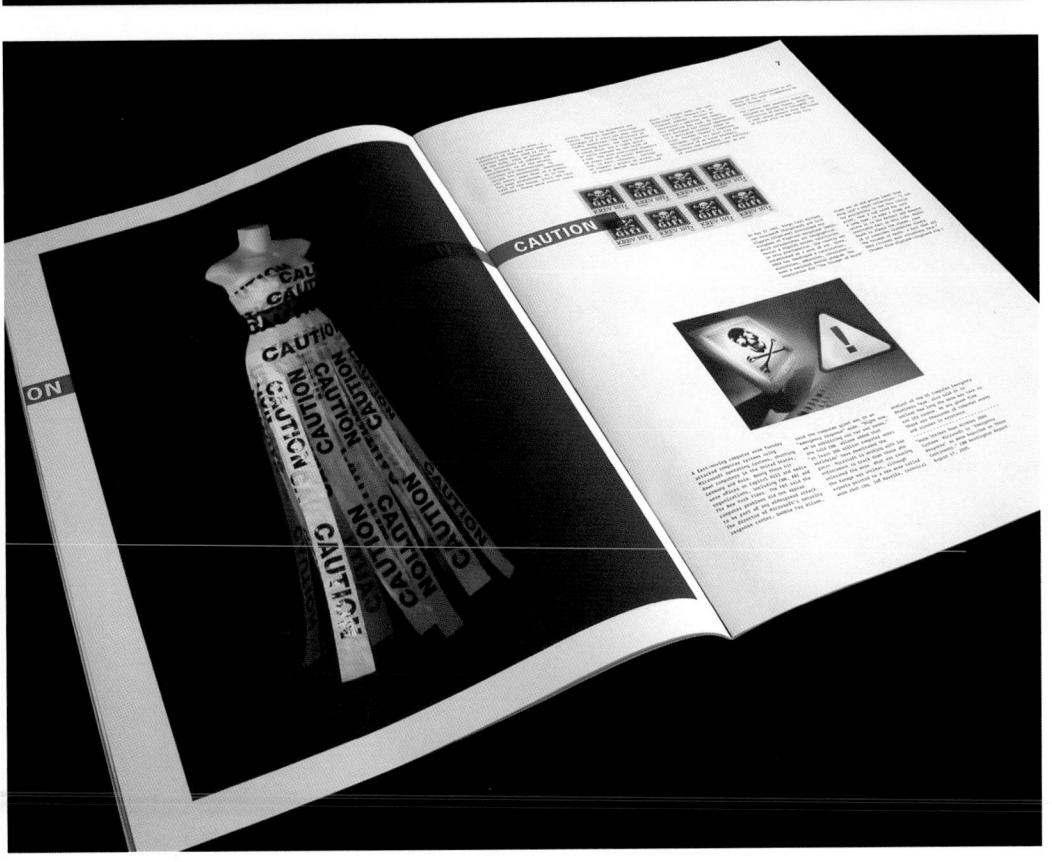

Stephanie Zehender and Kirsten Dietz Stuttgart, Germany

ART DIRECTION Kirsten Dietz

CREATIVE DIRECTION Jochen Rädeker

LETTERING Stephanie Zehender

PHOTOGRAPHY Armin Brosch Munich, Germany

AGENCY strichpunkt

CLIENT Papierfabrik Scheufelen

PRINCIPAL TYPE Univers and FF Scala

DIMENSIONS 9.1 x 12.6 in. (23 x 32 cm)

Serious control of the control of th

INTELLIGENT DESIGN

CREATING AN EVOLVED RED VS BLUE STATE OF MIND

THE THERST THEOR

	LOS X DESCRIPTION	0.0000000000000000000000000000000000000	803000000	ON STREET				(25) (S) (S)		ENGEN STORY				SOME SOUR	030000000	SCHOOL STANS	5020000	855A55EA56	I SOUTH THE PARTY OF
100001	01101110	01100100	00100000	01101100	91199191	01110100	99199999	01110100	01101000	01100101	91191191	00100000	01101000	01100001	01110110	01100101	00100000	01100100	911911
	01101010																		
	01101111																		
1110010																			
					01101110														
					01101000														
					01100101														
	01100101																		
101101																			
					00100000														
					01100101														
	01100001																		
	01101111				01101100														
		010000111			01100110														
					01100101														
1100010	01100100	01110101	01100101	00100000	01101001	01110100	00111010	00100000	01100001	01101110	01100100	00100000	01101000	01100001	01110110	01100101	00100000	01100100	01101
1101101	01101001	01101110	01101001	01101111	01101110	00100000	01101111	01110110	01100101	01110010	00100000	01110100	01101000	01100101	00100000	01100110	01101001	01110011	01101
	01101111																		
					00100000														
	00101100																		
	01101001				01110100														
	01101000	00100000	01110101	01110000	01101111	01101110	00100000	01110100	01101000	01100101	01100100	90101100	01100001	01110010	01110100	01101000	011011110	01101100	81188
					01100001														
					01101000														
	00100000																		
	01110100																		
9100000	01101001	01101110	00100000	01110100	01101000	01100101	6616666	01110111	01101000	01101001	01100011	01101000	00100000	01101001	01110011	00100000	01110100	01101000	01100
	01100110	01110010																	
		01110011																	
		01000001											81111001						
				01110100		01100101							00101100						
					01110010								01101111						
1100001	01101001	01110010	00101100	00100000	01100001	01101110	01100100	00100000	01110100	01101111	00100000	01100101	01110110	01100101	01110010	01111001	00100000	01110100	01101
	01101110																		
1101111	01101110	00100000	01110100	01101000	01100101	99199999	01100101	01100001	01110010	01110100	01101000	00101100	00100000	01110111	01101000	01100101	01110010	01100101	01101
	00100000																		
	01110110				01101001								01110010						
	01101001																		
2100000	01110011	01110100	91119111	00100000	81188181	91119119	01100101	01110011	01111001	00101110	01110100	01101000	01101001	01101110	01100111	00100000	01110100	91101000	01100
	00100000												00101100						
1100010	01100101	01101000	01101111	01101100	01100100	00101100							01110011						
		01101111											00100000						
	00100000																		
	01100101												01100100						
	01110101				01101000 01100001														
					01100001														
					01110100														
		00100000																	
													00100000						
		01100101																	
1101110 1101000	01100100 01100101	00100000	01101000	01100001	01100100		01101101												
1101110 1101000 1110010	01100100 01100101 01100101	00100000 01110011	01101000 01110100	01100001 01100101	01100100 01100100	00100000	01101111	01101110	00100000	01110100	01101000	01100101	00100000	01110011	01100101	01110110	01100101	01101110	01110
1101110 1101000 1110010 1101000	01100100 01100101 01100101 00100000	00100000 01110011 01100100	01101000 01110100 01100001	01100001 01100101 01111001	01100100 01100100 00100000	00100000 01100110	01101111 01110010	01101110 01101111	00100000 01101101	01110100 00100000	01101000 01100001	01100101 01101100	00100000 01101100	01110011 00100000	01100101 01101000	01110110 01101001	01100101 01110011	01101110 00100000	01116
1101110 1101000 1110010 1101000 1101111	01100100 01100101 01100101 00100000 01110010	00100000 01110011 01100100 01101011	01101000 01110100 01100001 00100000	01100001 01100101 01111001 01110111	01100100 01100100 00100000 01101000	00100000 01100110 01101001	01101111 01110010 01100011	01101110 01101111 01101000	00100000 01101101 00100000	01110100 00100000 01101000	01101000 01100001 01100101	01100101 01101100 00100000	00100000 01101100 01101000	01110011 00100000 01100001	01100101 01101000 01100100	01110110 01101001 00100000	01100101 01110011 01101101	01101110 00100000 01100001	01116 01116 01106
1101110 1101000 1110010 1101000 1101111 1100101	01100100 01100101 01100101 00100000	00100000 01110011 01100100 01101011 00001101	01101000 01110100 01100001 00100000 00001010	01100001 01100101 01111001 01110111 01000001	01100100 01100100 00100000 01101000 011011	00100000 01100110 01101001 01100100	01101111 01110010 01100011 00100000	01101110 01101111 01101000 01000111	00100000 01101101 00100000 01101111	01110100 00100000 01101000 01100100	01101000 01100001 01100101 00100000	01100101 01101100 00100000 01100010	00100000 01101100 01101000 01101100	01110011 00100000 01100001 01100101	01100101 01101000 01100100 01110011	01110110 01101001 00100000 01110011	01100101 01110011 01101101 01100101	01101110 00100000 01100001 01100100	01110 01110 01100 00100

9099		n an an		an an	
	*********	88 8888888	*******	********	50050550
******* ******	*************	05 50055000	5585555	50555000	10010000
		05 50055050	*******	50005055	50055050
	*******	55 50055050	55855555	50050555	50055050
		25 55255555	50055550	50050005	50055055
******* *****		58 55855556			10001101
	*********	** *******	10010005	*****	55855555
		** *******	50055550	40004404	50005055
		50 50005500	55055555	40004000	80050550
			55855555	50055005	10010000
	. 55855555 588555	50 50050005	*****	*****	50005005
			50055550	90090009	50055055
*******		25 52252522	50050005	*****	40005500
		40 40004400	8686866		50005555
	********	55 50050555	50055050	*****	50055005
******** *******		** *******	50055005	5525555	******
50050555 50055051		55 50055050	50055050	50005555	******
*******		55 55855555	*****	52252555	*******
*******		56 5666566	80080880	*****	55855555
********	* ******* *****	** *******	50055055	*****	*****
		55 55855555	50005050	58885555	*******
		95 50055050	*****	*****	*******

	95855555	10010000	10051001	88888888	50005055	50050555
	90009000	50055550		50055050	*****	*****
*******	8888888	50050005	50055055	55855555	*******	40040000
********	10004100	90099999	50050550	50055055	55656655	55855555
10110011 10011010	50005055	55855555	******	40050555	*****	******
********	40044404	*******	55855555	50050055	50050550	*******
******* *****	******	8888888	50055550	50050005	50055055	55855555
******* ******	*******	******	50055050	55855555	********	40044440
*********	50050055	******	50055000	80050555	*****	******
*******	******	*****	65855555	*******	*******	40055055
*******	******	*****	55855555	90009099	80050555	******
55055555 50050055	50050550	40055000	50050555	*****	55858855	95895959
	******	******	55855555	******	*****	55855555
10001000 10011110	40004400	55855555	50055000	10010000	50050000	50055055
*******	40044440	50050005	50055055	99899999	40555000	*******
********	50055055	50050550	50005005	98888888	58855855	50055050
*******	50005055	50050555	50055050	55855555	50050055	******
40055000 50050555	50005055	*****	50055005	*****	50050000	50050050
******* ****	******	50055050	55855555	50055055	50055550	80005505
********	******	50005500	50005500	******	85888888	8255556
	55855555	32355522	*******	*****	55855555	5055550
50055550 50050055	50050055	******	80088088	55855555	50005055	*****
********	50050055	40030440	50055000	50050555	10003045	65866666
40455055 5005555	50000550	55855555	50055550	40040004	50055055	55855555
*******	50055050	55855555	50055055	40044440	50005505	10010100
The second secon	The state of the s		metanore (200 page 100)	- 1212 - 1212		- Commence of the Commence of

DESIGN TO THE

Robb Irrgang, John Pobojewski,

Rick Valicenti, and Gina Vieceli-Garza

Barrington, Illinois

ART DIRECTION

Rick Valicenti

CREATIVE DIRECTION

Rick Valicenti

PHOTOGRAPHY

Gina Vieceli-Garza

ILLUSTRATION

Gina Vieceli-Garza

PROGRAMMER

Robb Irrang

STUDIO

Thirst

PRINCIPAL TYPE

Kroeger 05-53

DIMENSIONS

16 x 20 in.

 $(40.6 \times 50.8 \text{ cm})$

DESIGN MALLER

Chris Hoch, Beth Singer, Howard Smith,

and Sucha Snidvongs Arlington, Virginia

ART DIRECTION

Beth Singer

CREATIVE DIRECTION

Howard Smith

Beth Singer Design, LLC

DESIGN OFFICE

CLIENT

American Institute of Graphic Arts,

Washington, D.C.

PRINCIPAL TYPE

Interstate and FF Meta Plus

DIMENSIONS

25 x 22 in.

(63.5 x 55.9 cm)

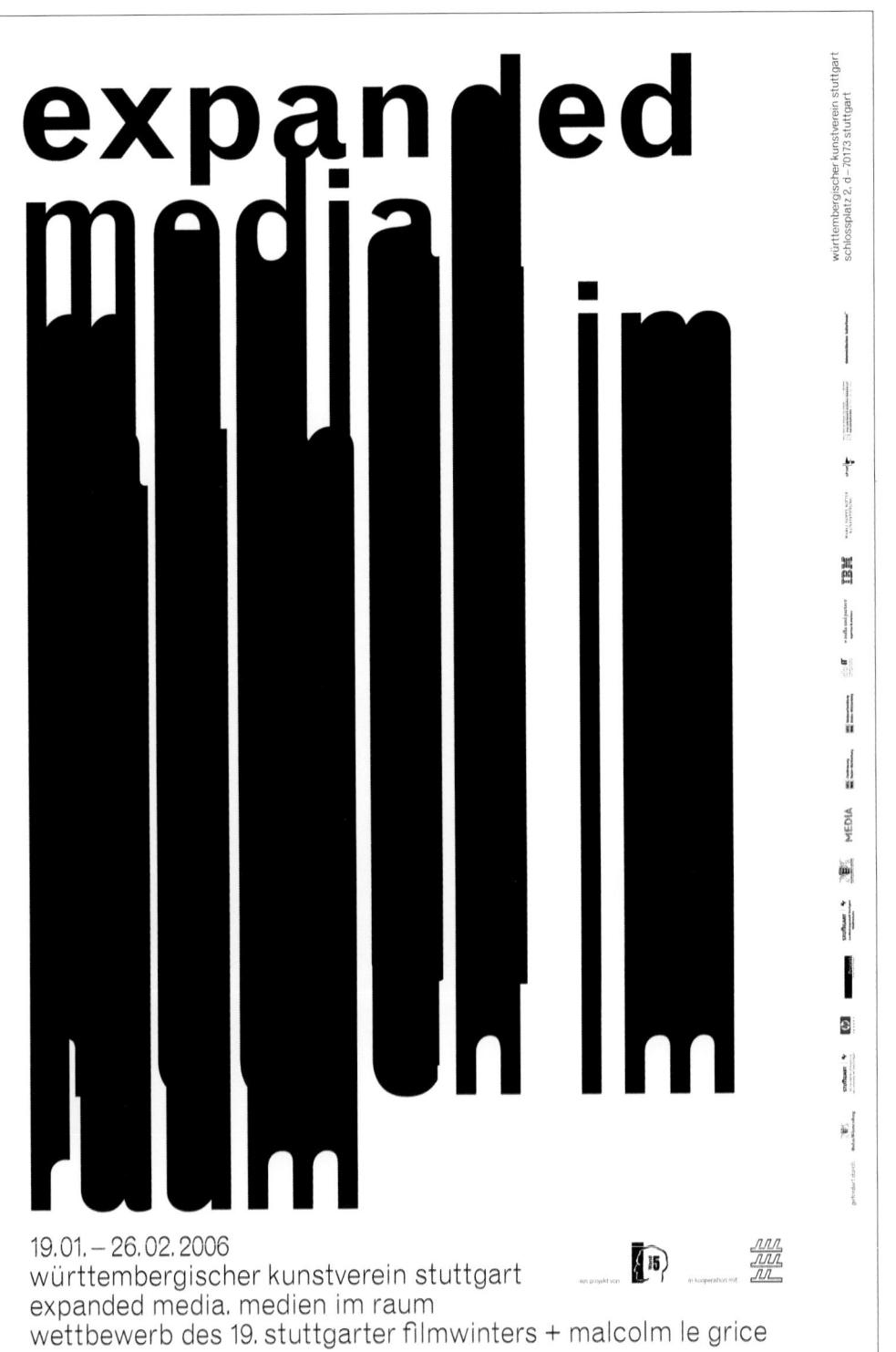

Sascha Lobe and Ina Bauer Stuttgart, Germany

DESIGN OFFICE

L2M3 Kommunikationsdesign GmbH

CLIENT

Württembergischer Kunstverein Stuttgart, Germany

PRINCIPAL TYPE

Monotype Grotesque

DIMENSIONS

23.4 x 33.1 in.

(59.4 x 84.1 cm)

OAT FOR ENTRIES

Susanne Hörner

Stuttgart, Germany

ART DIRECTION

Kirsten Dietz

CREATIVE DIRECTION

Jochen Rädeker and Felix Widmaier

LETTERING

Susanne Hörner

AGENCY

strichpunkt

CLIENT

Art Directors Club Deutschland

PRINCIPAL TYPE

Various

DIMENSIONS

8.3 x 10.6 in.

 $(21 \times 27 \ cm)$

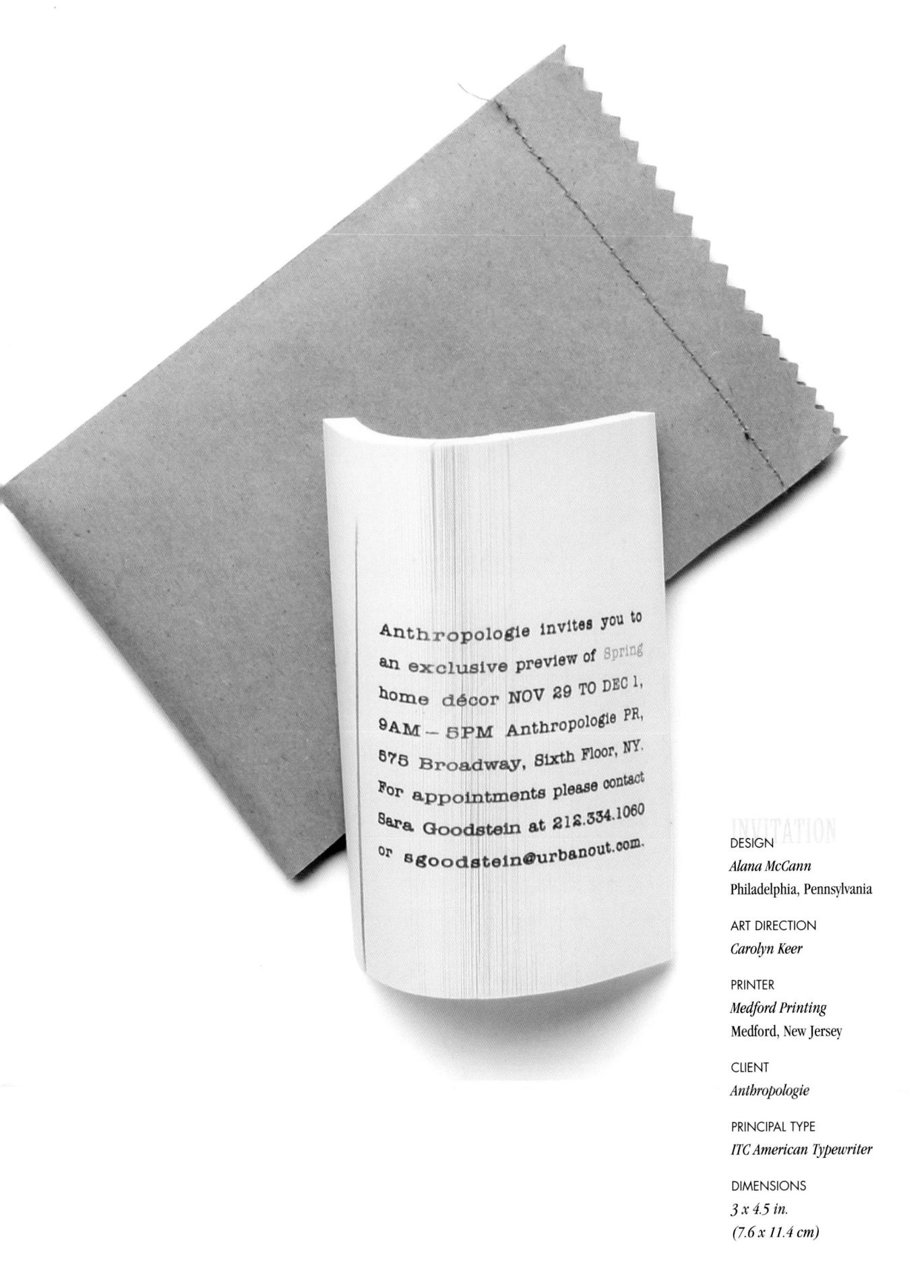

DACK AGING

Thomas Markl

Munich, Germany

ART DIRECTION

Thomas Markl

CREATIVE DIRECTION

Stefan Bogner

LETTERING

Oliver Koftalki and Thomas Markl

AGENCY

Factor Product GmbH

CLIENT

Great Stuff GmbH

PRINCIPAL TYPE

Rinzen Bits

DIMENSIONS

12.4 x 12.3 in.

 $(31.5 \times 31.3 \text{ cm})$

Susanne Hörner and Felix Widmaier Stuttgart, Germany

ART DIRECTION

Kirsten Dietz

CREATIVE DIRECTION

Kirsten Dietz and Jochen Rädeker

AGENCY strichpunkt

CLIENT
Papierfabrik Scheufelen

PRINCIPAL TYPE

FF Scala

DIMENSIONS 24.4 x 31.5 in.

(62 x 80 cm)

Koen Geurts, Marenthe Otten, and Floris Schrama The Hague, The Netherlands

ART DIRECTION

Koen Geurts and Marenthe Otten

DESIGN OFFICE

Studio 't Brandt Weer

PRINCIPAL TYPE

AT Riot, Tarzana Narrow,
and handmade type

DIMENSIONS 7.7 x 10.2 in. (19.5 x 26 cm)

Katsunori Aoki Tokyo, Japan

ART DIRECTION

Katsunori Aoki

CREATIVE DIRECTION

Katsunori Aoki

ILLUSTRATION

Shuzo Hayashi

DESIGN OFFICE

 $\textit{Butterfly} \, \bullet \, \textit{Stroke Inc.}$

CLIENT

AVEX ENTERTAINMENT INC.

PRINCIPAL TYPE

Afloat

DIMENSIONS

75.1 x 53.2 in.

(190.8 x 135 cm)

ENVIRONMENTAL DISCIPLIAY DESIGN

Lonny Israel, Alan Sinclair, and Brad Thomas San Francisco, California

LETTERING

Brad Thomas

ARCHITECT

Kye Archuleta, Michael Duncan,
and Patricia Yeb

DESIGN OFFICE Skidmore, Owings & Merrill LLP

CUENT
Chongqing Financial Street Real
Estate, Ltd.

PRINCIPAL TYPE

Handlettering

SEQUENCE FIVE / SECONDS :21

2/3 BUILDING NAME

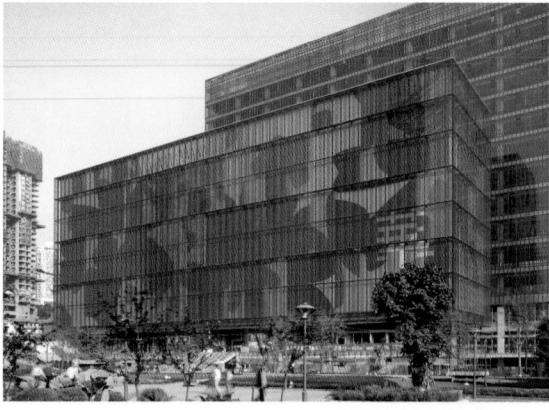

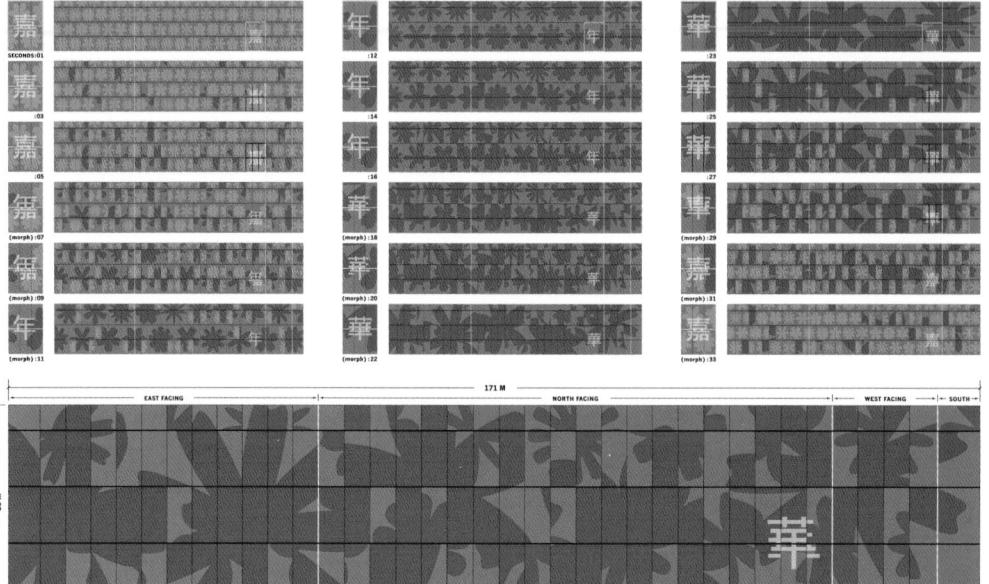

DESIGN

Boris Ljubicic

Zagreb, Croatia

ART DIRECTION

Boris Ljubicic

CREATIVE DIRECTION

Boris Ljubicic

STUDIO

 $Studio\ International$

CLIENT

Museum Documentation Centre, Croatia

PRINCIPAL TYPE

Helvetica Medium

DIMENSIONS 26.8 x 38.6 in. (68 x 98 cm)

PACK AGING

Richard Kegler and Colin Kahn Buffalo, New York

ART DIRECTION

Richard Kegler

CREATIVE DIRECTION

Richard Kegler

PRINTER AND PACKAGE FORMAT Bruce Licher Sedona, Arizona

STUDIO P22

CLIENT
P22 Records

PRINCIPAL TYPE

LTC Caslon family

DIMENSIONS 5.5 x 5 in. (14 x 12.7 cm)

DESIGN AL REPORT

Maja Bagic

Maja Bagic Zagreb, Croatia

ART DIRECTION

Maja Bagic

AGENCY

Bruketa&Zinic

CLIENT

Adris Group

PRINCIPAL TYPE

Didot

DIMENSIONS

13.4 x 9.25 in.

(34 x 23.5 cm)

ANNIAL REPORT

Kelly Atkins, Nancy Caal, and Brad Simon New York, New York

ART DIRECTION

John Klotnia and Brad Simon

CREATIVE DIRECTION

John Klotnia

Opto Design

CLIENT

Alexandria Real Estate Equities, Inc.

PRINCIPAL TYPE

Trade Gothic and Bembo

DIMENSIONS

6 x 9 in.

 $(15.2 \times 22.9 \text{ cm})$

DESIGN OFFICE

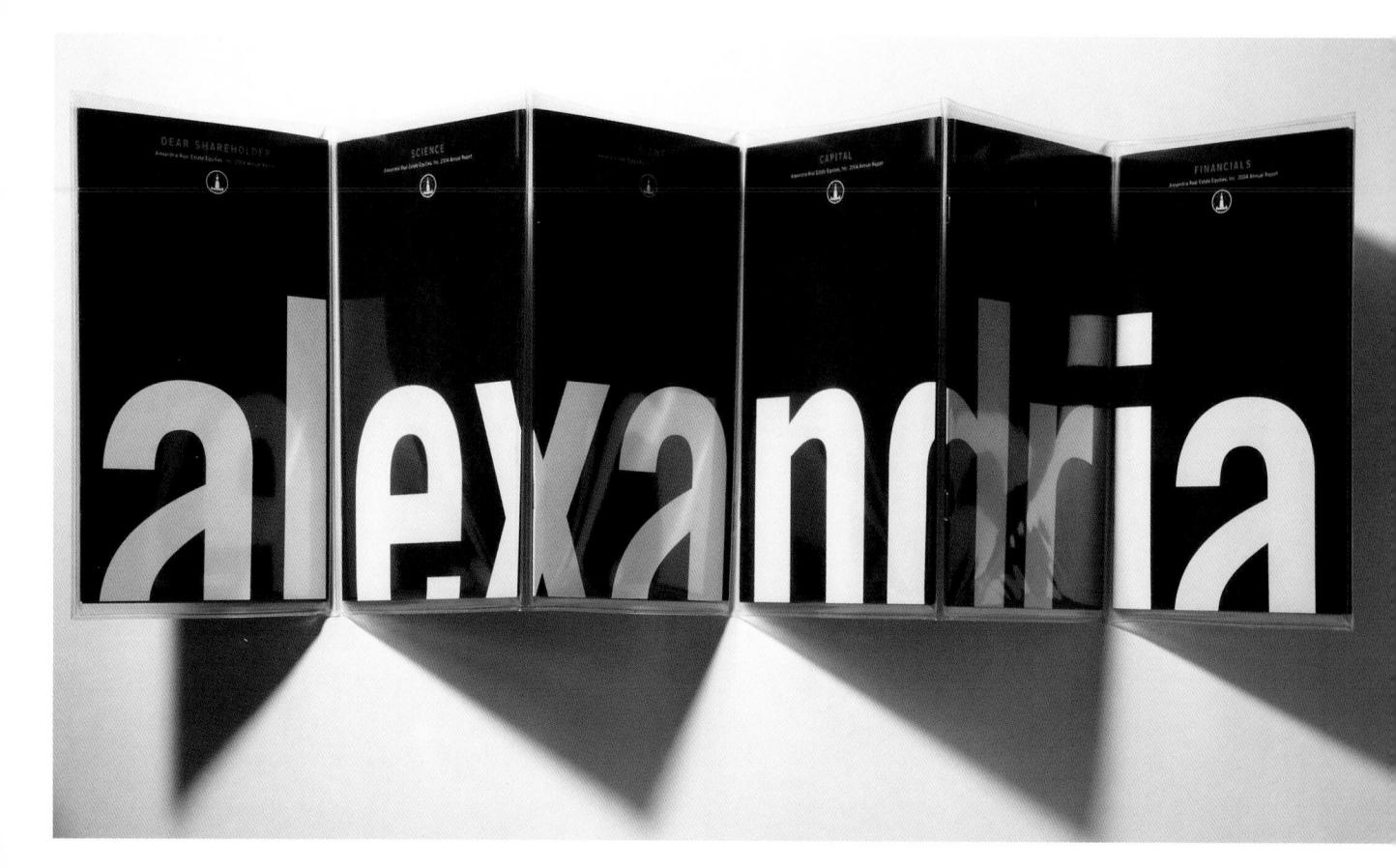

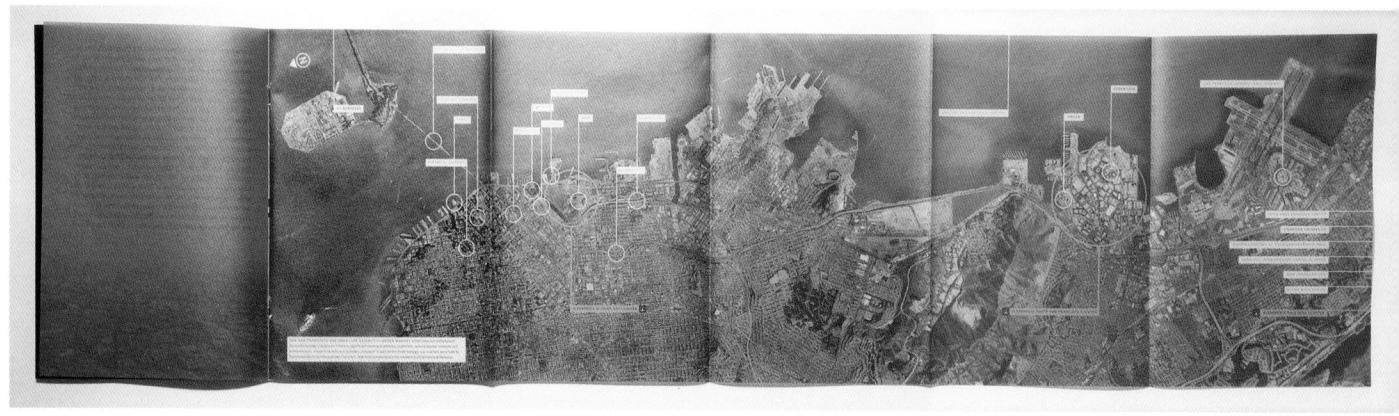

DESIGN REPORT

Davor Bruketa and Nikola Zinic Zagreb, Croatia

ART DIRECTION

Davor Bruketa and Nikola Zinic

CREATIVE DIRECTION

Davor Bruketa and Nikola Zinic

PHOTOGRAPHY

Marin Topic and Domagoj Kunic

AGENCY

Bruketa&Zinic

CLIENT *Podravka d.d.*

PRINCIPAL TYPE

DIN, Minion, and Milton

DIMENSIONS 8.9 x 10.5 in. (22.5 x 26.7 cm) STUDENT PROJECT

Iran Narges

San Francisco, California

SCHOOL

California College of the Arts

INSTRUCTOR

Emily McVarish

PRINCIPAL TYPE

ITC Fenice

DIMENSIONS

8 x 10 in.

(20.3 x 25.4 cm)

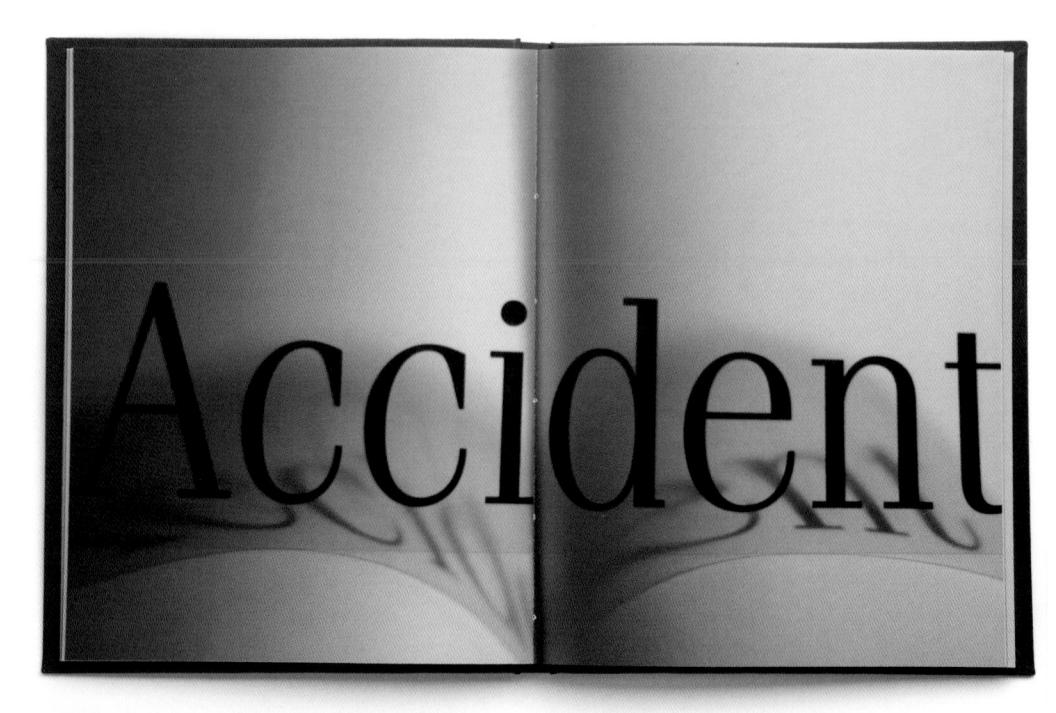

David Guarnieri Montreal, Canada

ART DIRECTION

David Guarnieri and Rene Clement

CREATIVE DIRECTION

Louis Gagnon

DESIGN OFFICE

Paprika

CLIENT

Commissaires

PRINCIPAL TYPE

Didot

DIMENSIONS

32 x 40 in.

(81.3 x 101.6 cm)

DESIGN ENT PROJECT

Kate Rascoe

San Francisco, California

SCHOOL

California College of the Arts

INSTRUCTOR

Emily McVarish

PRINCIPAL TYPE

Freehand 521, Helvetica Neue,

Orator, and wood type ornaments

DIMENSIONS

14 x 8 in.

(35.6 x 20.3 cm)

Pepe Gimeno and Dídac Ballester

Valencia, Spain

DESIGN STUDIO

Pepe Gimeno Proyecto Grafico

CLIENT

Feria Internacional del Mueble de

Valencia

PRINCIPAL TYPE

FF DIN

DIMENSIONS

27.6 x 39.4 in.

(70 x 100 cm)

DACTER

Klaus Hesse

Erkrath, Germany

DESIGN OFFICE Hesse Design

CLIENT

HfG Offenbach

PRINCIPAL TYPE

Corporate S

DIMENSIONS

27.6 x 39.4 in. (70 x 100 cm)

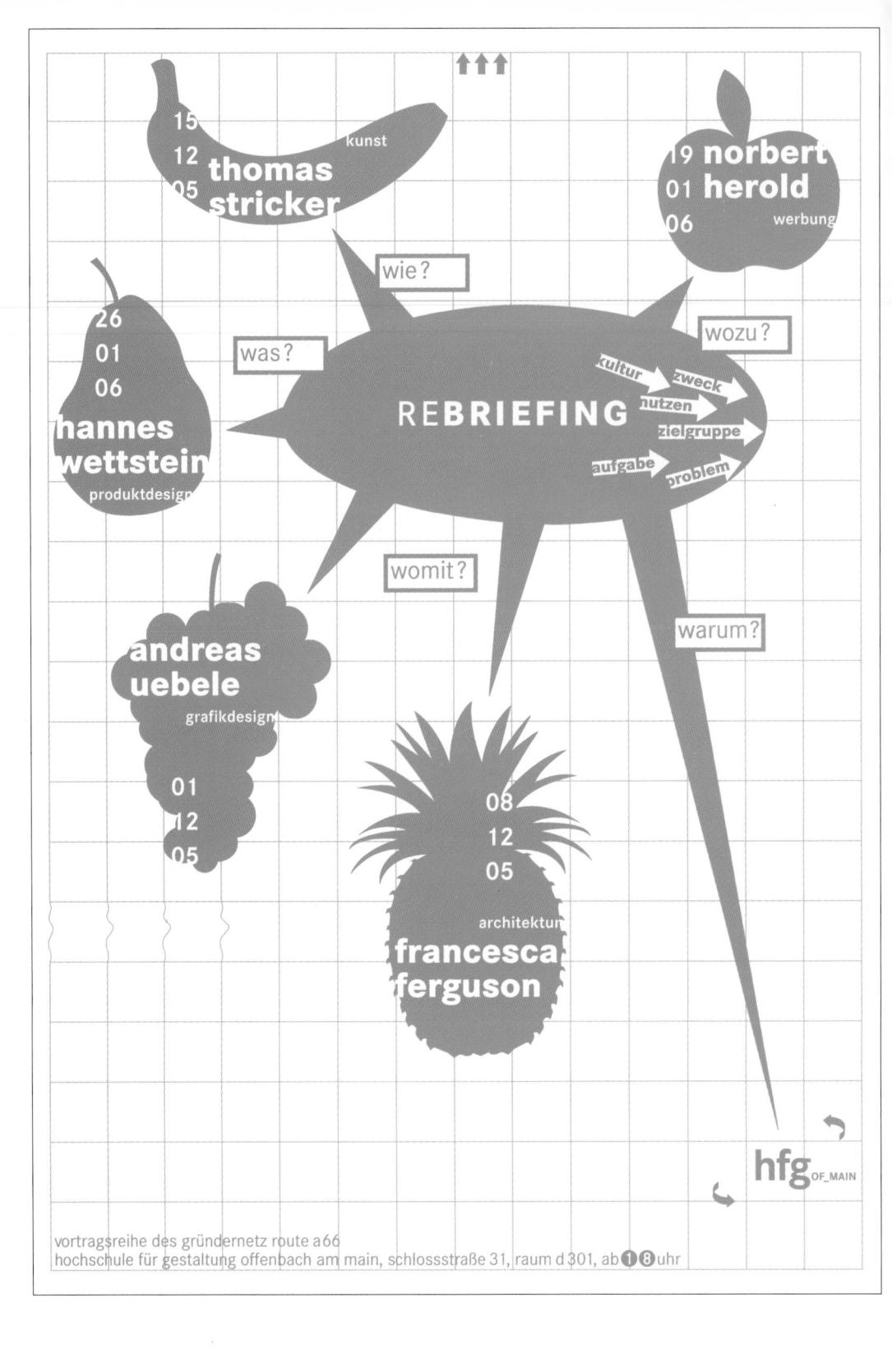

*Dirk Fowler*Lubbock, Texas

STUDIO

f2 design

CLIENT

Anti-Pop Festival

PRINCIPAL TYPE

Handcut and Twentieth Century

DIMENSIONS

18 x 24 in.

 $(45.7 \times 61 \text{ cm})$

Pazu Lee Ka Ling Shenzhen, China

ART DIRECTION

Pazu Lee Ka Ling

LETTERING

Pazu Lee Ka Ling

CLIENT

Shenzhen Graphic Design Association

PRINCIPAL TYPE

Custom and handlettering

DIMENSIONS

27.6 x 39.4 in.

 $(70 \times 100 \text{ cm})$

DAGTER

Pazu Lee Ka Ling Shenzhen, China

ART DIRECTION

Pazu Lee Ka Ling
CLIENT

Shenzhen Graphic Design Association

PRINCIPAL TYPE

Custom

DIMENSIONS 27.6 x 39.4 in. (70 x 100 cm)

Niklaus Troxler

Willisau, Switzerland

LETTERING

Niklaus Troxler

DESIGN OFFICE

Niklaus Troxler Design

CLIENT

Jazz in Willisau

PRINCIPAL TYPE

Custom

DIMENSIONS 35.6 x 50.4 in. (90.5 x 128 cm)

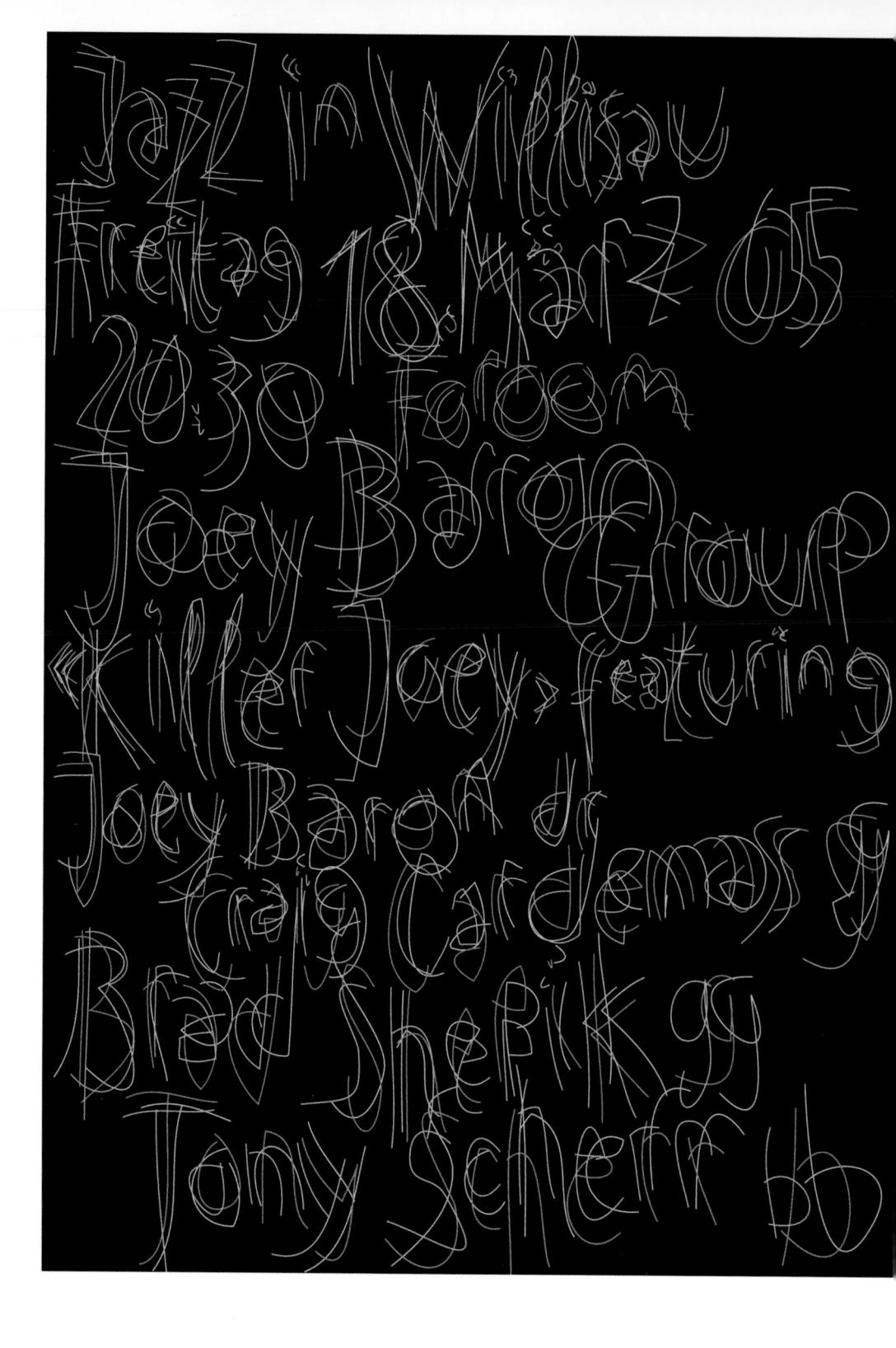

DAGIGNI AGIN

Domenic Lippa and Paul Skerm

London, England

ART DIRECTION

Domenic Lippa

CREATIVE DIRECTION

Domenic Lippa

TYPOGRAPHER

Domenic Lippa

DESIGN OFFICE

Lippa Pearce Design

CLIENT

Heal & Son

PRINCIPAL TYPE

Helvetica Heavy (85), Helvetica Light (45), and Helvetica Roman (55)

DIMENSIONS

Various

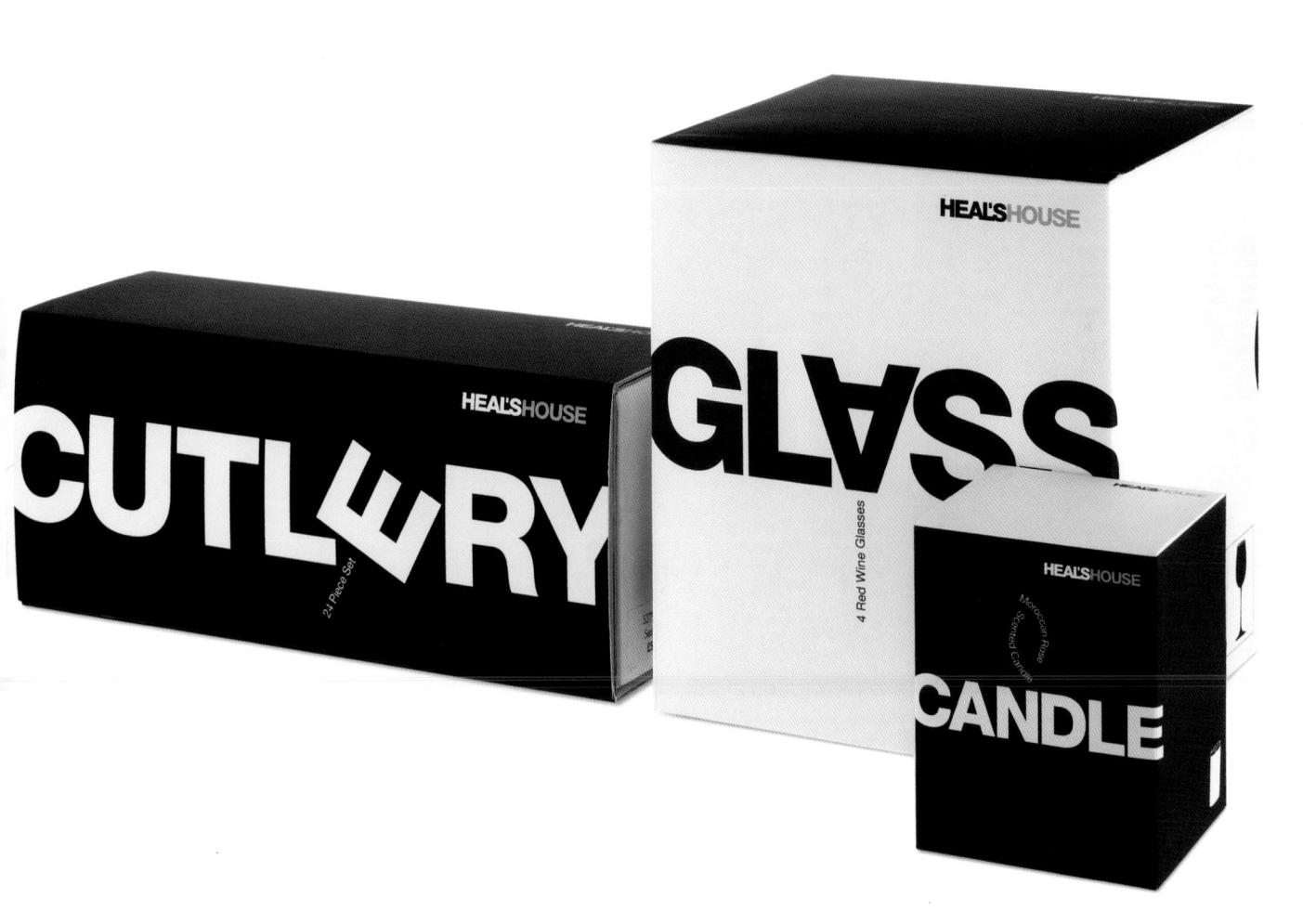

DESIGNAGE

Stephen Doyle New York, New York

CREATIVE DIRECTION
Stephen Doyle

DESIGN OFFICE

Doyle Partners

CLIENT Stora Enso

PRINCIPAL TYPE

Custom

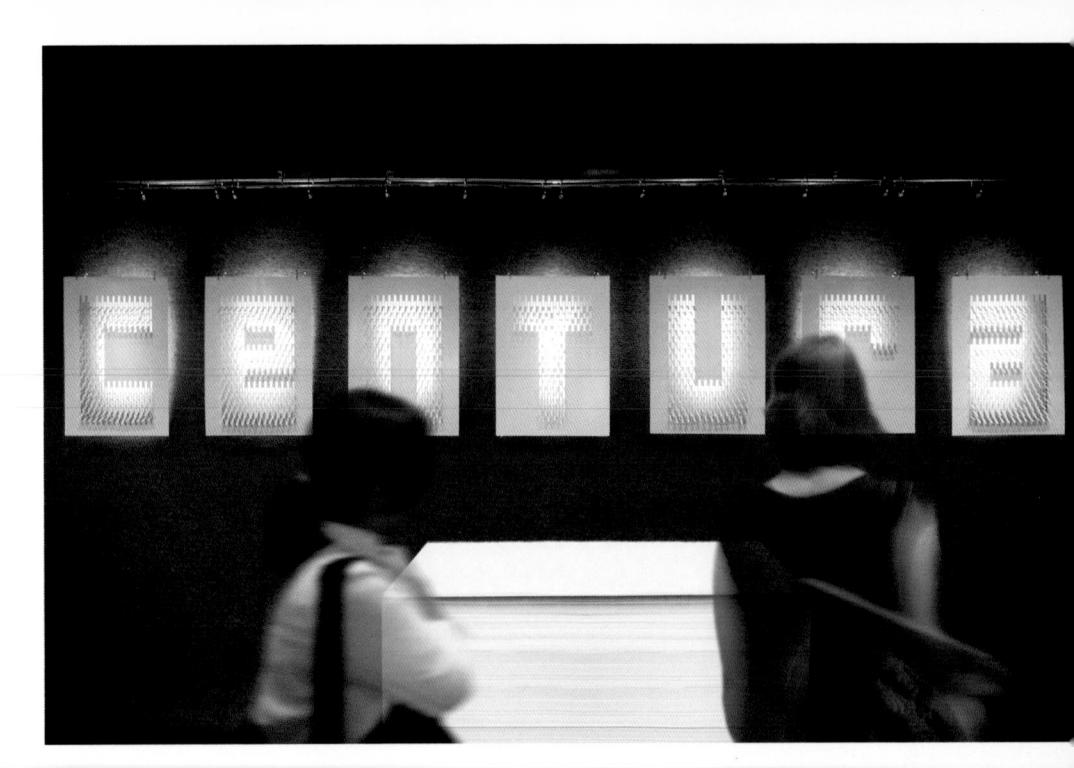

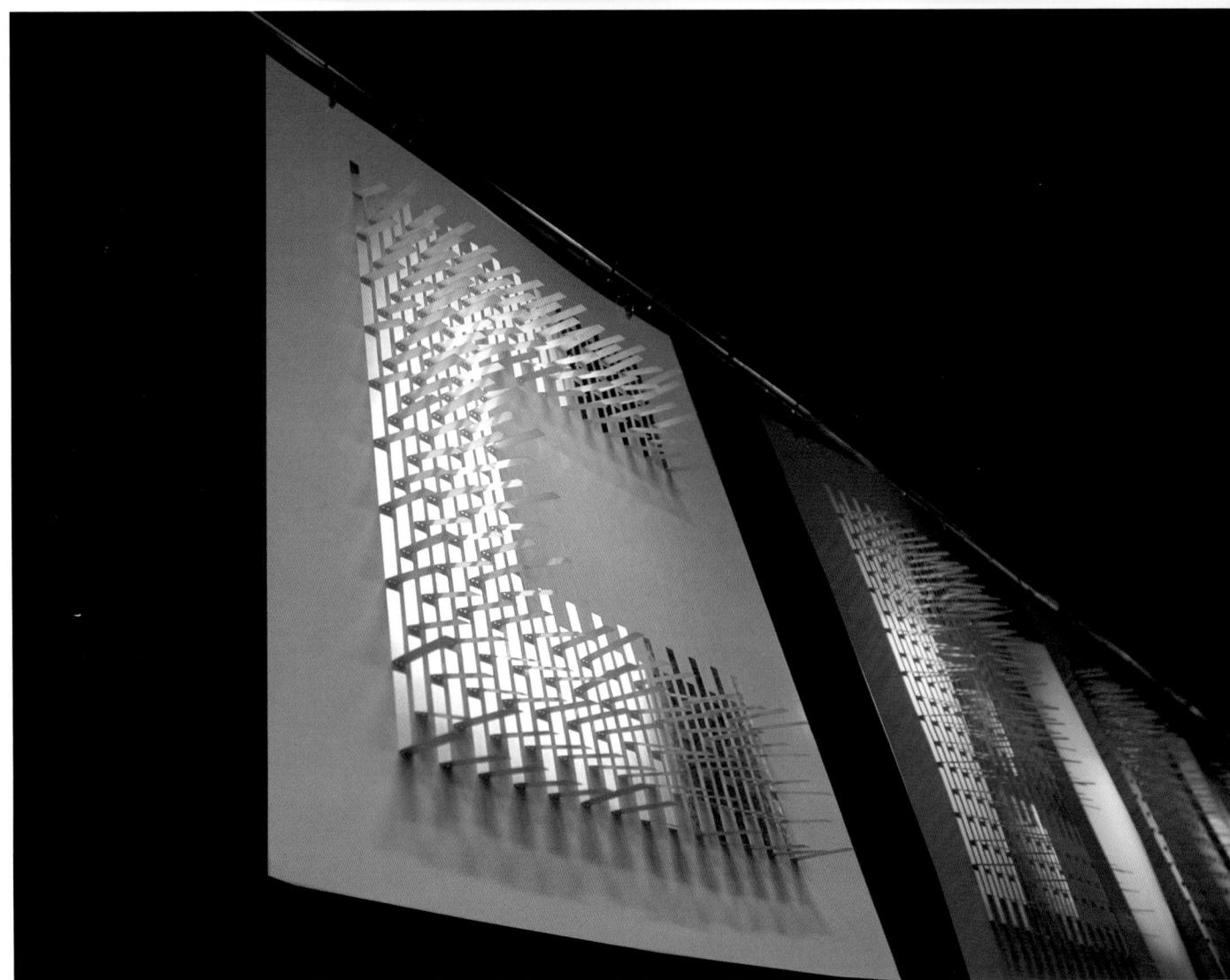

Eric Cai Shi Wei Beijing, China

ART DIRECTION

Eric Cai Shi Wei

CREATIVE DIRECTION

Eric Cai Shi Wei

DESIGN OFFICE

Eric Cai Design Co.

PRINCIPAL TYPE

Times New Roman

DIMENSIONS 25.6 x 35.4 in. (65 x 90 cm)

Ken Sakurai

Minneapolis, Minnesota

CREATIVE DIRECTION

Dan Olson

COPYWRITER

Lisa Pemrick

DESIGN OFFICE

Duffy & Partners

CLIENT

Thymes

PRINCIPAL TYPE

Bryant and Bulldog

DIMENSIONS

Various

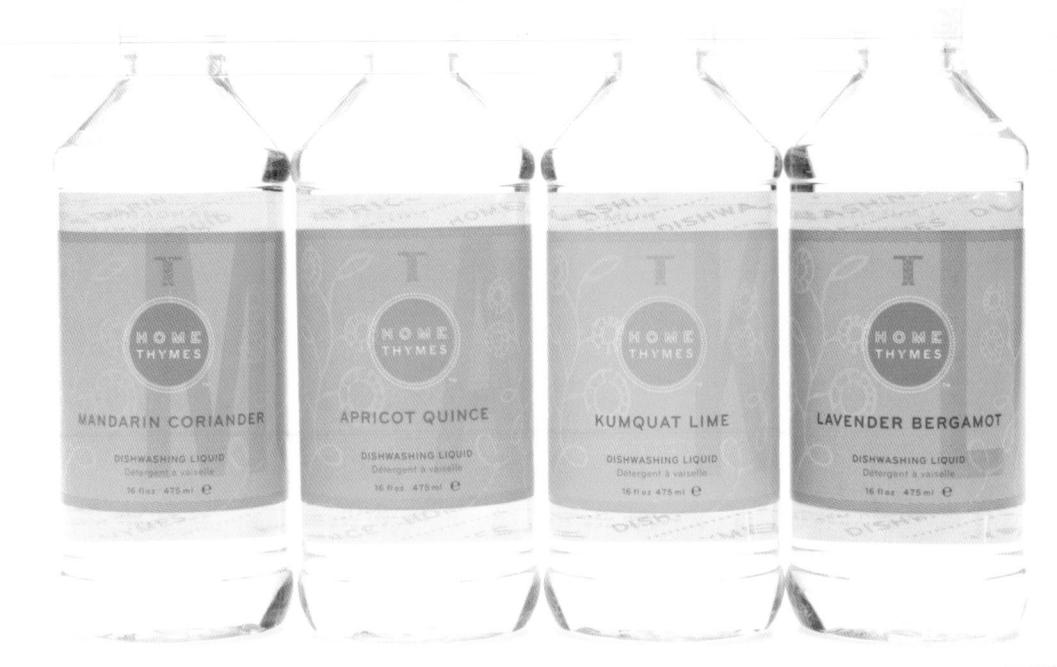

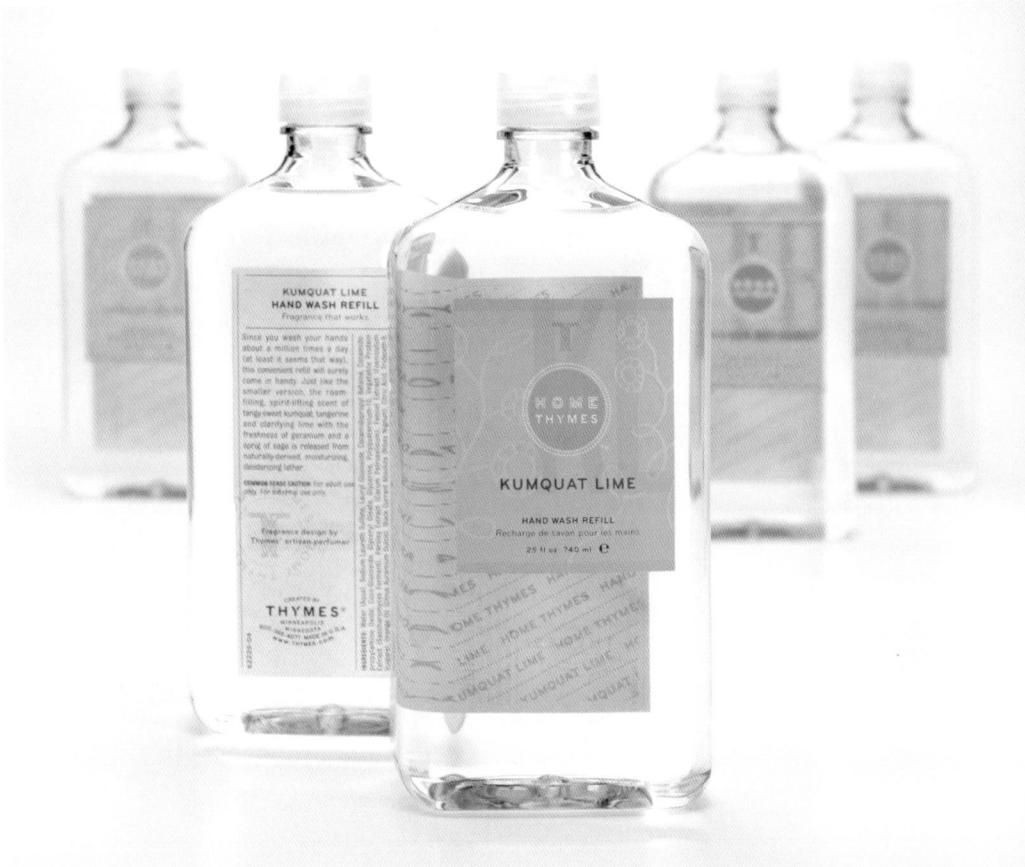

DESIGN ACTIV

Amanda Lawrence

New Canaan, Connecticut

CREATIVE DIRECTION

Amanda Lawrence and Dave Lyon

New Canann and

Norwalk, Connecticut

LETTERING

Ian Brignell

Toronto, Canada

DESIGN OFFICE

White Dot Inc.

CLIENT

Bath and Body Works

PRINCIPAL TYPE

AT Sackers Antique Solid

and Trade Gothic

DIMENSIONS

Various

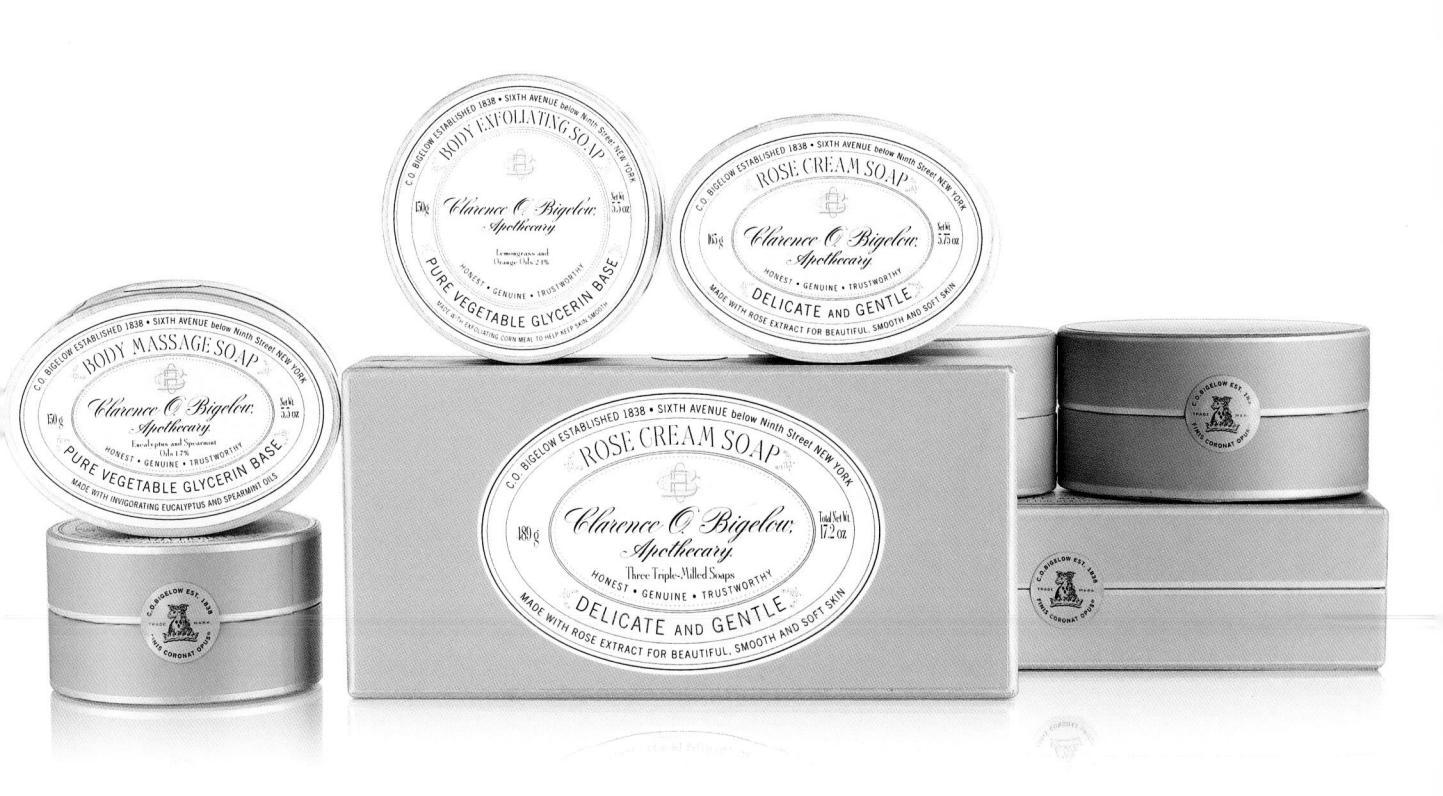

DESIGNIONERY

Clive Piercy and Carol Kono-Noble Santa Monica, California

CREATIVE DIRECTION

Clive Piercy and Michael Hodgson

LETTERING

Clive Piercy and Carol Kono-Noble

DESIGN OFFICE

Ph.D

CLIENT

Nook Bistro

PRINCIPAL TYPE

News Gothic and handlettering

DIMENSIONS *Various*

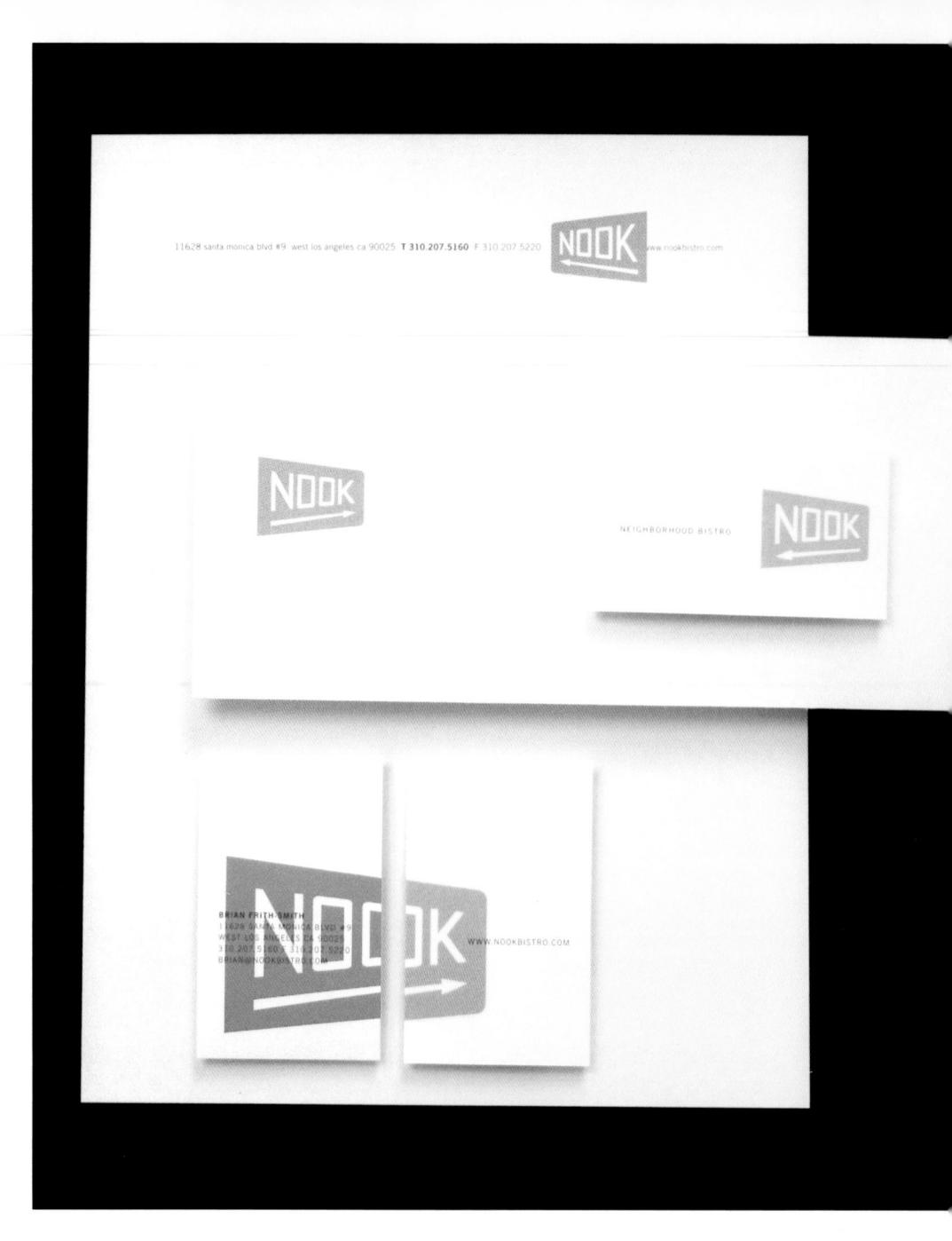

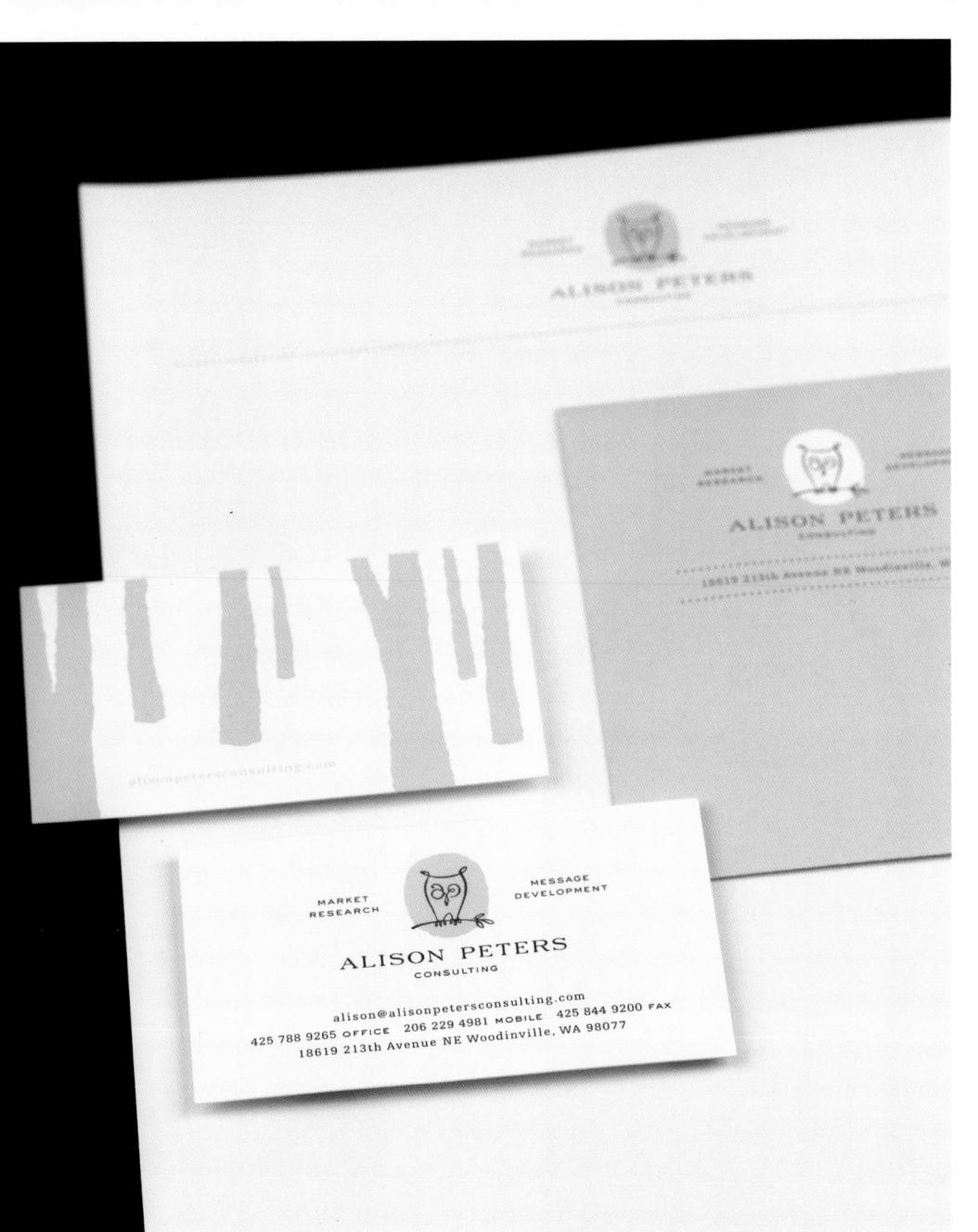

CORPORATE IDENTITY

Pat Snavely

Seattle, Washington

DESIGN OFFICE

Partly Sunny

CLIENT

Alison Peters Consulting

PRINCIPAL TYPE

Egyptienne, Engravers Roman, and AT Sackers Gothic

DIMENSIONS

Various

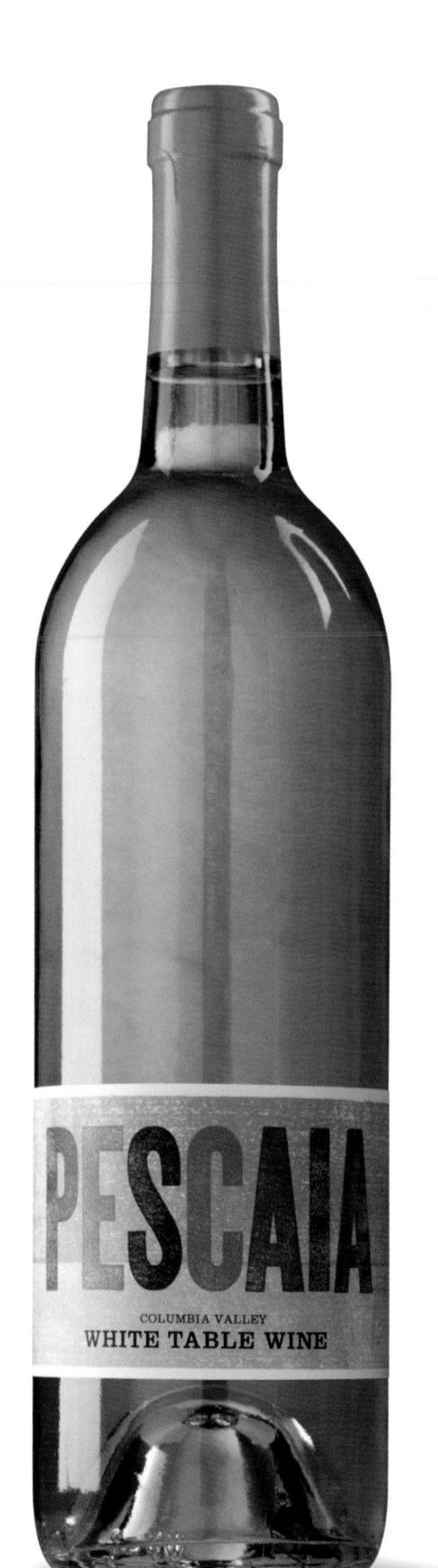

*Giorgio Davanzo*Seattle, Washington

DESIGN OFFICE

Giorgio Davanzo Design

CLIENT
Facelli Winery

PRINCIPAL TYPE

Clarendon and wood type

DIMENSIONS 7.75 x 2.25 in. (19.7 x 5.7 cm)

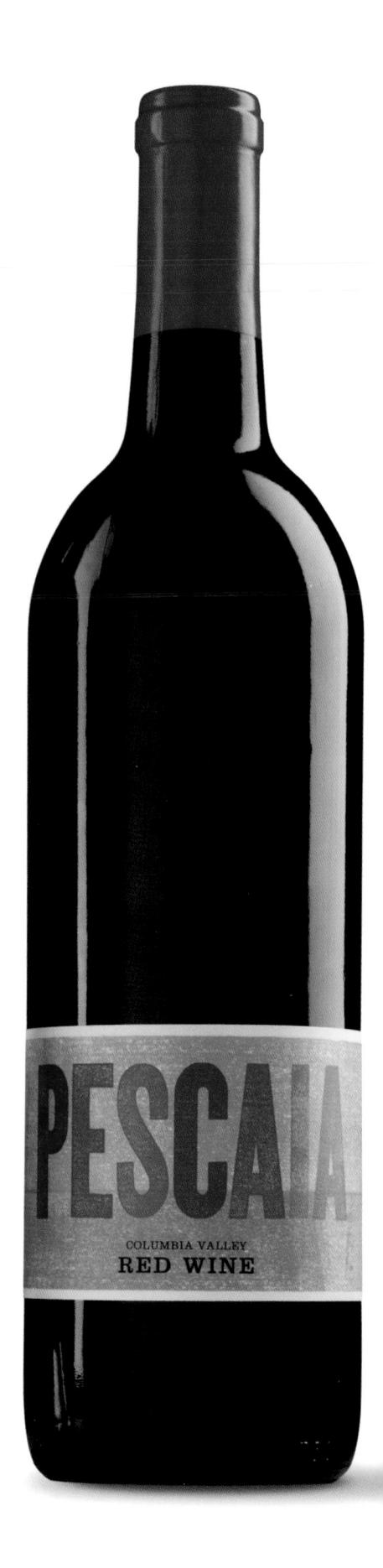

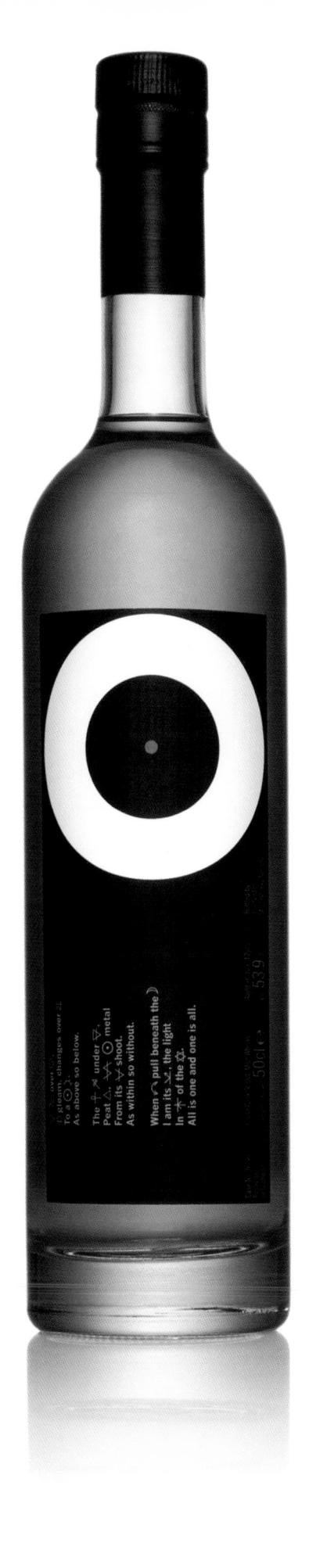

DAGY AGING DESIGN

Harry Pearce London, England

ART DIRECTION

Harry Pearce

CREATIVE DIRECTION

Harry Pearce

TYPOGRAPHER *Harry Pearce*

WRITER

John Simmons

DESIGN OFFICE

Lippa Pearce Design

CLIENT

"26" and The Scotch Malt

Whiskey Society

PRINCIPAL TYPE

News Gothic Bold and News Gothic

Extra Condensed

Dimensions 2.4 x 5.5 in. (6 x 14 cm)

PRODUCTION

Katja Schmelz

Munich, Germany

кији зелте

CLIENT

Claudia Bannwarth

PRINCIPAL TYPE

Locator

DIMENSIONS

Various

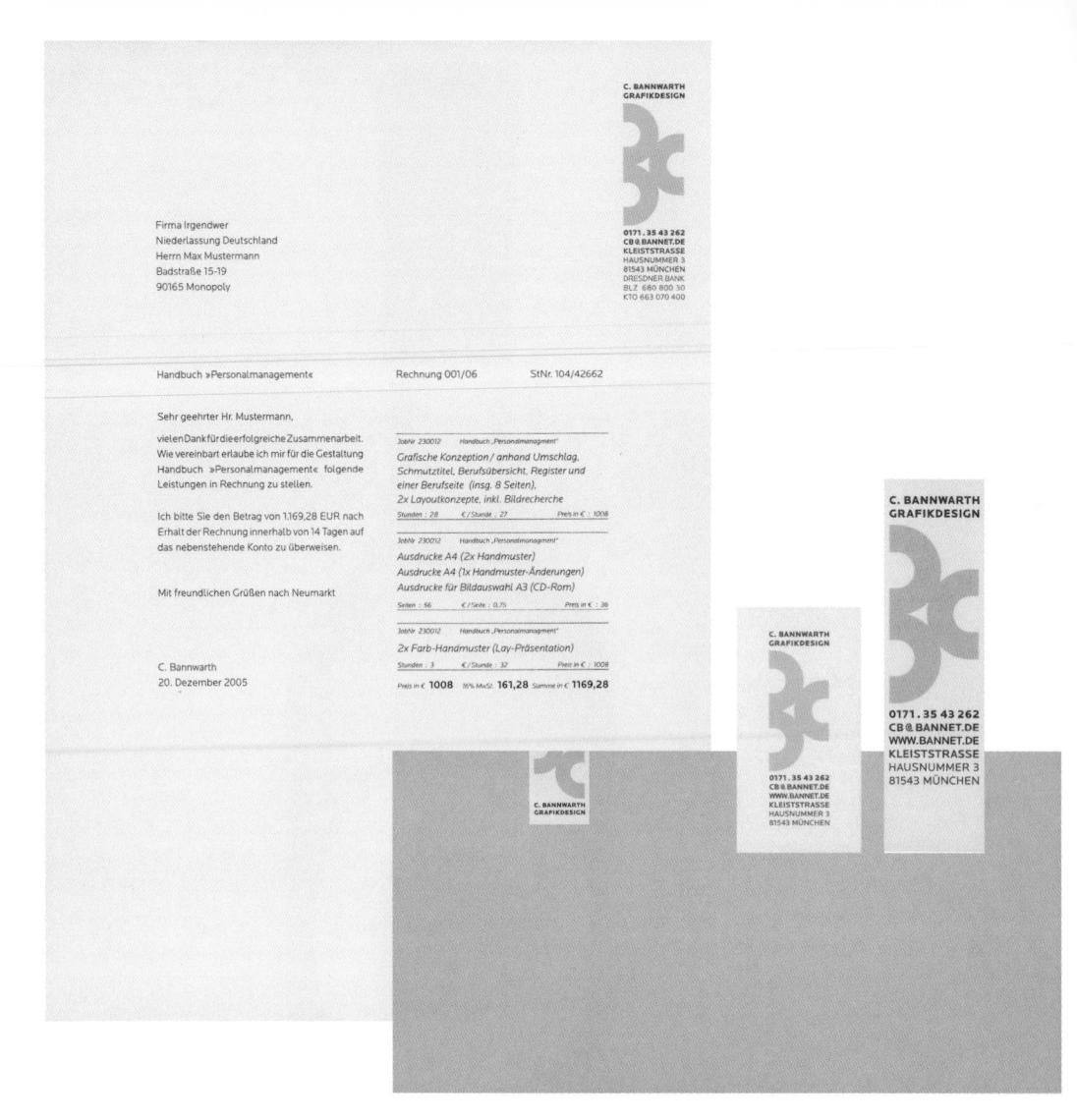

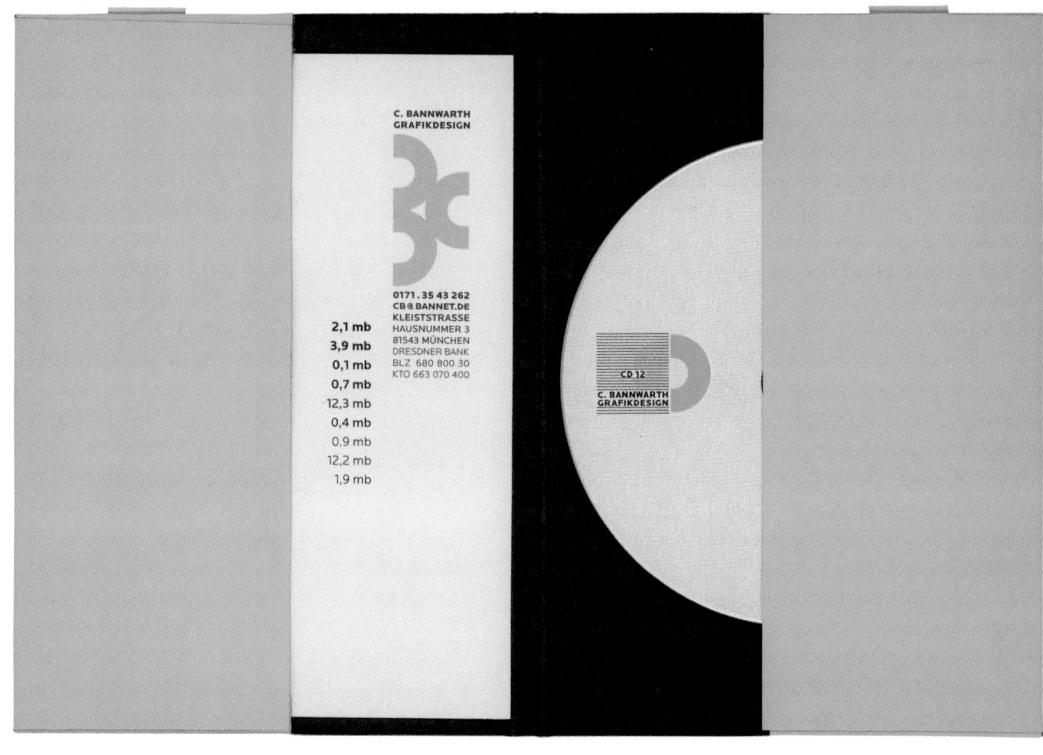

CORPORATE IDENTITY

Richard Boynton
Minneapolis, Minnesota

ART DIRECTION

Richard Boynton and Scott Thares

CREATIVE DIRECTION

Richard Boynton and Scott Thares

LETTERING

Richard Boynton

DESIGN OFFICE

Wink

CLIENT Copycats

PRINCIPAL TYPE

Futura, Monterey, and

Trade Gothic Extended

DIMENSIONS

HI-FI MEDIA

Various

ONTARIO AVENUE WEST MINNEAPOLIS, MN 55403 PHONE (612) 371-8008 FAX (612) 371-8011 TOLL FREE (888) 698-8008

pycats Copyca (III)

TO ONTERIO EVENUE WEST MINNEAPOLIS, MM 55403

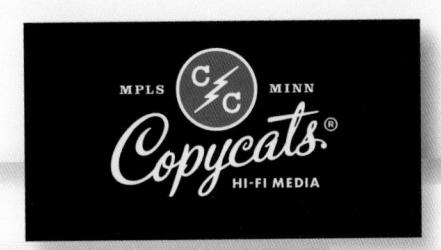

JOSHUA WERT

JOSHUA.WERT@COPYCATSMEDIA.COM

712 ONTARIO AVENUE WEST MINNEAPOLIS, MN 55403
PHONE (612) 371-8008 FAX (612) 371-8011
TOLL FREE (888) 698-8008 COPYCATSMEDIA.COM

DESIGN AGING

Marie-Élaine Benoît and Laurence Pasteels Montreal, Canada

CREATIVE DIRECTION *Hélène Godin*

LETTERING

Graphiques M&H

PHOTOGRAPHY

Raoul Manuel Schnell

ILLUSTRATION

Jo Tyler and Gérard Dubois
Boston, Massachusetts,

and Montreal, Canada

PRODUCER

Peter Pigeon

WRITERS

Mariève Guertin-Blanchette

and Jonathan Rosman

agency *Diesel*

CLIENT

Les Fromages Saputo

PRINCIPAL TYPE

Nathalie Gamache

DIMENSIONS Various

DACK AGING

Thomas Markl and Stephanie Hugel Munich, Germany

ART DIRECTION

Thomas Markl and Stefan Bogner

CREATIVE DIRECTION

Stefan Bogner

LETTERING

Thomas Markl and Stephanie Hugel

AGENCY

Factor Product GmbH

CLIENT

Kosmo Records

PRINCIPAL TYPE

ITC Edwardian Script, Trade Gothic Condensed, and handlettering

DIMENSIONS

23.4 x 33.1 in.

(59.4 x 84.1 cm)

CORPORATE IDENTITY

Scott Thares and Richard Boynton Minneapolis, Minnesota

CREATIVE DIRECTION

Richard Boynton and Scott Thares

DESIGN OFFICE

Wink

CLIENT

Girard Management

PRINCIPAL TYPE

Clarendon, HTF Gotham,
and Monoline Script

DIMENSIONS *Various*

2017 PILLSBURY AVENUE SOUTH, SUITE 313, MINNEAPOLIS, MINNESOTA 55404

EMILY DOYLE

President

EMILY.OOYLE@GIRARDMANAGEMENT.COM
Phone (612) 377-2792 Jax (612) 377-2750

2017 PILLSBURY AVENUE SOUTH, SUITE 313
MINNEAPOLIS, MINNESOTA 55404

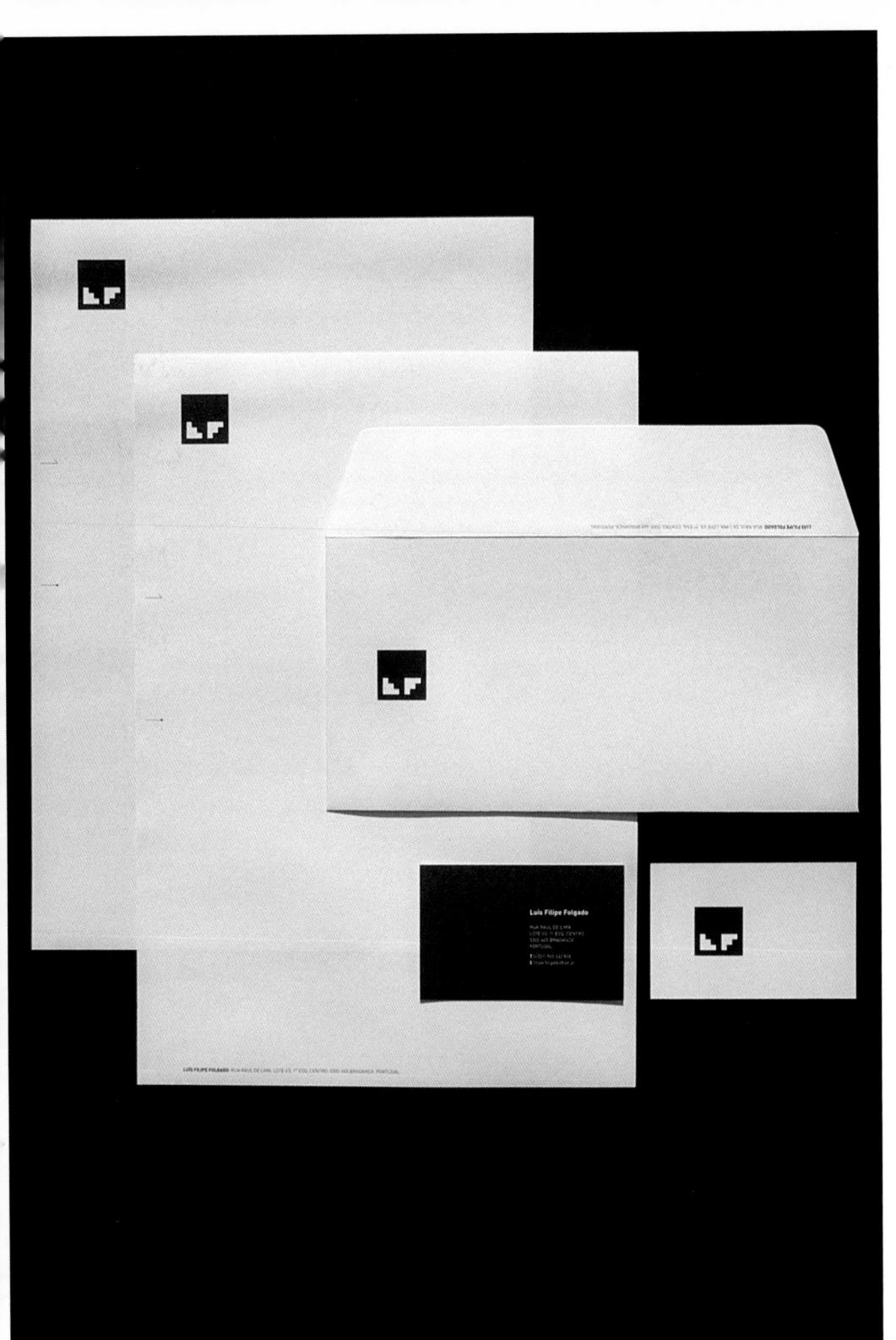

CORPORATE IDENTITY

Vitor Quelhas Maia, Portugal

CLIENT

Luis Filipe Folgado

PRINCIPAL TYPE

LF and FF DIN

DIMENSIONS 14.2 x 17.9 in. (36 x 45.5 cm) DACK AGING DESIGN AGING

Guy Pask and Kerry Argus

Christchurch, New Zealand

ART DIRECTION

Guy Pask

CREATIVE DIRECTION

Guy Pask and Douglas Maclean

LETTERING

Guy Pask

STUDIO

Strategy Design & Advertising

CLIENT

Bell Hill Vineyard

PRINCIPAL TYPE

Futura and Indian typeface redrawn

DIMENSIONS

Various

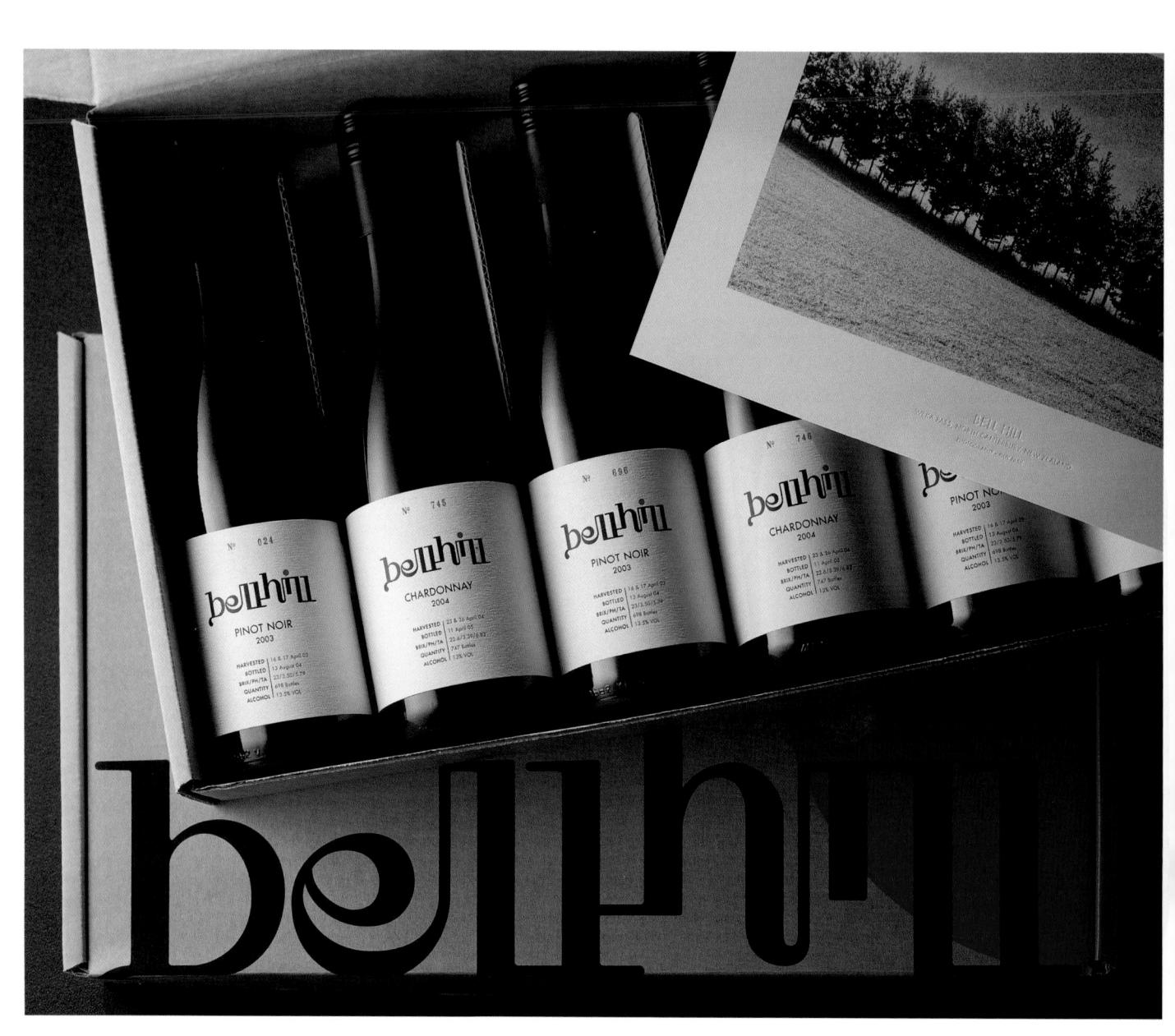

Larry Anderson, Elmer dela Cruz, Jay Hilburn, and Bruce Stigler Seattle, Washington

ART DIRECTION

Bruce Stigler

CREATIVE DIRECTION

Jack Anderson

DESIGN STUDIO

Hornall Anderson Design Works

CLIENT

Widmer Brothers Brewery

PRINCIPAL TYPE

Helvetica and FF Trixie

DIMENSIONS

Various

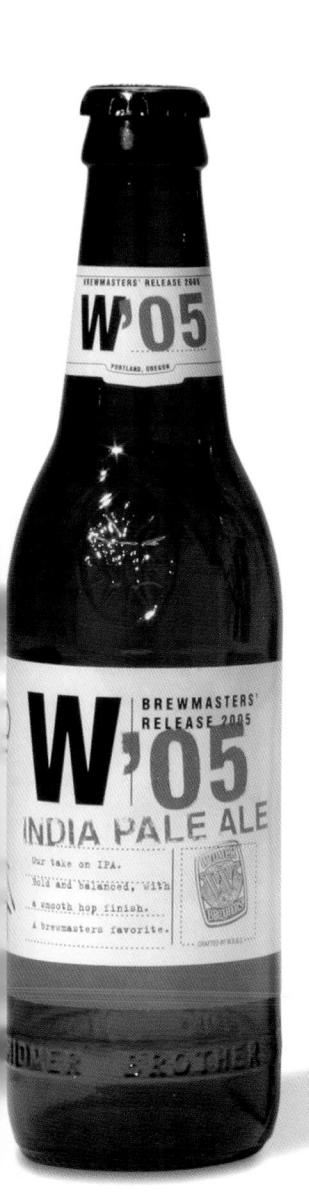

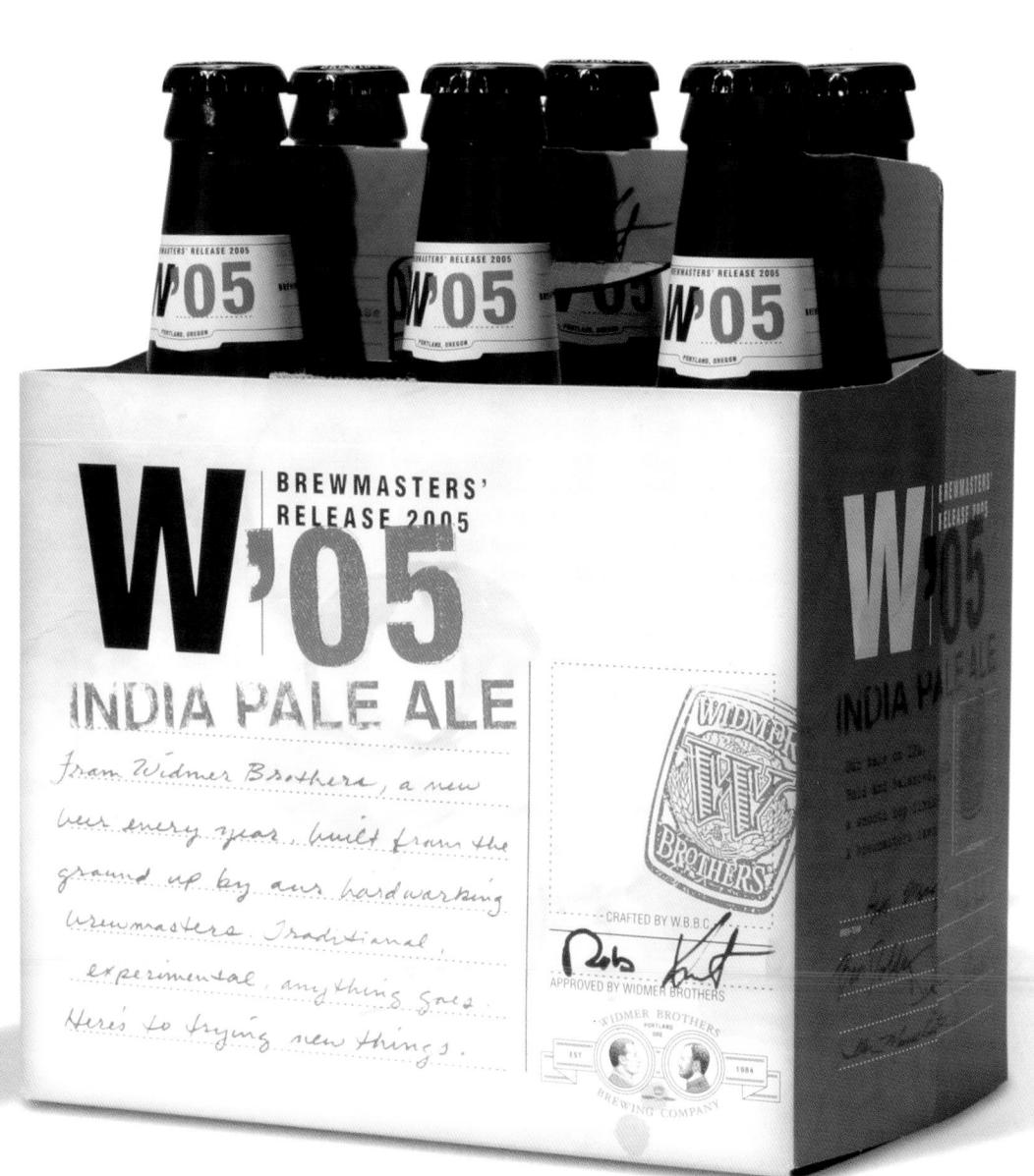

Len Cheeseman and Jason Bowden Newmarket, New Zealand

ART DIRECTION

Len Cheeseman and Chris Bleackley

CREATIVE DIRECTION

Nick Worthington

LETTERING

Jason Bowden

COPYWRITER

John Plimmer

AGENCY

Publicis Mojo

CLIENT

Remix Magazine

PRINCIPAL TYPE

FF The Serif

DIMENSIONS

16.5 x 23.4 in.

 $(42 \times 59.4 \text{ cm})$

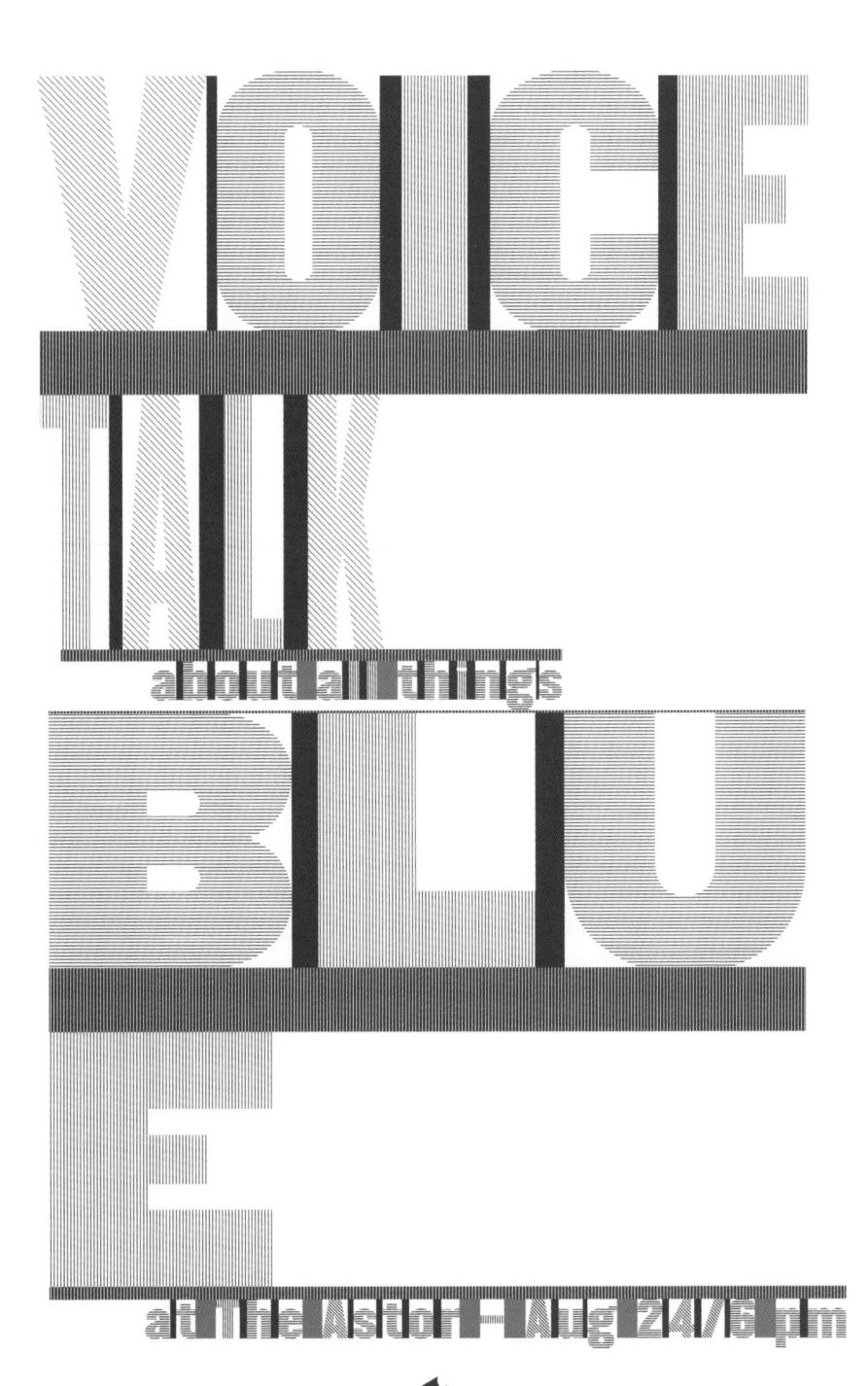

Stock proudly supplied by: Spicers Paper PhoeniXmotion Xantur 150 gsm

DESIGN

Scott Carslake

Adelaide, Australia

ART DIRECTION

Scott Carslake

CREATIVE DIRECTION

Scott Carslake

LETTERING

Scott Carslake

DESIGN OFFICE

Voice

CLIENT

TAFE SA

PRINCIPAL TYPE

HTF Champion Gothic and FF Unit

DIMENSIONS

16.5 x 23.4 in.

(42 x 59.4 cm)

DACK AGING

Eszter Clark

San Francisco, California

ART DIRECTION

Joel Templin and Gaby Brink

CREATIVE DIRECTION

Joel Templin and Gaby Brink

DESIGN OFFICE

Templin Brink Design

CLIENT

Michael Austin Wines

PRINCIPAL TYPE

FF Trixie

DIMENSIONS

2.9 x 3.9 in.

 $(7.4 \times 9.9 \text{ cm})$

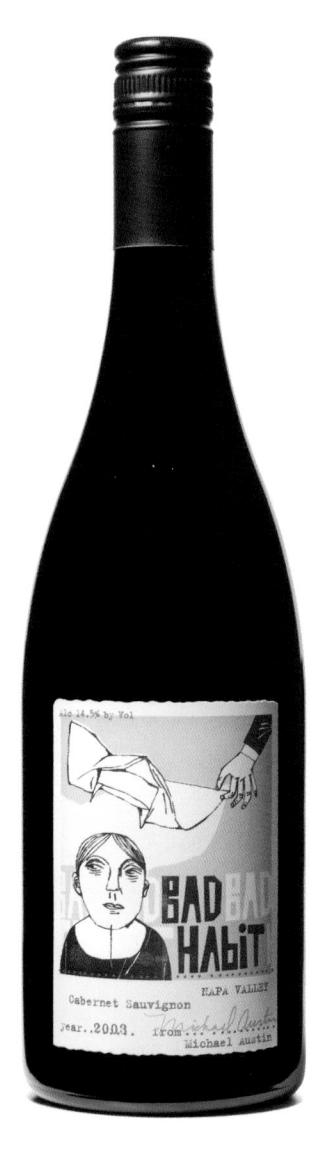

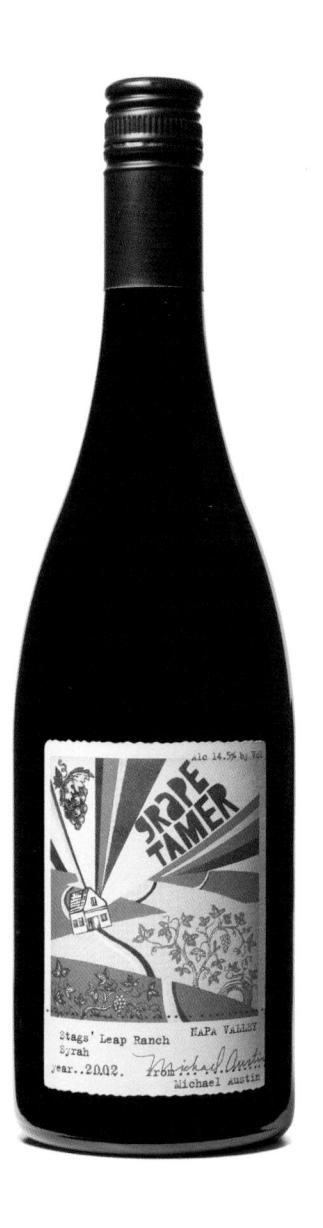

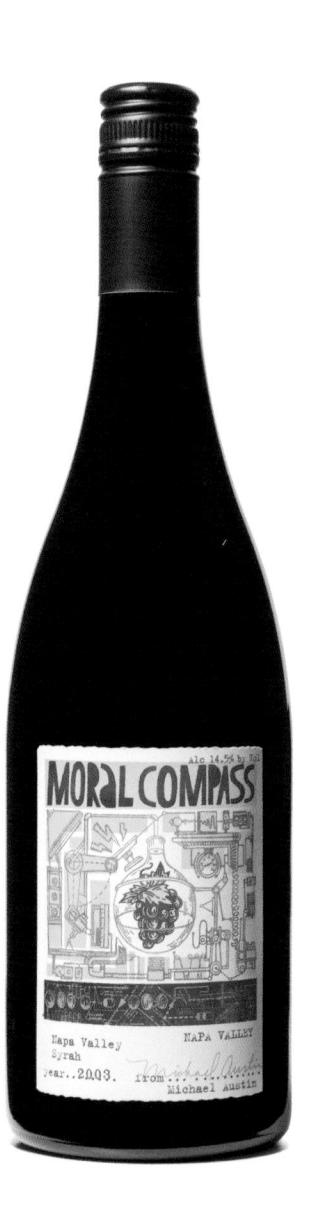

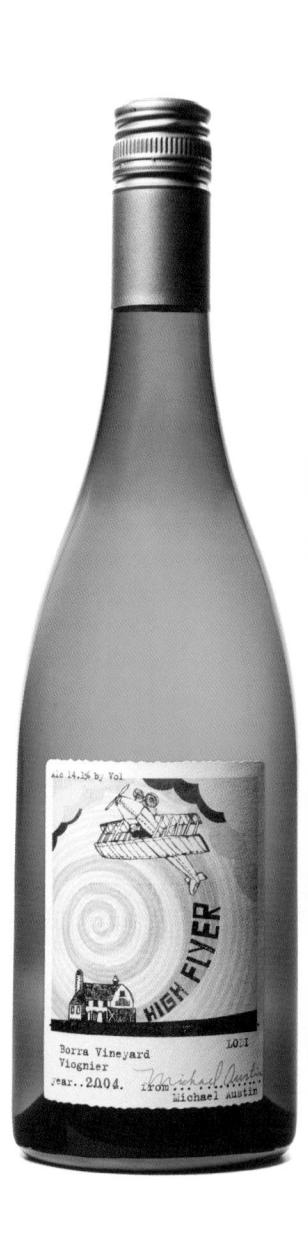

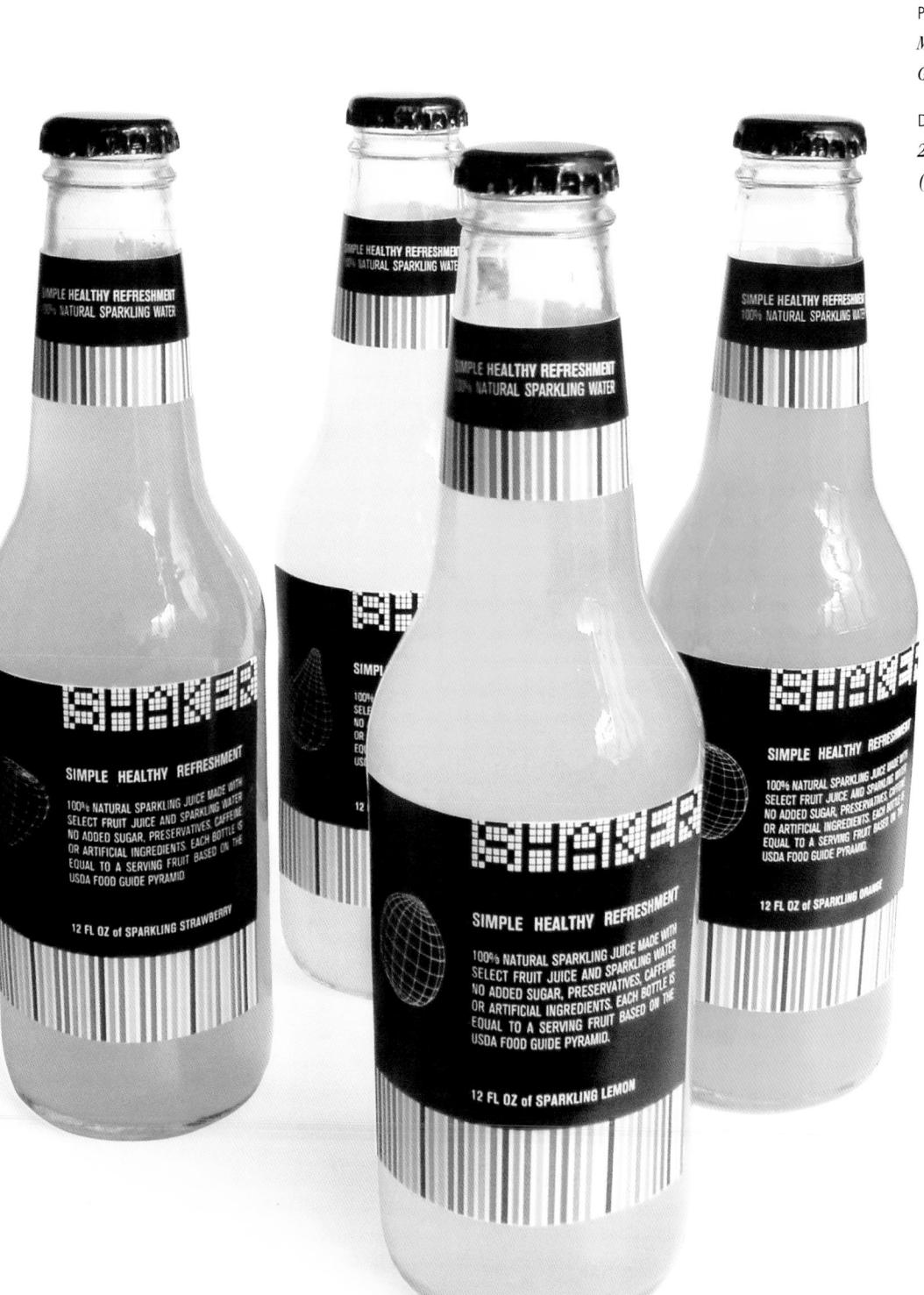

DESIGN ENT PROJECT

Dimitrios Stefanidis New York, New York

SCHOOL

Pratt Institute

INSTRUCTOR

Chava Ben Amos

PRINCIPAL TYPE

Matrix CF and Akzidenz

Grotesk Condensed

DIMENSIONS

2.25 x 8.5 in.

 $(5.7 \times 21.6 \text{ cm})$

Ace Angara, Rafael Esquer, Allison Ruiz, and Olivia Ting New York, New York

ART DIRECTION

Rafael Esquer

CREATIVE DIRECTION

Rafael Esquer

PRINTER

Pazazz

Montreal, Canada

DESIGN OFFICE

Alfalfa

CLIENT

John Connelly Presents

PRINCIPAL TYPE

Adine Kimberg and ITC Conduit

DIMENSIONS

6.75 x 9.25 in.

(17.2 x 23.5 cm)

Oded Ezer

Givatayim, Israel

ART DIRECTION

Oded Ezer

CREATIVE DIRECTION

Oded Ezer

LETTERING

Oded Ezer

STUDIO

Oded Ezer Typography

PRINCIPAL TYPE

Frankrühlya

DADUR BAG DESIGN BAG

Rosa Pupillo, Alex Stertzig, and Marcus Wichmann Stuttgart, Germany

ART DIRECTION

Susanne Wacker and Wolfram Schäffer

CREATIVE DIRECTION

Susanne Wacker and

Wolfram Schäffer

DESIGN OFFICE

design boch drei GmbH & Co. KG

PRINCIPAL TYPE

Akzidenz Grotesk, Corporate S, DIN, Eurostile, Gill Sans, and Stencil

DIMENSIONS

12.6 x 16.5 in.

 $(32 \times 42 \text{ cm})$

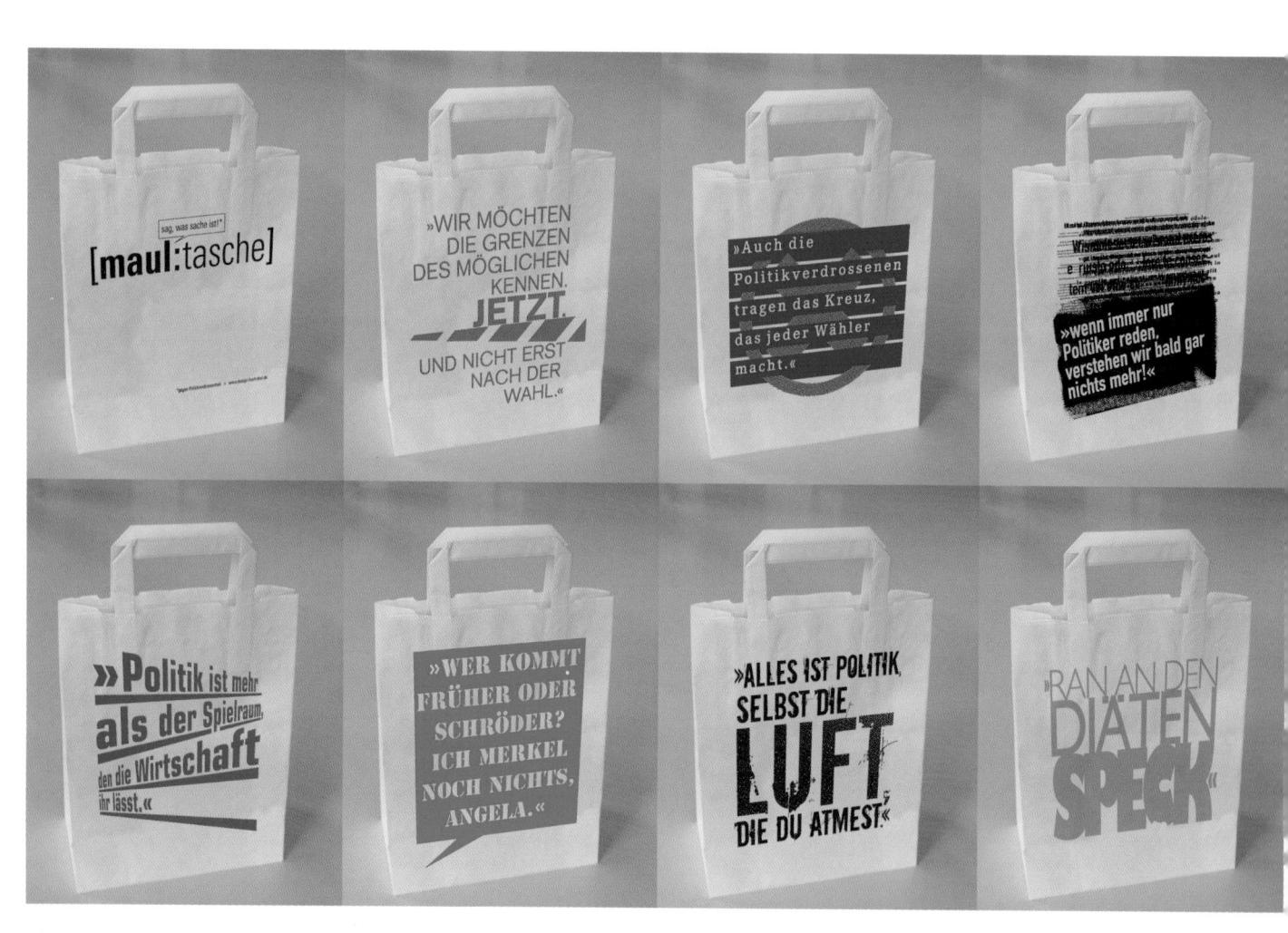

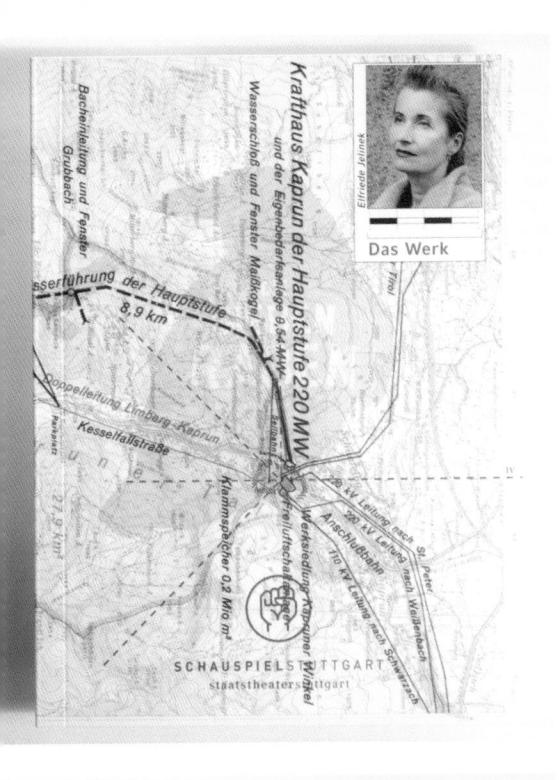

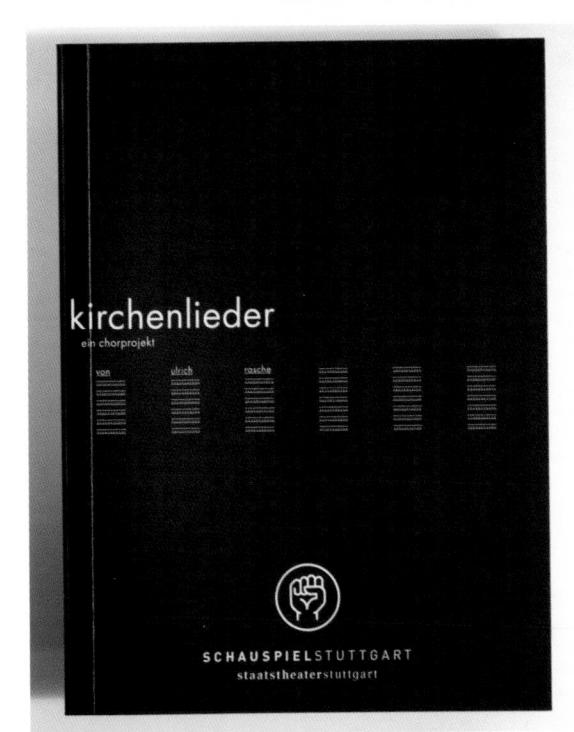

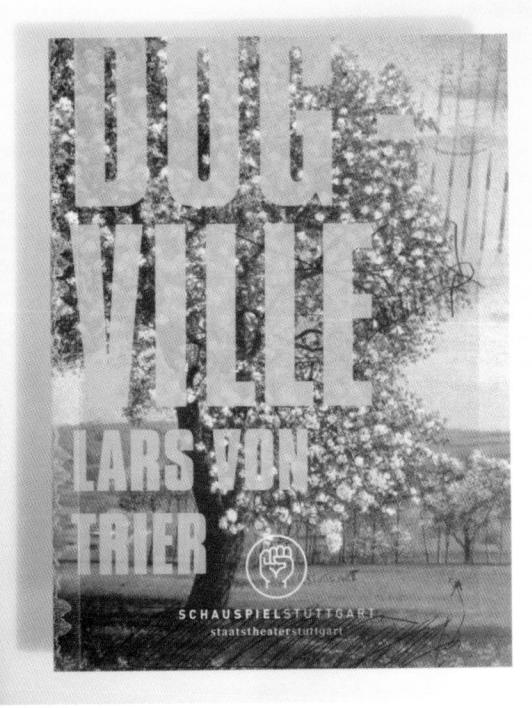

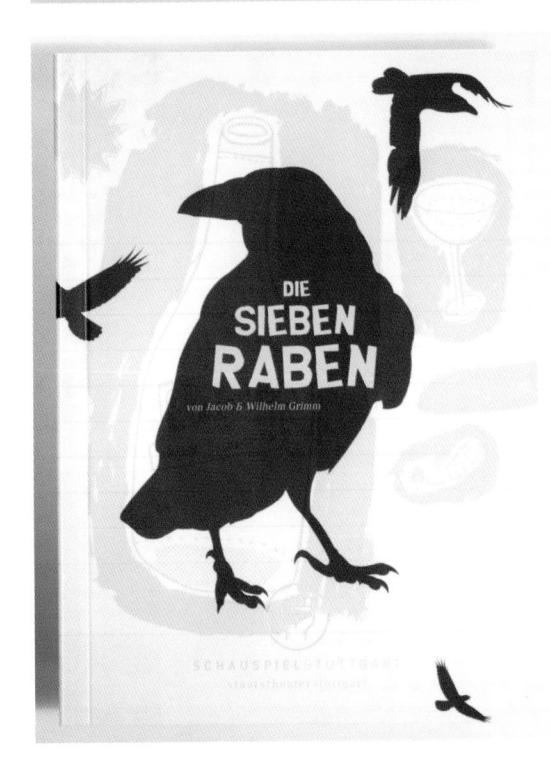

Anders Bergesen, Kirsten Dietz, and Ankia Marquardsen Stuttgart, Germany

ART DIRECTION

Kirsten Dietz

CREATIVE DIRECTION Kirsten Dietz and Jochen Rädeker AGENCY strichpunkt

CLIENT

Staatstheater Stuttgart, Schauspiel Stuttgart

PRINCIPAL TYPE

Compatil

DIMENSIONS 4.7 x 6.3 in. (12 x 16 cm)

Marie-Élaine Benoît, Jonathan Nicol, and Laurence Pasteels Montreal, Canada

CREATIVE DIRECTION

Hélène Godin

LETTERING

Graphiques M&H

PHOTOGRAPHY

Raoul Manuel Schnell

WRITERS

Mariève Guertin-Blanchette and
Jonathan Rosman

PRODUCER *Marie-Pierre Lemieux*

agency *Diesel*

CLIENT

Les Fromages Saputo

PRINCIPAL TYPE

Nathalie Gamache

DIMENSIONS 11.5 x 15 in. (29.2 x 38.1 cm)

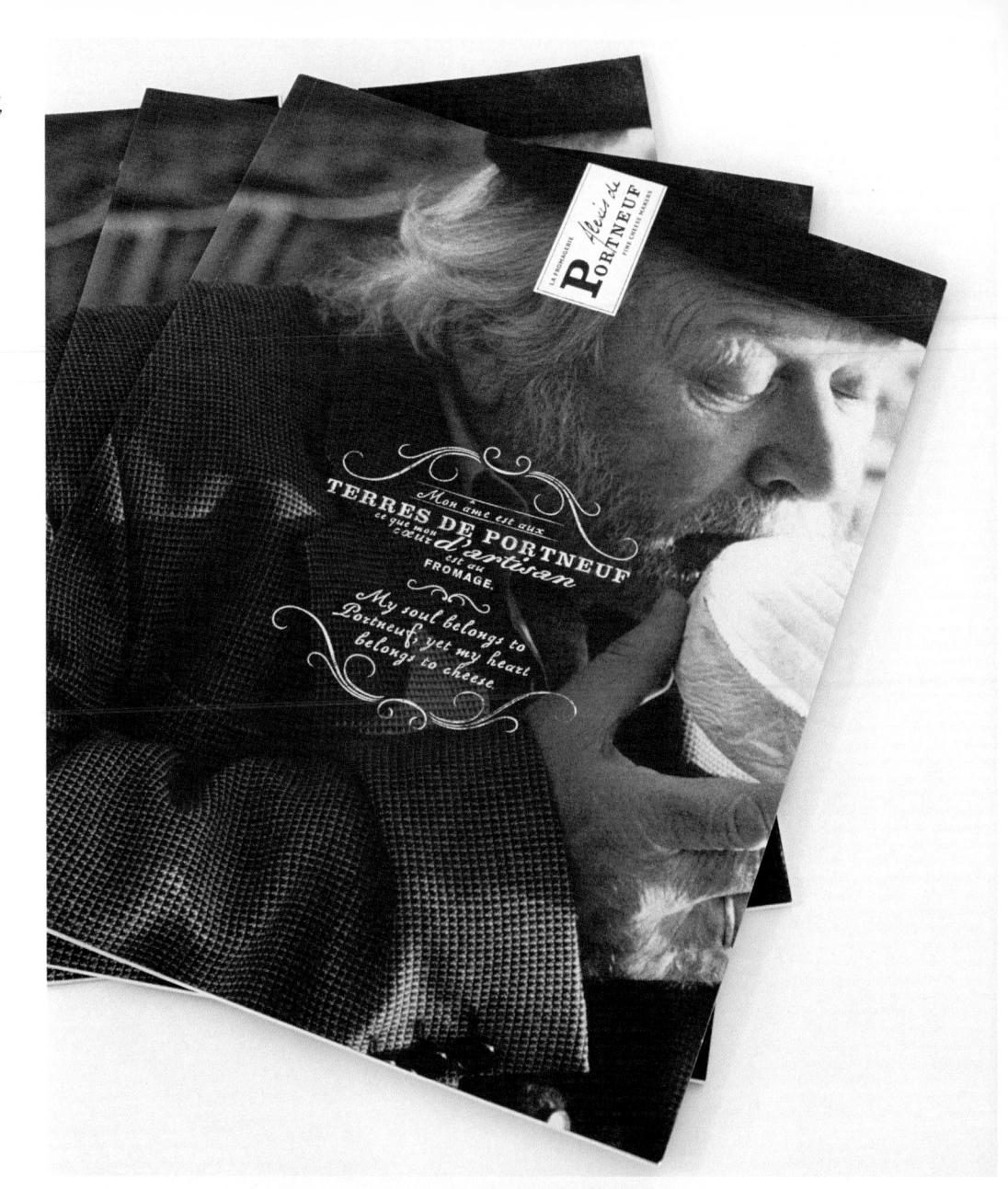

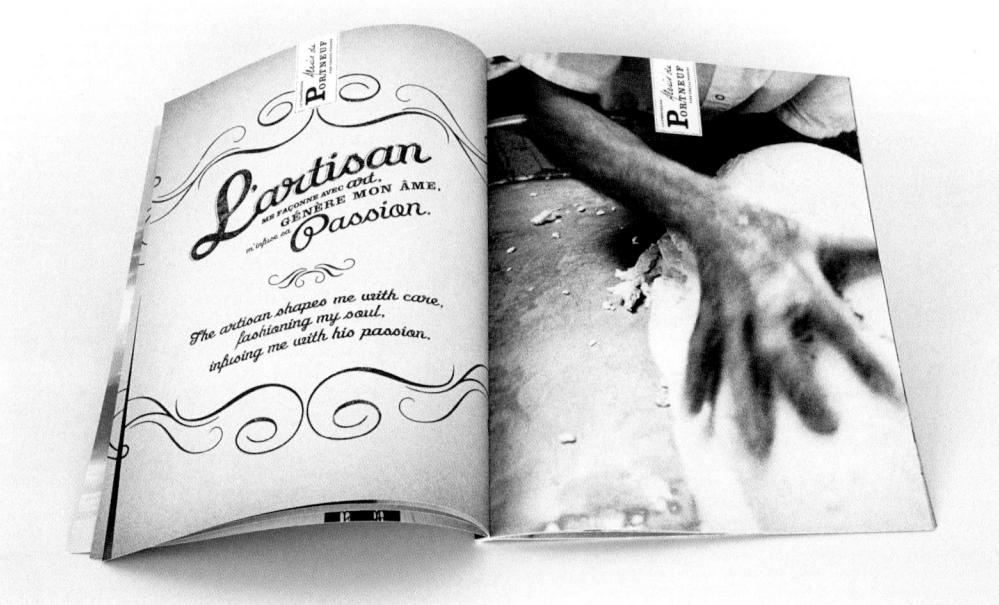

CREATIVE DIRECTION

Garry Emery

DESIGN STUDIO emerystudio

CLIENT
Workshop 3000 and Susan Cohn

PRINCIPAL TYPE FF DIN

DIMENSIONS 8.3 x 8.3 in. (21 x 21 cm)

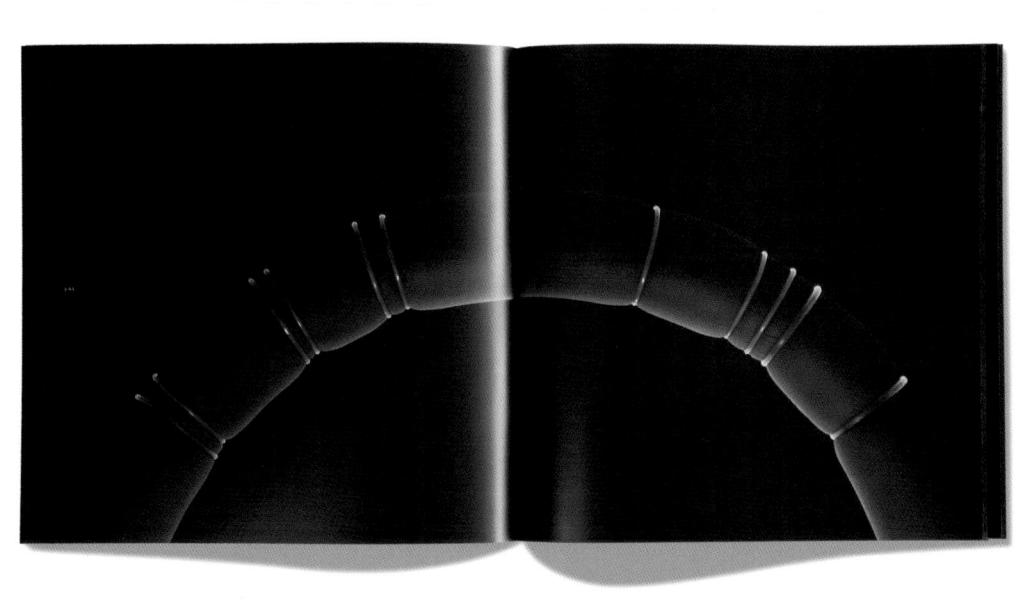

Micabel Bierut and Tracey Cameron

New York, New York

ART DIRECTION

Michael Bierut

PHOTOGRAPHY

Peter Mauss/ESTO

FABRICATION

VGS

CONSULTANTS

Suben/Dougherty

DESIGN OFFICE

Pentagram Design Inc.

CLIENT

Robert F. Wagner Graduate School of Public Service, New York University

PRINCIPAL TYPE

FF Meta Bold and FF Meta Normal

Len Cheeseman

and Mikhail Gherman

Newmarket, New Zealand

ART DIRECTION

Len Cheeseman and

Mikhail Gherman

CREATIVE DIRECTION

Nick Worthington

LETTERING

Mark van der Hoeven

COPYWRITER

Nick Worthington

AGENCY

Publicis Mojo

CLIENT

Rodney Wayne

PRINCIPAL TYPE

HTF Champion Welterweight

DIMENSIONS

16.5 x 11.7 in.

(42 x 29.7 cm)

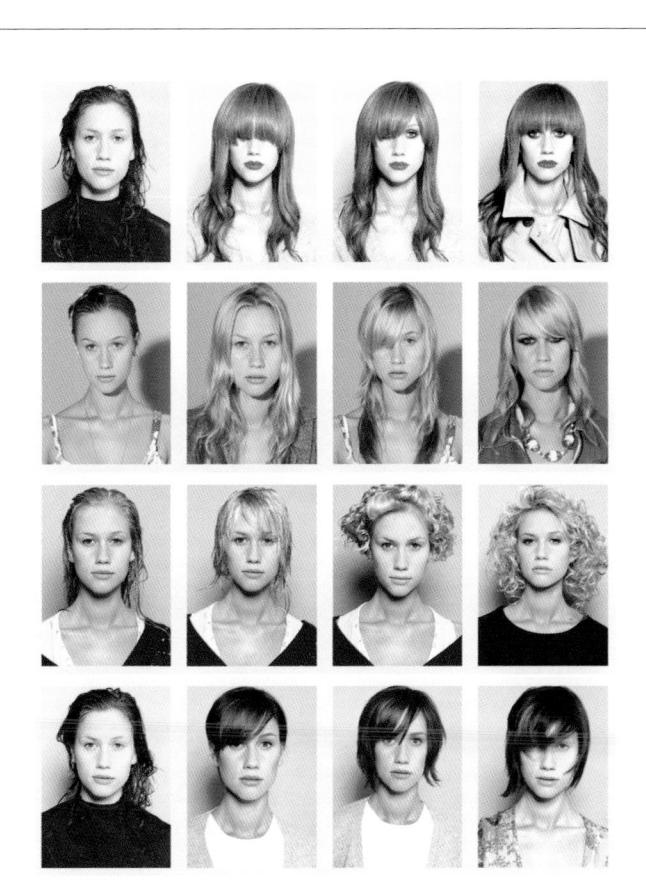

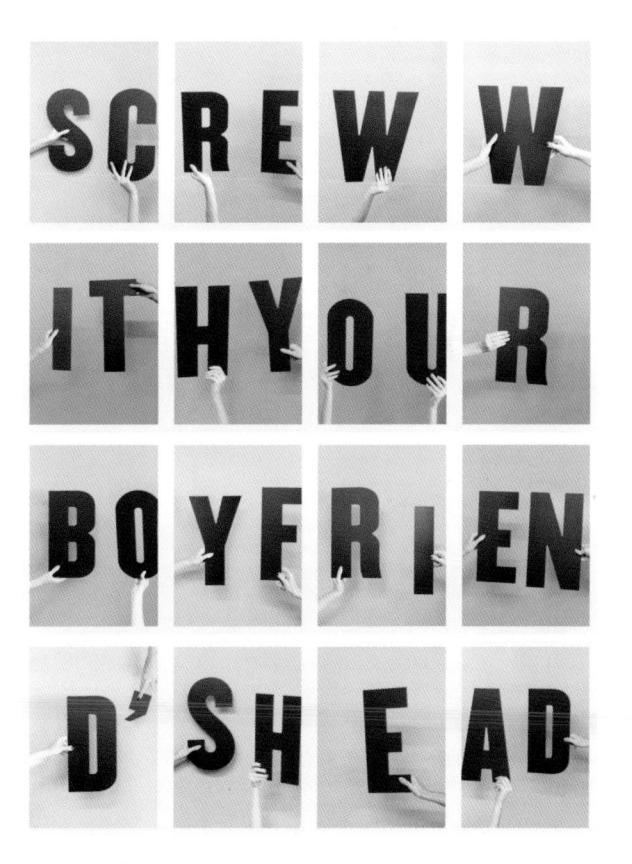

reinventyourself

RODNEY WAYNE

Giorgio Baravalle Millbrook, New York

ART DIRECTION

Giorgio Baravalle

CREATIVE DIRECTION

Giorgio Baravalle

PHOTOGRAPHY

Antonin Kratochvil

New York, New York

DESIGN OFFICE de.MO

PRINCIPAL TYPE Ruse

DIMENSIONS 14.25 x 9.5 in. (36.2 x 24.1 cm)

Paul Belford, Steve Davies, and Nils Leonard London, England

ART DIRECTION Paul Belford

CREATIVE DIRECTION Paul Belford and Nigel Roberts

AGENCY AMV BBDO

CLIENT

Newspaper Marketing Agency

PRINCIPAL TYPE Courier, Sun Futura, and Times Roman

DIMENSIONS 19.25 x 28.9 in. (48.9 x 73.3 cm)

DESIGN ENT PROJECT

DESIGN

Dirk Wachowiak Stuttgart, Germany

SCHOOL

Yale University School of Art

INSTRUCTORS

Barbara Glauber and David Israel

PRINCIPAL TYPE

Lambrecht, Moire Style, and Pressure Style

DIMENSIONS

11.4 x 11.8 in.

 $(29 \times 30 \text{ cm})$

CORPORATE IDENTITY

Domenic Lippa and Paul Skerm London, England

ART DIRECTION

Domenic Lippa

CREATIVE DIRECTION

Domenic Lippa

TYPOGRAPHER

Domenic Lippa

DESIGN OFFICE

Lippa Pearce Design

CLIENT

Heal & Son

PRINCIPAL TYPE Helvetica Heavy (85), Helvetica Light (45), and Helvetica Roman (55)

DIMENSIONS Various

us

Thomas Neeser and Thomas Müller Basel, Switzerland

ART DIRECTION

Thomas Neeser and Thomas Müller

CREATIVE DIRECTION

Thomas Neeser and Thomas Müller

LETTERING

Thomas Neeser and Thomas Müller

STUDIO

Neeser & Müller

CLIENT

Verein Neue Musik Rümlingen and Christoph Merian Verlag

PRINCIPAL TYPE

Hornet MonoMassiv and Hornet DuoMassiv

DIMENSIONS

11.2 x 11.8 in.

 $(28.5 \times 30 \text{ cm})$

Lydia Jeschke, Daniel Ott, Lukas Ott j'Hg

EXPERIMENT ...NEUE MUSIK RUMLINGEN

mit 140 Minuten Musik
—— auf 2 CDs

Christoph Merian Verlag

DESIGN ORATE IDENTITY

Büro Uebele Visuelle Kommunikation

Stuttgart, Germany

ART DIRECTION Claudia Burtscher

CREATIVE DIRECTION Andreas Uebele

CLIENT

Society for the Advancement of Architecture, Engineering and Design (AED)

PRINCIPAL TYPE

Akzidenz Grotesk Bold

DIMENSIONS

Various

HOLLDAY CARD

Harry Pearce

London, England

ART DIRECTION

Harry Pearce

CREATIVE DIRECTION

Harry Pearce

TYPOGRAPHER

Harry Pearce

AUTHOR OF QUOTE

Spike Milligan

DESIGN OFFICE

Lippa Pearce Design

PRINCIPAL TYPE

Rockwell Bold Condensed

DIMENSIONS

23.6 x 33.1 in.

 $(60 \times 84 \ cm)$

Elizabeth Cory Holzman

New York, New York

ART DIRECTION

Michael Bierut

DESIGN OFFICE

Pentagram Design Inc.

CLIENT

Yale School of Architecture

PRINCIPAL TYPE

News Gothic and HTF Ziggurat

DIMENSIONS

22 x 34 in.

(55.9 x 86.4 cm)

ART DIRECTION

Jens Stein

COPYWRITER Philipp Woehler

AGENCY

Berlin, Germany

Scholz & Friends

CREATIVE DIRECTION

Matthias Schmidt

CLIENT

and Constantin Kaloff

Holsten-Brauerei AG

LETTERING

Annegret Richter, Jens Stein,

and Julia Witsche

PRINCIPAL TYPE Handlettering

PHOTOGRAPHY

DIMENSIONS 16.5 x 11.7 in. $(42 \times 29.7 \text{ cm})$

Heribert Schindler

"Delicious Holsten is now also available in a 10-litre barrel which has lots of delicious Holsten in it as you can imagine I really liked it a lot and I think the idea with the 10-litre barrel is pretty brilliant and also incredibly handy because it contains 10 litres of delicious Holsten but I think I've already mentioned that ..." HOLSTEN. Cheers, men. [Holsten. Auf uns, Männer.]

CTILDENT PROJECT

Kerstin Wolf

Mannheim, Germany

SCHOOL

Fachbochschule Mainz, University of Applied Sciences

PROFESSOR

Ulysses Voelker

PRINCIPAL TYPE

Trade Gothic Bold and FF Info Office

DIMENSIONS

7.5 x 9.7 in.

(19 x 24.7 cm)

STUDENT PROJECT

Julia Trudeau

Montreal, Canada

SCHOOL

École de Design, UQAM

INSTRUCTOR

Judith Poirier

PRINCIPAL TYPE

Univers 47

DIMENSIONS

 $7 \times 11 in.$

 $(17.8 \times 27.9 \text{ cm})$

DESIGN PROJECT

Jeehwan Yeo

New York, New York

SCHOOL
School of Visual Arts

INSTRUCTOR

Mike Joyce

PRINCIPAL TYPE

Auriol, Big Caslon, Georgia,

and Adobe Jenson Pro

DIMENSIONS 8 x 3.5 in. (20.3 x 8.9 cm)

STIDENT PROJECT

Byron Regej New York, New York

SCHOOL School of Visual Arts

INSTRUCTOR Robert Best

PRINCIPAL TYPE

Acclamation and Electra

DIMENSIONS 7.75 x 10 in. (19.7 x 25.4 cm)

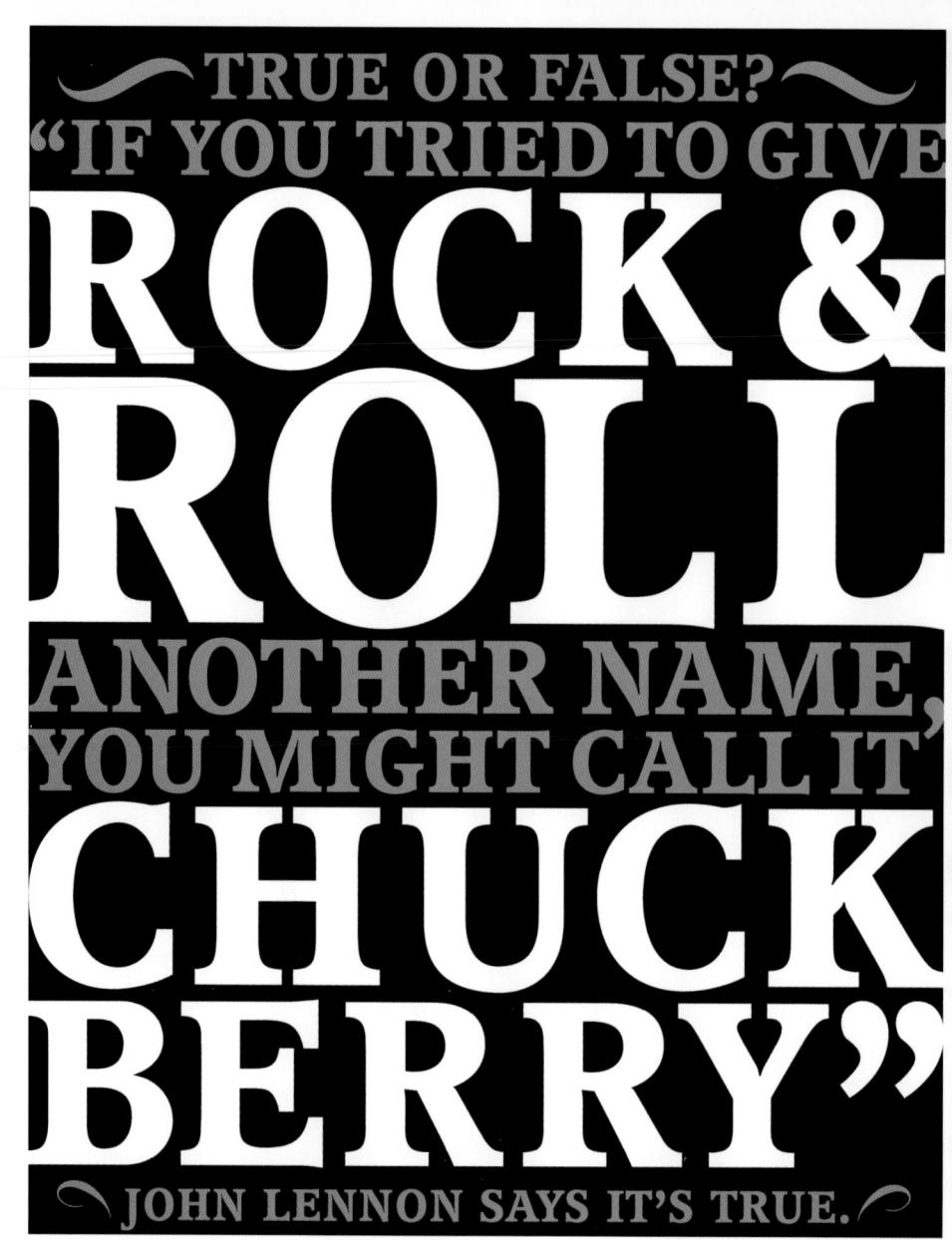

DESIGN ENT PROJECT

Mariko Yokogi Osaka, Japan

SCHOOL
Saito I.M.I. Graduate School

PROFESSOR

Akio Okumura

PRINCIPAL TYPE
Helvetica and custom

DIMENSIONS 28.7 x 40.6 in.

(72.8 x 103 cm)

STIDENT PROJECT

Randy J. Hunt

New York, New York

SCHOOL

School of Visual Arts, MFA Design

INSTRUCTOR

Gail Anderson

PRINCIPAL TYPE

Foundry Gridnik

DESIGN

Hong Ko

Hong Kong, China

ART DIRECTION
Hong Ko

CREATIVE DIRECTION Hong Ko

DESIGN OFFICE www.kosiuhong.com

PRINCIPAL TYPE

Custom

STUDENT PROJECT

Agung Wimboprasetyo Valencia, California

SCHOOL

California Institute of the Arts

INSTRUCTORS

Shelley Stepp and Jae-Hyouk Sung

PRINCIPAL TYPE

Custom

DIMENSIONS

20 x 30 in.

 $(50.8 \times 76.2 \text{ cm})$

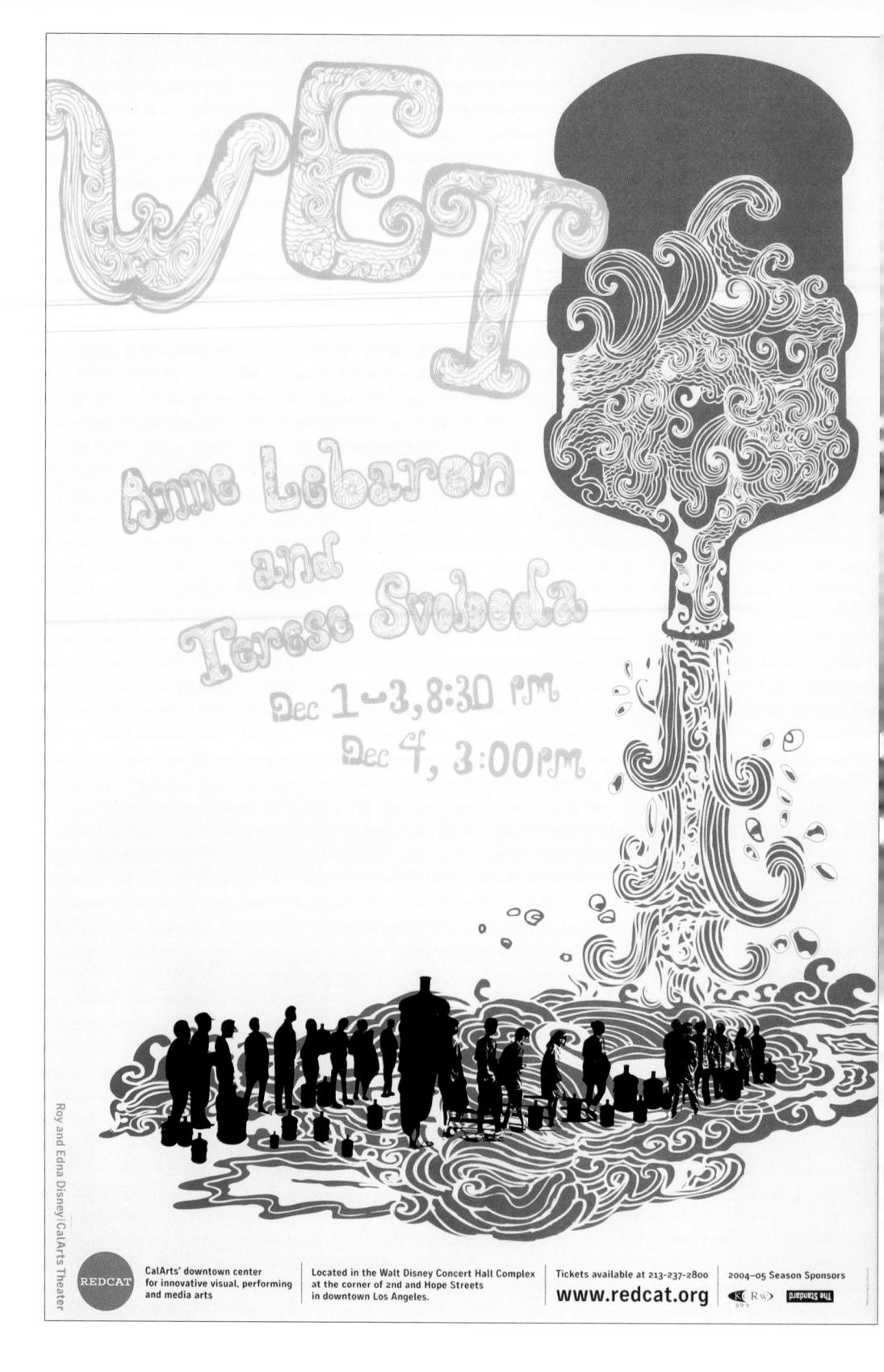

STILD ENT PROJECT

Colin Graham and Justin O'Brien Valencia, California

SCHOOL

California Institute of the Arts

INSTRUCTORS

Shelley Stepp and Jae-Hyouk Sung

PRINCIPAL TYPE

Custom

DIMENSIONS

20 x 30 in.

(50.8 x 76.2 cm)

DESIGN ENT PROJECT

Colin Graham Valencia, California

SCHOOL

California Institute of the Arts

INSTRUCTORS

Shelley Stepp and Jae-Hyouk Sung

PRINCIPAL TYPE

Custom

DIMENSIONS

20 x 30 in.

(50.8 x 76.2 cm)

STILDENT PROJECT

Jason Mendez

Valencia, California

SCHOOL

California Institute of the Arts

INSTRUCTORS

Shelley Stepp and Jae-Hyouk Sung

PRINCIPAL TYPE

Custom

DIMENSIONS

20 x 30 in.

(50.8 x 76.2 cm)

DESIGN ENT PROJECT

Anne-Marie Clermont Montreal, Canada

SCHOOL

École de Design, UQAM

INSTRUCTOR

Yann Mooney

PRINCIPAL TYPE

Custom

DIMENSIONS

27 x 39 in.

(68.6 x 99.1 cm)

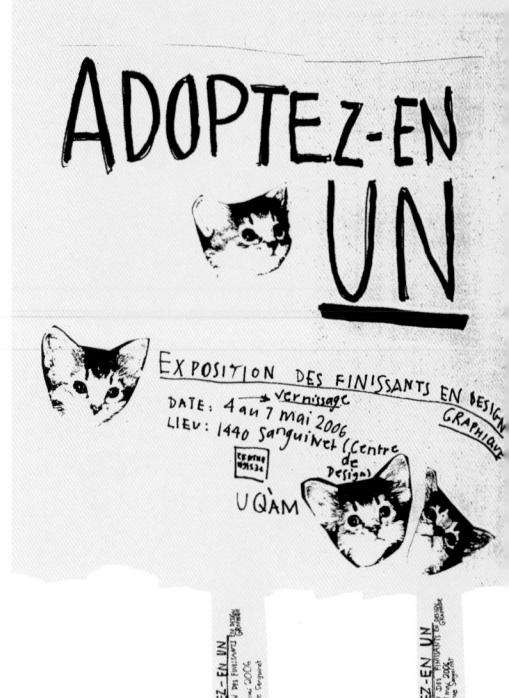

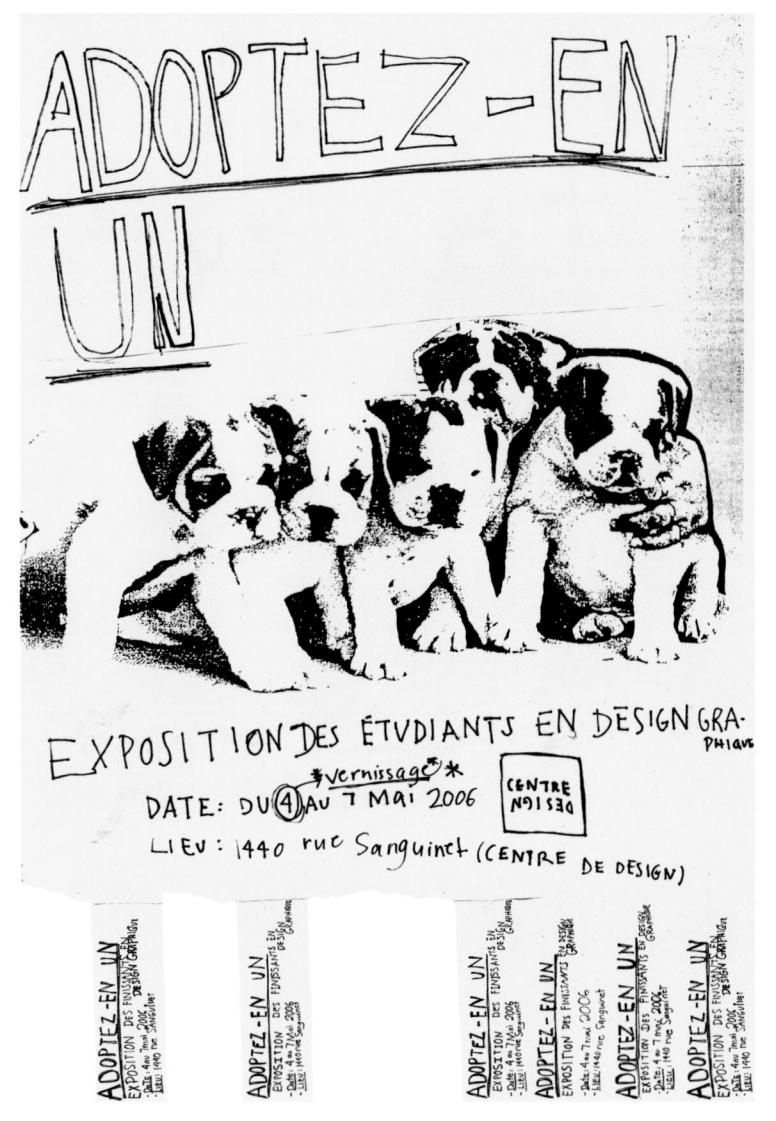

JAN PAULS FOTOGRAFIE DAS SCHEINBAR ALLTÄGLI FRAUEN IN DEUTSCHLAND EIN SELBSTPORTRAIT/ F TEST/ DAS VERFAHREN/

DESIGN
Christoph Bebermeier
and David Krause
Berlin, Germany

CREATIVE DIRECTION

Christoph Bebermeier

and David Krause

DESIGN OFFICE BÜRO WEISS

CLIENT Jan Pauls

PRINCIPAL TYPE

Helvetica Condensed Bold

JAN PAULS FOTOGRAF DAS SCHEINBAR ALLTA ICHE/ FRAUEN IN DEUTSCHLAN EIN SELBSTPORTRAIT/ FINANZTEST/ DAS VERFAHREN/

DESIGN ENT PROJECT

Andy Outis

New York, New York

SCHOOL

School of Visual Arts

INSTRUCTOR

Stephen Doyle

PRINCIPAL TYPE

News Gothic

SUSPECTS

HE USUAL

STEPHEN BALDWIN

PETE POSTLETHWAITE

CHAZZ PALMINTERI

KEVIN SPACEY LANDRIEL

RNE

DESIGN ENT PROJECT

Ryan Feerer

New York, New York

SCHOOL

School of Visual Arts, MFA Design

INSTRUCTOR

Gail Anderson

PRINCIPAL TYPE

Antique, Batak Condensed, and Bokka

STILDENT PROJECT

Maris Bellack

New York, New York

SCHOOL

School of Visual Arts

INSTRUCTOR

Paula Scher

PRINCIPAL TYPE

Trade Gothic

DIMENSIONS

Various

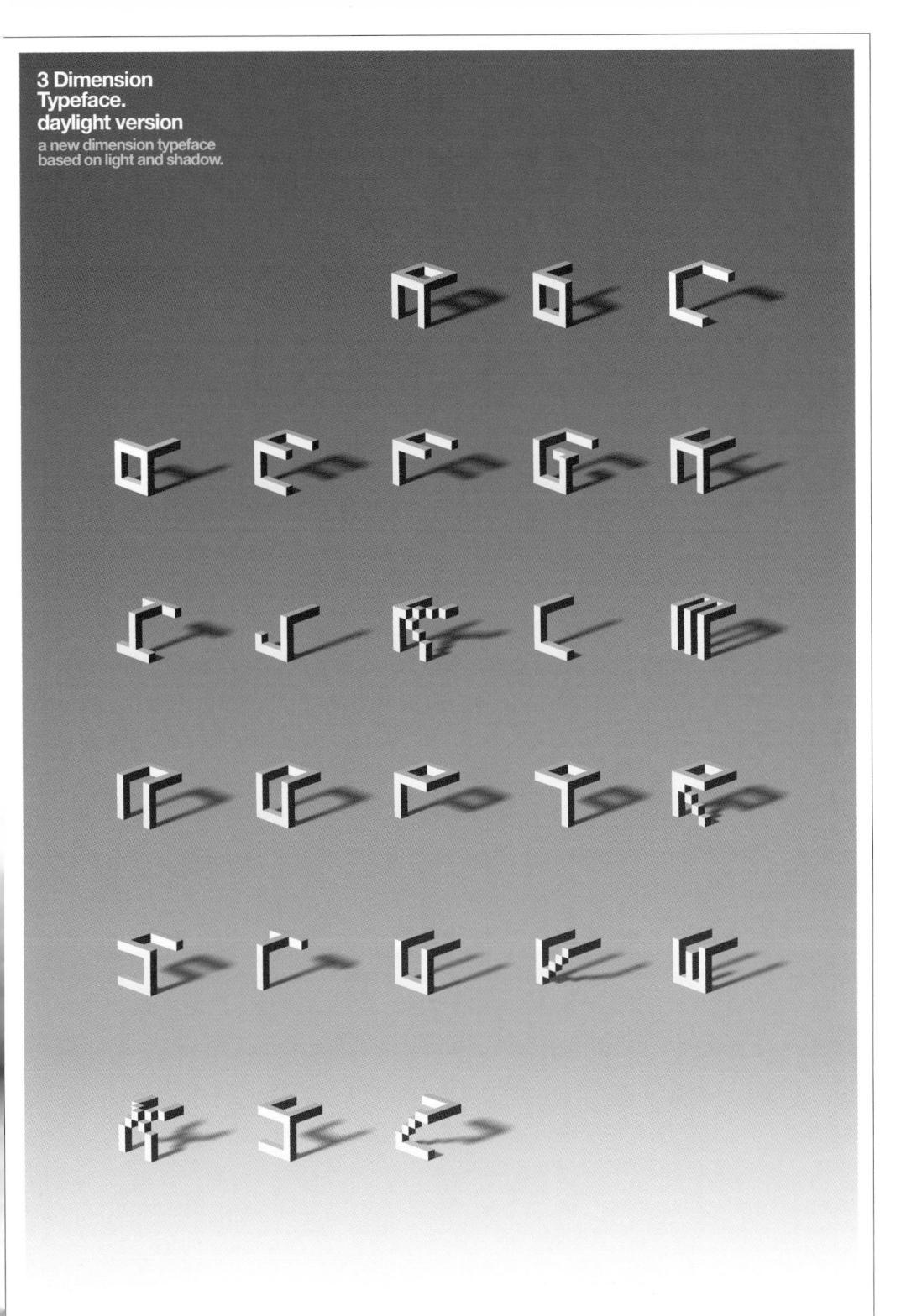

STUDENT PROJECT

Yoni Kim

New York, New York

SCHOOL

School of Visual Arts

INSTRUCTOR

Kim Maley

PRINCIPAL TYPE

Helvetica Neue and custom

DIMENSIONS

28 x 36 in.

 $(71.1 \times 91.4 \text{ cm})$

FI FOTRONIC

*Niels Schrader*Amsterdam, The Netherlands

MUSIC

Sister Love

PROCESSING

Jelle Herold

CLIENT

Stichting Pleinmuseum, Amsterdam

PRINCIPAL TYPE

FFF Mono 01

TEXT VISION OPENER

Sean Dougherty, Dennis Go, Kevin Robinson, and Danny Ruiz New York, New York

LETTERING
Sean Dougherty

STUDIO

Brand New School

CLIENT
Country Music Television (CMT)

PRINCIPAL TYPE

Various and handlettering

Mariana Contegni and Vanessa Eckstein Mexico City, Mexico

CREATIVE DIRECTION

Vanessa Eckstein

DESIGN OFFICE Bløk Design

CLIENT

Museo Marco

PRINCIPAL TYPE

Blender and Helvetica Neue

DIMENSIONS 5.75 x 8.25 in. (14.6 x 21 cm) Projecto paru Bodeya lantas Palio de las narunjas) Museo de Arte Contemporanco de Monterrey

en la planta baja del muro, al timal de la sala cinco, existía en acceso que comunicaba el patro de los nuranjes, uno de los expercies que han desguarcies del plano arquitectonico eniginal del museo. Actualmente este sitio, convertido en bodega, almucena diverses muteriales de trabajo de dutintos deportamentos.

Una reconstrucción del legar permitinà recuperar la historia del recinto y levarla a convinir con su condición actual. Hacirndo uso de la cirbotes, eterentes referenciales que formuban parte dal logar, utilizaremos doce nurunjes, de forme tel que se adeann a la sinúmina actual del sitio y a la actividades que ahi se levan a cuba. A su vee, las cirbotes seran el enentes que conviriran con el colorno cohabitando en todo momento con la remoria del museo.

Este projecto pretendo integrar a la dinámico de las salas de exponición un apucio que sude permunecer oculto mastrando pourte de su estrutura interna-funcional.

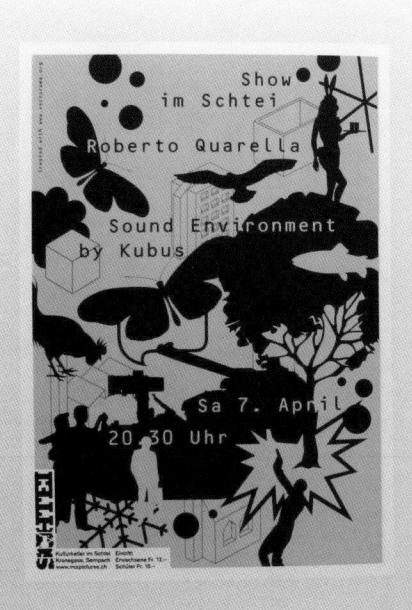

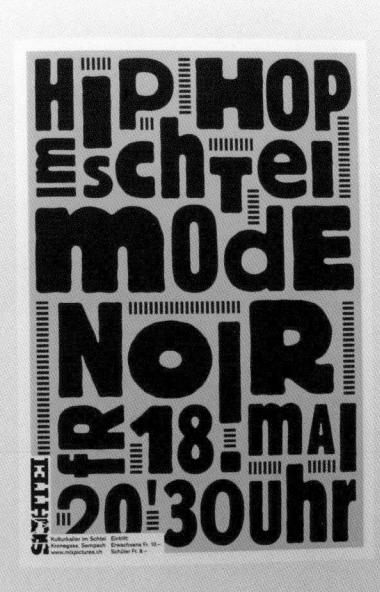

Erich Brechbühl Lucerne, Switzerland

design office Mixer

PRINCIPAL TYPE

Akzidenz Grotesk

DIMENSIONS 5.8 x 7.5 in. (14.8 x 19 cm)

Die String Die String Die Schrift das Plakat als Information und die Schrift des Plakat als Informuck des Inhaltes das Konzert, in L. Die grafische Gwartungen. Das wartungen. Das wartungen. Das swork in progres mer besser. Bildfindung. Die Lu Halling die Typografie. Qual immer wied u finden. Der Spass

Adam Figielski, Helmut Himmler, and Ina Thedens Frankfurt, Germany

ART DIRECTION Helmut Himmler and Till Schaffarczyk

CREATIVE DIRECTION Helmut Himmler and Lars Huvart

LETTERING Adam Figielski, Helmut Himmler, and Ina Thedens

AGENCY Ogilvy & Mather Frankfurt

CLIENT MYFonts.com

PRINCIPAL TYPE Armada Condensed, ITC Aspirin, Bureau Grotesque, and Radiant

DIMENSIONS 46.8 x 66.1 in. (118.8 x 168 cm)

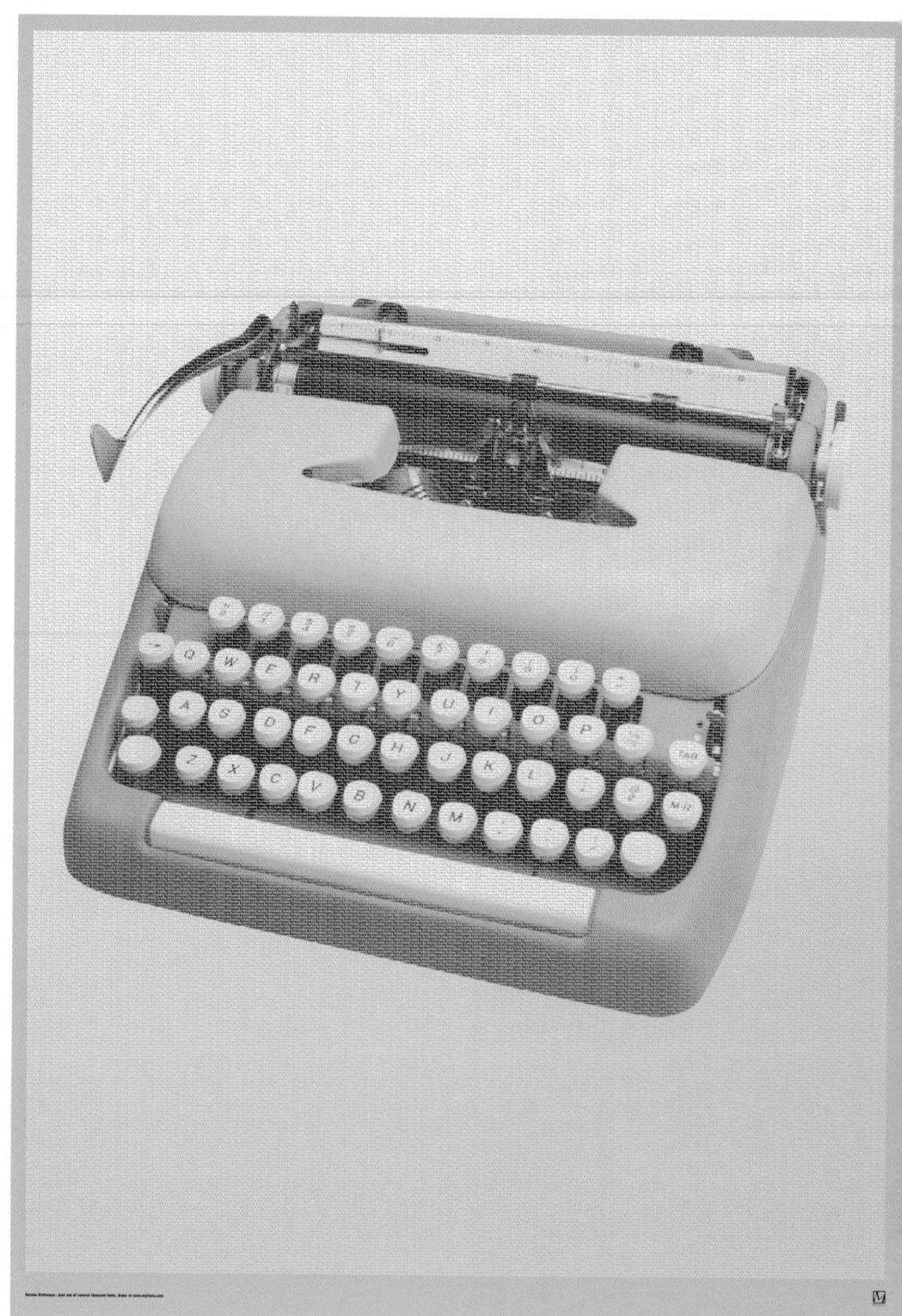

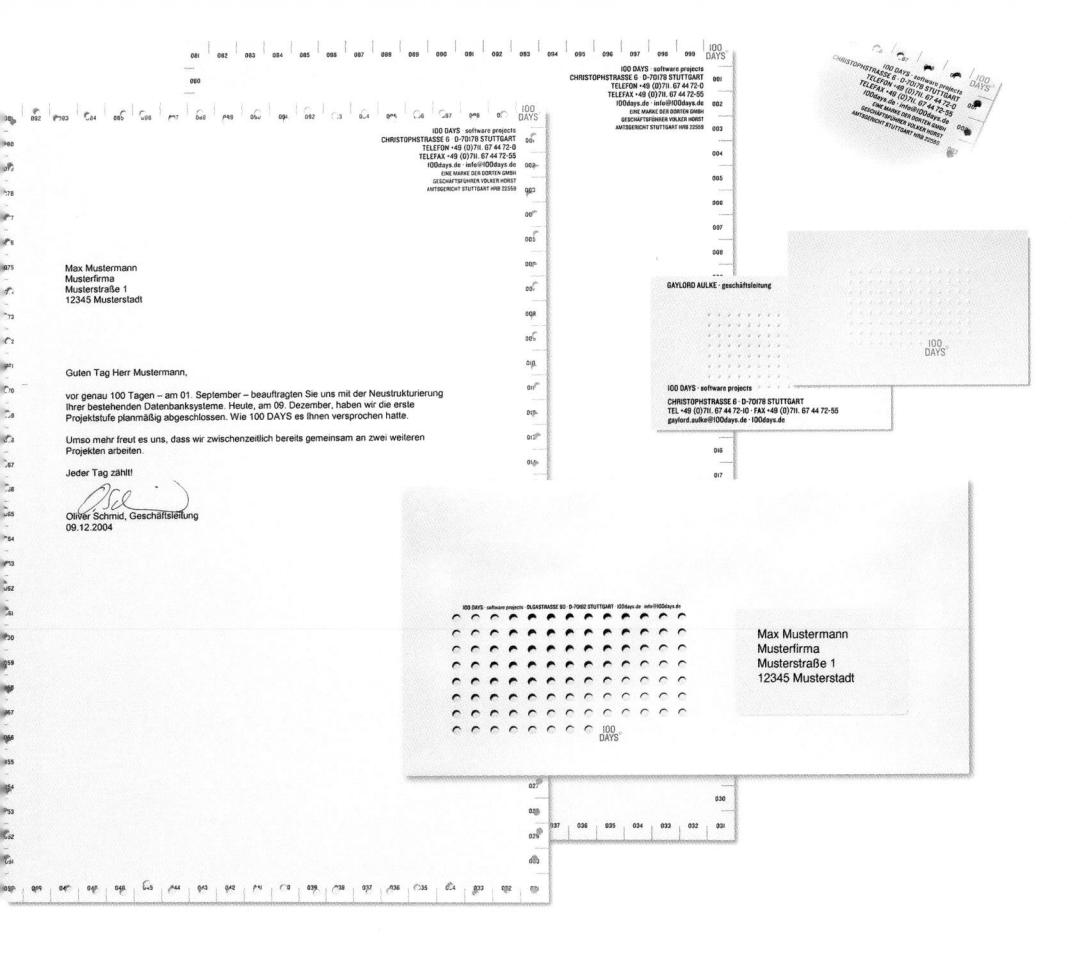

Joerg Bauer

Stuttgart, Germany

ART DIRECTION

Joerg Bauer

CREATIVE DIRECTION

Joerg Bauer and Christian Schwarm

DESIGN OFFICE

Dorten Bauer

CLIENT

100 Days

PRINCIPAL TYPE

HTF Knockout

DIMENSIONS

Various

Kan Akita

Tokyo, Japan

ART DIRECTION

Kan Akita

DESIGN OFFICE

Akita Design Kan Inc.

PRINCIPAL TYPE

Avant Garde Bold

DIMENSIONS

57.3 x 40.6 in.

(145.6 x 103 cm)

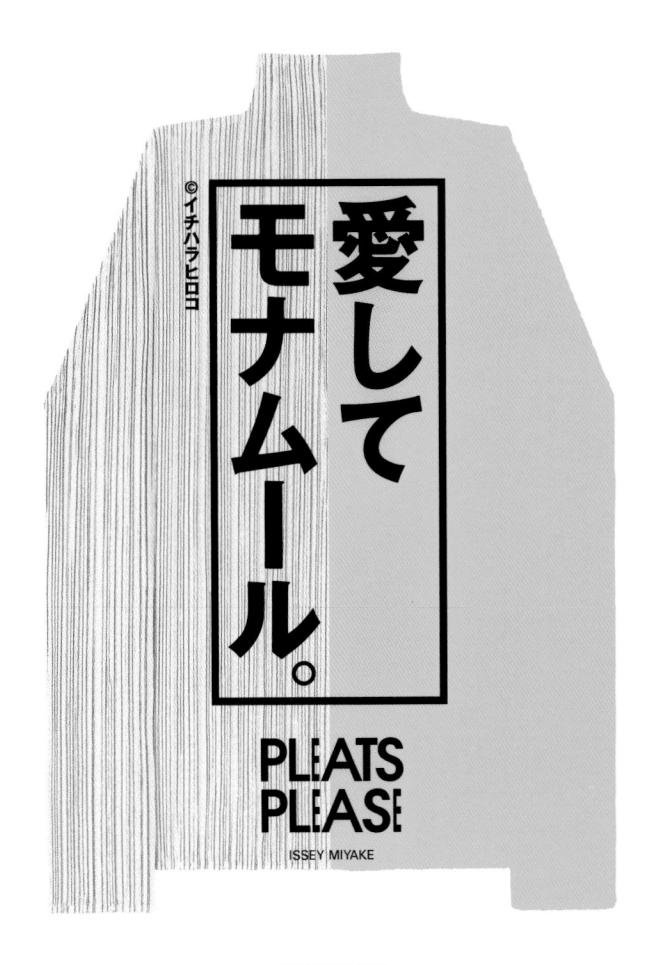

Kan Akita

Tokyo, Japan

ART DIRECTION

Kan Akita

CREATIVE DIRECTION

Midori Kitamura

PHOTOGRAPHY

Yasuaki Yoshinaga

ARTIST

Hiroko Ichihara

DESIGN OFFICE

Akita Design Kan Inc.

CLIENT

Issey Miyake Inc.

PRINCIPAL TYPE

Custom

DIMENSIONS

40.6 x 28.7 in.

(103 x 72.8 cm)

Mariana Contegni and Vanessa Eckstein Mexico City, Mexico

CREATIVE DIRECTION

Vanessa Eckstein

DESIGN OFFICE Bløk Design

CLIENT ING

PRINCIPAL TYPE

Tsar Mono Round and Franklin

Gothic

DIMENSIONS 10.4 x 10.4 in. (26.5 x 26.5 cm)

And the first of the CTT carrier. A section of a factor and the CTT carrier. A section of the CT

154 155

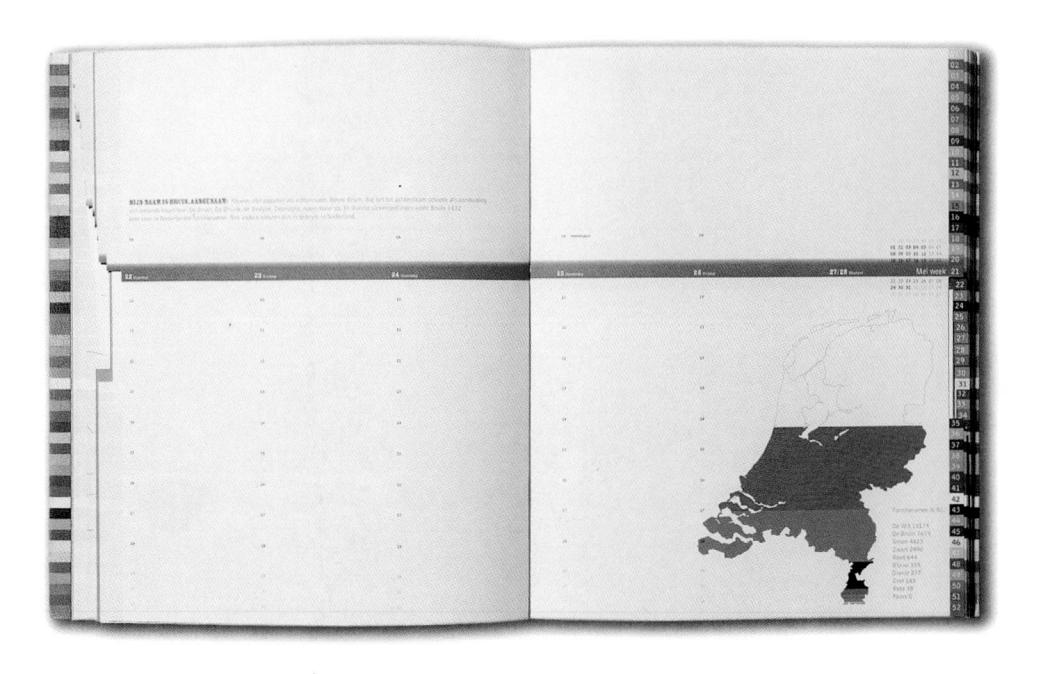

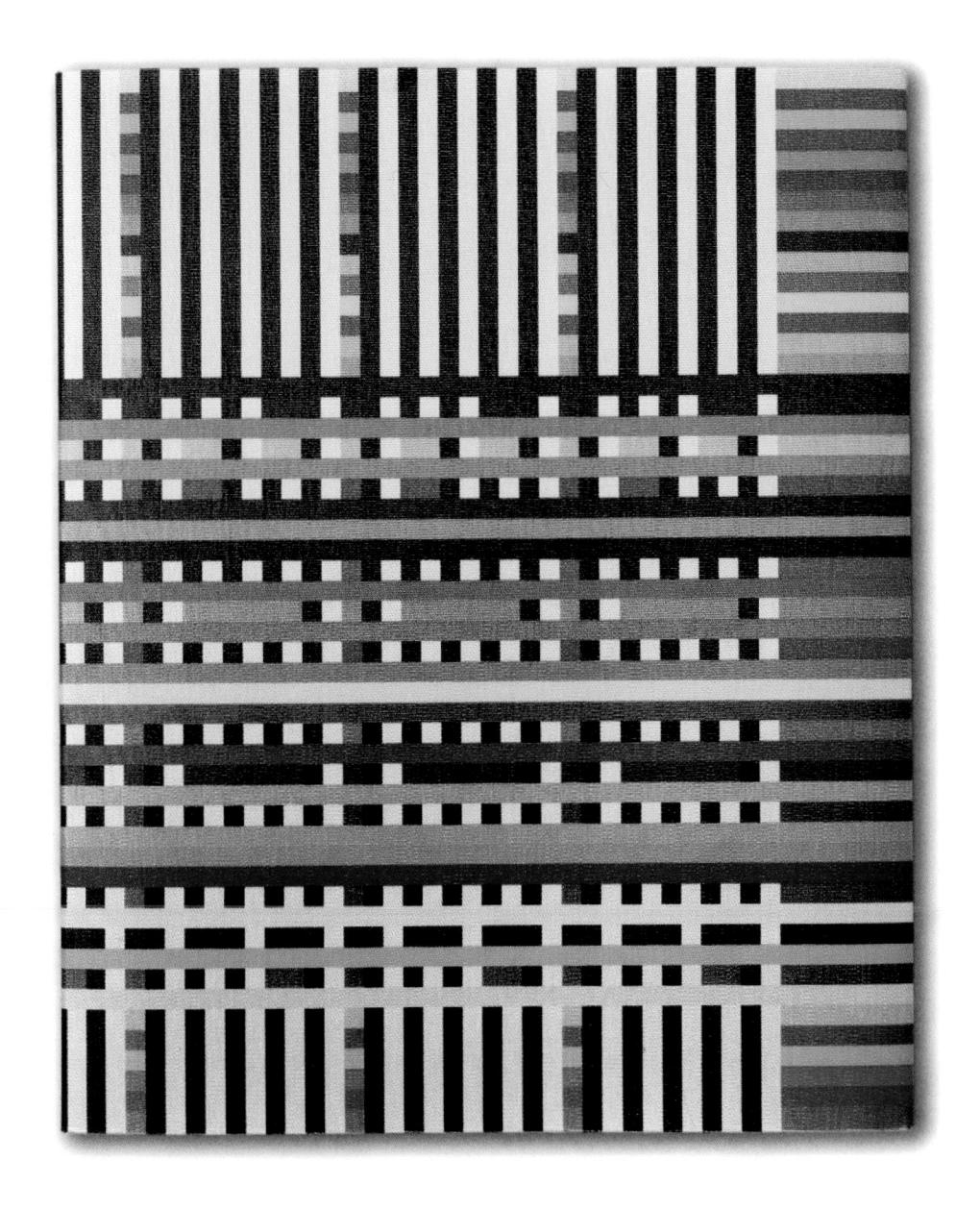

Barlock

The Hague, The Netherlands

ART DIRECTION

Hélène Bergmans, Käthi Dübi, and Saskia Wierinck

CREATIVE DIRECTION

Hélène Bergmans, Käthi Dübi, and Saskia Wierinck

ILLUSTRATION

Fréderiek Westerweel

DESIGN OFFICE

Ando bv

PRINCIPAL TYPE

Rosewood and Bell Gothic

DIMENSIONS

7.9 x 9.7 in.

(20 x 24.5 cm)

DACK AGING DESIGN AGING

Michael Vanderbyl

San Francisco, California

ART DIRECTION

Michael Vanderbyl

CREATIVE DIRECTION

Michael Vanderbyl

DESIGN OFFICE

Vanderbyl Design

CLIENT

Wildass Vineyards

PRINCIPAL TYPE

Ironwood

DIMENSIONS

3 x 4.7 in.

 $(7.6 \times 11.9 \text{ cm})$

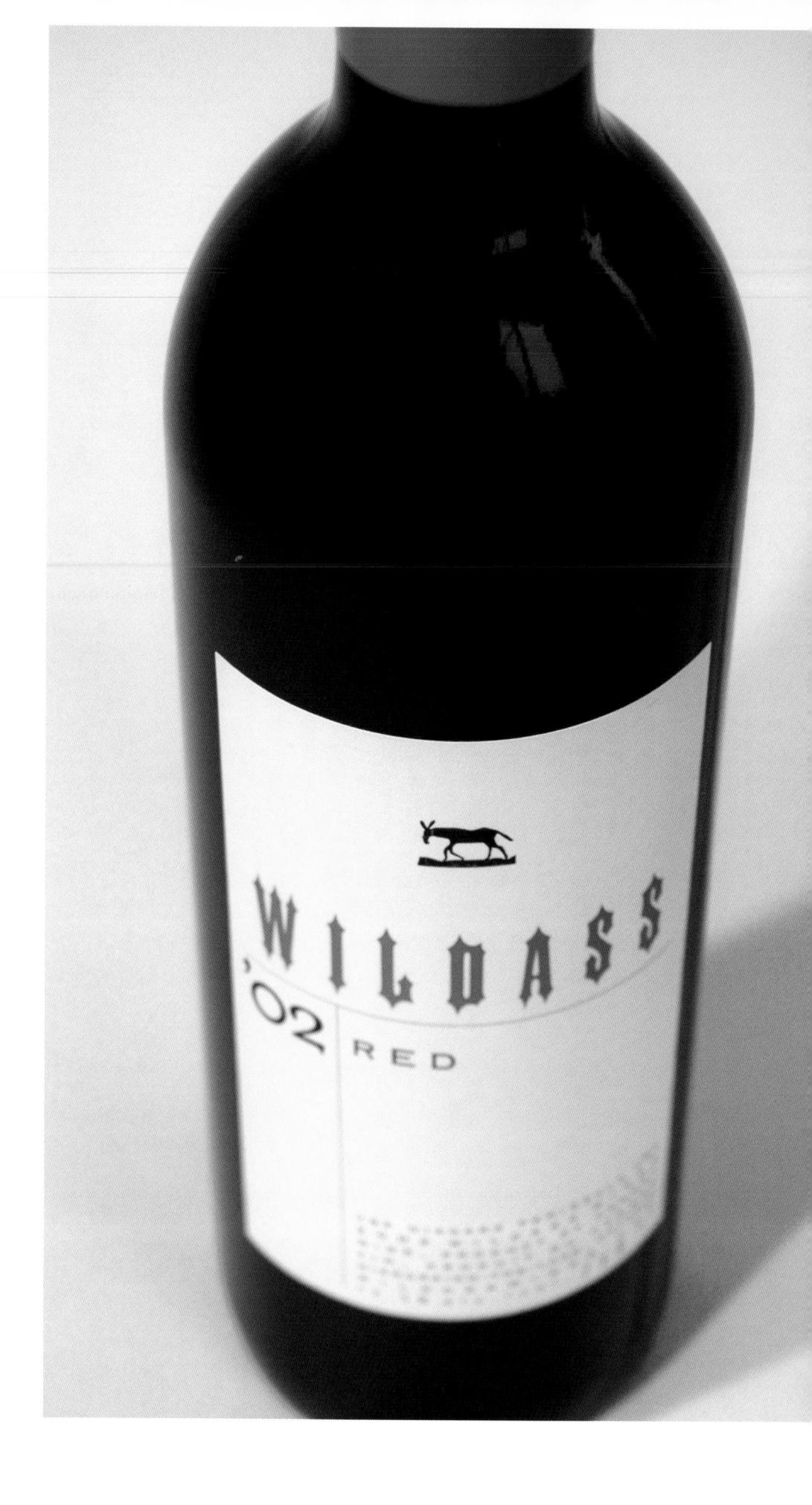

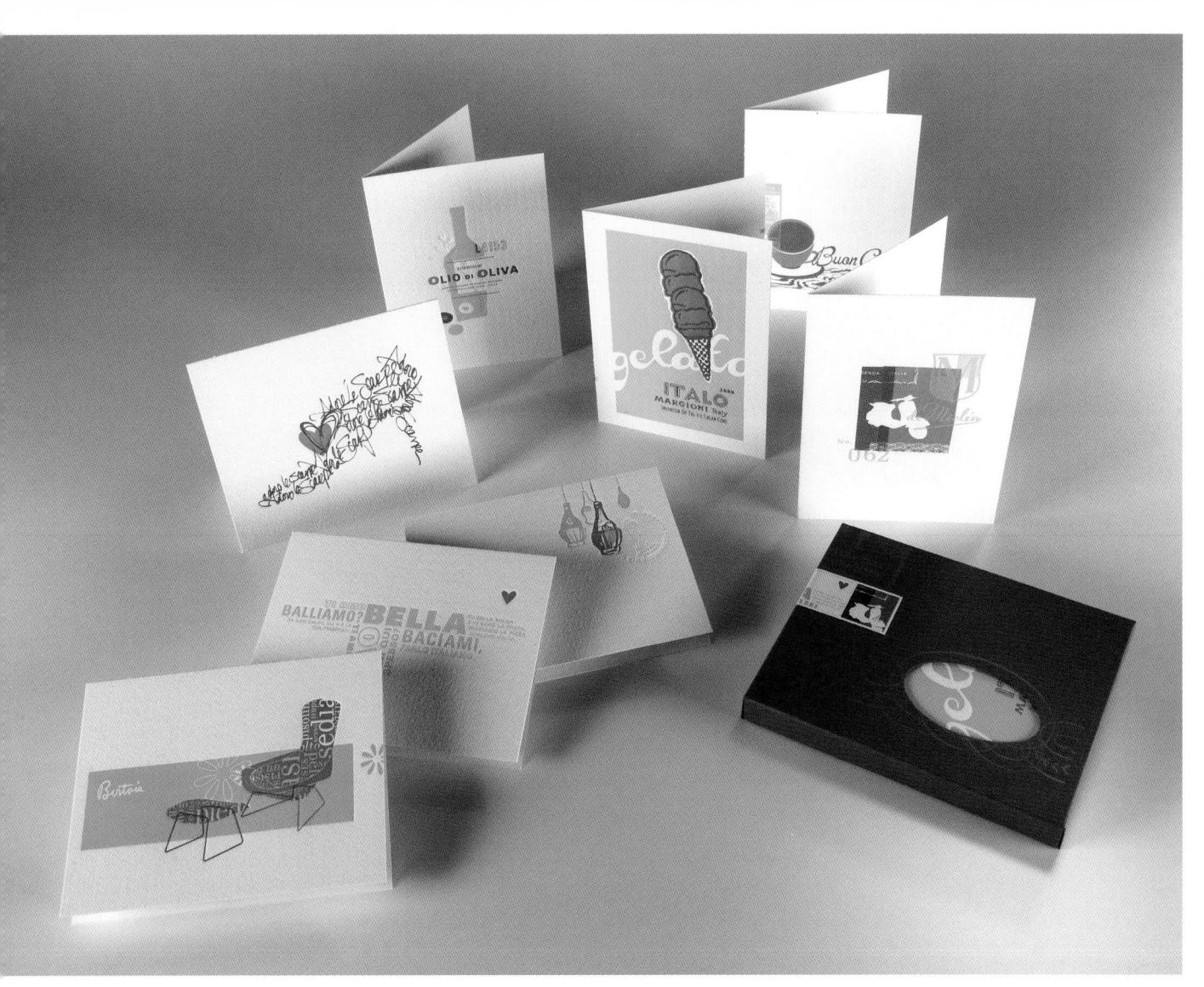

DESIGN CARDS

Sallie Reynolds Allen, Dennis Garcia, Tracy Meiners, Robert Palmer, and Justin Skeesuck San Diego, California

ART DIRECTION

Dennis Garcia

LETTERING

Tracy Meiners and

Sallie Reynolds Allen

PRINTER

DeFrance Printing

DESIGN OFFICE

Miriello Grafico

CLIENT

DeFrance Printing, Fox River Paper, and Miriello Grafico

PRINCIPAL TYPE

Berthold Akzidenz Grotesk, Filosofia,
Sabon, Univers, and bandlettering

DIMENSIONS 4.5 x 5.5 in. (11.4 x 14 cm)

*Michael Vanderbyl and Ellen Gould*San Francisco, California

ART DIRECTION

Michael Vanderbyl

CREATIVE DIRECTION

Michael Vanderbyl

DESIGN OFFICE

Vanderbyl Design

CLIENT

Mohawk Fine Papers, Inc.

PRINCIPAL TYPE

Clarendon and Artscript

DIMENSIONS

11 x 17 in.

(27.9 x 43.2 cm)

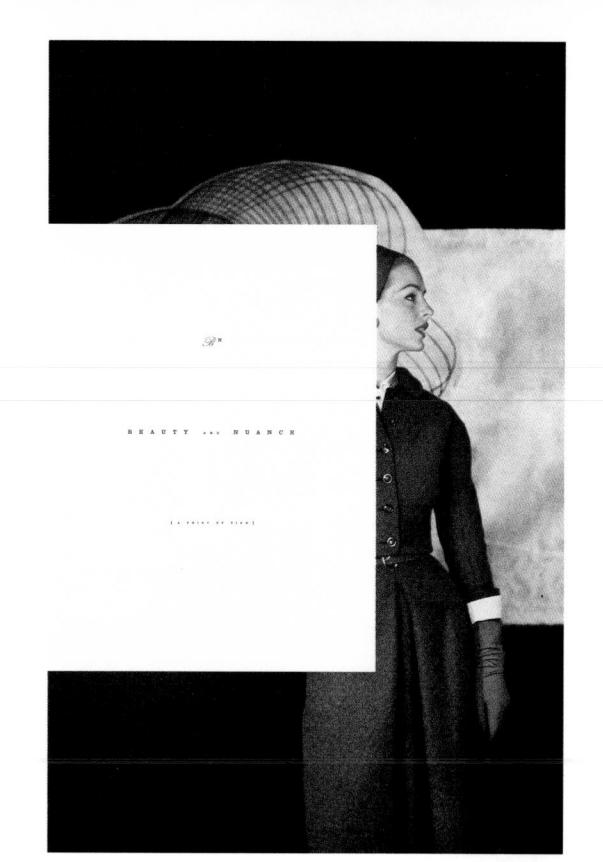

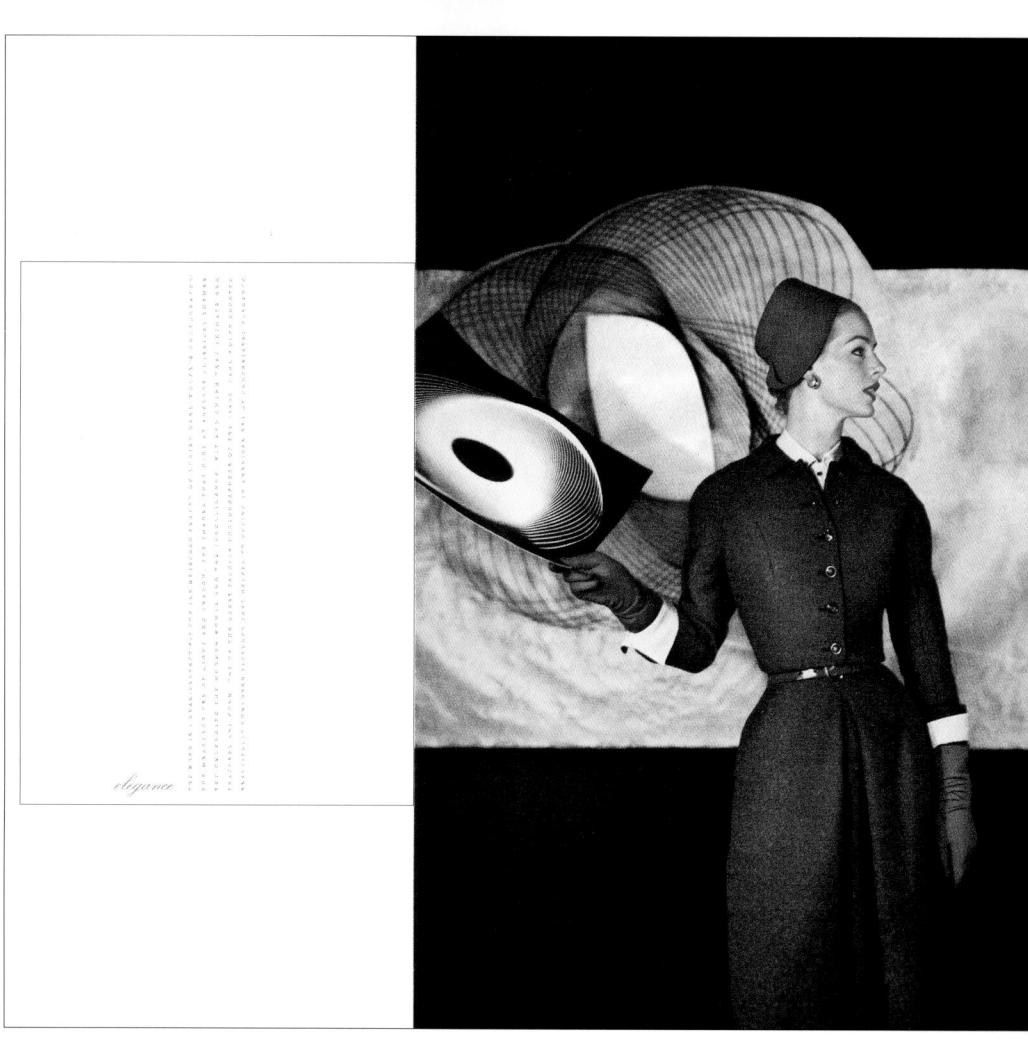

DESIGN

Eric Cai Shi Wei
Beijing, China

ART DIRECTION

Eric Cai Shi Wei

CREATIVE DIRECTION

Eric Cai Shi Wei

DESIGN OFFICE

Eric Cai Design Co.

PRINCIPAL TYPE

Times New Roman

DIMENSIONS 25.6 x 35.4 in. (65 x 90 cm)

Karin Bryant, Aine Coughlan, and Nathan Durrant San Francisco, California

CREATIVE DIRECTION

Jennifer Jerde

LETTERING

Nathan Durrant

ILLUSTRATION

Polly Becker

Boston, Massachusetts

DESIGN OFFICE

Elixir Design

CLIENT

Buck & Rose Road Trip Productions

PRINCIPAL TYPE

ITC Galliard, Italienne (bandrendered), and Plantagenet

DIMENSIONS

Various

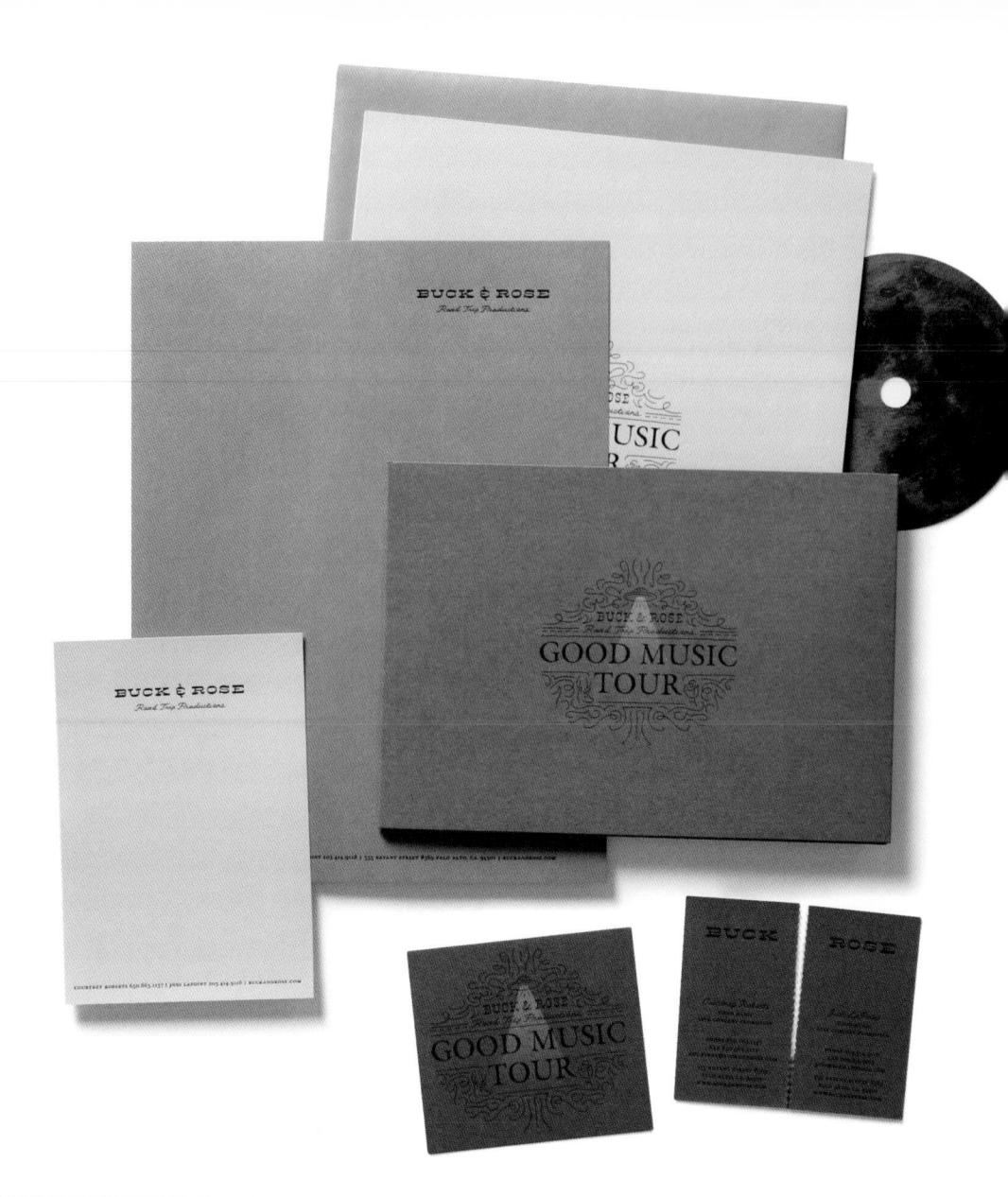

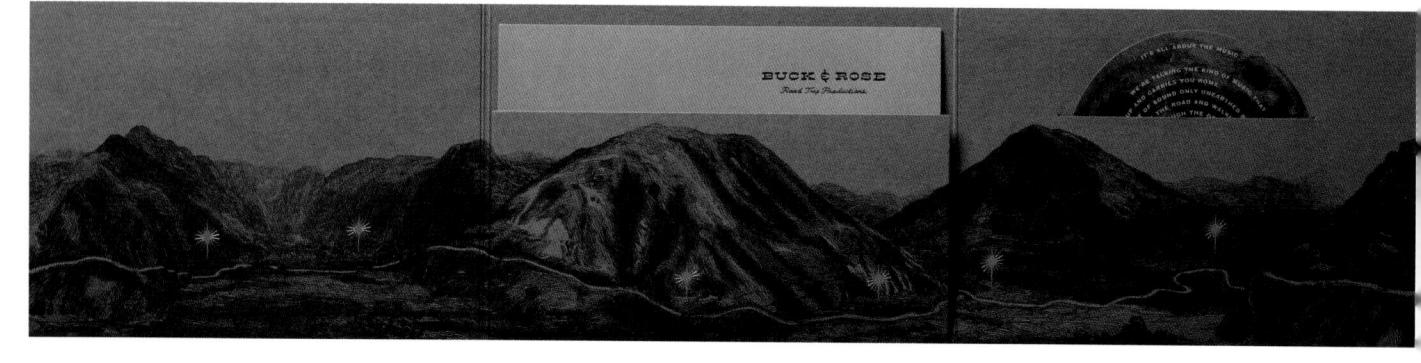
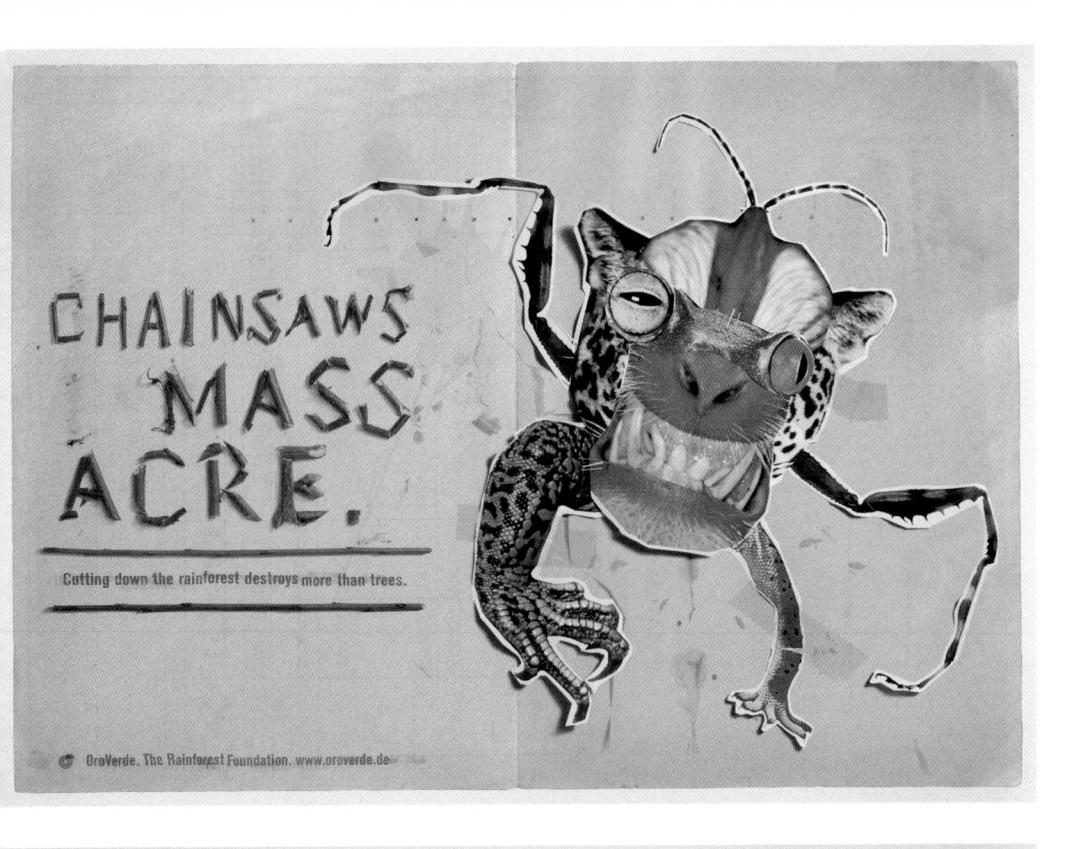

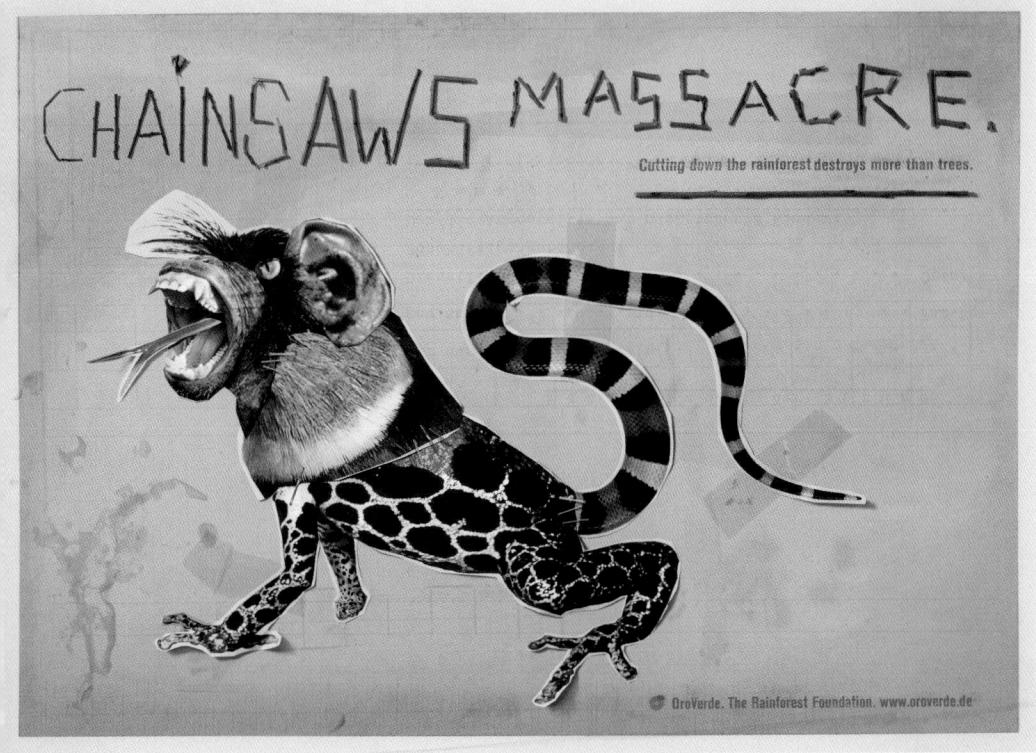

*Till Schaffarczyk*Frankfurt, Germany

ART DIRECTION

Till Schaffarczyk

CREATIVE DIRECTION

Helmut Himmler and Lars Huvart

LETTERING

Till Schaffarczyk

COPYWRITER

Ales Polcar

AGENCY

Ogilvy & Mather

Frankfurt

CLIENT

OroVerde Rainforest Foundation

Germany

PRINCIPAL TYPE Handlettering

DIMENSIONS 33.1 x 23.4 in. (84 x 59.4 cm) DESIGN HURE

Sarah Nelson, Paul Sieka, and Sharon Werner Minneapolis, Minnesota

CREATIVE DIRECTION

Sharon Werner

DESIGN OFFICE

Werner Design Werks, Inc.

CLIENT

Contractors Property Developers

Company

PRINCIPAL TYPE

Old Typewriter and ITC Franklin

Gothic

DIMENSIONS Various

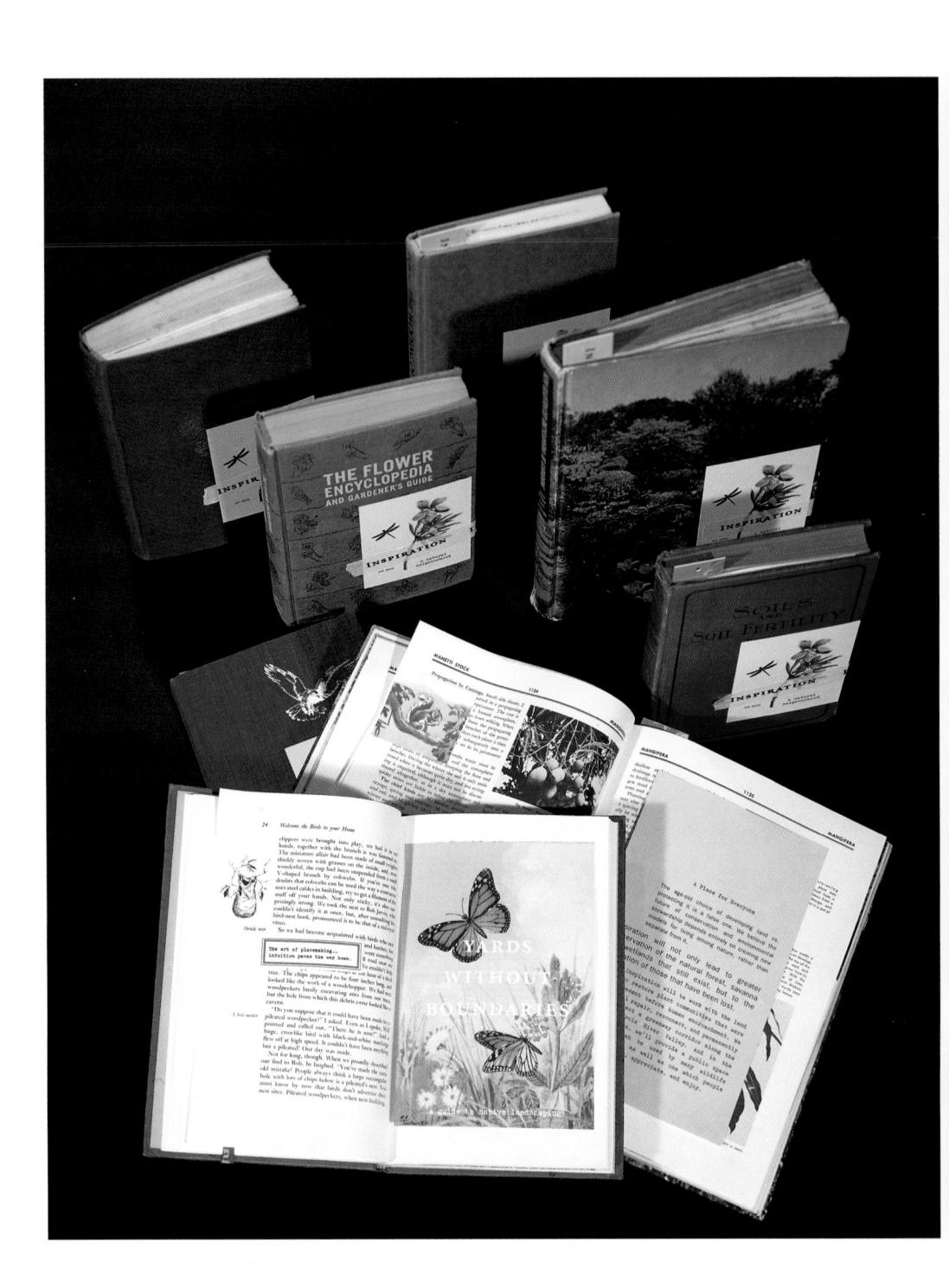

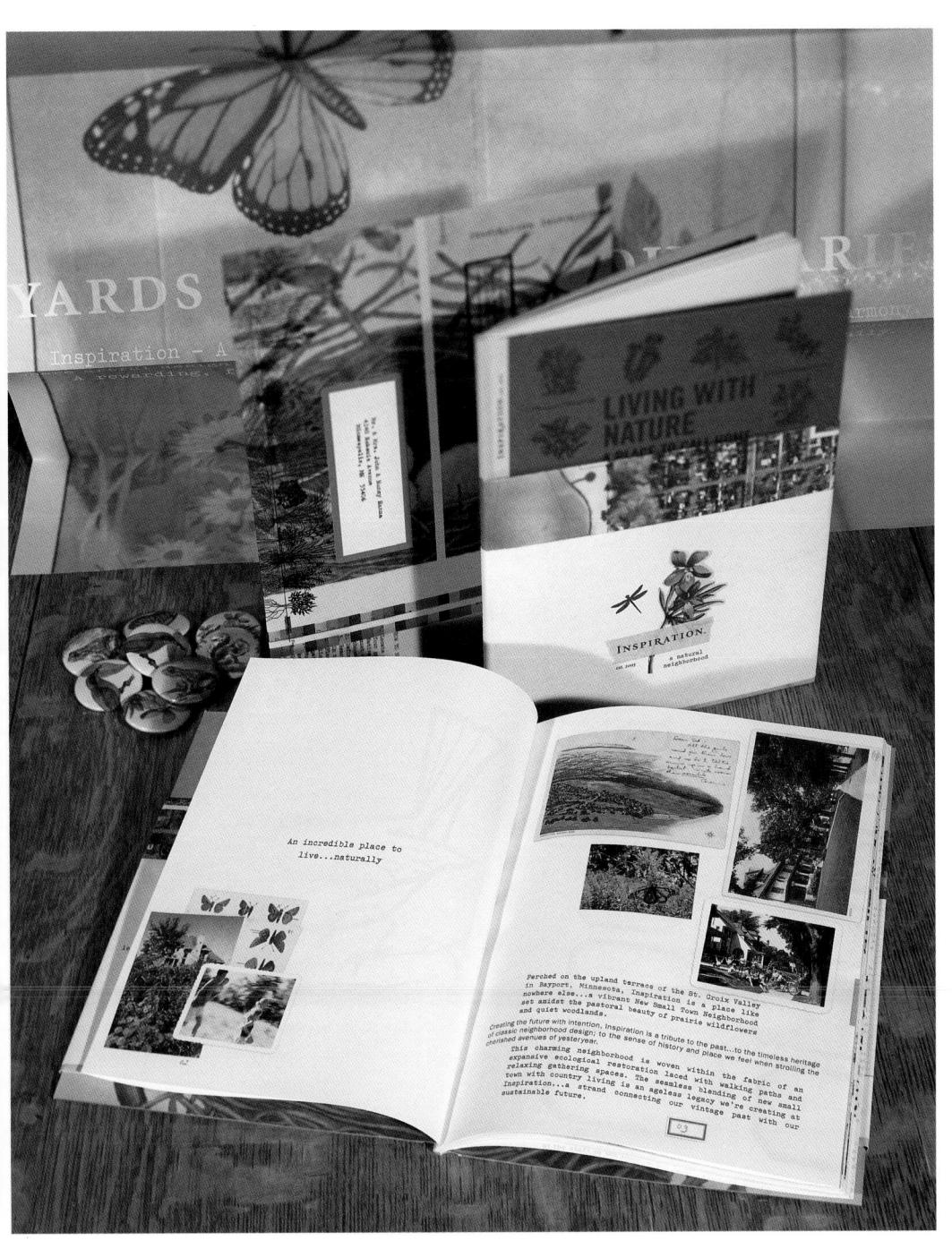

Sharon Werner and Sarah Nelson Minneapolis, Minnesota

CREATIVE DIRECTION Sharon Werner

STUDIO

Werner Design Werks, Inc.

CLIENT

Contractor Property Development Company

PRINCIPAL TYPE Old Typewriter and ITC Franklin

DIMENSIONS Various

Gothic

DESIGN COVER

Christopher Simmons San Francisco, California

CREATIVE DIRECTION

Christopher Simmons

DESIGN OFFICE $MINE^{\mathrm{TM}}$

CLIENT Rockport Publishers

коскрогі Ривііѕве

PRINCIPAL TYPE FF DIN

DIMENSIONS 9 x 12 in. (22.9 x 30.5 cm)

218

Fred Woodward and Ken DeLago New York, New York

PHOTOGRAPHY

Mark Seliger

CLIENT

Rizzoli

PRINCIPAL TYPE

Titling Gothic

DIMENSIONS

12 x 15.25 in.

(30.5 x 38.7 cm)

MAGAZINE SPREAD

Ken DeLago

New York, New York

DESIGN DIRECTION

Fred Woodward

PUBLICATION

GQ

PRINCIPAL TYPE

Miller

DIMENSIONS

15.6 x 11 in.

(39.6 x 27.9 cm)

+A¹/₄n Gr³/₃n...span Tak³/_{5...} a Bath

For the past eighteen years, the Oz-like ALAN GREENSPAN has used his position as chairman of the Federal Reserve to push, behind the scenes, for strict budgetery discipline. Now, in his final year in office, he has watched the Bush administration destroy the budget surplus and drive the deficit to record highs. So the mysterious chairman must decide: Will he continue to fight for his economic principles, even if it means fighting his own party?

MACAZINE SPREAD

Ken DeLago

New York, New York

DESIGN DIRECTION

Fred Woodward

PUBLICATION

GQ

PRINCIPAL TYPE

Farnham

DIMENSIONS

15.6 x 11 in.

 $(39.6 \times 27.9 \text{ cm})$

CATALOG

Michael Vanderbyl and Amanda Linder San Francisco, California

ART DIRECTION

Michael Vanderbyl

CREATIVE DIRECTION

Michael Vanderbyl

PHOTOGRAPHY

Jim Hedrich of Hedrich Blessing

Chicago, Illinois

COPYWRITER

Penny Benda

DESIGN OFFICE Vanderbyl Design

CLIENT *Teknion*

PRINCIPAL TYPE

Adobe Garamond Expert, Adobe Garamond Regular, and FF Meta Plus Book

DIMENSIONS 7 x 9 in. (17.8 x 22.9 cm)

MALLONÉE & ASSOCIATES

F O O D S T R A T E G I E S

DESIGN

Michael Vanderbyl and Ellen Gould San Francisco, California

ART DIRECTION

Michael Vanderbyl

CREATIVE DIRECTION

Michael Vanderbyl

DESIGN OFFICE Vanderbyl Design

CLIENT

Mallonée & Associates

PRINCIPAL TYPE Filosofia

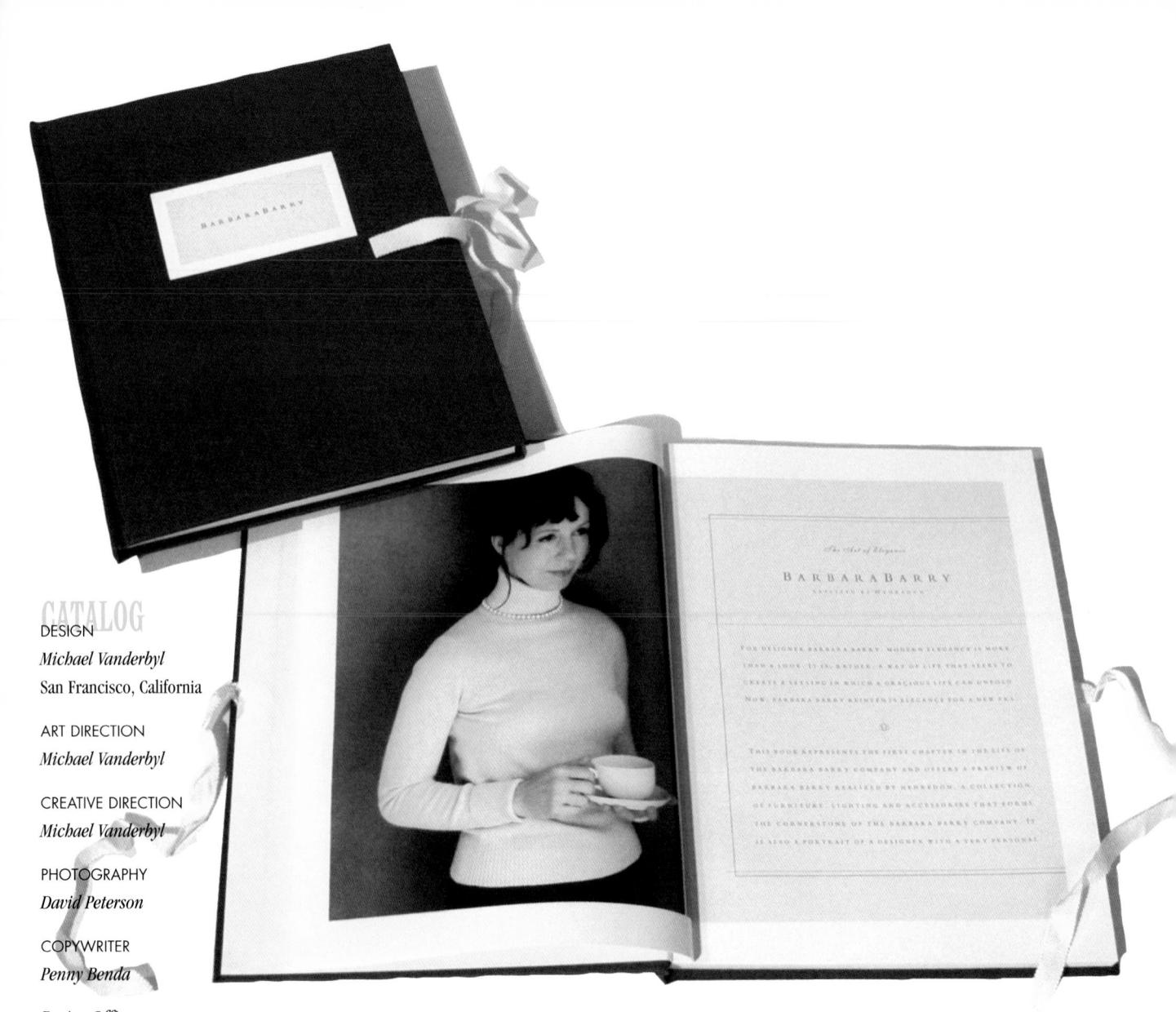

Design Office Vanderbyl Design

CLIENT *Henredon*

PRINCIPAL TYPE

Bembo and Shelley Allegro Script

DIMENSIONS 7.25 x 9.25 in. (18.4 x 23.5 cm)

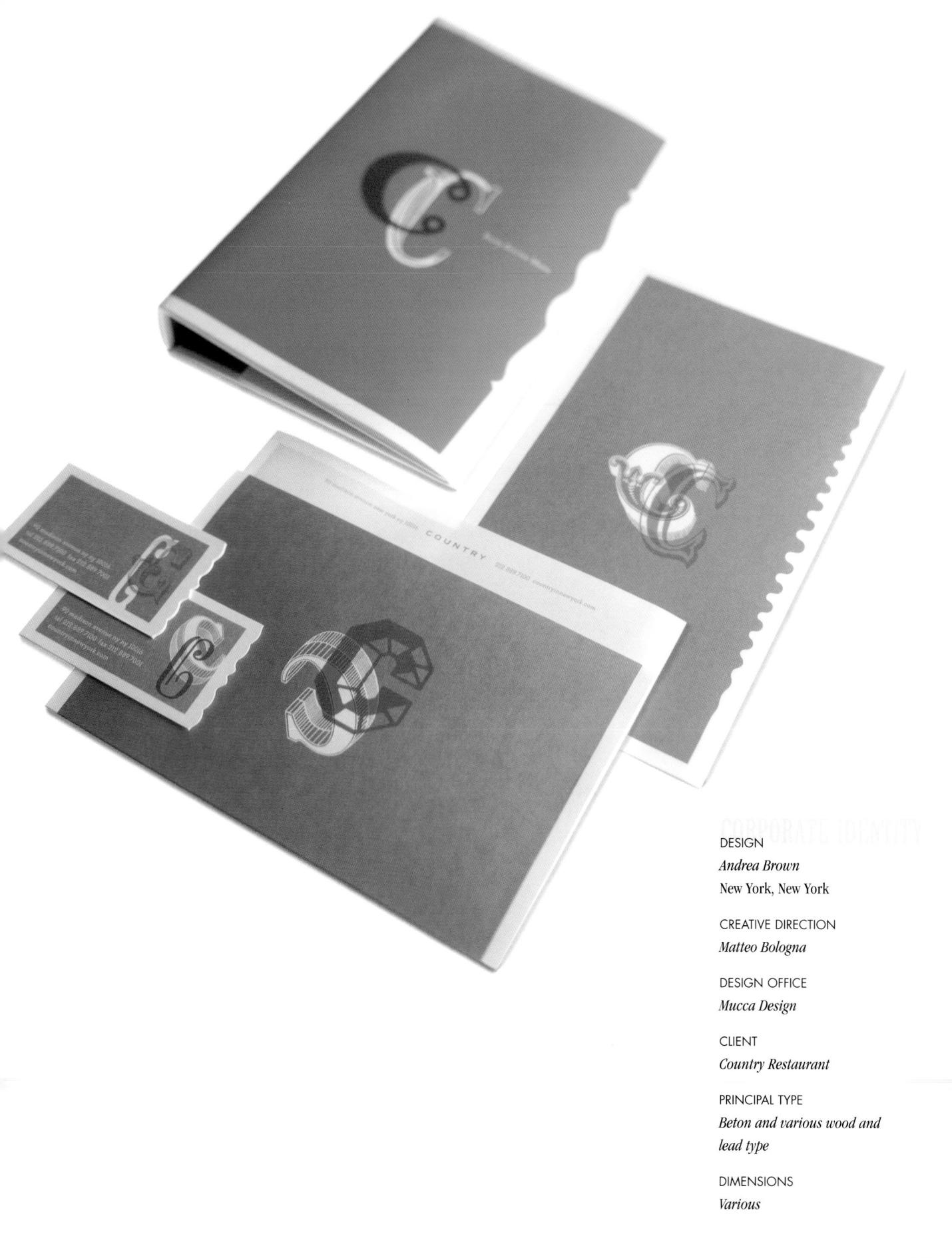

Ken-Tsai Lee and Yao-Feng Chou Taipei, Taiwan

ART DIRECTION

Ken-Tsai Lee

CREATIVE DIRECTION

Ken-Tsai Lee

STUDIO

Ken-Tsai Lee Design Studio

CLIENT

Fonso Interprise Co., Ltd.

PRINCIPAL TYPE

Custom

DIMENSIONS

15.8 x 24.4 in.

 $(40 \times 62 \ cm)$

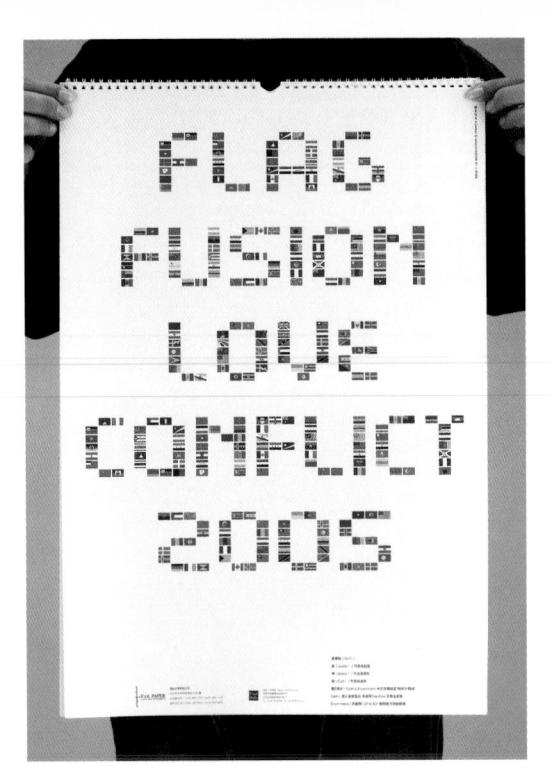

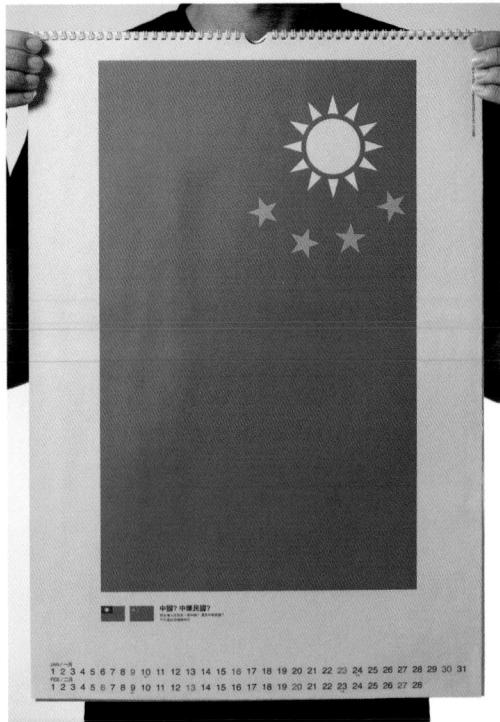

Caro Hansen, Fons Hickmann, Sabine Kornbrust, Franziska Morlok, Verena Petrasch, and Annik Troxler Berlin, Germany

ART DIRECTION Fons Hickmann

CREATIVE DIRECTION
Fons Hickmann

PUBLISHER

Die Gestalten Verlag (dgv)

DESIGN STUDIO
Fons Hickmann m23

CLIENT www.touch-me-there.com

PRINCIPAL TYPE for_boys_only

DIMENSIONS 9.5 x 11 in. (24 x 28 cm)

Michael Jakab

San Francisco, California

ART DIRECTION

Michael Jakab

CREATIVE DIRECTION

Michael Jakab

AGENCY

Collective

CLIENT

Yale School of Art

PRINCIPAL TYPE

Booble, Monolab, and Prestige Elite

DIMENSIONS

6 x 10 in.

(15.2 x 25.4 cm)

Masayoshi Kodaira and Emi Ikami Tokyo, Japan

ART DIRECTION

Masayoshi Kodaira

PHOTOGRAPHY

Mikiya Takimoto

STUDIO

FLAME, Inc.

CLIENT

PIE BOOKS

PRINCIPAL TYPE

Custom based on Helvetica

DIMENSIONS

10.1 x 14.3 in.

(25.7 x 36.4 cm)

Mark Denton London, England

CREATIVE DIRECTION

Mark Denton

LETTERING

Alison Carmichael

DESIGN OFFICE

Mark Denton Design

CLIENT

Alison Carmichael

PRINCIPAL TYPE

Handlettering

DIMENSIONS

16.5 x 23.4 in.

 $(42 \times 59.4 \text{ cm})$

WORDS LOOK MUCH NICER WHEN THEY'RE HAND LETTERED

ALISON CARMICHAEL Lettering Artist phone/fax +44 (0)20 8789 3509 mobile +44 (0)775 398 6699 www.ulisoncarmichael.com

DESIGN

Kozue Takechi
Tokyo, Japan

ART DIRECTION

Kozue Takechi

LETTERING Futaba

ILLUSTRATION
Futaba

CLIENT chutte

PRINCIPAL TYPE

Handlettering

DIMENSIONS 20.3 x 28.7 in. (51.5 x 72.8 cm)

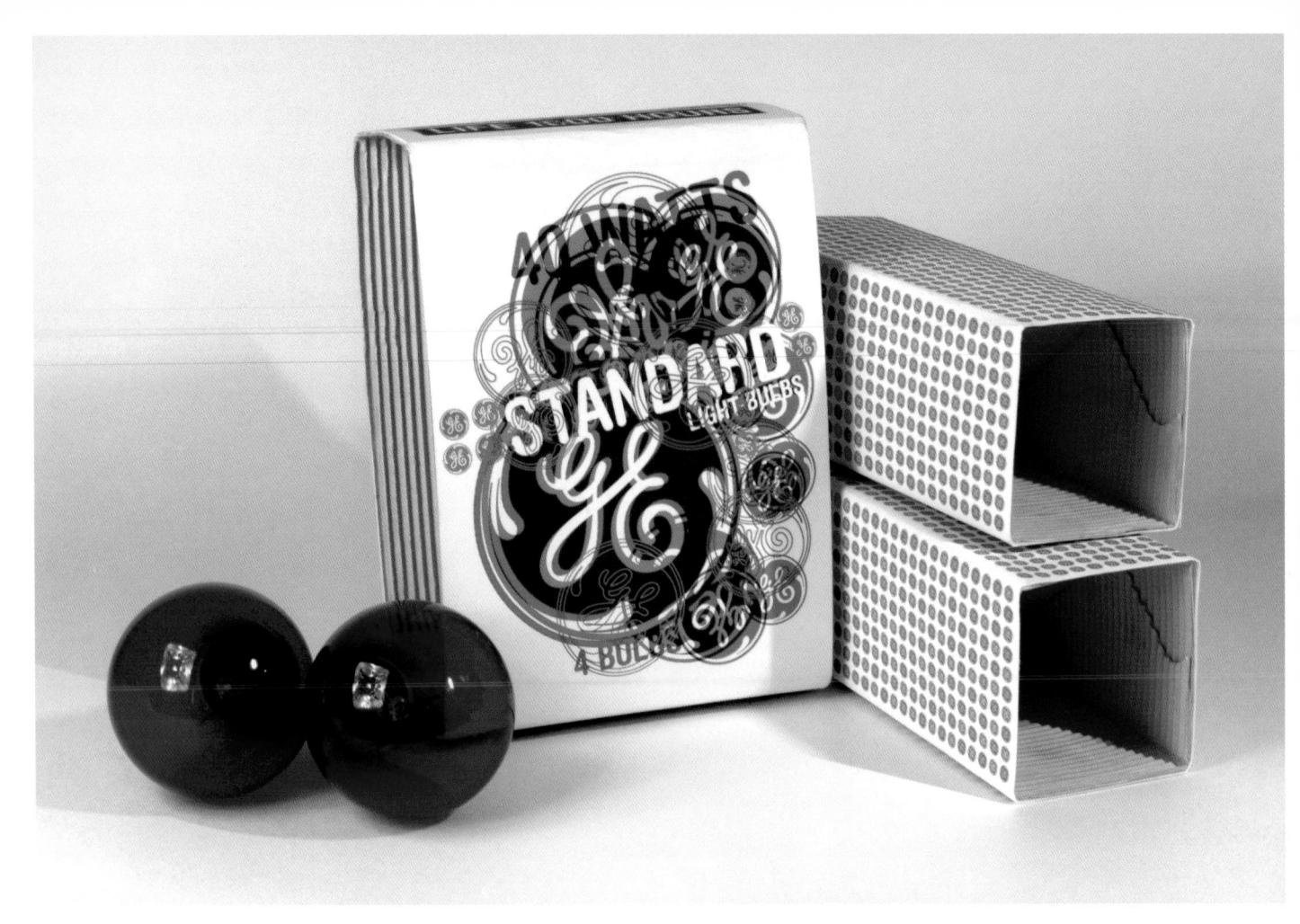

STILDENT PROJECT

Mike Krol

New York, New York

SCHOOL

School of Visual Arts

INSTRUCTOR

Mike Joyce

PRINCIPAL TYPE

Helvetica Round

DIMENSIONS

Various

CARPORATE IDENTITY

Richard Belanger Montreal, Canada

ART DIRECTION

Louis Gagnon

CREATIVE DIRECTION

Louis Gagnon

DESIGN OFFICE
Paprika

PRINCIPAL TYPE

Helvetica Neue, Helvetica Neue Bold, and Helvetica Neue Roman

DIMENSIONS Various

CORPORATE IDENTITY

David Guarnieri Montreal, Canada

ART DIRECTION

Louis Gagnon and David Guarnieri

CREATIVE DIRECTION

Louis Gagnon

DESIGN OFFICE
Paprika

CLIENT Commissaires

PRINCIPAL TYPE Helvetica Neue, Helvetica Neue Bold, and Helvetica Neue Roman

DIMENSIONS *Various*

Masayoshi Kodaira and

Namiko Otsuka

Tokyo, Japan

ART DIRECTION

Masayoshi Kodaira

STUDIO

FLAME, Inc.

CLIENT

Magnum, Inc.

PRINCIPAL TYPE

Helvetica and bandlettering

DIMENSIONS

15.75 x 15.75 in.

(40 x 40 cm)

DESIGN ENT PROJECT

David Guarnieri Montreal, Canada

SCHOOL École de Design, UQAM

INSTRUCTOR *Judith Poirier*

PRINCIPAL TYPE

FF DIN, Edwardian Script,
and Mrs. Eaves

DIMENSIONS Various

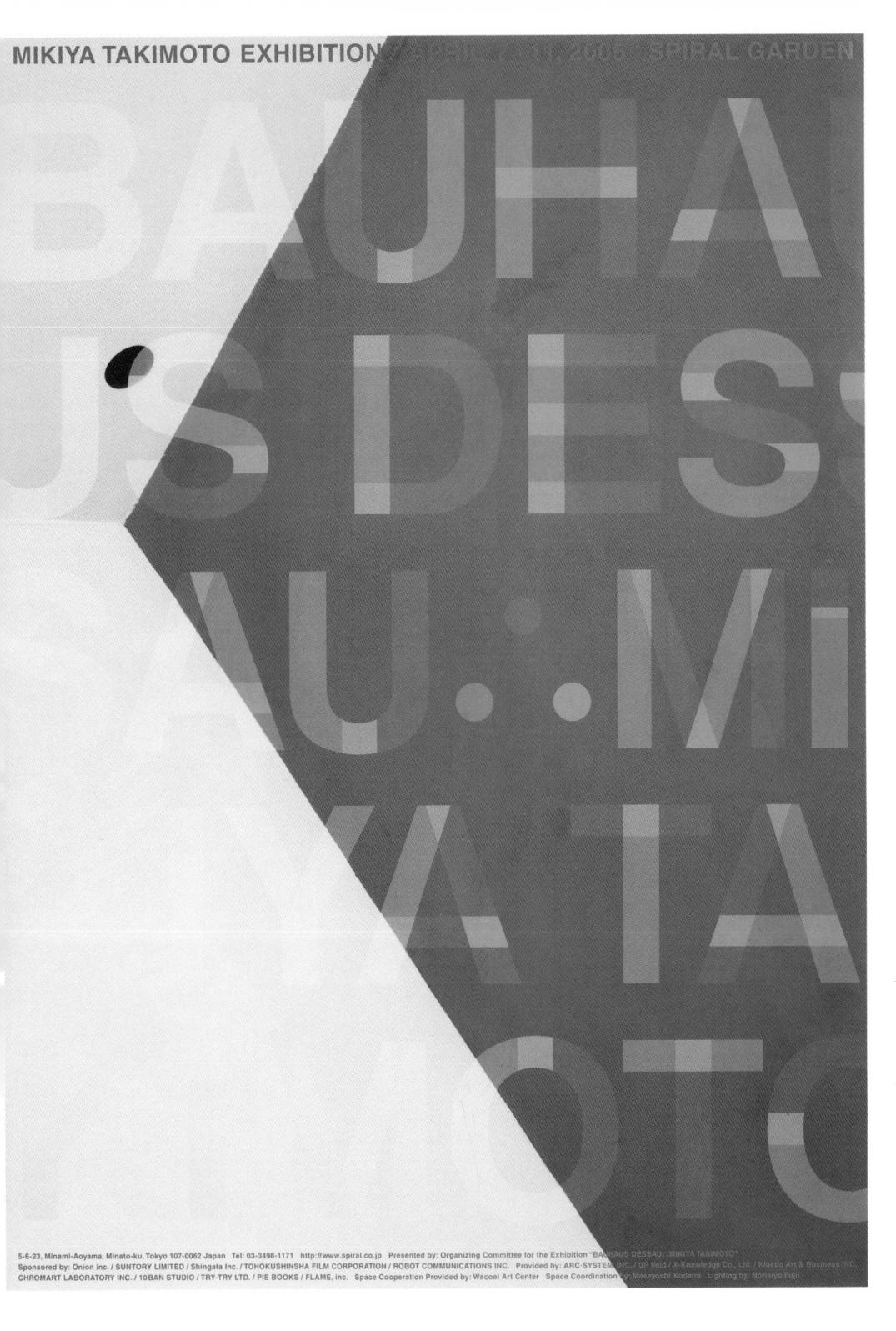

DESIGN Masayoshi Kodaira Tokyo, Japan

ART DIRECTION

Masayoshi Kodaira

CREATIVE DIRECTION

Masayoshi Kodaira

PHOTOGRAPHY

Mikiya Takimoto

STUDIO FLAME, Inc.

CLIENT
Organizing Committee for the
Exhibition "Bauhaus Dessau:
Mikiya Takimoto"

PRINCIPAL TYPE

Custom based on Helvetica

DIMENSIONS Various

DESIGN ENT PROJECT

Mike Krol

New York, New York

SCHOOL

School of Visual Arts

INSTRUCTOR

Mike Joyce

PRINCIPAL TYPE

Disneyland and Futura

DIMENSIONS

8 x 11 in.

(20.3 x 27.9 cm)

Nina Neusitzer and Nicolas Markwald Frankfurt, Germany

ART DIRECTION

Nina Neusitzer and Nicolas Markwald

DESIGN OFFICE

Markwald und Neusitzer

CLIENT

Arbeitskreis Film Regensburg e.V.

PRINCIPAL TYPE

FF DIN

DIMENSIONS

23.4 x 33.1 in.

(59.4 x 84 cm)

Matthias Ernstberger and Richard The New York, New York

LETTERING

Matthias Ernstberger

CREATIVE DIRECTION
Stefan Sagmeister

DESIGN OFFICE

Sagmeister Inc.

CLIENT

Experimenta, Lisbon, Portugal, and Superbock

PRINCIPAL TYPE

Handlettering

DIMENSIONS 169.3 x 63.5 ft (8 x 3 m)

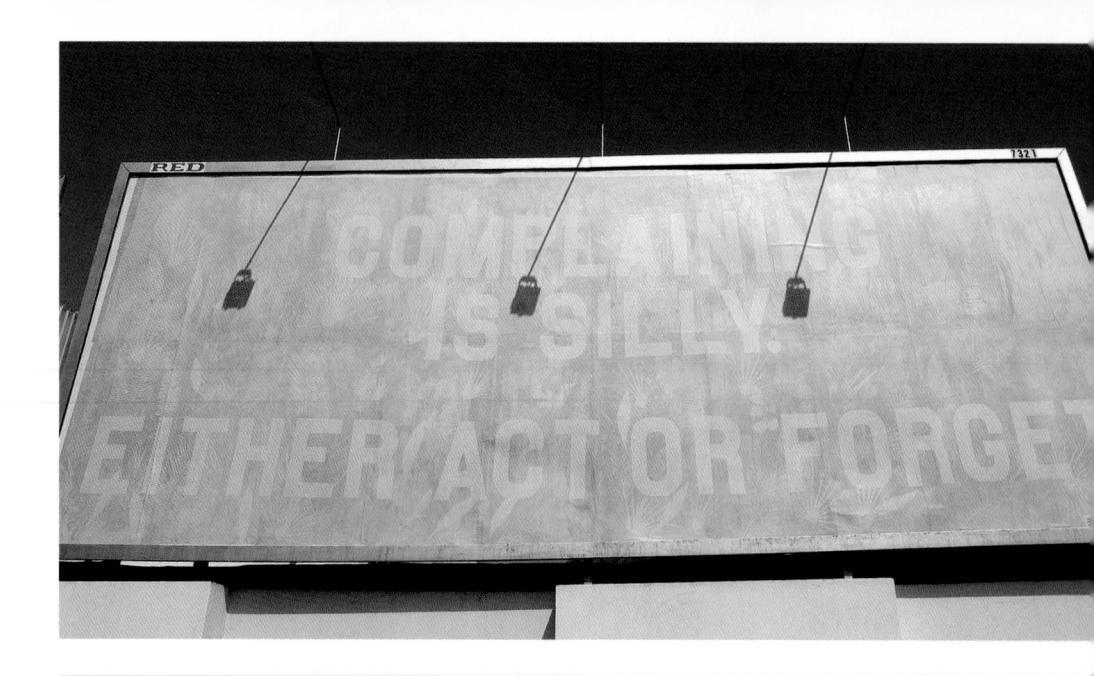

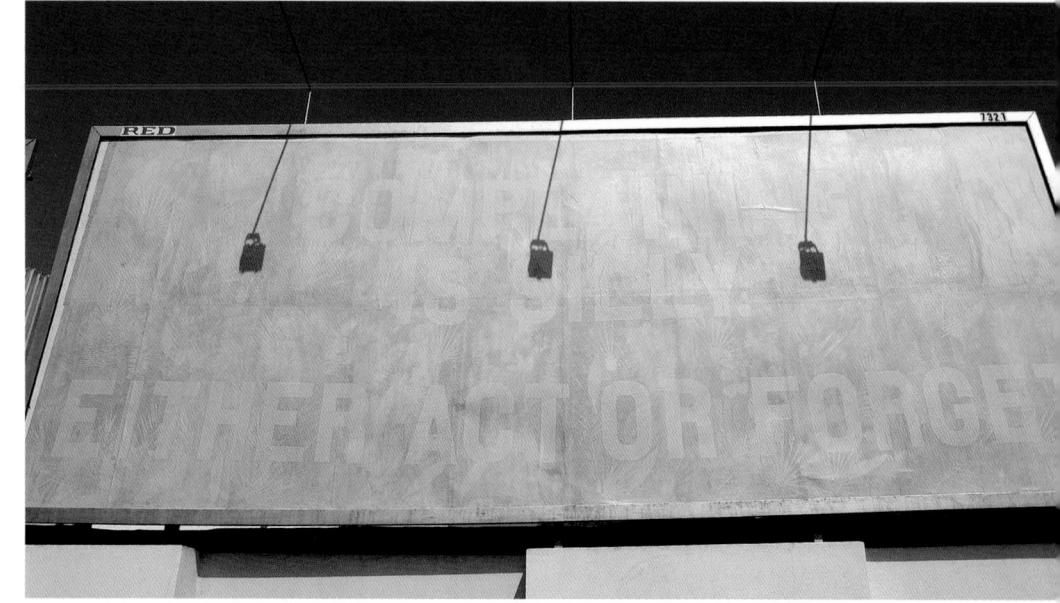

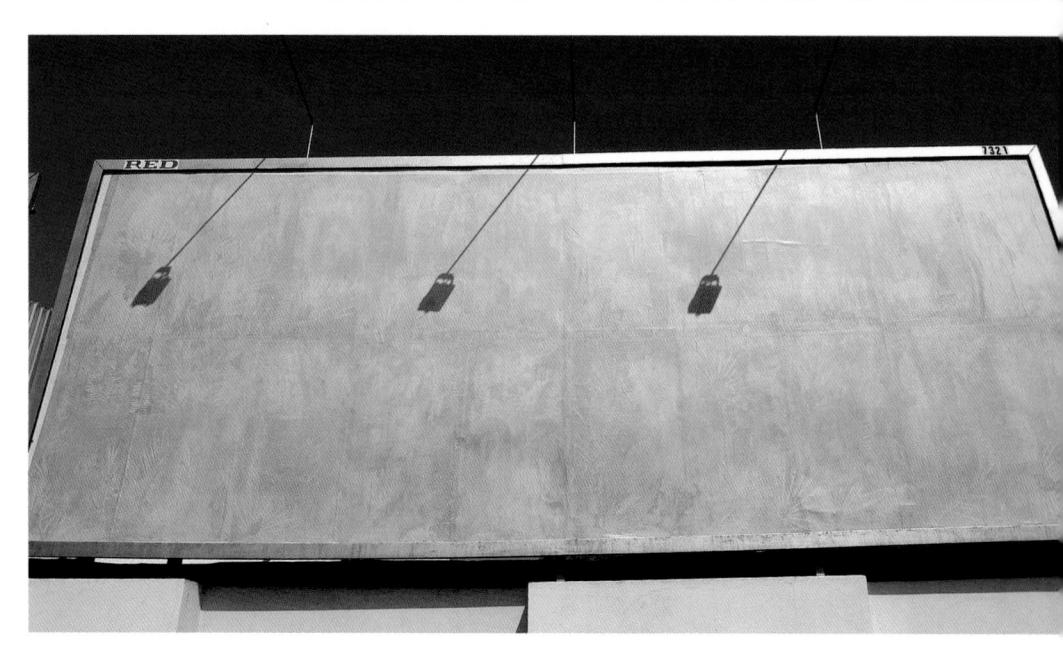

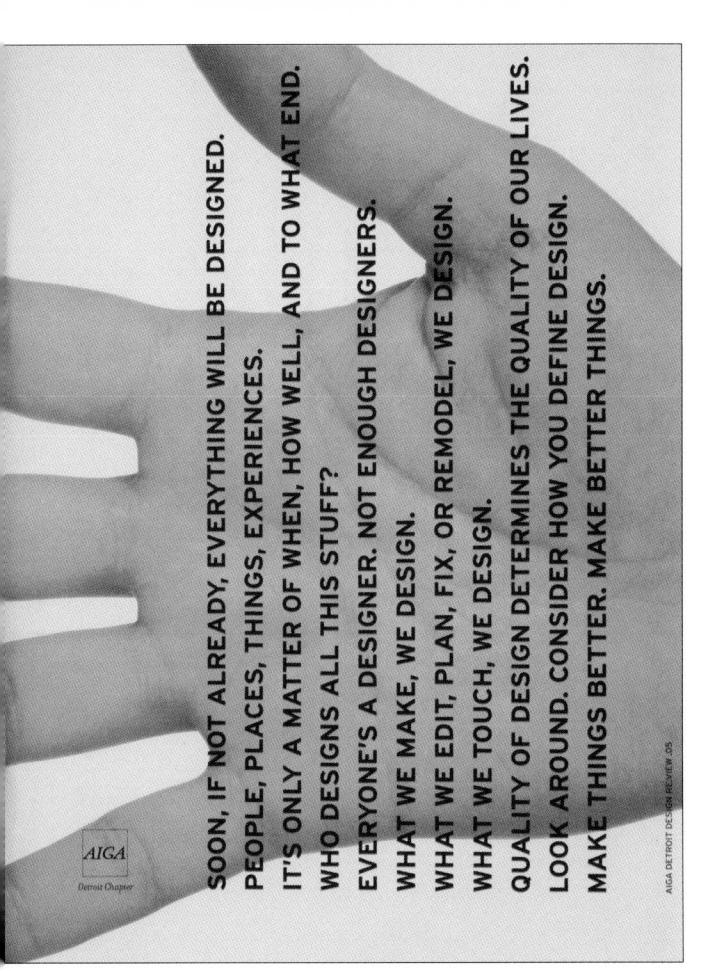

Brian Hauch and Jason Murray Grand Rapids, Michigan

ART DIRECTION

Brian Hauch

CREATIVE DIRECTION

Kevin Budelmann

ILLUSTRATION

Kevin Budelmann and Jason Murray

STUDIO

BBK Studio

CLIENT

American Institute of Graphic Arts

Detroit

PRINCIPAL TYPE

Interstate

DIMENSIONS

11 x 14.5 in.

(27.9 x 36.8 cm)

Martin Schoberer

Hamburg, Germany

CREATIVE DIRECTION

Wolfgang von Geramb

DESIGN OFFICE

Robinizer

CLIENT

Walter Pfisterer Fotografie

PRINCIPAL TYPE

Egyptienne F

DIMENSIONS

Various

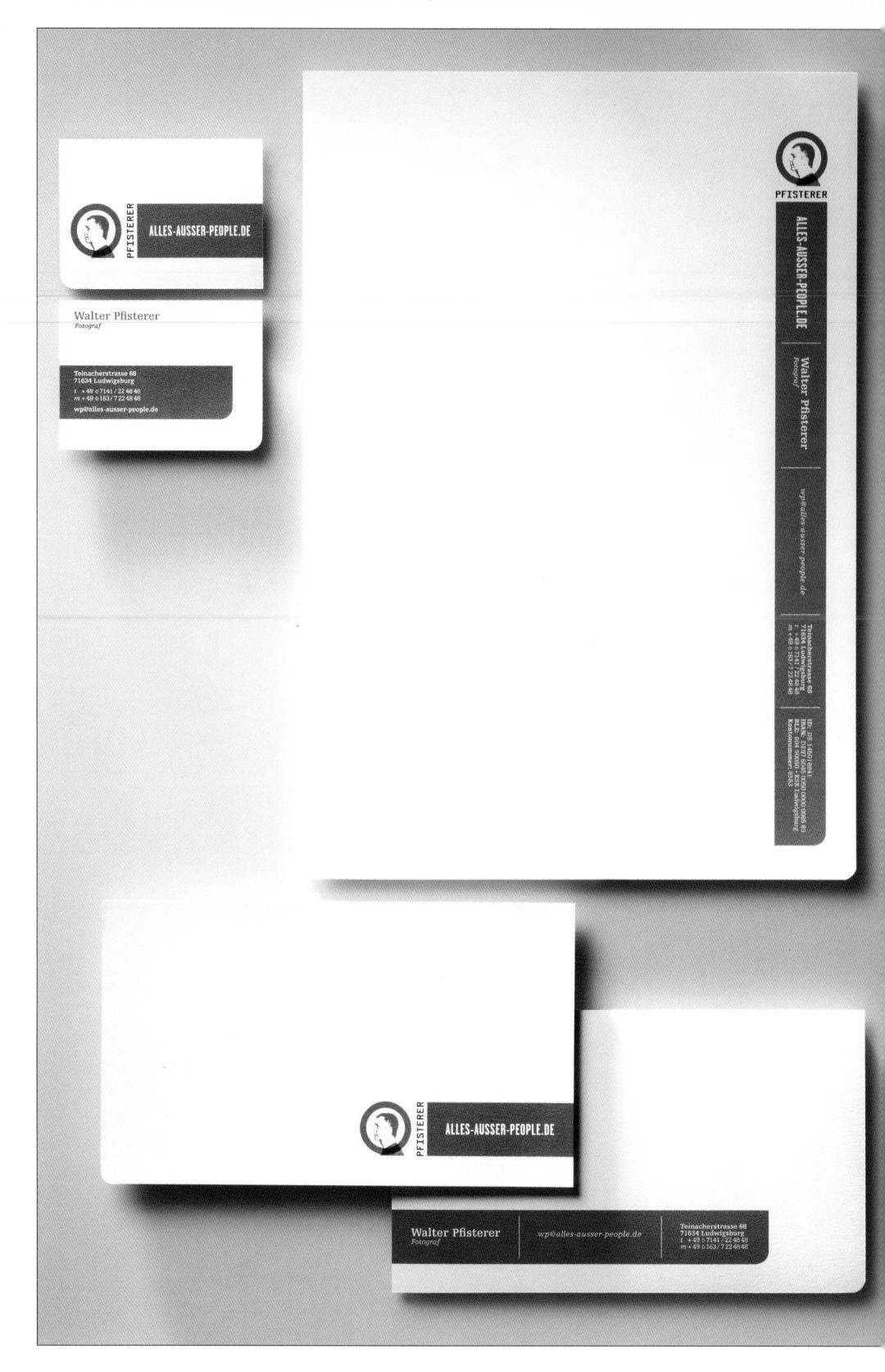

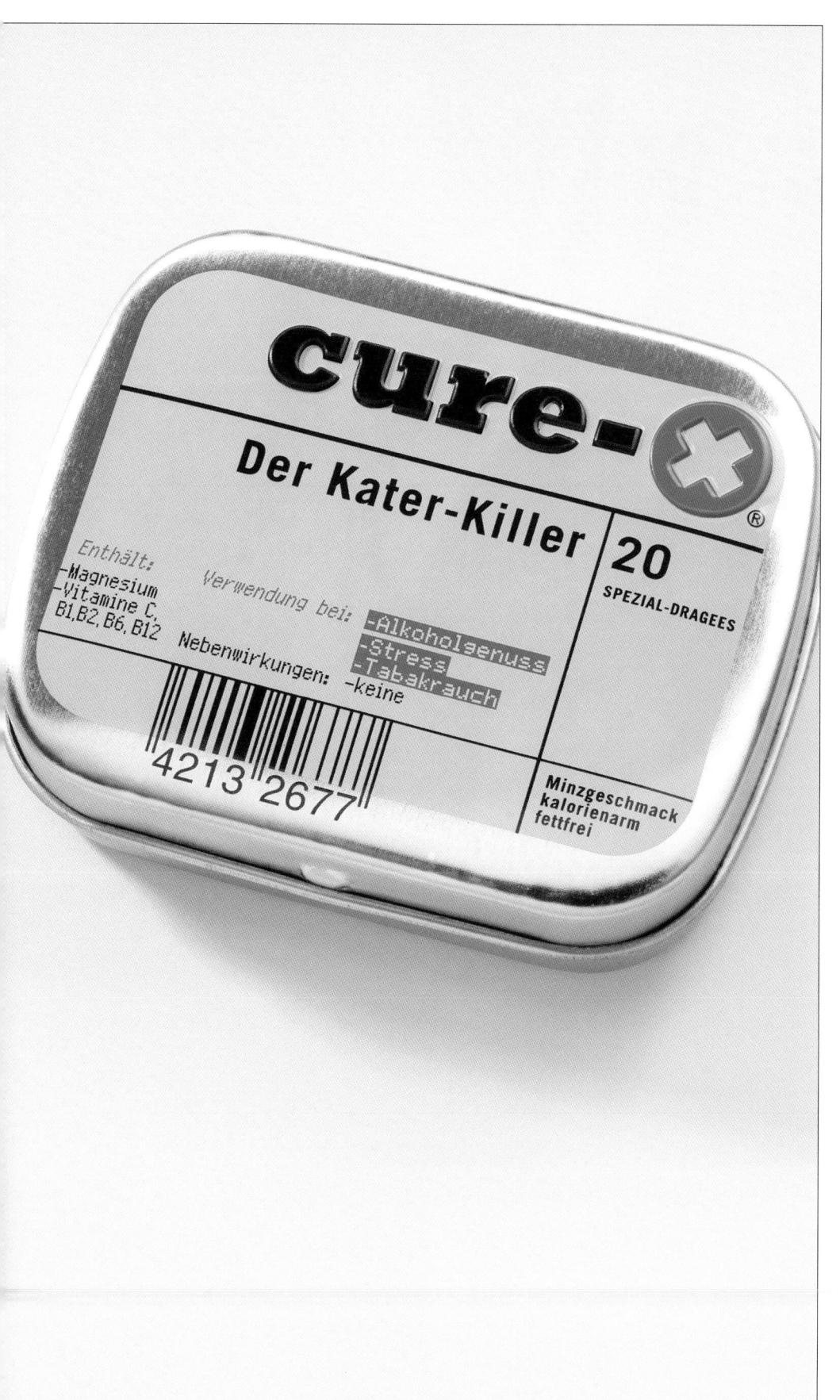

Klaus Trommer

Essen, Germany

ART DIRECTION

Klaus Trommer

CREATIVE DIRECTION

Klaus Trommer

LETTERING

Klaus Trommer

DESIGN AGENCY

HOME ^ Agentur für Kommunikation

CLIENT

Cure-X GmbH

PRINCIPAL TYPE

Call One, Call Six, and Trade Gothic

DIMENSIONS

2.4 x 2 x .6 in.

 $(6.2 \times 5 \times 1.6 \text{ cm})$

DANK AGING DESIGN

Lee O'Brien and Andy Trantham Winston-Salem, North Carolina

ART DIRECTION

Lee O'Brien and Andy Trantham

AGENCY

Elephant In The Room

CLIENT

Glass Half Full

PRINCIPAL TYPE

Vendetta and HTF Knockout

DIMENSIONS

10 x 3.5 in.

(25.4 x 8.9 cm)

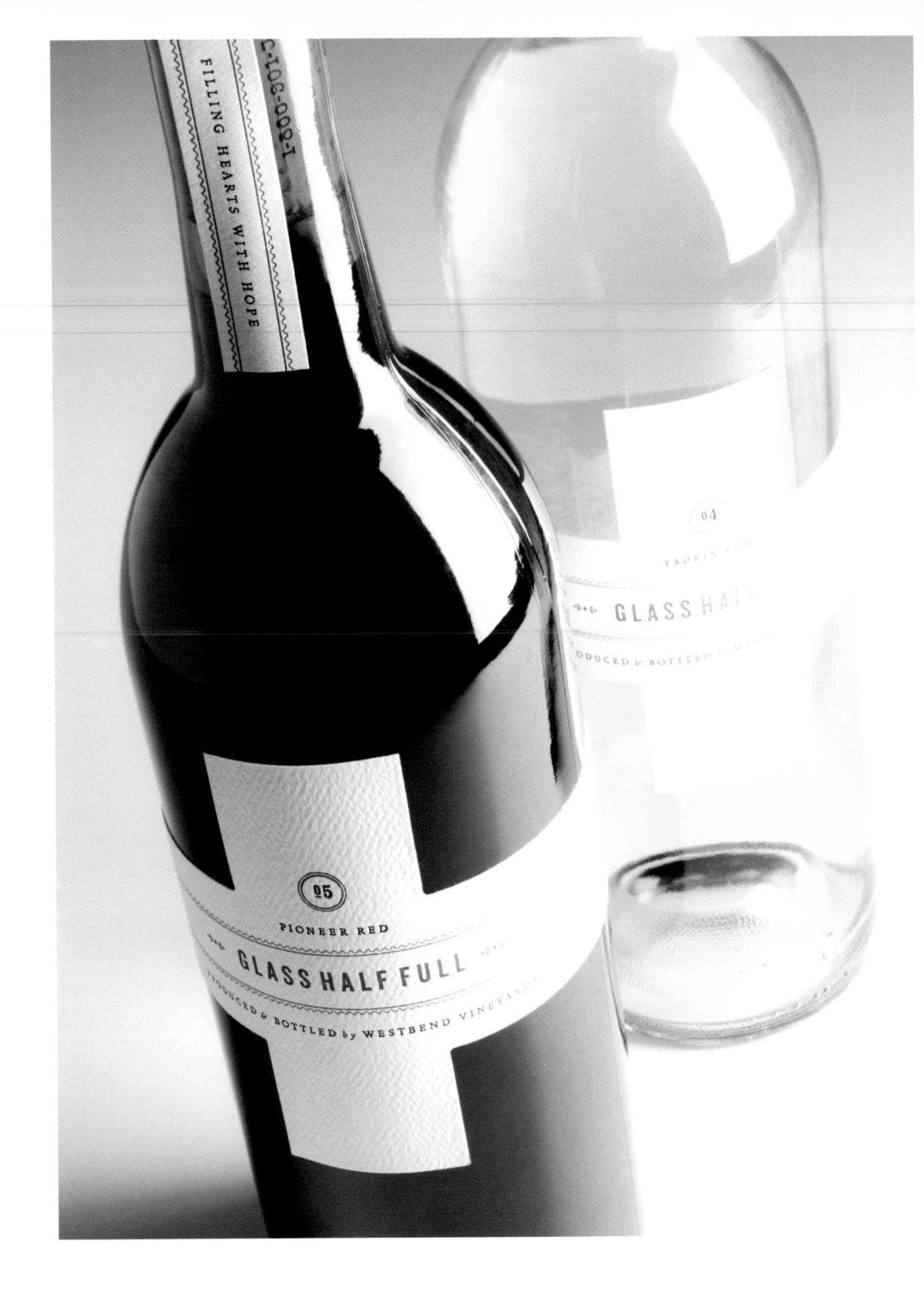

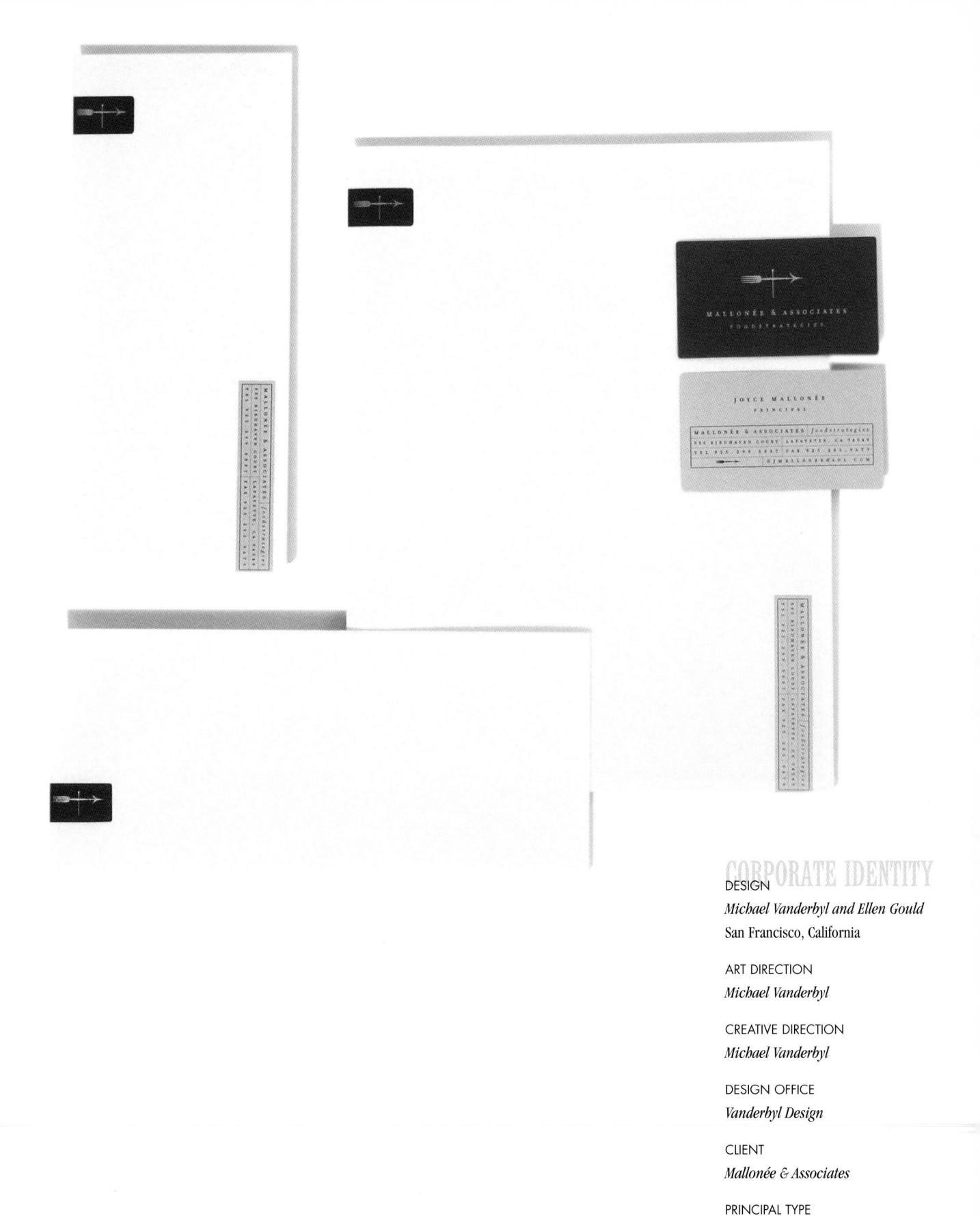

245

Filosofia

DIMENSIONS Various

SWXDALZGUOSNW MAXBALGOLIAIUS MAXBALGOLIAIUS MAYBALZGUAS MAYBALZGUAS

205 AND

aVVVÜÜÜUUSAQDÖÖÖÖÖ 3333JWWWWWWXAXN DECCHINKLANDORG ជម្រុបប្រហែលមាន១០២១១១១១១១១១១១ {-[], +, ;; , 16-, +, []-} وعودز «0/068Z95h&ZVO» Zhxn [~<5=≠=∨·+<=>+] սնվե ii --- ?! :: ; -- 4 , __

IUD .

+-+×+=×=×=×=×=×i3DAS E 2 2 8 4 8 4 6 6 () () (1/---- ... H w. 2. 20 50 A. D. D. L. L. 0000000000 Y-BUALDELLI- WOEBLS E. E. E. E. E. E. E. ILOSULO ILON ON アビススエグ 112 00 105 201 a ca ca ca ca We Me Me the the selville de la < 6 £ 5 شده ه د د د د 575071

ARMRMAKAM

222220000

Ilene Strizver

Ilene Strizver, founder of The Type Studio, is a noted typographic educator, consultant, designer, and writer. She specializes in all aspect of visual communication—from the aesthetic to the technical. Ilene has written and lectured extensively on type and typographic design to both students and professionals in the field. She conducts her widely acclaimed Gourmet Typography workshops internationally.

From 1977 to 2000 Ilene was director of typeface development for International Typeface Corporation (ITC) where she developed more than 300 text and display typefaces with such respected and world-renowned type designers as Jim Bell, Tim Donaldson, Jim Parkinson, Erik Spiekermann, Sumner Stone, and the late Phill Grimshaw. She "cut her typographic teeth" by working on Upper and Lowercase (U&lc) and other type projects with such legendary icons as Ed Benguiat, Aaron Burns, and Herb Lubalin.

Ilene's clients bave included Adobe, bethere.com, BJ's Wholesale, Galápagos Design Group, Haband, International Typeface Corporation, Johnson & Johnson, Linotype, Monotype Imaging Corporation, Nassau Guardian, and RGD Ontario. Ilene has written for Dynamic Graphics, HOW, and STEP Inside, as well as authoring the popular column, fy(t)I (For Your Typographic Information), which can be found on www.fonts.com and www.itcfonts.com. Her current book, the 2nd edition of Type Rules! The Designer's Guide to Professional Typography, has received numerous accolades from the type and design community.

Typeface design has come a long way in the digital age both technically and conceptually. Only 25 years ago, typefaces were painstakingly drawn by hand. Every stroke of every character of every weight was individually drawn, taking many months and sometimes years before they were completed. At this point it was delivered to a foundry to be digitized by a highly skilled person operating high-end equipment. It was only at this late stage in the design's development that the designer could truly see what the typeface looked like in text.

Light years have passed since then. The digital age has brought with it software which allows virtually anyone to design a typeface, often at breakneck speed. This "democratization of type design" has literally changed the face of type design.

As a former two-term Type Directors Club board member, former judge, and most recently TDC² 2006 chairperson, I've had the privilege of seeing hundreds of typeface submissions over the years. The nature of the entries has definitely changed over time. When the competition began ten years ago, type design software was still relatively new, and the entries reflected this. A higher percentage of display designs were submitted to the competition then, probably because these required less time and tradition skills (or so many believed). These earlier designs were often conceptual and experimental in nature—heavy on concept and often weak on execution. They often showed great creativity but poor practicality as a useable typeface.

This year's type design entries showed a lot more maturity. The entries consisted of a higher percentage of text than display in comparison to earlier years. The entries in general showed a high degree of skill and attention to detail. In fact, so much emphasis was paid to exquisite execution that creativity and innovation were often lost in the shuffle.

I believe this is the natural course of type design evolution in the digital age. The pendulum swings in both directions before it settles in a place of balance in the center. I look forward to the coming years when type design will also find its center and be a harmonious blend of concept and execution.

ITC VINTAGE

ITC VINTAGE

ABCDEFGHIJKLMNOPQR/TUVWXYZ

ABCDEFGHIJKLMNOPQR/TUVWXYZ0123456789

0123456789ÇØÆOEFIFL

&\$\\$\psi\\$\£\\\?\f\%\@

()[[{\}\""'---\"\\\\\?\\?\!];.;;†\\$\\$\\\$

ITC Vintage, designed by Ilene Strizver and Holly Goldsmith.

Yvonne Diedrich

Yvonne Diedrich was born in Vienna and raised bilingually in a family rooted partially in Slovakia, France, Germany, and England. She started working as a freelance designer and letter artist in 1994, though she had planned originally to become a painter.

The label ydt fonts was founded in 2000 by Yvonne Diedrich as an independent foundry for the design and implementation of exclusive typefaces and corporate images. The main focus of the foundry is on family type systems and corporate fonts, with the aim of developing new typographic moldings. Thus her work attempts to utilize typography as an artistic medium to create a differential context as typographic demands are diversifying.

Yvonne has designed typefaces for ITC International Typeface Corporation, Letraset Ltd., and custom clients. Her work has been published in *U&lc*, the TDC Annual, and *Type Rules!*, among others. Her text family ITC Dyadis was released in 1998. This project gave Yvonne the opportunity to work together with Ilene Strizver. In 2000 Letraset released the binary-based text family Eplica. The series won an award from the Type Directors Club and was the primary text used by Gail Anderson for TDC Annual *Typography 22*. Diego Vainesman chose Eplica as the primary typeface for the TDC newsletter *Letterspace*.

Currently Yvonne Diedrich is working on the launch of her new text family YDT Advena, which will be released by ydt fonts in 2006. For more about Yvonne visit www.ydt-fonts.com.

Advena Sans

HfyQ27

ABCDEFGHIJKLMNOPQ RSTUVWXYZabcdefghi jklmnopqrstuvwxyz 1234567890ABCDEFG HIJKLMNOPQRSTUVWX YZabcdefghijklmnopq rstuvwxyz1234567890 NEOHUMANIST TYPE unifying acuity & blurring SMOOTH TRANSITION letterform reflexive finish DIFFERENT TYPE MATTER

Advena Sans

ADVENA SANS issued by ydt-fonts.com

HfyQ27

Eplica

Distinctively Distinctive Distinctively Distinctive Distinctively Distinctive

HQ27il

Distinctively DISTINCTIVE Distinctively DISTINCTIVE Distinctively DISTINCTIVE

HQ27il

ff ty ff ty ff ty

Mark Jamra

Mark Jamra is a type designer, typographic designer, and associate professor at Maine College of Art in Portland, Maine. He has designed and produced typefaces for over 20 years and is the founder of TypeCulture, a digital type foundry and academic resource. He also designs books, creates short documentary films, and is a partner in Alice Design Communication, a collective of communication designers and specialists in Portland. His typeface designs include Alphatier, Brynmorgen Greek, Expo Sans, Expo Sans Dotscreen, Expo Sans Inline, ITC Jamille, Latienne, Quelle Bold, and Tacitus. His Kinesis is an Adobe Original. His lettering and typefaces have been shown in numerous exhibitions and have received awards from the Type Directors Club and the Association Typographique Internationale.

Mark graduated with a BFA degree from Kent State University and completed his graduate studies in 1983 at the School of Design in Basel, Switzerland. He has lectured, conducted workshops, and taught graphic design, typography, letterform design, and type history at colleges in the United States and Europe. He has also been a typographic consultant to the Hewlett-Packard Research Laboratories in Bristol, England, and for URW Software & Type GmbH in Hamburg, Germany.

Alphatier

Musical Events on Stage in 2006

Quality Writings

A Master's Symposium on Architectural Styles

It's 84% of what you're seeing

Expo Sans

A [Short] History of Contemporary Foundries

WEEKLY RECORD

The Old Orchard near Sebago Lake TIBERIUS CLAUDIUS DRUSUS NERO GERMANICUS

The Trading Game

Smally, Patina, Roberts & Endicott

Early Paintings of Noted Personages in the National Gallery

UNDERGROUND

Lectures at the Edgewater Institute Auditorium

TACITUS

THE THIRTY-SEVENTH ARCHEOLOGICAL SYMPOSIUM IN ROME 2006

EQUESTRIAN ARTS EXHIBITION

BELGIUM · IRELAND · DENMARK · FRANCE · GERMANY · GREAT BRITAIN · MEXICO

Kinesis

Through the Eyes of a Child: Personality & Ego in the Playroom

Printing Types and Ornaments

The Great Lakes Concert Hall adjacent to Potter Hardware

China's New Artists

J'entrevoyais à l'extrémité de la place quatre

Ich weiß es nicht

The Archés Guide to Fine Cuisine · Second Edition

DECATURIS UNIVERSITATIS

The twinkle that softens a rebuke; the scorn that can lurk under civility

Orange-Grapefruit Marmalade

Teri Kahan

In Hawaiian, *kaha* means to draw, make marks, turn, or surf. The same letters make up the last name of designer Teri Kahan, and it is no mere coincidence. Teri loves to draw, and a passion for nature, the ocean, and all things Hawaiian inspires her life and artwork.

The free-spirited Southern California artist wears many hats: graphic designer, type designer, calligrapher, illustrator, photographer, and educator. With a career spanning almost 30 years, she currently specializes in logos and corporate communications.

Teri has designed fonts for ITC and also develops proprietary fonts. A notable example is the Lexus font designed for Toyota Motor Corporation, USA. She has received numerous design awards and been published in countless books and magazines. She also exhibits as a fine artist, and her serene shoreline photomontages were recently exhibited in the prestigious juried Festival of Arts in Laguna Beach, California.

Teri discovered her passion for the letter arts at a young age and shares her interests by teaching workshops at colleges, conferences, and museums. Proficient in multiple media, her courses range from pencil to pixel, encompassing both the traditional and digital realms of lettering and design. See Teri's work at www.terikahandesign.com

Like palm trees swaying in the ocean breeze

Puamana

ABCDET-GHIJKLMNOPQRS TUVWXYZ&abcdefghijklmnopq rstmwxyz1234567890@!?(*/~

ITCPuamana & ITCKahana

ITCPuamana captures the essence of the tropics, suggesting the sway of palm trees in the ocean air. Puamana' is a Hawaiian word with several meanings, among them are 'sea breeze' and 'the blossoming of miraculous power.' With its ragged edges and talki (sant, this brush written alphabe thas a visual texture that graces the page with spirited movement.

EM HAWAIIAN KAHA MEANS

ABCDEFGHIJKLMHOPQ
RSTUVWXYZ&ABCDEFGH
IJKLMNOPQRSTUVWXYZ
1234567890!?(*/~}-\$)

As if gliding on an ocean tide, ITCKahana floats across the page with the pulse and sway of the sacred Hawaiian hula dance. The word "kahana" is more than just a namesake. In Hawaiian, "kaha" means 'to mark, draw, place, turn or surf." An enchanting decorated alphabet in the lowercase position expands this typeface's usefulness.

This "Design Font" is composed of 68 pictographs which capture the sentiments of relationship, connection and synchronicity. The clean, simple illustration style of ITCConnectivities originates from the look of hand-carved rubber stamps, and lends itself well to logos and graphics.

Like a tree rooted in ancient philosophy with branches reaching into the new age, ITC Holistics encompasses 82 pictographs of astrology, healing, magic, nature and spirituality. As in the companion font above, the illustration style originates from hand-carved rubber stamps.

ITCConnectivities & ITCHolistics

James | Montalbano

James Montalbano's professional career began as a public school graphic arts teacher. After receiving an MEd in technology education, he studied lettering with Ed Benguiat, began drawing type, and working in the wild world of New York City type shops and magazine art departments. His career continued as a magazine art director, moving on to become a design director responsible for twenty trade magazines whose subject matter no one should be required to remember. He tried his hand at designing pharmaceutical packaging, but that only made him ill.

Montalbano is principal of Terminal Design, Inc. (www.terminaldesign.com). His Brooklyn, New York, firm specializes in typeface design, font development, and digital lettering. He has designed custom fonts and lettering for editorial, corporate, government, and publishing clients, including *Brides, Fortune, Glamour, Money, Vanity Fair*, and *Vogue* magazines; The American Medical Association, AT&T, Little Brown & Co. Inc., Miller Brewing, J.C. Penny, Scribner, and The U.S National Park Service. Over the last ten years he has been working on the Clearview™ type system for text, display, roadway, and interior guide signage. His work has been featured in *Creative Review, ID* magazine, *The New York Times, Print*, and *Wired*. He is a past president of the Type Directors Club and teaches at Parsons School of Design.

Enclave

Five big quacking zephyrs jolt my wax bed. Sympathizing would fix Quaker objectives. Cozy sphinx waves quart jug of bad milk. Thief, give back my prized wax jonquils! Jackdaws love my big sphinx of quartz. Pack my box with five dozen liquor jugs. Quick waxy bugs jump the frozen veldt. Blowzy red vixens fight for a quick jump. Judges vomit; few quiz pharynx block. How quickly daft jumping zebras vex. The five boxing wizards jump quickly. Foxy nymphs grab quick-lived waltz. Brick quiz whangs jumpy veldt fox. Quick wafting zephyrs vex bold Jim. Nymphs vex, beg quick fjord waltz. Sphinx of black quartz judge my vow.

TDC² 2006 JUDGES' CHOICES AND DESIGNERS' STATEMENTS

The second of th

Yvonne Diedrich JUDGE

Blackletter scripts exist in many variations. They evolved out of the medieval manuscript tradition and are distinguished by their rigidity of form. As printing encouraged diversity in the written word, scripts began to evolve into instruments of artistic expression.

This design is a fine example that exercises the historical variety in a freely hybrid manner. Its transitional structure draws on the tradition of Textura, the oldest form of blackletter, with its angular, wide-nibbed pen strokes interrelated with fine hairlines and sharp finals. The short compressed x-height of the lowercase creates an interesting bridging to the Gothic minuscule. Reminiscent of Bocskay's calligraphic virtuosity, this typeface has strong character. Its dominant caps comprise a vital interpretation of the historical models with expressive swash flourishes. The swash finals have been superbly executed with subtle nib detailing.

Another elaborate feature of this design is the addition of alternate glyphs, forming a rich appearance as if letters had risen from the hand of the calligrapher. When set in text, this face creates a strong consistency of tone, a very even rhythm across the page. Overall this is a well-executed design of beautiful detailing and powerful calligraphic texture.

Gabriel Martínez Meave DESIGNER

In these times of globalization, minimalism, and widespread use of sans serif, designing a Gothic font could seem to be an unforgivable aberration. However, blackletters have traditions and uses other than heavy-metal albums and Teutonicinspired designs. In Mexico, for instance, Gothic fonts were used in the first books printed in the continent (1539). Though they were replaced by Roman typefaces in the early 1600s, they never entirely vanished from the popular taste, reaching a peak in the 19th and early 20th centuries, when they were seen everywhere, from tequila labels to taxicabs.

This use of blackletters to this day in vernacular, nondesigner lettering has never ceased to amaze me. In these popular signs, the shapes of Bâtarde, Fraktur, Rotunda, and Textura have been mixed and reinvented by people who were not aware of the context these traditional styles had in old Europe. They seem to just enjoy the complex, convoluted, intoxicating forms of the letters.

Digital technology, on the other hand, enables us to render the powerful shapes of Gothic letterforms to their fullest expression and calligraphic detail, free from the constrains of metal type. Darka is a personal exercise of these ideas: an eclectic, Latin-flavored blackletter that plays strictly but freely with the great Gothic calligraphic styles I am so fond of.

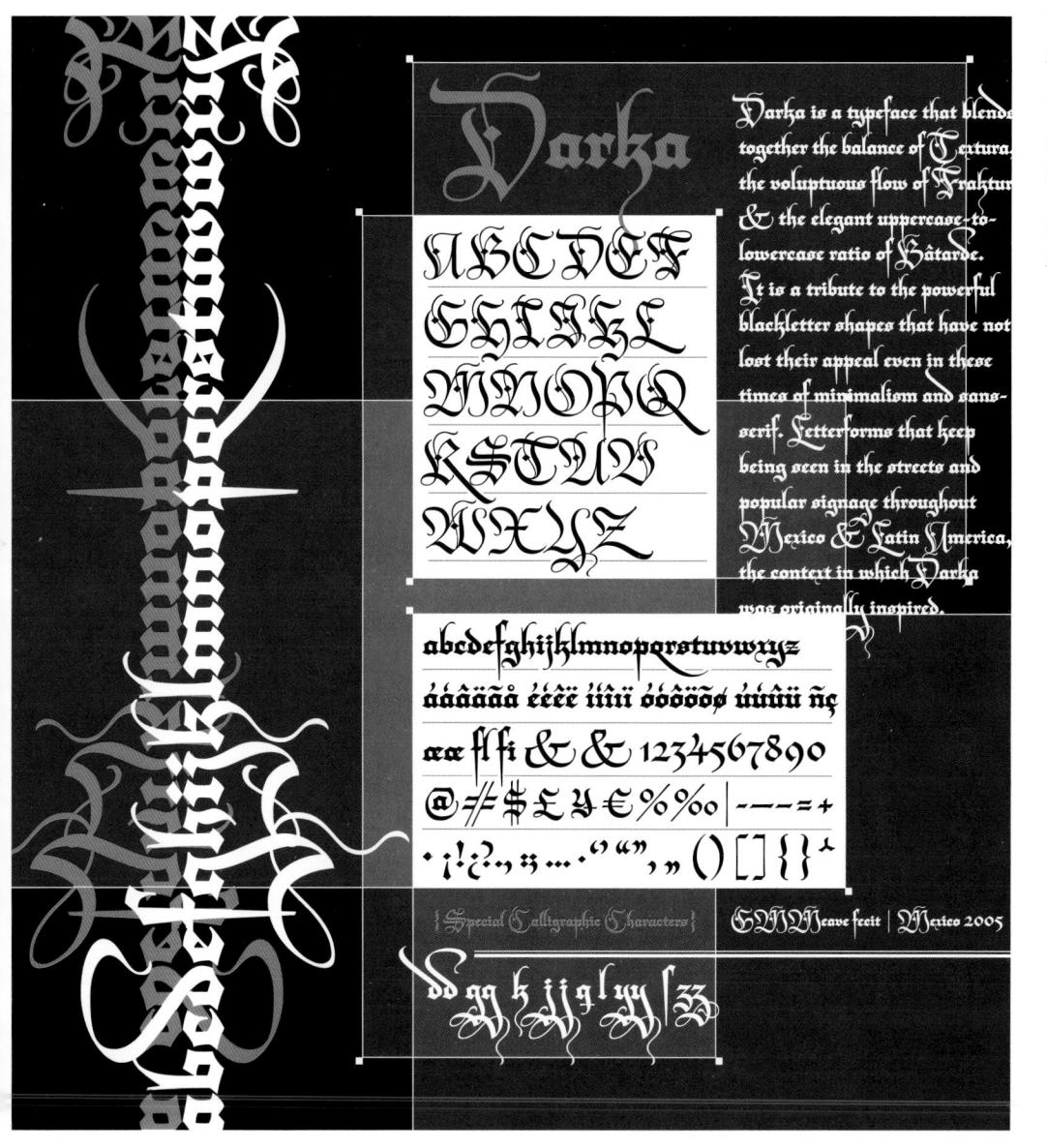

TYPEFACE *Darka*

TYPEFACE DESIGNER

Gabriel Martínez Meave

Mexico City, Mexico

FOUNDRY

Kimera Type Foundry

Mark Jamra JUDGE

Vista is a robust and intelligent design. I was attracted to it by the apparent willingness of the designer to try out some unconventional ideas in a sans serif type—ideas that rise above a mere quest for quirkiness and that seem to follow a personal and well-considered strategy of invention. This is coupled with the designer's obvious ability to translate those ideas into glyphs with a strong formal integrity and proportional balance.

Simplicity and thoroughness are also decisive factors here. The concept for the alternate caps is showcard-like, humorous, and cleverly straightforward. I find the black weights have a quality akin to wood types, while the alternate lowercase characters are capable of subtly transforming the underlying tone of the whole design. Close attention to form is also apparent in the math symbols, currency symbols, reference marks, and diacritical marks—with little gems of inventiveness showing up throughout the complement.

A good measure of confidence and creative maturity is visible here, most notably in the merging of adventurousness and restraint. It's important to note that the excellent spacing is another feature that made this design stand out from the majority of submissions. The glyph and word spacing create a rhythm and color that bring the personality of the design to full effect in a display line or text. In all, an important combination of talents is evident: ambition and intellect in challenging typographic conventions and the capabilities in craftsmanship and production skills that are necessary to yield a well-functioning and broadly useable typeface.

Xavier Dupré DESIGNER

The concept for Vista began in July 2002 when I sketched a few characters in a notebook while staying in Sumatra on a one-month holiday. Most of the shop signs in Sumatra feature idiosyncratically decorative lettering, inspired by the American West and other unusual shapes.

In reaction to this, I intended to design a semi-serif typeface for text and display, useful for general application. I was inspired by Erik Spiekerman's FF Meta, which is very successful at combining the humanist appeal of calligraphic forms with the pragmatic simplicity of the sans. Then, two years later in May 2004, I revisited this unfinished family and redesigned all the characters. I threw out the serif companion to make the family simpler, narrower, and more useful. I found the right proportions for a text font—not too condensed to preserve comfort in reading, not too wide for economy of space.

TYPEFACE

Vista Sans

TYPEFACE DESIGNER

Xavier Dupré

Bangkok, Thailand

FOUNDRY

Emigre, Inc.

MEMBERS OF TYPEFACE

FAMILY/SYSTEM

36: Regular, Alternate, Alternate Italic, Black Standard, Bold, Book, Italic, Light, Medium, Small Caps, and Small Caps Italic

Teri Kahan JUDGE

Years ago, when I used to read U&lc in print, I would dream of becoming involved at this echelon of typography. It still astounds me that my path has led to significant opportunities to grow as an artist and to establish relationships with others who are passionate about lettering and design. So it was that collaborating with the four gifted and knowledgeable members of the TDC jury increased my appreciation for the people of the art, the depth of the field, and the many talents of contemporary font designers. By looking through the eyes and minds of the entire jury, we managed a nuanced appreciation of the subtleties within each of the submitted fonts. Some stood out for their consistencies in weight, form, flavor, maturity, flair. Some were distinguishable by their sheer beauty.

As a lover of brush scripts, it is no wonder my judge's choice selection was Sweepy, the handsome, flowing font by Michael Clark. Though I did not know who created it at the time of judging (designer names are deliberately kept confidential), it turns out that I have long been an admirer of this artist's lettering talents. The movement of the hand is keenly reflected in the verve of his alphabet—slightly curving downstrokes, exaggerated exits that make for successful joining, a strong slant, beautiful swashes. Open spacing enhances the grace and legibility. The capitals are unique in that they are informal and condensed in contrast to the more open, formal lowercase forms. The myriad ligatures, flourishes, and alternate glyphs provide many opportunities for creative application.

The Type Directors Club continues to highlight the rich and varied tapestry that is modern typography. I am delighted to have met many of their members and honored to have been a part of this process.

Michael Clark DESIGNER

I have always been predisposed to titling faces. As a lettering artist, I create enough garbage to pick through it, looking for potential typefaces. The problem, as everyone knows, is setting aside the time to do the digital work. Sweepy is the outgrowth of a variety of lettering styles, done with Speedball pens, that I use in commercial applications.

Pooper Black was the first of this genre that I chose to rein into a typographic format. As its popularity grew I knew I needed to do a lighter version. What transpired though was a shift in my thinking: why not create a semi-joining "script." The final product is a fun and flowing font.

Aquilegia Buddleia Clematis Delphinium Euphorbia Foxglove Gaillardia Honeysuckle Iceplant Juniper Kiwi Liziope Miscanthus Nicotiana Oxalis Psimrose Quince Rudbeckia Switchgrass Thyme Undulata Viburnum Wisteria Kylem Yucca and Zinna Alternates include: t f o At the the the vy f & p with y s ss f t £?! g € 1 () 9 B àéîöúñç

TYPEFACE
P22 Sweepy

TYPEFACE DESIGNER

Michael Clark

Richmond, Virginia

FOUNDRY

P22 Type Foundry and International House of Fonts

MEMBERS OF TYPEFACE FAMILY/SYSTEM P22 Sweepy and P22 Sweepy OpenType

James Montalbano JUDGE

I have always found that the most successful type designs are ones that have been created for a specific purpose. As the designer explains, this is not a slavish historical revival but a modern interpretation of a classic work. The attention to detail is superb, the range of style and weight are appropriate for modern uses, and all the while the influence of the source is never obscured. No smudges or odd bumps from page proofs that so often make their way into revivals due to some misplaced desire to have the fonts look "old" or "authentic."

From the moment I saw this example in the competition I was impressed by two things: the excellence of the actual type design and, equally important, the quality of the samples provided for the judging. Each piece was a wonderful piece of typography in its own right and would have won most typographic design competitions as well. This allowed the type design to be judged in the environment for which it was created. That's truly the only way any type can be judged.

Iñigo Jerez DESIGNER

This project takes as its starting point the first edition of Don Quijote, printed in 1605 by Juan de la Cuesta, but it is not a work of archeology intended to improve the original edition with digital media. The objective of this alphabet is to create a new tool that catches and expresses the style of that Quijote and transmits the spirit of Cervantes's book.

In the personal interpretation of this idea a series of licenses were adopted that, strictly speaking, are not of the 17th century, like the exaggeration of some forms, the inclusion of new glyphs, and the creation of a boldface. Therefore Quixote is not a rigorously historic version, despite reflecting some details and anecdotes of the original. The intention of the project is to pay homage to one of the greatest milestones of universal literature with an alphabet especially designed to compose a new edition of El Ingenioso Hidalgo Don Quijote de la Mancha.

PRIMERA PARTE DEL INGENIOSO HIDALGO DON QUIXOTE DE LA MANCHA

CAPÍTULO PRIMERO

Que trata de la condición y ejercicio del famoso y valiente hidalgo don Quijote de la Manchas

En un lugar de la Mancha, de cuyo nombre no quiero acordarme, no ha mucho tiempo que vivía un hidalgo de los de lanza en astillero, adarga antigua, rocín flaco y galgo corredor. Una olla de algo más vaca que carnero, salpicón las más noches, duelos y quebrantos los sábados, lantejas los viernes, algún palomino de añadidura los domingos, consumían las tres partes de su hacienda. El resto della concluían sayo de velarte, calzas de velludo para las fiestas, con sus pantuflos de lo mesmo, y los días de entresemana se honraba con su vellorí de lo más fino. Tenía en su casa una ama que pasaba de los cuarenta y una sobrina que no llegaba a los veinte, y un mozo de campo y plaza que así ensillaba el rocín como tomaba la podadera. Frisaba la edad de nuestro hidalgo con los cincuenta años. Era de complexión de carnes, enir

Quixote Regular, *Italic*, **Bold**, *Bold Italic* & CAPS

Textaxis.com

TYPEFACE *Ouixote*

TYPEFACE DESIGNER *Iñigo Jerez*Barcelona, Spain

FOUNDRY textaxis.com

MEMBERS OF TYPEFACE FAMILY/SYSTEM Regular, Italic, Bold, Bold Italic, and Caps

Securitarian Porstulation of the Confession of t

TYPEFACE

Rayuela Chocolate 2.0

TYPEFACE DESIGNER *Alejandro Lo Celso*Cholula, Mexico

FOUNDRY

PampaType Digital Foundry

ABCDEFGHIJKLMNOPQRSTU VWXYZabcdefghijklmnopqrstuv wxyzo123456789*ABCDEFGHIJKL MNOPQRSTUVWXYZabcdefghijkl mnopqrstuvwxyz*ԱԲԳԴԵՁԷԸԹԺ ԻԼԽԾԿՀՁՂՃՄՅՆՇՈՉՊՋՌՍՎՏ ՐՑՒՓՔՕՖաբգդեզԷըթժիլխծկի ձղճմյնշոչպջոսվտրցւփքօֆև

unnna

TYPEFACE Calouste

TYPEFACE DESIGNER

Miguel Sousa

Lisbon, Portugal

LANGUAGE

Latin and Armenian

MEMBERS OF TYPEFACE FAMILY/SYSTEM Regular and Italic TYPEFACE

Relato Sans

TYPEFACE DESIGNER

Eduardo Manso

Barcelona, Spain

FOUNDRY

Emtype Foundry

MEMBERS OF TYPEFACE

FAMILY/SYSTEM

Light, Regular, Medium, Semibold, Bold, and Black Roman and Italics, Small Caps, and Small Cap Italics for all weights

Historia universal de la infamia ATHLETIC ARE LOOKING FOR A SIXTH PREMIERSHIP Reinhal el Imperio Birmingham will be without influential Hamburg & Barcino The newsletter publisher & Antho ok

Sphinx of black quartz, judge my vow. Thief, give back my prized wax jonquils. The quick brower the lazy dog. Sixty zippers were quickly picked from the woven jute bag. Jaded zombies acted quaintly by their oxen forward. In a formula deus, qualem paulus creavit, dei negatio. Such a religion as christianity, we entrype net touch reality at a single point and which goes to pieces the moment reality asserts its rights at any point must be inevitably the deadly enemy of the wisdom of this world which is to say of science and it will give the name of good to whatever means serve to poison, calumniate and cry down all intellectual discipline. Paul well knew that lying that faith was necessary. Later on the church borrowed the fact from Paul. The god that Paul invented for himself, a god who reduced to absurdity the wisdom of this world especially the two great enemies of superstition, philology and medicine, is in truth only an indication of Paul resolute determination to accomplish that very thing himself to give one own will the name of god, thora that is essentially Jewish. Paul wants to dispose of the wisdom of this world his enemies are the good philologians and physicians of the Alexandrine school on them he makes his war.

Frutiger" Next Greek

Η επικοινωνιακή πολιτική only ενός μουσείου

Frutiger Next Greek regular

περιλαμβάνει δραστηριότητες signage

Frutiger Next Greek regular italic

που every πραγματοποιούνται εντός

Frutiger Next Greek medium

και εκτός sometimes του φυσικού του χώρου

Frutiger Next Greek medium italic

πριν όμως typeface design εξετάσουμε

Frutiger Next Greek bold

τους authors παραπάνω τομείς

Frutiger Next Greek bold italic

θα επιχειρήσουμε μια colour θεωρητική

Frutiger Next Greek heavy

προσέγγιση find του ζητήματος

Frutiger Next Greek heavy italic

της επικοινωνιακής standar πολιτικής

Frutiger Next Greek black

τούτο κρίνεται always απαραίτητο.

Frutiger Next Greek black italic

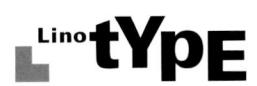

www.Linotype.com

Frutiger is a trademark of Heidelberger Druckmaschinen AG, which may be registered in certain jurisdictions, exclusively licensed through Linotype GmbH, a wholly owned subsidiary of Heidelberger Druckmaschinen AG.

TYPEFACE

Frutiger Next Greek

TYPEFACE DESIGNERS

Adrian Frutiger and Eva Masoura

Bad Homburg, Germany

FOUNDRY

Linotype GmbH

LANGUAGE

Greek

MEMBERS OF TYPEFACE

FAMILY/SYSTEM

Regular, Regular Italic, Medium, Medium Italic, Bold, Bold Italic,

Heavy, Heavy Italic, Black,

and Black Italic

TYPEFACE

Garamond Premier Pro

TYPEFACE DESIGNER

Robert Slimbach

Mountain View, California

FOUNDRY

Adobe Systems, Incorporated

LANGUAGE

Latin, Cyrillic, and Greek

MEMBERS OF TYPEFACE
FAMILY/SYSTEM
Regular, Bold, Bold Italic, Italic,
Medium, Medium Italic, Semibold,
and Semibold Italic

Caption: Bold, Bold Italic, Italic, Medium, Medium Italic, Semibold, and Semibold Italic

Subbead: Bold, Bold Italic, Italic, Medium, Medium Italic, Semibold, and Semibold Italic

Display: Bold, Bold Italic, Italic, Semibold, and Semibold Italic

Garamond Premier

ABCDE abcdefghijklm nopgrstuvwxyz

ΑΒΓΔΕΖΗΘΙΚΛΜΝΞΟΠΡΣΥΦΧΨΩ

αβγδεζηθικλμν FGHIJK ξοπρστυφχψω FGHIJK ΑΒCDEFGHIJKLMNOPQRSTUVWXYZ

LMNO Рабведежзийкл мнопрстуфхц

ઝુલ રહિ એલ રહિ

АБВГГДЕЖЗИЙКАМНОПРСТУФХЦЧ

એલ કહે એલ કહે

abcdefghijklm QRSTU

ШЩЪЫЬЭЮЯЁЂЃЄЅІЇЈЉЊЋЌЎЏѢѲѴ

and the same and t

VWXYZ »

TYPEFACE

Aniene

TYPEFACE DESIGNER

Adriane Krakowski

Braunschweig, Germany

FOUNDRY

Elsner+Flake

MEMBERS OF TYPEFACE

FAMILY/SYSTEM

Aniene Nuova and Aniene Vecchia

TYPEFACE FF Headz

TYPEFACE DESIGNER

Florian Zietz

Hamburg, Germany

FOUNDRY

FontFont

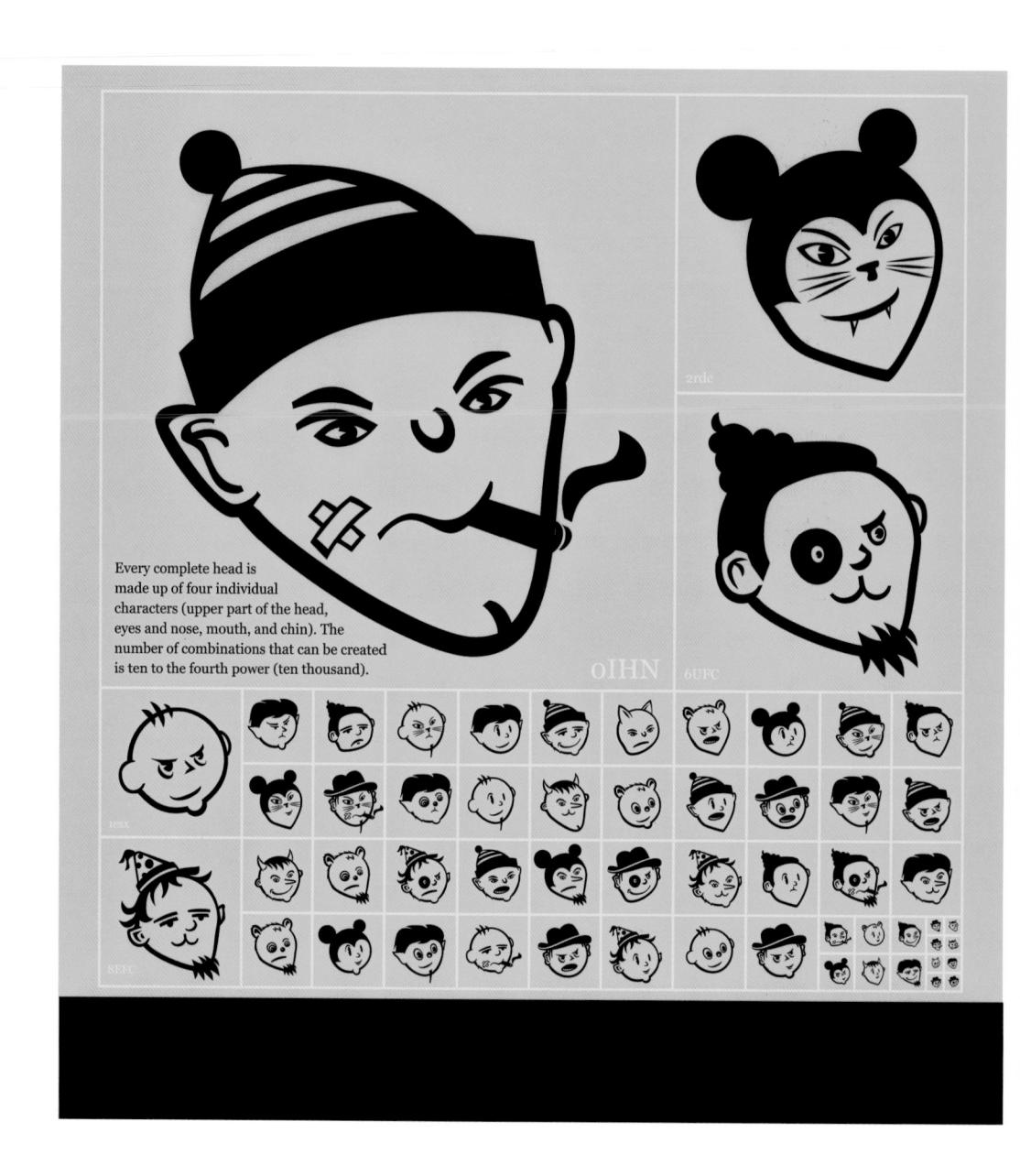
TYPEFACE

Adobe Arabic

TYPEFACE DESIGNER

Tim Holloway

Edgware, England

FOUNDRY

Adobe Systems, Incorporated

LANGUAGE Arabic

MEMBERS OF TYPEFACE
FAMILY/SYSTEM
Regular, Italic, Bold, and Bold Italic

لما كان الاعتراف بالكرامة المتأصلة في جميع أعضاء الأسرة البشرية وبحقوقهم المتساوية الثابتة هو أساس الحرية والعدل والسلام في العالم. ولما كان تناسي حقوق الإنسان وازدراؤها قد أفضيا إلى أعمال همجية آذت الضمير الإنساني. وكان غاية ما يرنو إليه عامة البشر انبثاق عالم يتمتع فيه الفرد بحرية القول والعقيدة ويتحرر من الفزع والفاقة. ولما كان من الضروري أن يتولى القانون حماية حقوق الإنسان لكيلا يضطر المرء آخر الأمر إلى التمرد على الاستبداد والظلم. ولما كانت شعوب الأمم المتحدة قد أكدت في الميثاق من جديد إمانها بحقوق الإنسان الأساسية وبكرامة الفرد وقدره وما

للرجال والنساء من حقوق متساوية وحزمت أمرها على أن تدفع بالرقي الاجتماعي
قدمًا وأن ترفع مستوى الحياة في جو من
الحرية أفسح ولما كانت الدول الأعضاء
قد تعهدت بالتعاون مع الأمم المتحدة
على ضمان إطراد مراعاة حقوق الإنسان
والحريات الأساسية واحترامها ولما كان

للإدراك العام لهذه الحقوق والحريات الأهمية الكبرى للوفاء التام بهذا التعهد. فإن الجمعية العامة. تنادي بهذا الإعلان العالمي لحقوق الإنسان. على أنه المستوى المشترك الذي ينبغي أن تستهدفه كافة الشعوب والأمم حتى يسعى كل فرد وهيئة في المجتمع، واضعين على الدوام هذا الإعلان نصب أعينهم، إلى توطيد احترام هذه الحقوق والحريات عن طريق التعليم والتربية واتخاذ إجراءات مطردة، قومية وعالمية، لضمان الإعتراف بها ومراعاتها بصورة عالمية فعالة بين الدول الأعضاء ذاتها وشعوب البقاع الخاضعة لسلطانها. يولد جميع الناس أحرارًا متساوين في الكرامة والحقوق. وقد وهبوا عقلًا وضميرًا وعليهم أن يعامل بعضهم بعضًا بروح الإخاء. لكل

لمًا كان الاعتراف بالكرامة المتأصلة في جميع أعضاء الأسرة البشرية وبحقوقهم المتساوية الثابتة هو أساس الحرية والعدل والسلام في العالم. ولما كان تناسي حقوق الإنسان وازدراؤها قد أفضيا إلى أعمال همجية آذت الضمير الإنساني. وكان غاية ما يرنو إليه عامة البشر انبثاق عالم يتمتع فيه الفرد بحرية القول والعقيدة ويتحرر من الفزع والفاقة. ولما كان من الضروري أن يتولى القانون حماية حقوق الإنسان لكيلا يضطر المرء آخر الأمر إلى التمرد على الاستبداد والظلم. ولما كانت شعوب الأمم المتحدة قد أكدت في الميثاق من جديد إيمانها بحقوق الإنسان الأساسية وبكرامة الفرد وقدره وما للرجال والنساء

من حقوق متساوية وحزمت أمرها على أن تدفع بالرقي الاجتماعي قدمًا وأن ترفع مستوى الحياة في جو من الحرية أفسح. ولما كانت الدول الأعضاء قد تعهدت بالتعاون مع الأمم المتحدة على ضمان إطراد مراعاة حقوق الإنسان والحريات الأساسية واحترامها. ولما كان للإدراك العام لهذه

الحقوق والحريات الأهمية الكبرى للوفاء التام بهذا التعهد. فإن الجمعية العامة. تنادي بهذا الإعلان العالمي لحقوق الإنسان. على أنه المستوى المشترك الذي ينبغي أن تستهدفه كافة الشعوب والأمم حتى يسعى كل فرد وهيئة في المجتمع، واضعين على الدوام هذا الإعلان نصب أعينهم، إلى توطيد احترام هذه الحقوق والحريات عن طريق التعليم والتربية واتخاذ إجراءات مطردة، قومية وعالمية، لضمان الإعتراف بها ومراعاتها بصورة عالمية فعالة بين الدول الأعضاء ذاتها وشعوب البقاع الخاضعة لسلطانها. يولد جميع الناس أحرارًا متساوين في الكرامة والحقوق. وقد وهبوا عقلًا وضميرًا وعليهم أن يعامل بعضهم بعضًا بروح الإخاء. لكل

"אזזנטייפ"- טסד פסטזדיז מזכיל בציצוב זפיתוח של טפני דפוס רב לשוניים מאז שנת 1998. התרזמה לתרכזת הטיפוקרפיה הצברית, החלה להתפטא, בסגטן מקזרי זמיזחד של פונטים- פרי יצירת הקלינרף-מצצב חזרי חביב אבגדה זד ח טיך כלמע נן ס צפףצ ץקר שת!?

@%1234567890

האלארול הפוס לברי

TYPEFACE Hogariet

TYPEFACE DESIGNER Habib N. Khoury

Fassouta, Israel

FOUNDRY

Avantype Foundry

language *Hebrew*

🗘 it with 🌣 🌣

expressive writing through automatic picture ligatures

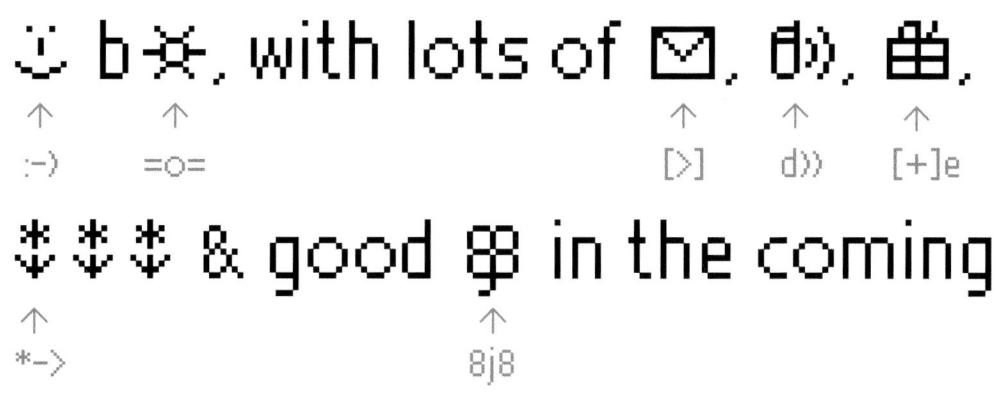

FF PicLig uses OpenType's "discretionary ligatures" to combine several characters into an icon, a "picture ligature".

fi
$$\Rightarrow$$
 fi \Rightarrow typographic ligature $8j8 \Rightarrow 8j \Rightarrow picture$ ligature

□ http://www.piclig.net

TYPEFACE FF PicLig

TYPEFACE DESIGNER

Christina Schultz

Berlin, Germany

FOUNDRY FontFont

TDC3 1956

"The aim: to feature outstanding material in which typography is the predominant visual element..." So reads the introduction to this Type Directors Club competition catalog from 1956. Nothing has changed, as you have seen in the winning samples throughout this Annual.

We began reproducing the earliest Type Directors Club competition catalogs in last year's Annual to ensure those early documents would live on. Complete sets of TDC catalogs are extremely rare, and those that exist are deteriorating with age.

Reproduced here is the second catalog (though it is named "Third Annual," because the first TDC competition, held in 1954 and open only to TDC members, had no catalog). Its twenty-four pages contain examples that have inspired many over the years and retain their power to teach if, as has been said, we will just open our eyes and listen.

The TDC Board of Directors

Reproduction Notes: Designed by Arthur B. Lee. 8 3/8 x 10 15/16 in. (21.3 x 27.8 cm), saddlestitched. All pages have been reduced slightly to show trim. Additional information on this catalog can be found in the colopbon on its page 26. Additional information on the development of the TDC Competitions can be found on page 266 in Typography 23.

THIRD ANNUAL AWARDS FOR TYPOGRAPHIC DESIGN EXCELLENCE

TYPE DIRECTORS CLUB OF NEW YORK

THE AIM: TO FEATURE OUTSTANDING MATERIAL IN WHICH TYPOGRAPHY IS THE PREDOMINANT VISUAL ELEMENT...

This booklet contains reproductions of the third annual typographic award winners chosen for 1957. The selections were made from more than 1500 entries, and demonstrate how type can provide impact and visual excitement in today's advertising and promotional material. These examples also show that the typographic designer knows how to produce visual excitement where it is needed most. Although the material was entered by categories to try and cover as wide a range as possible, it was judged primarily for its impact, typographic qualities and visual excitement. Throughout the entire exhibit the effects were achieved by the tasteful use of one or more of the following characteristics:

- Contrast of size extremely large letter forms used with small sizes create visual excitement because our eyes are accustomed to see reading matter without much contrast. Normal contrast in size is easy for the eye to see, however extreme contrasts are unusual.
- Contrast of direction horizontal opposed to vertical; also, condensed faces create a vertical line while extended faces cause a horizontal movement.
- 3. Contrast of tone value here again, extreme contrast is used to obtain visual shock, something very black contrasting something very light sets up visual extremes.
- 4. Contrast of space the blank space in contrast to the type elements is a subtle way to help achieve a visual shock.
- 5. Contrast of type forms the use of a rigid mechanical type such as a gothic in combination with a smooth flowing italic or script.
- 6. Contrast of color large areas of dark value used with small quantities of a brilliant color, or the play of pastel shades in contrast to large areas of dark values. The overprinting of colors is a way to create visual shock.
- Contrast of type with illustration light illustrations used with dark areas of type and unusual integration of type with illustrations.

THIRD ANNUAL AWARDS FOR TYPOGRAPHIC DESIGN EXCELLENCE

The panel of judges include:

Chairman, Mahlon A. CLINE

AARON BURNS

FREEMAN CRAW

GLENN FOSS

EDWARD GOTTSCHALL

ARTHUR B. LEE

CLIFTON LINE

ALEXANDER NESBITT

HERBERT ROAN

Record Album Cover by Saul Bass for Capitol Records.

Record Album Cover by Robert M. Jones for RCA Victor.

Certificate by Gene Frederico for American Institute of Graphic Arts.

Booklet Keepsake by Bauer Alphabets.

Cover for Record Booklet by Ivan Chermayeff for Columbia Records.

Magazine ad by Gene Frederico (Douglas D. Simon Advertising) for Lord & Taylor.

Keepsake by Aaron Burns and Ellen Raskin for IBM.

(Above and below) Newspaper advertisements by Arnold Varga for Cox's.

BOOK BOOK BOOK BOOK

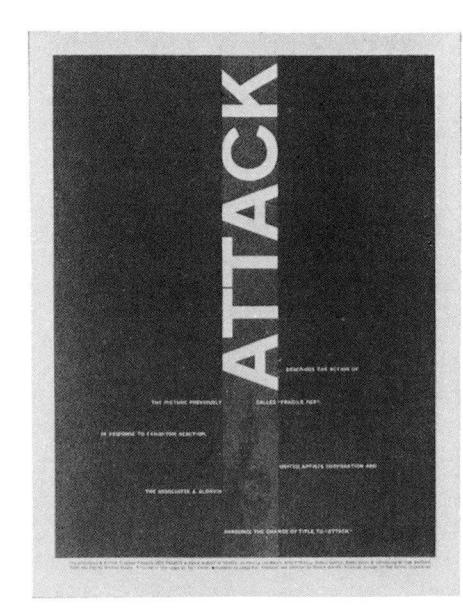

Magazine ad by Saul Bass for United Artists Corporation.

Booklet by Freeman Craw (Tri-Arts Press) for American Type Founders.

Record Album Cover by Robert M. Jones for RCA Victor.

Direct Mail piece by George Tscherny for C $\mbox{$\mbox{$\mbox{$\mathcal{C}$}$}$}$ I Art School.

Direct Mail piece by Herb Lubalin (Sudler & Hennessey) for E. R. Squibb & Sons.

Poster by Bob Gill for The Little Studio Ltd.

Record Album Cover by Robert M. Jones for RCA Victor.

Direct Mail piece by Herb Lubalin and John Graham for NBC Television.

Direct Mail post card by Peter Palazzo for I. Miller.

 $\begin{array}{c} Advertisement\ by\ Herb\ Lubalin\\ (Sudler\ \ \ \ \ Hennessey)\ for\ Ciba. \end{array}$

Direct Mail folder by Herb Lubalin (Sudler & Hennessey) for Upjohn.

Direct Mail booklet cover by Hy Farber.

Announcement folder by Bob Gill.

Greeting Card by Hap Smith.

Direct Mail card by Gene Frederico for William Helburn.

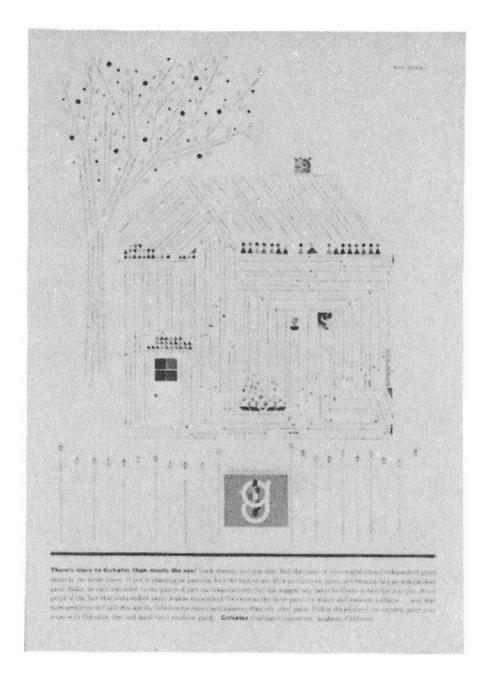

Magazine ad by Louis Danziger for Gelvatex Coatings Corporation.

Invitation folder printed by Davis-Delaney for Olivetti.

Magazine Cover by Norman Gollin for Art Direction Magazine.

Magazine ad by George Tscherny for J. G. Furniture Co.

Catalog Binder cover by Paul Rand for IBM.

Poster and Magazine Cover by Ivan Chermayeff for The Cambridge Review.

Drapes designed by Paul Rand for IBM.

Letterhead, Envelope and Card by James S. Ward (Peter Quay Yang Associates)

Advertisement by Louis Dorfsman for CBS Radio.

Letterhead and Envelope by Robert Nelson for XP Student Council, Augsburg College.

by Ivan Chermayeff.

Magazine ad by Bob Farber (Irving Serwer Co., Inc.) for Tish-u-Knit.

Greeting Card by Cal Freedman (Cal Art & Associates) for Ace Offset Printing Co.

Magazine ads by Will Burtin for American Type Founders.

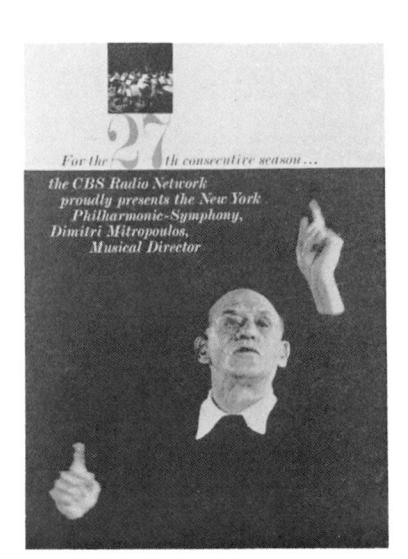

Magazine ad by Louis Dorfsman for CBS Radio.

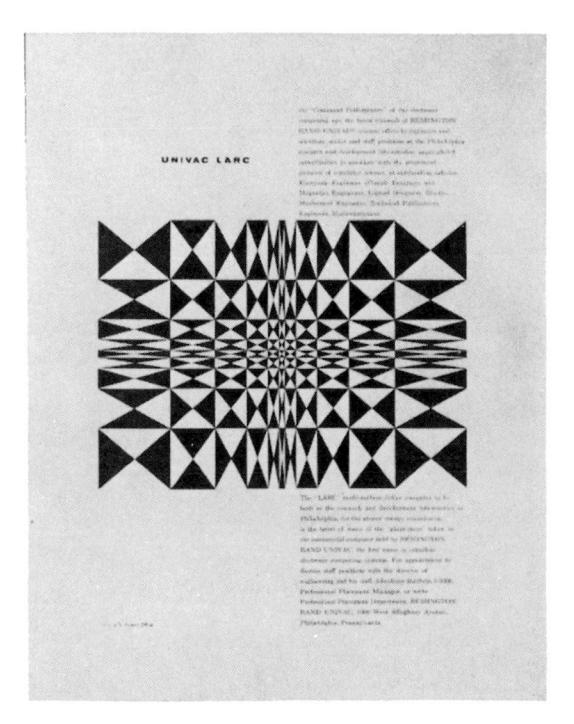

Magazine ad by Mel Richman Inc. for Remington Rand Univac.

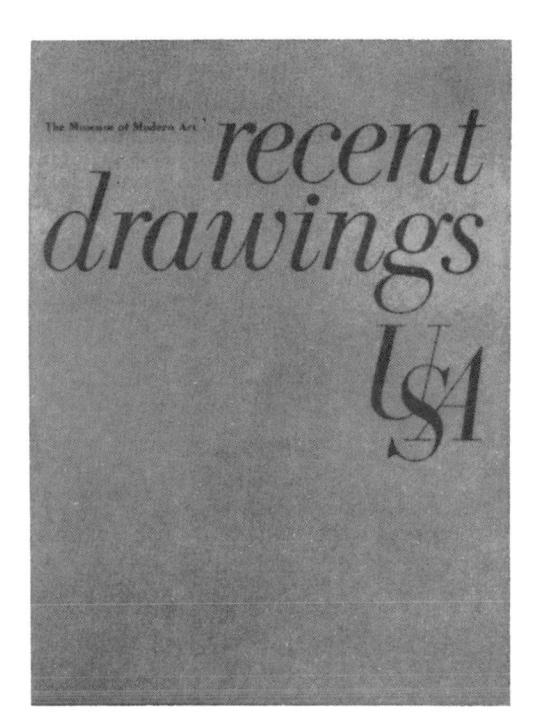

Exhibition Catalog by Helen Frederico for Museum of Modern Art.

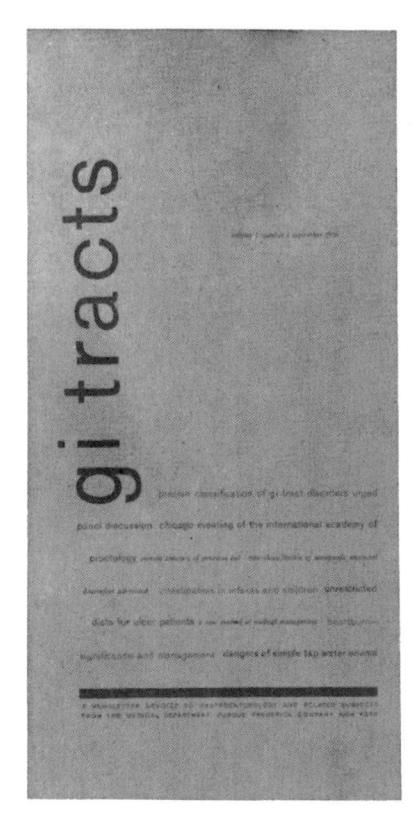

Booklet by Ted Bergman and Mordecai R. Craig (James Eng Assoc.) for Purdue Frederick Co.

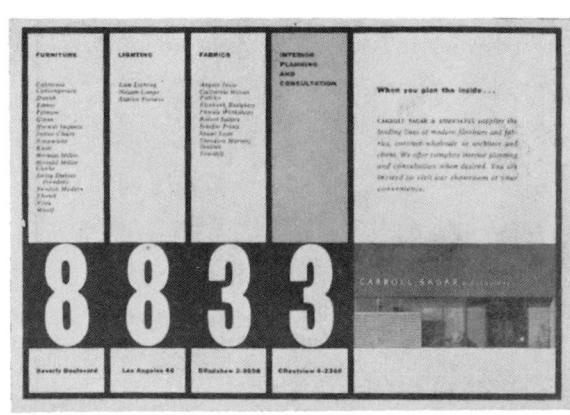

Trade ad by Allen Porter for Carroll Sagar & Associates.

Letterhead, Envelope and Card by Schroeder-Lewis.

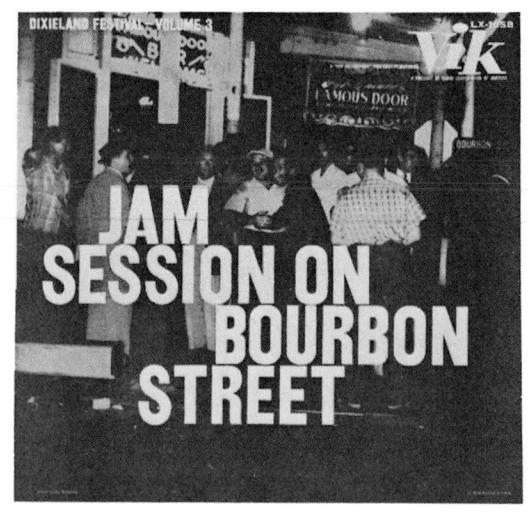

Record Album Cover by Acy Lehman for Radio Corporation of America.

Letterhead, Envelope and Card by Louis Danziger for Gelvatex Coatings Corporation.

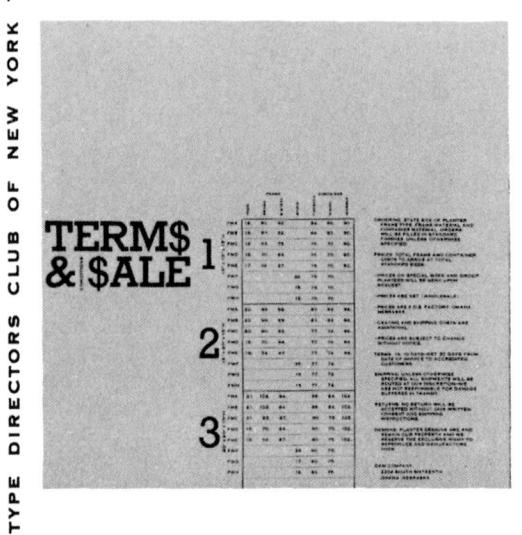

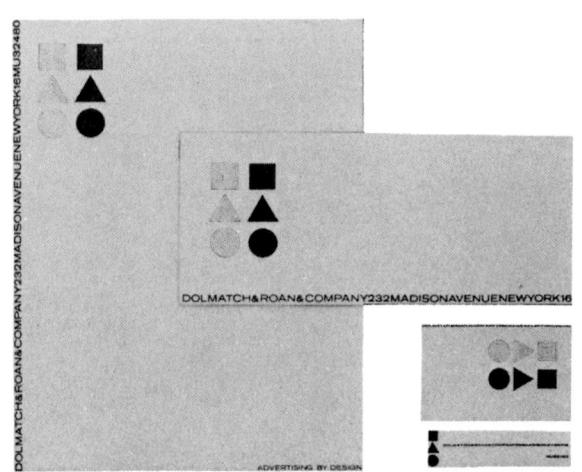

Letterhead, Envelope, Card and Label by Herbert Roan (Dolmatch & Roan & Co.)

Direct Mail folder by Robert Nelson for Daw Company.

Letterhead, Envelope and Business Forms by Morton Goldshall.

Folder printed by Davis-Delaney for Olivetti.

Magazine Cover by John Massey for the Water Well Journal.

AB DEFEMILIAN OPORSITY

ABCDEFGHIKLING
ABCDEFGHIKLI

Magazine ad by Louis Danziger for Advertising Composition Co.

The Cambridge Review

Poster and Magazine Cover by Ivan Chermayeff for The Cambridge Review.

Program booklet by A. Richard DeNatale for Reynolds Metals Company.

Letterhead and Envelope by Jerome Gould for Gould and Associates.

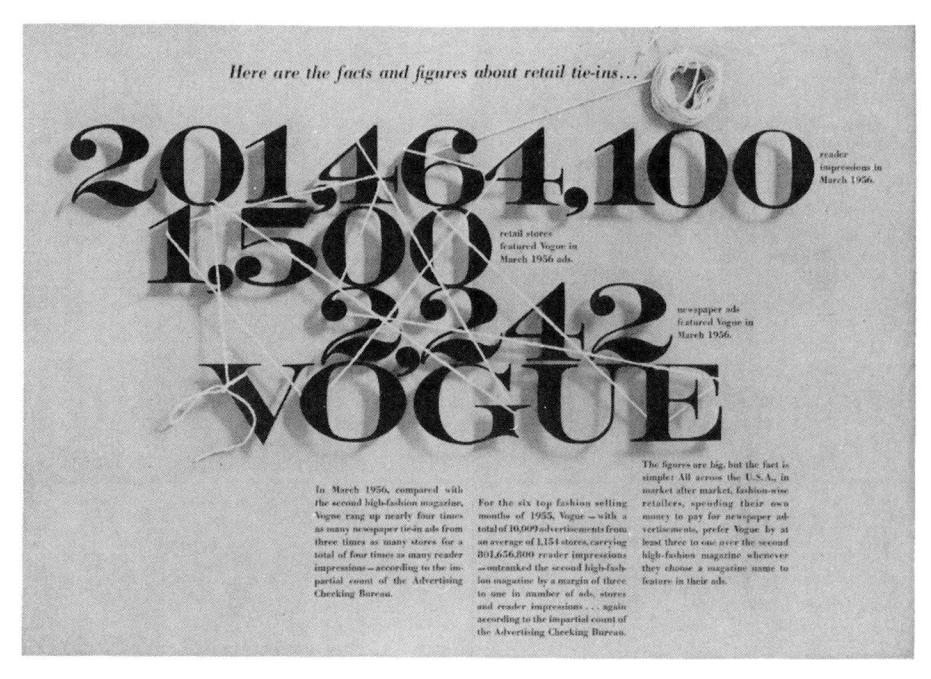

Magazine ad by Richard Loew for Vogue Magazine.

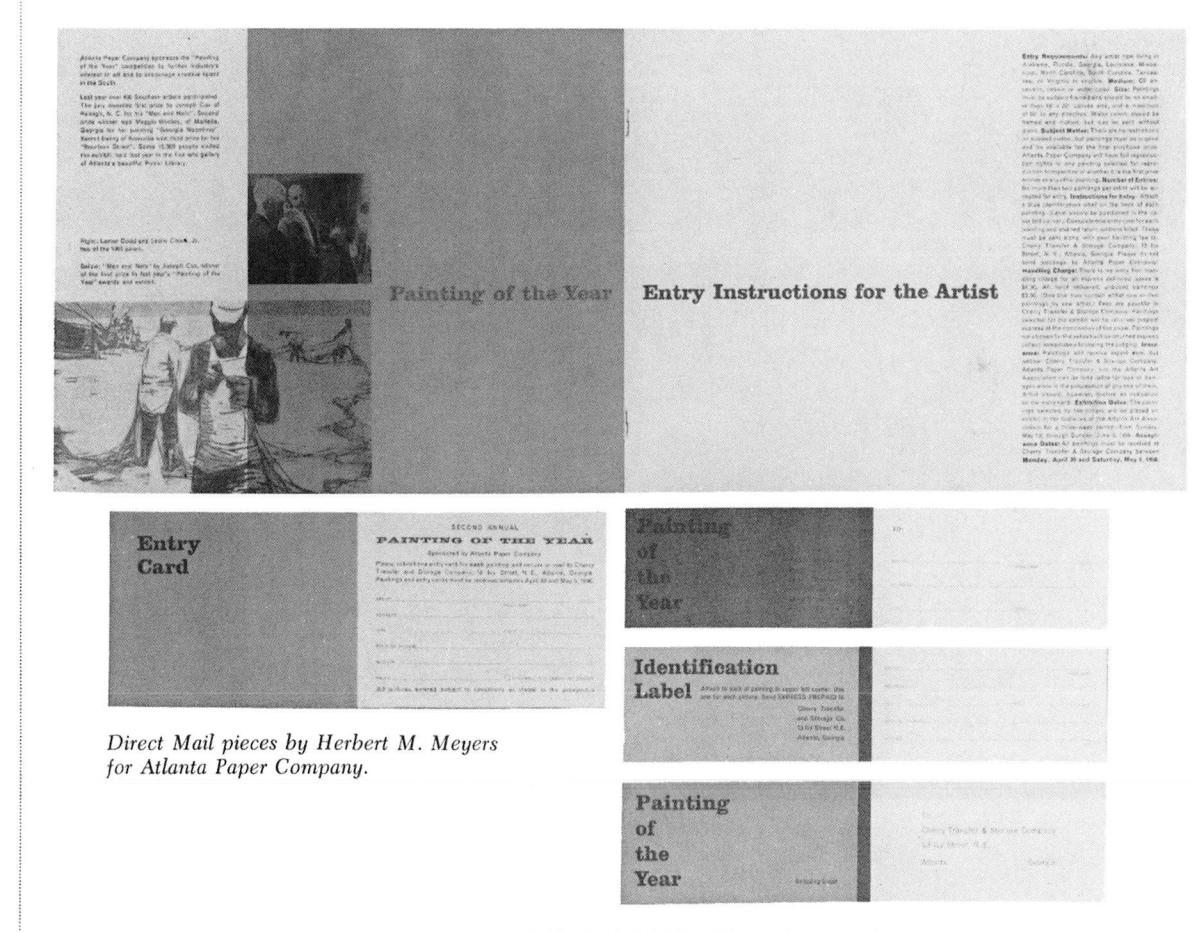

Advertisement by Herb Lubalin for Sudler & Hennessey.

Direct Mail piece by Robert M. Jones for The Glad Hand Press.

Direct Mail card by Allen Lazaroff for 11th Annual West Coast Exhibition of Advertising and Editorial Art.

Special occasion piece by Asdur Takakjian for Nation's Business.

Letterheads, Envelopes and Business Stationery by Louis Danziger for Kittleson Company.

Catalog Cover by Design Department of Corning Glass Works.

Direct Mail cards by Herbert M. Meyers for 5th Annual Exhibition of Advertising and Editorial Art.

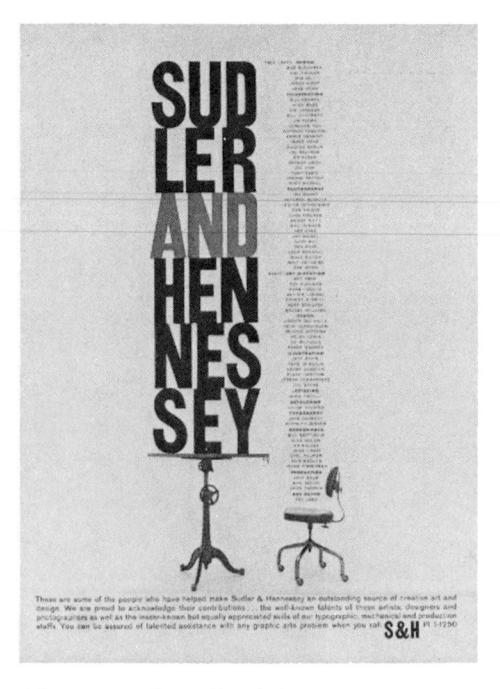

Advertisement by Herb Lubalin for Sudler & Hennessey.

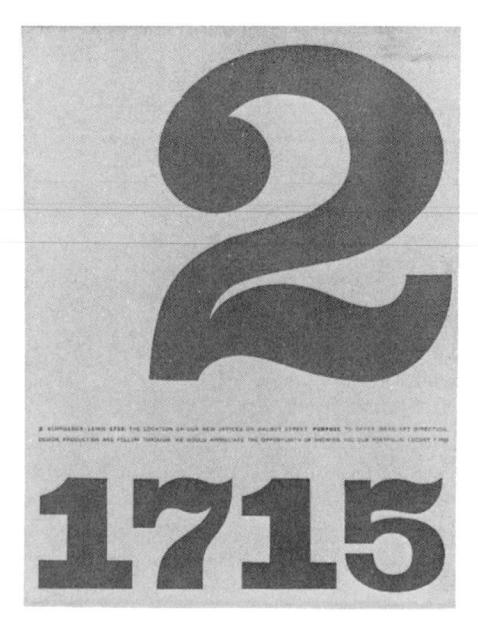

 $Direct\ Mail\ piece\ by\ Schroeder\text{-}Lew is.$

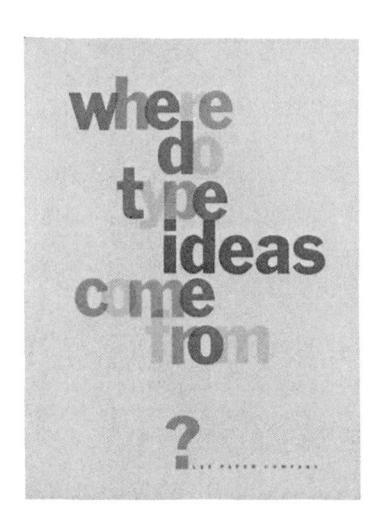

Direct Mail folder by Morton Goldshall for Lee Paper Company.

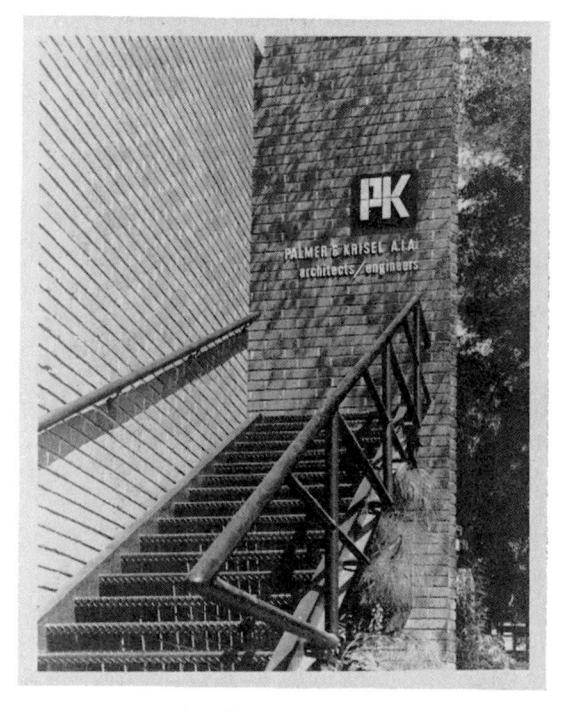

Architectural sign by Allen Porter for Palmer & Krisel.

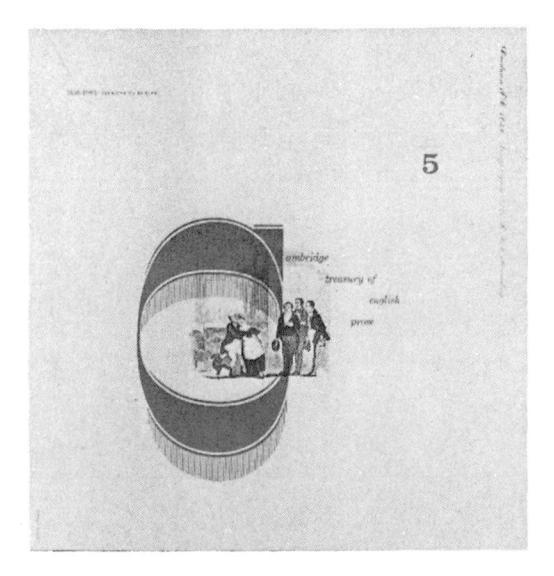

 $Record\ Album\ Covers\ by\ Matthew\ Leibowitz.$

Magazine Cover by Charles Kratka for Arts and Architecture.

Direct Mail folder by Herb Lubalin (Sudler & Hennessey) for Wm. S. Merrell Co.

Record Album Cover by Norman Gollin and Don Ornitz for Imperial Records.

Architectural Sign by Allen Porter and Fred Usher for Sy Art Construction Co.

Direct Mail folder by Roy Kuhlman (Sudler & Hennessey) for Merck, Sharp & Dohme.

Editorial pages by Henry Wolf for Esquire Magazine.

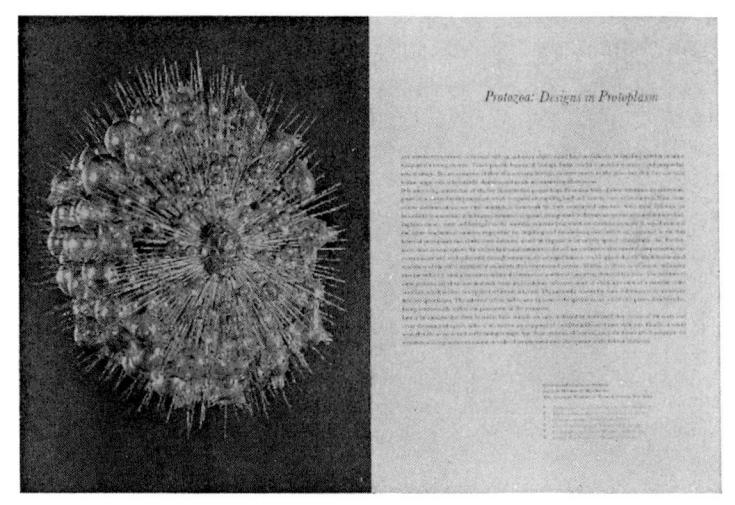

Magazine editorial pages by Will Burtin for The Upjohn Co.

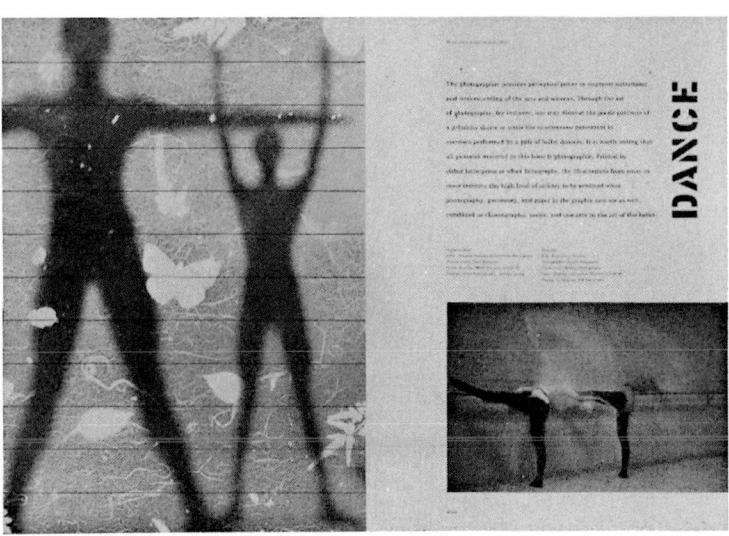

House magazine pages by Bradbury Thompson for Westvaco Inspirations.

Christmas card by Marilyn and John Neuhart for The Hand Press.

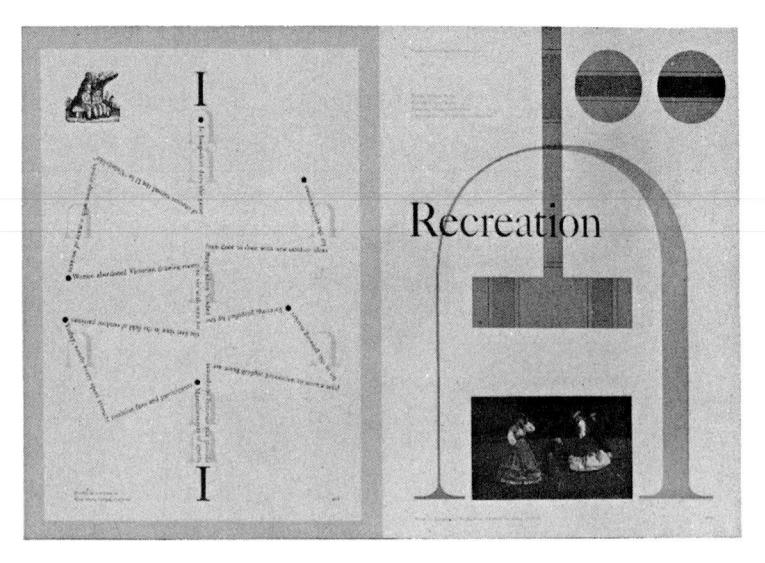

House magazine pages by Bradbury Thompson for Westvaco Inspirations.

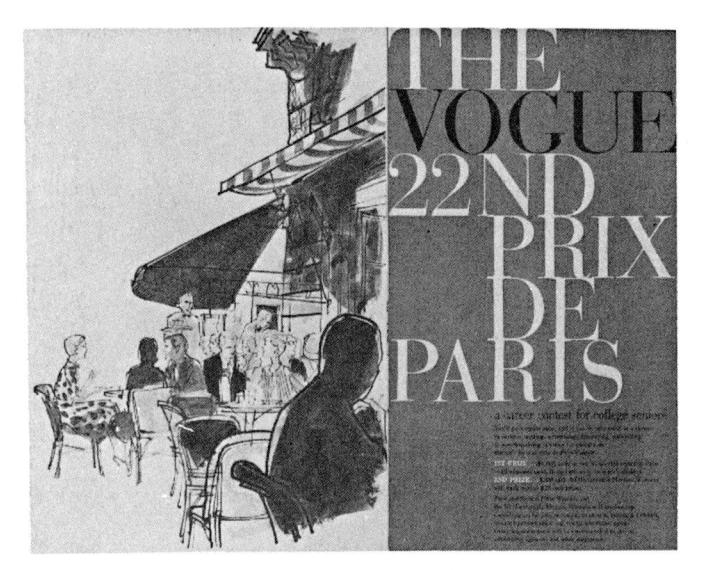

Direct Mail piece by Richard Loew for Vogue Magazine.

Announcement card by Marilyn and John Neuhart for The Hand Press.

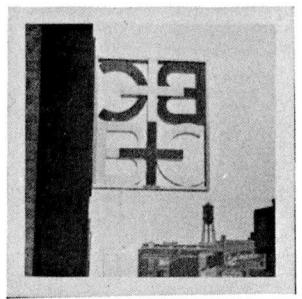

Design ARTHUR B. LEE
TDC Emblem HAL ZAMBONI Typography THE COMPOSING ROOM
TUDOR TYPOGRAPHERS
BAUER ALPHABETS Type Faces Horizon Light, Caledonia, COPPERPLATE GOTHIC BOLD Printing THE LENMORE PRESS

Paper ARTEMIS COVER AND SUPERFINE TEXT BY MOHAWK Membership List: ARNOLD BANK

AMOS G. BETHKE IRWIN L. BOGIN BERNARD BRUSSEL-SMITH FRANCIS MONACO AARON BURNS WILL BURTIN BURTON CHERRY TRAVIS CLIETT MAHLON A. CLINE MARTIN CONNELL EUGENE DE LOPATECKI O. ALFRED DICKMAN LOUIS DORFSMAN GENE DUNN EUGENE M. ETTENBERG GEORGE A. PODORSON GENE FEDERICO SIDNEY FEINBERG CHARLES J. FELTEN BRUCE FITZGERALD GLENN FOSS TED F. GENSAMER VINCENT GIANNONE LOUIS L. GLASSHEIM WILLIAM P. GLEASON EDWARD M. GOTTSCHALL EDWIN W. SHAAR HOLLIS W. HOLLAND HERBERT STOLTZ HAROLD HORMAN EDWARD N. JENKS RANDOLPH R. KARCH EMIL J. KLUMPP EDWIN B. KOLSBY RAY KONRAD ARTHUR B. LEE CLIFTON LINE GILLIS L. LONG MELVIN LOOS

HERB LUBALIN EDGAR J. MALECKI FRANK MERRIMAN ROSS MORRIS TOBIAS MOSS LOUIS A. MUSTO ARIOSTO NARDOZZI ALEXANDER NESBITT GERARD J. O'NEILL JERRY O'ROURKE DR. G. W. OVINK EUGENE P. PATTBERG WILLIAM PENKALO JAN VAN DER PLOEG FRANK E. POWERS ERNEST REICHL HERBERT ROAN EDWARD RONDTHALER FRANK ROSSI GUSTAVE L. SAELENS WILLIAM H. SCHULZE JAMES SECREST WILLIAM L. SEKULER WILLIAM A. STREEVER DAVID B. TASLER WILLIAM TAUBIN GEORGE F. TRENHOLM ABRAHAM A. VERSH MEYER WAGMAN STEVENS L. WATTS JOSEPH F. WEILER HERMANN ZAPF HAL ZAMBONI MILTON K. ZUDECK

Sustaining Members:

JOHN H. LORD

ADVERTISING AGENCIES SERVICE COMPANY INC. THE COMPOSING ROOM INC. ELECTROGRAPHIC CORPORATION SUPERIOR TYPOGRAPHY INC. WESCOTT AND THOMSON INC. TUDOR TYPOGRAPHERS ATLANTIC ELECTROTYPE & STEREOTYPE COMPANY STERLING ENGRAVING COMPANY MOHAWK PAPER COMPANY A. T. EDWARDS TYPOGRAPHY, INC. AMSTERDAM CONTINENTAL TYPES AND GRAPHIC EQUIPMENT INC.

LITHO'D IN U. S. A.

TDC OFFICERS, MEMBERS, AND INDEXES

TDC OFFICERS

BOARD OF DIRECTORS 2005/2006

OFFICERS

President

Gary Munch Munchfonts

Vice President

Alex W. White Alexander W. White Art Direction

Secretary/Treasurer

Charles Nix Scott & Nix, Inc.

Directors-at-Large

Christopher Andreola *adcStudio*

Matteo Bologna Mucca Design

Graham Clifford

Graham Clifford Design

Ted Mauseth

Mauseth Design LLC

Susan L. Mitchell Farrar Straus & Giroux

Diego Vainesman

MJM Creative Services

Maxim Zhukov

Chairman of the Board

James Montalbano Terminal Design, Inc.

Executive Director Carol Wahler

BOARD OF DIRECTORS 2006/2007

OFFICERS

President

Alex W. White Alexander W. White Art Direction

Vice President

Charles Nix Scott & Nix, Inc.

Secretary/Treasurer

Diego Vainesman

MJM Creative Services

Directors-at-Large

Christopher Andreola adcStudio

Matteo Bologna Mucca Design

Graham Clifford Design

Ted Mauseth

Mauseth Design LLC

Chad Roberts Louise Fili, Ltd.

Ann Twomey

Hachette Book Group USA

Maxim Zhukov

Chairman of the Board

Gary Munch Munchfonts

Executive DirectorCarol Wahler

COMMITTEE FOR TDC52

Chairman

Diego Vainesman

Designer

Andrew Kner

Associate Designer

Michele L. Trombley

Coordinator

Carol Wahler

Assistants to Judges

Chris Andreola, Peter Bain, Lilian Citron, Deborah Gonet, Aaron Knapp, Nana Kobayashi, Mike Krol, Ted Mauseth, Gary Munch, Omar Mvra, Daniel Pelavin, Travis Simon, Bruno Toporowsky, Allan R. Wahler, Alex W. White, and Maxim Zhukov

TYPE DIRECTORS CLUB

127 West 25 Street 8th Floor New York, NY 10001 212-633-8943 Fax: 212-633-8944 E-mail: director@tdc.org www.tdc.org

Carol Wahler,
Executive Director

For membership information please contact the Type Directors Club office.

TYPE DIRECTORS CLUB PRESIDENTS

Frank Powers, 1946, 1947 Milton Zudeck, 1948 Alfred Dickman, 1949 Joseph Weiler, 1950 James Secrest, 1951, 1952, 1953 Gustave Saelens, 1954, 1955 Arthur Lee, 1956, 1957 Martin Connell, 1958 James Secrest, 1959, 1960 Frank Powers, 1961, 1962 Milton Zudeck, 1963, 1964 Gene Ettenberg, 1965, 1966 Edward Gottschall, 1967, 1968 Saadyah Maximon, 1969 Louis Lepis, 1970, 1971 Gerard O'Neill, 1972, 1973 Zoltan Kiss, 1974, 1975 Roy Zucca, 1976, 1977 William Streever, 1978, 1979 Bonnie Hazelton, 1980, 1981 Jack George Tauss, 1982, 1983 Klaus F. Schmidt, 1984, 1985 John Luke, 1986, 1987 Iack Odette, 1988, 1989 Ed Benguiat, 1990, 1991 Allan Haley, 1992, 1993 B. Martin Pedersen, 1994, 1995 Mara Kurtz, 1996, 1997 Mark Solsburg, 1998, 1999 Daniel Pelavin, 2000, 2001 James Montalbano, 2002, 2003 Gary Munch, 2004, 2005 Alex W. White. 2006

TDC MEDAL

RECIPIENTS Hermann Zapf, 1967 R. Hunter Middleton, 1968 Frank Powers, 1971 Dr. Robert Leslie, 1972 Edward Rondthaler, 1975 Arnold Bank, 1979 Georg Trump, 1982 Paul Standard, 1983 Herb Lubalin, 1984 (posthumously) Paul Rand, 1984 Aaron Burns, 1985 Bradbury Thompson, 1986 Adrian Frutiger, 1987 Freeman Craw, 1988 Ed Benguiat, 1989 Gene Federico, 1991 Lou Dorfsman, 1995 Matthew Carter, 1997 Rolling Stone magazine, 1997 Colin Brignall, 2000 Günter Gerhard Lange, 2000 Martin Solomon, 2003 Paula Scher, 2006

SPECIAL CITATIONS TO TDC MEMBERS

Edward Gottschall, 1955 Freeman Craw, 1968 James Secrest, 1974 Olaf Leu, 1984, 1990 William Streever, 1984 Klaus F. Schmidt, 1985 John Luke, 1987 Jack Odette, 1989

2006 SCHOLARSHIP RECIPIENTS

Melanie Duarte

Maine College of Art

Wei Lieh Lee School of Visual Arts

Poliana Kirst Fashion Institute of Technology

Louise Ma The Cooper Union

Adam Mignanelli Parsons School of Design

Mitja Miklavčič University of Reading, UK

Eric Wrenn, Pratt Institute

2006 STUDENT AVVARD WINNERS

First Place (\$500)

Daniel Janssen (University of Applied Sciences Hamburg, Germany)

Second Place (\$300)

Ryan Feerer (School of Visual Arts, New York)

Third Place (\$200)

Peter Brugger (Hochschule Pforzheim, Germany)

INTERNATIONAL LIAISON

Chairpersons

ENGLAND

David Farey

HouseStyle

27 Chestnut Drive

Bexleyheath

Kent DA7 4EW

FRANCE

Christopher Dubber

Signum Art

94, Avenue Victor Hugo

94100 Saint Maur Des Fosses

GERMANY

Bertram Schmidt-Friderichs Verlag Hermann Schmidt Mainz GmbH & Co. Robert Koch Strasse 8 Postfach 42 07 28 55129 Mainz Hechtsheim

IAPAN

Zempaku Suzuki Japan Typography Association Sanukin Bldg. 5 Fl. 1-7-10 Nihonbashi-honcho Chuo-ku, Toyko 104-0041

MEXICO

Prof. Felix Beltran Apartado de Correos M 10733 Mexico 06000

SOUTH AMERICA

Diego Vainesman 181 East 93 Street, Apt. 4E New York, NY 10128

SWITZERLAND

Erich Alb Lindenbuehl 33 CH 6330 Cham

VIETNAM

Richard Moore 21 Bond Street New York, NY 10012

TDC MEMBERSHIP

Saad Abulhab '04 Marcelle Accardi '98s Christian Acker '02 Pete Aguanno '06 Masood Ahmed '06s Erich Alb '96 Sallie Reynolds Allen '06 Natascha Ampunant '02 Jack Anderson '96 Gabriela Varela Andrade '05 Lück Andreas '06 Christopher Andreola '03 Debi Ani '01 Martyn Anstice '92 Pratima Aravabhoomi '06s I.R. Arebalo, Ir. '03 Don Ariev '98 Robyn Attaway '93 Bob Aufuldish '06 Levi Bahn '06a George Baier IV '04s Peter Bain '86 Bruce Balkin '92 Juergen Bamberg '04 Stephen Banham '95 Jennifer Bankenstein '05 Joshua Bankes '06 Neil Barnett '01 Frank Baseman '03 Mark Batty '03 Anna Bauer '05s Barbara Baumann '96 Gerd Baumann '95 Greg Beechler '05s Sofie Beier '06s Paul Belford '05 Felix Beltran '88 Ed Benguiat '64 Kai Bergmann '06 Anna Berkenbusch '89 William Berkson '06 John D. Berry '96 Peter Bertolami '69 Marianne Besch '06 Davide Bevilacqua '99 Tadeusz Biernot '00 Klaus Bietz '93 Henrik Birkvig '96 R. P. Bissland '04

Roger Black '80 Linda Blackwell Bently '05 Marc Blaustein '01 Claas Blüher '01 Anders Bodebeck '04 Christine Boerdner '06 Matteo Bologna '03 Teresa Bonner '05 Gianni Bortolotti '98 Rachel Bosley '06s Thad Boss '01 Brandt Brinkerhoff '05s Ed Brodsky '80 Craig Brown '04 Johannes Bruckner '05s Bill Bundzak '64 David Cabianca '05 Chase Campbell '06s Mike Campbell '04 Ronn Campisi '88 Aaron Carambula '05 William Carlson '06s Ingrid Carozzi '06s Scott Carslake '01 Matthew Carter '88 Ken Cato '88 Eduard Cehovin '03 Virginia Chan '00s Florence Chapman '06s Len Cheeseman '93 Eric Ping-Liang Chen '04 Jeff Chen '02s David Cheung, Jr. '98 Kai-Yan Choi '90 Johng Won Choi '05s Hyun Joo Choi '06s Crystal Chou '06s Seungmin Chung '03s Stanley Church '97 Traci Churchill '06 Nicholas Cintron '03s Alicia Clarens '05 Travis Cliett '53 Graham Clifford '98 Tom Cocozza '76 Stuart Cohen '96 Kathleen Cole '05s

Angelo Colella '90

Ed Colker '83

Nick Cooke.'01 Heather Corcoran '05 Rodrigo Corral '02 Madeleine Corson '96 Fabio Costa '03 Susan Cotler-Block '89 Kristin Cox '05s Daniel Covne '05a James Craig '04 Freeman Craw* '47 Martin Crockatt '02 Laura Crookston-Deleot '00 Andeeas Croonenbroeck '06 Bart Crosby '95 Matthew Crow '06 Ray Cruz '99 Brian Cunningham '96 Rick Cusick '89 Susan Darbyshire '87 Giorgio Davanzo '06 Einat Lisa Day '97s Filip De Baudringhien '03 Josanne De Natale '86 Roberto de Vicq de Cumptich '05 Matej Decko '93 Kymberly DeGenaro '06 Olivier Delhave '06 Liz DeLuna '05 Alfonso Demetz '06 Richard R. Dendy '00 Mark Denton '01 James DeVries '05 N. Cameron deZevallos '06s Cara DiEdwardo '06 Chank Diesel '05 Claude A. Dieterich '84 Kirsten Dietz '00 Joseph DiGioia '96 Sandra DiPasqua '04 Sebastian Doerken '05s Lou Dorfsman '54 Dino Dos Santos '04 Bill Douglas '06 Pascale Dovic '97 Stephen Doyle '98 Christopher Dubber '85 Claus Due '05 Joseph P. Duffy III '03 Tim Duke '05s

Kim Duksoo '04s Denis Dulude '04 Arem Duplessis '06 Simon Dwelly '98 Lutz Dziarnowski '92 Lasko Dzurovski '00 Don Easdon '05 Beau Eaton '05s Dayna Elefant '06 Elizabeth Elsas '05 Garry Emery '93 Stefan Engelhardt '01 HC Ericson '01 Joseph Michael Essex '78 Manuel Estrada '05 Florence Everett '89 Peter Fahrni '93 John R. Falker '00 David Farey '93 Saied Farisi '06 Matt Ferranto '04 Debra Ferrer '05 Mark Fertig '04 Robert Festino '05 Vicente Gil Filho '02 Louise Fili '04 Simon Fitton '94 Kristine Fitzgerald '90 Julie Flahiff '04 Marie Flores '05s Gonçalo Fonseca '93 John Fontana '04 James Ford '05s Lorraine Forte '05 Carin Fortin '02 Dirk Fowler '03 Thomas Fowler '93 Mark Fox '06 Alessandro Franchini '96 Laura Franz '06 Carol Freed '87 Ryan Pescatore Frisk '04s Janet Froelich '06 Adrian Frutiger ** '67 Jason Fryer '04s Takayoshi Fujimoto '06s

Kyoto Fukuma '05s

Kenny Funk '05

Louis Gagnon '02

Ohsugi Gaku '01 David Gallo '06s Paul Garbett '05 Catalina Garcia '03s Christof Gassner '90 Martina Gates '96s David Gatti '81 Wolfgang Geramb '06 Pepe Gimeno '01 Lou Glassheim * '47 Howard Glener '77 Mario Godbout '02 Giuliano Cesar Gonçalves '01 Deborah Gonet '05 Carole Goodman '06 Edward Gottschall '52 Mark Gowing '06 Norman Graber '69 Diana Graham '85 Austin Grandjean '59 Marion Grant '04s Kathervne Grav '04 Stephen Green '97 Virgina Green '05s Ramon Grendene '06s Simon Grendene '02s James Grieshaber '96 Rosanne Guararra '92 Christine Gude '97 Nora Gummert-Hauser '06 Matthias Gunkel '05 Ramiz Guseynov '04 Einar Gylfason '95 Peter Gyllan '97 Tomi Haaparanta '01 Brock Haldeman '02 Allan Haley '78 Debra Hall '96 Angelica Hamann '03 Dawn Hancock '03 Graham Hanson '04 Egil Haraldsen '00 Rachel Hardy '06s Keith Harris '98 Knut Hartmann '85 Lukas Hartmann '03 Williams Hastings '05s Diane Hawkins '04

William Hayden '05s

Luke Hayman '06 Bonnie Hazelton '75 Amy Hecht '01 Eric Heiman '02 Arne Heine '00 Hayes Henderson '03 Michael Hendrx '06 Rebecca Henretta '05s Bosco Hernandez '05 Earl M. Herrick '96 Ralf Hermannn '02s Klaus Hesse '95 Darren Hewitson '05s Fons M. Hickmann '96 Jay Higgins '88 Cheryl Hills '02 Helmut Himmler '96 Kit Hinrichs '04 Norihiko Hirata '96 Michael Hodgson '89 Robert Hoffman '05s Fritz Hofrichter '80 Michael Hoinkes '06 David Hollingsworth '03a Clark Hook '06 Amy Hooper '05 Kevin Horvath '87 Fabian Hotz '01 Diana Hrisinko '01 Christian Hruschka '05 Yuonheng Hsu '05s Anton Huber '01 Jack Huber '06 John Hudson '04 Simon Huke '05s Randy Hunt '06s Dennis Y Ichiyama '06 Mariko Iizuka '05 Yanek Iontef '00 Alexander Isley '05 Donald Jackson ** '78 Alanna Jacobs '05 Ed Jacobus '03 Michael Jager '94 Torsten Jahnke '02 Preeti Jalan '05s Aleksi Jalonen '05s Mark Jamra '99

Jennifer Jerde '06

Jenny Ji '04s Giovanni Jubert '04s William Jurewicz '04 John Kallio '96 Stefan Kalscheid '06s Tai-Keung Kan '97 I-Ching Kao '02 Diti Katona '06 Carolyn Keer '06 Richard Kegler '02 Brunnette Kenan '99 Russell Kerr '05s Habib Khoury '06 Ben Kiel '06 Satohiro Kikutake '02 Yeon Jung Kim '05 Yong Keun Kim '05s Rick King '93 Katsuhiro Kinoshita '02 Nathalie Kirsheh '04 Rhinnan Kith '01s Arne Alexander Klett '05 Akira Kobayashi '99 Nana Kobayashi '94 Claus Koch '96 Boris Kochan '02 Masayoshi Kodaira '02 Jesse Taylor Koechling '98s Jonny Kofoed '05 Steve Kopec '74 Damian Kowal '05 Marcus Kraus '97 Matthias Kraus '02 Stephanie Kreber '01 Bernhard J. Kress '63 Ivan Krevolin '05s Gregor Krisztian '05 Kewvin Krueger '06 Toshiyuki Kudo '00 Felix Kunkler '01 Christian Kunnert '97 James Kuo '05 Dominik Kveck '02 Gerry L'Orange '91 Raymond F. Laccetti '87 Ying Ching Lai '06s Ellen Lampl '05 Melchior Lamy '01 John Langdon '93

Jean Larcher '01 Marcia Lausen '05 Amanda Lawrence '06 Christine Lee '02s Jee-Eun Lee '05s Julianna Lee '04 Wei Lieh Lee '05s Jennifer Lee-Temple '03 Pum Lefebure '06 Elizabeth Leih '05s David Lemon '95 Jean-Paul Leonard '06 Olaf Leu '65 Ioshua Levi '06 Howard Levine '05 Laura Lindgren '05 Jan Lindquist '01 I. Nils Lindstrom '06 Christine Linnehan-Sununu '04 Domenic Lippa '04 Wally Littman '60 Uwe Loesch '96 Oliver Lohrengel '04 John Howland Lord ** '47 Christopher Lozos '05 Alexander Luckow '94 Frank Luedicke '99 Gregg Lukasiewicz '90 Danusch Mahmoudi '01 Boris Mahovac '04 Donna Meadow Manier '99 Marilyn Marcus '79 Peter Markatos '03s Nicolas Markwald '02 Gabriel Meave Martinez '01 Rammer Martinez '05s Magui Martinez-Pena '05 Vanessa Marzaroli '06 Shigeru Masaki '06 Maurizio Masi '05 Christopher Masonga '03s Steve Matteson '06 Ted Mauseth '01 Andreas Maxbauer '95 Loie Maxwell '04 Trevett McCandliss '04 Rod McDonald '95 Mark McGarry '02

326

Guenter Gerhard Lange '83

Joshua McGrew '05s Kelly McMurray '03 Marc A. Meadows '96 Matevz Medja '02 Roland Mehler '92 Uwe Melichar '00 Bob Mellett '03s Francesa Messina '01 Frédéric Metz '85 ID Michaels '03 Joe Miller '02 Ron Miller '02 John Milligan '78 Jennifer Miraflor '06s Elena Miranda '05 Michael Miranda '84 Ralf Mischnick '98 Susan L. Mitchell '96 Bernd Moellenstaedt '01 Preeti Monga '05 Sakol Mongkolkasetarin '95 Stephanie Mongon '05s James Montalbano '93 Richard Earl Moore '82 Minoru Morita '75 Jimmy Moss '04 Emmaniel Mousis '05s Kirk Mueller '06s Lars Müller '97 Joachim Müller-Lancé '95 Gary Munch '97 Matthew Munoz '04 Claire Murphy '05 Jerry King Musser '88 Louis A. Musto '65 Steven Mykolyn '03 Cristiana Neri-Downey '97 James Nesbitt '06 Helmut Ness '99 Adam Neumann '05s Nina Neusitzer '03s Robert Newman '96 Vincent Ng '04 Charles Nix '00 Shuichi Nogami '97 Gertrud Nolte '01s Alexa Nosal '87 Beth Novitsky '06

Tim Oakley '06

Robb Ogle '04 Wakako Okamoto '06s Ezidinma Okeke '05 Akio Okumara '96 Robson Oliveira '02 Jourdanet Olivier '05 Toshihiro Onimaru '03 Andy Outis '06s Petra Cerne Oven '02s Robert Overholtzer '94 Michael Pacey '01 Jesse Packer '04s Frank Paganucci '85 Amy Papaelias '05s Stavros Papandreou '05s Anthony Pappas '05 Enrique Pardo '99 Jim Parkinson '94 Donald Partyka '05 Guy Pask '97 Lilliana Passalacqua '05s Dennis Pasternak '06 Gudrun Pawelke 96 Lauren Payne '04 David Peacock '06s Harry Pearce '04 Daniel Pelavin '92 Tamaye Perry '05 Giorgio Pesce '05 Steve Peter '04 Oanh Pham-Phu '96 Frank Philippin '06 Max Phillips '00 David Philpott '04 Clive Piercy '96 Ian Pilbeam '99 Michael James Pinto '05 Johannes Pohlen '06s J.H.M. Pohlen '06 Marcin Pokorski '05s Bernhard Pompey '04s Albert-Jan Pool '00 Tiffany Powell '05s Will Powers '89 Kevin Pratt '05s Vittorio Prina '88 James Propp '97 Chuck Queener '06 Jochen Raedeker '00

Mamta Rana '05 Sal Randazzo '97 Bob Rauchman '97 Robynne Rave '05 Byron Regej '05s Heather L. Reitze '01 Renee Renfrow '04 James Revman '05 Fabian Richter '01 Claudia Riedel '04s Helge Dirk Rieder '03 Robert Rindler '95 Tobias Rink '02 Phillip Ritzenberg '97 Jose Rivera '01 Chad Roberts '01 Eva Roberts '05 Phoebe Robinson '02 Luis Roca '05 Salvador Romero '93 Edward Rondthaler* '47 Kurt Roscoe '93 Roy Rub '05s Josh Rubinstein '06s Giovanni Carrier Russo '03 Erkki Ruuhinen '86 Jason Ryals '05s Timothy J. Ryan '96 Carol-Anne Ryce-Paul '01s Michael Rylander '93 Greg Sadowski '01 Jonathan Sainsbury '05 Rehan Saived '06 Mamoun Sakkal '04 Ilja Sallacz '99 David Saltman '66 Ina Saltz '96 Ksenya Samarskaya '05s Rodigo Sanchez '96 Michihito Sasaki '03 Nathan Savage '01 John Sayles '95 David Saylor '96 Nina Scerbo '06 Hartmut Schaarschmidt '01 David Schimmel '03 Peter Schlief '00s Hermann J. Schlieper '87

Erwin Raith '67

Hermann Schmidt '83 Klaus Schmidt '59 Christian Marc Schmidt '02s Bertram Schmidt-Friderichs '89 Nick Schmitz '05s Guido Schneider '03 Werner Schneider '87 Markus Schroeppel '03 Holger Schubert '06 Clemens Schulenburg '06 Eileen Hedy Schultz '85 Eckehart Schumacher-Gebler '85 Matthew Schwartz '05 Daniel Schweinzer '06s Peter Scott '02 Leslie Segal '03 Enrico Sempi '97 Ronald Sequeira '04s Thomas Serres '04 Patrick Seymour '06 Li Shaobo '04 Paul Shaw '87 Elizabeth Sheehan '03 Hyewon Shin '03s Ginger Shore '03 Philip Shore, Jr. '92 Derek Shumate '05s Robert Siegmund '01 France Simard '03 Mark Simkins '92 Scott Simmons '94 Todd Simmons '06 Leila Singleton '04 Martha Skogen '99 Pat Sloan '05 Sam Smidt '06 Sarah Smith '05 Steve Snider '04 Jan Solpera '85 Mark Solsburg '04 Brian Sooy '98 Peter Specht '06 Erik Spiekermann '88 Denise Spirito '02 Christoph Staehli '05

Frank Stahlberg '00

Dimitris Stefanidis '06

Rolf Staudt '84

Holger Schmidhuber '99

Olaf Stein '96 Notburga Stelzer '02 Charles Stewart '92 Michael Stinson '05 Anke Stohlmann '06 Clifford Stoltze '03 Sumner Stone '05 Peter Storch '03 Lorna Stovall '05 William Streever '50 Ilene Strizver '88 Alison Stuerman '04s Hansjorg Stulle '87 Derek Sussner '05 Zempaku Suzuki '92 Caroline Szeto '02s Barbara Taff '05 Douglas Tait '98 Yukichi Takada '95 Yoshimaru Takahashi '96 Katsumi Tamura '03 Jack Tauss '75 Pat Taylor '85 Rob Taylor '04 Anthony J. Teano '62 Marcel Teine '03 Régine Thienhaus '96 Wayne Tidswell '96 Eric Tilley '95 Colin Tillver '97 Siung Tjia '03 Alexander Tochilovsky '05 Laura Tolkow '96 Klemen Tominsek '05s Jakob Trollbäck '04 Klaus Trommer '99 Niklaus Troxler '00 Minao Tsukada '00 Viviane Tubiana '05 Manfred Tuerk '00 Marc Tulke '00 François Turcotte '99 Michael Tutino '96 Anne Twomey '05 Andreas Uebele '02 Thomas Gerard Uhlein '05 Diego Vainesman '91 Patrick Vallée '99

Christine Van Bree '98

JanVan Der Ploeg '52 Jeefrey Vanlerberghe '05 Yuri Vargas '99 Brady Vest '05 Barbara Vick '04 Mathias Vietmeier '06 Anna Villano '99s Robert Villanueva '02s Prasart Virakul '05 Thilo von Debschitz '95 Frank Wagner '94 Oliver Wagner '01 Allan R. Wahler '98 Jurek Wajdowicz '80 Sergio Waksman '96 Garth Walker '92 Katsunori Watanabe '01 Steven W. Watson '06 Harald Weber '99 Kim Chun Wei '02 Eric Cai Shi Wei '06 Kurt Weidemann '66 Claus F. Weidmueller '97 Sylvia Weimer '01 Ramon Wengren '02 Marco Wenzel '02 Sharon Werner '04 Judy Wert '96 Alex W. White '93 Christopher Wiehl '03 Heinz Wild '96 Richard Wilde '93 James Williams '88 Steve Williams '05 Grant Windridge '00 Mike Winegardner '05 Carol Winer '94 Conny J.Winter '85 Delve Withrington '97 Burkhard Wittemeier '03 Pirco Wolfframm '03 Peter Wong '96 Willy Wong '06 Fred Woodward '95 René Wynands '04 Sarem Yadegari '03s Erica Yamada '05s Oscar Yañez '06 Henry Yee '06

Garson Yu '05 David Yun '04s Christine Zangrilli '06s Hermann Zapf ** '52 David Zauhar '01 Philip Zelnar '04s Maxim Zhukov '96 Roy Zucca '69 Jeff Zwerner '97

SUSTAINING MEMBERS

Conair Corporation '06 Diwan Software '03 Hachette Book Group '05 Massholfer/Gutmayer '06 Pentagram Design, Inc., New York '04

- * Charter member
- ** Honorary member
- s Student member
- a Associate member

Membership as of May 24, 2006

TYPE INDEX

When there are several variations of	ITC Aspirin, 204	FF Call One, 243
a typeface, faces are grouped together under the primary name. Some type-	Taouffik Semmad	Astrid Scheuerhorst
face names are preceded by the name	Auriol, 185	FF Call Six, 243
or abbreviation of the type foundry that created them (such as Monotype	Matthew Carter after Georges Auriol	Astrid Scheuerhorst
or ITC), but they are alphabetized	Auto 1 Black, 89	Calouste, 281
under the generic name.	Underware	Miguel Sousa
	Avant Garde Bold, 206	Adobe Caslon, 39, 116
Acclamation, 186 <i>Unknown</i>	Herb Lubalin and Tom Carnase	William Caslon
	Avenir, 41	LTC Caslon family, 132
Adine Kimberg, 166 <i>David Rakowski</i>	Adrian Frutiger	William Caslon
	Baskerville, 109	Big Caslon, 185
Advena Sans, 257 Yvonne Diedrich	John Baskerville	Matthew Carter after William Caslor
	Batak Condensed, 197	Centaur, 48
Afloat, 129 Shuzo Hayashi	Charles Nix	Bruce Rogers
	Bell Gothic, 209	Century Schoolbook, 90
Akzidenz Grotesk, 99, 168, 203, 211 <i>H. Berthold AG</i>	Chauncey H. Griffith	Morris Fuller Benton
	Bembo, 106, 107, 113, 134, 224	New Century Schoolbook, 55
Akzidenz Grotesk Bold, 179	Monotype design staff, 1929. Based on	Morris Fuller Benton
H. Berthold AG	drawings by Francesco Giffo (1495) and Giovantonio Tagliente (1524)	Chalet Book, 61
Akzidenz Grotesk Condensed, 165		Paul van der Laan influenced by
H. Berthold AG	Beton, 225 Heinrich Jost	René Chalet
Alphatier, 259		HTF Champion, 64
Mark Jamra	Blender, 202	Jonathan Hoefler
	Eran Bachrach	
ITC American Typewriter, 125	p = p 1 : 50	HTF Champion Gothic, 163
Joel Kaden and Tony Stan	Bauer Bodoni, 50 After Giambattista Bodoni	Jonathan Hoefler
Aniene, 285	D. I.I. 407	HTF Champion Welterweight, 173
Adriane Krakowski	Bokka, 197 John Critchley and Davren Raven	Jonathan Hoefler
Antique, 197	n 11 aaa	Chisel Wide, 73
Jordan Davies	Booble, 228 Michael Jakab	Robert Harling
Adobe Arabic, 287	- 1 - 11 6/	Citizen, 108
Tim Holloway	Brothers Bold, 64 John Downer	Zuzana Licko
Armada Condensed, 204	D	Clarendon, 72, 152, 212
Tobias Frere-Jones	Bryant, 78, 148 Eric Olson	Hermann Eidenbenz and Edouard Hoffmann
Artscript, 212		
Scangraphic design staff	Bulldog, 148	Compatil, 169
	Adrian Williams	Olaf Leu and Linotype design staff

ITC Conduit, 111, 166	Electra, 186	Franklin Gothic, 208	Adobe Garamond Premier Pro, 284
Mark van Bronkhorst	William Addison Dwiggins	Morris Fuller Benton	Robert Slimbach after Claude
nam v viii Brommoroi	,, ,,,,,,,,,,,,,,,,,,,,,,,,,,,,,,,,,,,	Morrio Timer Bellion	Garamond
ITC Connectivities, 261	Enclave, 263	Franklin Gothic Extra Bold	Garamona
Teri Kahan	James Montalbano	Condensed, 83	Coorgia 195
тен кинип	jumes Montuouno		Georgia, 185 Matthew Carter
Compoundate (modified) 77	Engagona Bomon, 151	Morris Fuller Benton	Matthew Carter
Copperplate (modified), 77	Engravers Roman, 151	ITTO D 11: 0 -11: 21/ 217	0110 /1.160
After Frederic Goudy	Unknown	ITC Franklin Gothic, 216, 217	Gill Sans, 41, 168
0 0 1/0 1/0	D. L. 257	After Morris Fuller Benton	Eric Gill
Corporate S, 140, 168	Epica, 257		
Kurt Weidemann	Yvonne Diedrich	Frankrühlya, 167	HTF Gotham, 72
		Oded Ezer after Hebrew Frank-Rühl	Tobias Frere-Jones with Jesse Regan
Courier, 117, 175	FF Eureka, 96	font (designed by Rafael	
Adrian Frutiger	Peter Bilak	Frank in 1909)	Gravur Condensed, 79, 106
			Cornel Windlin
Darka, 269	Eurostile, 168	Freehand, 521, 138	
Gabríel Martinez Meave	Aldo Novarese	After Mandate by Robert Hunter	Foundry Gridnik
		Middleton	David Quay
Didot, 61, 85, 133, 137	Expo Sans, 259		
Adrian Frutiger	Mark Jamra	Frutiger, 85	Gringo, 37
	·	Adrian Frutiger	Peter Brugger
DIN, 135, 139, 168, 239	Farnham, 221		
German Institute for Industrial	Christian Schwartz	Frutiger Next Greek, 283	Bureau Grotesque, 204
Standards		Adrian Frutiger and Eva Masoura	David Berlow
	Fedra Mono, 119		
FF DIN, 74, 97, 105, 159, 171, 218,	Peter Bilak	Futura, 59, 60, 69, 92, 155, 160, 238	Monotype Grotesque, 35, 123
236	2000	After Paul Renner	Monotype staff and F. H. Pierpont
Albert-Jan Pool	ITC Fenice, 136	·	1
	Aldo Novarese	Futura Book, 56	Grotzec Headline Condensed, 33
FF DIN Bold, 107	11110 1100011000	After Paul Renner	Unknown
Albert-Jan Pool	Fette Fraktur, 113		
	Unknown	Sun Futura, 175	Halfink, 101
FF DIN Light, 107		After Paul Renner	Takayoshi Fujimoto
Albert-Jan Pool	Filosofia, 93, 211, 223, 245		J
·	Zuzana Licko	ITC Galliard, 214	FF Headz, 286
FF DIN Regular, 107	Zuzuw Zieno	Matthew Carter	Florian Zietz
Albert-Jan Pool	FF Flightcase, 108		
	Just van Rossum	Garamond, 57	Helvetica, 82, 84, 88, 109, 161, 187,
DIN Mittelschrift, 80	just van Rossum	Claude Garamond	235
Unknown	Fobia Gothic, 169		Max Miedinger
	Daryl Roske	Adobe Garamond, 56	
Disneyland, 238	Duryt Roske	Robert Slimbach after Claude	Helvetica Condensed Bold, 195
Unknown	Folio SP Pold Condensed 72	Garamond	Max Miedinger
	Folio SB Bold Condensed, 72 Konrad F. Bauer and Walter Baum	dirimoni	new mewnger
ITC Edwardian Script, 157, 236	Konraa r. Dauer ana waiier Daum	Adobe Garamond Expert, 222	Helvetica Heavy, 145, 177
Ed Benguiat	for hour only 227	Robert Slimbach after Claude	Max Miedinger
Z. Dengama	for_boys_only, 227 Fons Hickmann	Garamond	man mounisci
Egyptienne, 151	FORS HICKMANN	Garanona	Helvetica Light, 145, 177
Adrian Frutiger	Foundaries Caldada 105, 100	Adobe Garamond Regular, 222	Max Miedinger
In this I was	Foundry Gridnik, 105, 188	Robert Slimbach after Claude	man meaniger
Egyptienne F, 242	David Quay	Garamond	Helvetica Medium, 131
Advisor Emition	7. 16	Garamona	May Mindinger

Adrian Frutiger

Frankfurter, 59

Nick Belshaw and Alan Meeks

Max Miedinger

Helvetica Roman, 145, 177 Max Miedinger	Adobe Jenson, 41, 185 Robert Slimbach after Nicolas Jenson	FF Meta Bold, 172 Erik Spiekermann	Nathalie Gamache, 156, 170 Marie-Élaine Benoit and
Helvetica Round, 232 Max Miedinger	Adobe Jenson Pro, 185 Robert Slimbach after Nicolas Jenson	FF Meta Normal, 172 Erik Spiekermann	Laurence Pasteels News Gothic, 116, 150, 181, 196
Helvetica Neue, 95, 113, 138,		FF Meta Plus, 122	Morris Fuller Benton
202, 233, 234 Max Miedinger	Teri Kaban	Erik Spiekermann	News Gothic Bold, 153 Morris Fuller Benton
Helvetica Neue Black, 52 Max Miedinger	Kinesis, 259 <i>Mark Jamra</i>	FF Meta Plus Book, 222 Erik Spiekermann	News Gothic Extra Condensed, 153 Morris Fuller Benton
	HTF Knockout, 205, 244	Milk Script, 79	
Helvetica Neue Bold, 233, 234 Max Miedinger	-	Alejandro Paul	OCR B, 67 Adrian Frutiger
	Kroeger 05-53, 121	Miller, 220	
Helvetica Neue Roman, 233, 23 Max Miedinger		Matthew Carter, Tobias Frere-Jones, and Cyrus Highsmith	Old Typewriter, 216, 217 Unknown
	Lambrecht, 176		
Hogariet, 288	Dirk Wachowiak	Milton, 135	Orator, 138
Habib N. Khoury	W - V - P 1 - 117	Mecanorma Collection	John Scheppler
PTC Heliation 261	House Las Vegas Fabulous, 117	Minison 125	FF D'-1'- 200
ITC Holistics, 261 <i>Teri Kaban</i>	House Industries staff	Minion, 135 Robert Slimbach	FF PicLig, 289 Christina Schultz
тен кизин	Le Corbusier, 99	Robert Stimbach	Christina Schutz
Hornet MonoMassiv, 178	Nico Schweizer and Philippe	Moire Style, 176	Plantagenet, 214
Thomas Neeser and Thomas N	**	Dirk Wachowiak	Ross Mills
TROTING NOCCOT WITH TROTING IS	Time? Describents type? Le coronser	DITA HACIOWAK	ROSS ITMS
Hornet DuoMassiv, 178	LF, 159	FFF Mono 01, 200	Plume, 39, 91
Thomas Neeser and Thomas N		Unknown	Dalton Maag
			S
Indian typeface (redrawn), 92	, 160 Locator, 154	Monolab, 228	Pressure Style, 176
Unknown	Eric Olson	Michael Jakab	Dirk Wachowiak
FF Info Office, 183	Lo-Res Teens, 96	Monoline Script, 158	Prestige Elite, 228
Erik Spiekerman and Ole Sch	äfer Zuzana Licko	Mecanorma Collection	Howard Kettler
FB Interstate, 122, 241	Lutz Headline, 86	Monterey, 69, 155	FF Profile, 169
Tobias Frere-Jones	Cornel Windlin	Bistream Staff	Martin Majoor
100ms Frere Jones	Gornel winduit	Distream stagy	танн тидоог
Iowan, 111	Matrix CF, 165	Mrs. Eaves, 236	Proforma Medium, 89
John Downer	Yiannis Karlopoulos	Zuzana Licko	Peter van Blokland
	1		
Adobe Ironwood, 210	MeMimas, 80	Adobe Myriad, 26, 117	ITC Puamana, 261
Joy Redick	Joan Barjau and José Manuel Urós	Robert Slimbach and Carol Twombly	Teri Kahan
Italienne, 214	FF Meta, 85, 108	Adobe Myriad Pro Light, 41	FF Quadraat Italic, 66

Robert Slimbach and Carol Twombly

Fred Smeijers

Nathan Durrant

Erik Spiekermann

FF Quadraat Regular, 49 AT Sackers Gothic, 151 Times Roman, 175 Univers 47, 184 Stanley Morrison Adrian Frutiger Fred Smeijers Monotype staff FF Quadraat Small Caps, 66 FF Scala, 120, 127 Times New Roman, 147, 213 Wilma, 71 Fred Smeijers Martin Majoor Victor Lardent under Stanley Enric Jardi Morrison's direction Quixote, 275 FF Seria, 102 Vendetta, 244 Titling Gothic, 219 Iñigo Jerez Martin Majoor John Downer David Berlow Radiant, 204 Serifa BQ, 86 ITC Vintage, 251 Steve Jackaman after Robert Hunter Adrian Frutiger Trade Gothic, 73, 134, 149, 198, 243 Ilene Strizver and Holly Goldsmith Middleton **Jackson Burke** Shelley Allegro Script, 224 Vista Sans, 271 Trade Gothic Bold, 183 Radio, 73 Matthew Carter Xavier Dupré Magnus Rakeng Iackson Burke Shelley Andante Script, 56 Zentenar-Fraktur, 56 Rayuela Chocolate 2.0, 280 Matthew Carter Trade Gothic Condensed, 157 Dieter Steffmann after unknown Alejandro Lo Celso Jackson Burke Stencil, 168 HTF Ziggurat, 181 Relato Sans. 282 Gerry Powell Trade Gothic Extended, 69, 155 Jonathan Hoefler Eduardo Manso lackson Burke Stereopticon, 79 Dover Publication HTF Requiem, 48 FF Trixie, 161, 164 Jonathan Hoefler Erik van Blokland ITC Stone Sans (modified), 62 Rinzen Bits, 126 Sumner Stone FF Trixie Plain, 108 Unknown Erik van Blokland Stymie, 98 AT Riot, 128 Morris Fuller Benton Tsar Mono Round, 208 The ATTIK Unknown P22 Sweepy, 273 Rockwell Bold Condensed, 180 Michael Clark Twentieth Century, 141 F. H. Pierpont and Monotype Staff Paul Renner and Sol Hess Tacitus, 259 Rongel Osf, 33 Mark Jamra Typeka, 117 Feliciano Ilan Ronen Tarzana Narrow, 128 Rosewood, 209 Zuzana Licko FF Unit, 163 Kim Buker Chansler, Carl Crosgrove, Erik Spiekermann FF TheSerif, 162 and Carol Twombly Luc(as) de Groot UNIT 3 Extra, 58 Ruse, 174 Robert Lowe The Enschedé Font Foundry Thesis, 112 Luc(as) de Groot Univers, 87, 120, 211

Adrian Frutiger

Adrian Frutiger

Univers Bold Condensed, 110

Sabon, 82, 103, 169, 211 Jan Tschichold, Alexei Chekulayev,

and Hector Haralambousbon

AT Sackers Antique Solid, 149

Monotype staff

Tiki Holiday, 79

Timeless Regular, 49

Typoart Design Studio

Ken Barber

General Index

A0000A
a! Deseño, 16
Adidas, 22
Adobe Systems Incorporated, 254,
284, 287
Adris Group, 133
Adweek, 22
Agency:Collective, 228
Ahmed, Masood, 79 AIGA: metal, 20; 365, 14
Air America Radio. 18
Akita, Kan, 206, 207
Akita Design Kan Inc., 206, 207
Alam, Moyeenul, 62
Alexander, James, 39
Alexandria Real Estate
Equities, Inc., 134
Alfalfa, 166
Alice Deign Communication, 258
Alison Peters Consulting, 151
All American Rejects, The, 14
Allconnect, 54
Allen, Sallie Reynolds, 211
Alliance Graphique Internationale
(AGI), 20, 52
Altmann, Andy, 12-13, 30
Altos de Chavon Design School, 16
American Advertising Federation, 22
American Folk Art Museum, 20
American Institute of Graphic Arts,
Detroit, 241
American Institute of Graphic Arts,
national board, 18, 20
American Institute of Graphic Arts,
New York, 18
American Institute of Graphic Arts,
Washington, D.C., 122
American Medical Association, 262
Amnesty International, 20
Amos, Chava Ben, 165
AMV BBDO, 115, 175
Anderson, Gail, 79, 188, 197, 256
Anderson, Jack, 54, 65, 161
Anderson, Larry, 65, 161
Ando by, 209
Andys, 22
Angara, Ace, 166
Anieme, 97
Anni Kuan Design, 118
Anthony, Kyle, 117
·

Anthropologie, 93, 25 Anti-Pop Festival, 141 Arbeitskreis Firlm Regensburg e.V., 239 Archuleta, Kye, 130 Argentina, 6 Argus, Kerry, 92, 160 Arknipenko, Anastasiya, 100 Art Directors Club, 6, 14, 16, 18, 20, 22 Art Directors Club Deutschland, 51, 124 Association Typographique Internationale, 258 AT&T, 262 Atelier Poisson, 10 @Issue, 22 Atkins, Kelly, 134 Au, Benny, 30 Augustus St. Gaudens Award for Alumni of the Year at Cooper Union, 18 Avantype Foundry, 288 avedition, Ludwigsburg, 102 AVEX ENTERTAINMENT INC., 129

Bagic, Maja, 133 Bain, Peter, 38, 263, 264-65 Ballester, Dídac, 139 Bannwarth, Claudia, 154 Baravalle, Giorgio, 174 Bargstedt, Stefan, 96 Barkley Evergreen and Partners, 117 Barlock, 209 Basel, Switzerland, 258 Bath and Body Works, 149 Bauer, Ina, 34-35, 71, 123 Bauer, Joerg, 205 "Bauhaus Dessau: Mikiya Takimoto," Organizing Committee for the Exhibition, 237 Bauhaus University Weimar, 61 BBK Studio, 241 Bebermeier, Christoph, 195 Becker, Cordula, 113 Becker, H. P., 113 Becker, Leslie, 41 Becker, Polly 214 Belanger, Richard, 233 Beldings, 22 Belford, Paul, 115, 175 Bell, Jim, 254 Bell, Nick, 58

Bellack, Maris, 187 Benda, Penny, 222, 224 Benguiat, Ed, 70, 254, 262 Benoît, Marie-Élaine, 156, 170 Bergesen, Anders, 169 Bergmans, Hélène, 209 Berliner Magazine, 49 Best, Robert, 186 Beth Singer Design, LLC, 122 bethere.com, 254 Between, 16 Bexte, Professor Bernd, 96 Bierut, Michael, 172, 181 Bill, Max, 34-35 Billy, Muy, 64, 81 Billy Blue Creative, 68 BJ's Wholesale, 254 Bleackley, Chris, 162 Blisscotti, 65 Bløk Design, 202, 208 Bocskay, 268 BodyVox, 22 Bogner, Stefan, 126, 157 Bologna, Matteo, 225 Booth-Clibborn Editions, 12 Boros, 95 Boros, Christian, 95 Bosley, Rachel, 100 Bowden, Jason, 162 Bowling, Belinda, 54 Boynton, Richard, 60, 69, 155, 158 Branczyk, Alexander, 61 Brand New School, 201 Brechbühl, Erich, 203 Brides, 262 Brignell, Ian, 149 Brink, Gaby, 164 Bristol, England, 258 Brodsley, Adam, 105 Brooklyn, New York, 262 Brooklyn Ballet, 20 Brosch, Armin, 120 Brown, Andrea, 225 Brugger, Peter, 36-37 Bruketa, Davor, 135

Bruketa&Zinic, 133, 135

Buck & Rose Road Trip Productions, 214

Bryant, Karin, 214

Bell Hill Vineyard, 92, 160

Budelmann, Kevin, 241 Burns, Aaron, 254 Büro Uebele Visuelle Kommunikation, 179 BÜRO WEISS, 195 Burtscher, Claudia, 179 Butler, Liza, 48 Butterfly • Stroke Inc., 129

Caal, Nancy, 134 Cahan & Associates, 82 Cahan, Bill, 82 Cai Shi Wei, Eric, 147, 213 California College of the Arts, 40-41, 59, 136, 138, 190, 191, 192, 193 Callaway Golf, 20 Cameron, Tracey, 172 Campbell, Chase, 100 Canon, 6 Carin Goldberg Design, 109 Carslake, Scott, 163 Carver, Eric, 117 Cervantes, 274 CF Napa, 48 Channel 4, 12 Cheeseman, Len, 162, 173 Choi Han-Na, 107 Choi, James, 83 Chongqing Financial Street Real Estate,

Ltd., 130 Chou, Yao-Feng, 226 Christoph Merian Verlag, 178 Church of the Nazarene, 80 chutte, 231 Circular, 38-39 Clark, Eszter, 164 Clark, Michael, 272-273 Clément, René, 137 Clermont, Anne-Marie, 194 Clios, 22 Club Nobel, 77

Coca-Cola, 22 Cohn, Susan, 171 Colors magazine, 18 Commissaires, 137, 234 Communication Arts, 14, 22 Condé Nast, 18

Congregation B'nai Jeshurun, 6 Contegni, Mariana, 202, 208

Contractor Property Development Company, 216, 217 Converse, 22 Cooper Union, 18 Cooper-Hewitt Museum, 20 Copy magazine, 114 Copycats, 69, 155 Cost Vineyard, The, 22 Coughlan, Aine, 214 Country Music Television (CMT), 201 Country Restaurant, 225 Coupe, 14 Craven, Holly, 65 Creative Review, 262 Creativity, 22 Critique, 22 Croatian Designers' Society, 53 Cross, Jeffery, 105 Cure-X GmbH, 243 Curo Financial Management, 67

Dallas, 20 D&AD, 22 Darmstadt, Germany, 112 Darveau, Noémie, 110 Davanzo, Giorgio, 152 Davidson, Nicholas, 82 Davies, Steve, 175 Davies, Tivy, 58 DeFrance Printing, 211 dela Cruz, Elmer, 161 de la Cuesta, Juan, 274 DeLago, Ken, 219, 220, 221 de la Roza de Gutierrez, Olga, 57 Delikatessen Agentur für Marken und Design GmbH, 77 Demetz, Alfonso, 108 de.MO, 174 design hoch drei GmbH & Co. KG, 168 designfairs, Munich, 102 "Desperate Housewives," 18 Detjen, Klaus, 56, 89 Diageo-Smirnoff, 58

127, 169

Ezer, Oded, 167 Die Gestalten Verlag (dgv), 227 Diedrich, Yvonne, 256-57, 268 Facelli Winery, 152 Diesel, 156, 170 Fachhochschule Mainz, University of Applied Sciences, 183 Dietz, Kirsten, 51, 74, 120, 124, Factor Product GmbH, 126, 157 Faculty of Art and Design, Bauhaus Dohrn, Thees, 49, 103

ESTO, 172

Europe, 35

Estudio Ibán Ramón, 97

Experimenta, Lisbon, Superbock, 240

Dominican Republic, 16 Domino Records, 24 Don Quijote, 272 Donaldson, Tim, 254 Dörrie, Philipp, 96 Dorten Bauer, 205 Dougherty, Sean, 201 Downtown Arts District Association, 81 Doyle, Stephen, 146, 196 Doyle Partners, 146 Drenttel, William, 119 Dübi, Käthi, 209 Duffy & Partners, 78, 148 Dunn, Rick, 117 Dupré, Xavier, 270-271 Durrant, Nathan, 214 Dynamic Graphics, 254

Eckstein, Vanessa, 202, 208 École de Design, UQAM, 110, 184, 194, 236 Economist, The, 115 Ed Benguiat/Design, Inc., 70 Einblatt-Druck, Kiel, 72 Ekhorn, Kjell, 94 Elephant In The Room, 244 Ellis, David, 12 Elsner+Flake, 285 Emery, Garry, 171 Emerystudio, 171 Émigré, Inc., 271 Emtype Foundry, 282 Encuentro Internacional de Ensenanza del Deseño, Il, 16 Eric Cai Design Co., 147, 213 Ernstberger, Matthias, 84, 240 ESPN, 22 Esquer, Rafael, 166

University, Weimar, 61 Fall Out Boy, 14 Fashion Institute of Technology, 16 Feerer, Ryan, 197 Feria Internacional del Mueble de Valencia, 139 Festival of Arts (Laguna Beach, California), 260 Figielski, Adam, 204 Fiskars, 22 Fitzgibbons, Elizabeth, 105 FLAME, Inc., 229, 235, 237 Fleishman-Hillard Creative, 55 Fons Hickmann m23, 227 Fonso Interprise Co., Ltd., 226 FontFont, 286, 289 Forss, Jon, 94 Fortune, 262 Fowler, Dirk, 141 Fox, Mark, 59 Fox River Paper, 211 Francis, Kate, 105 Freed, Chris, 65 Froelich, Janet, 75 Fromages Saputo, Les, 156, 170 Frutiger, Adrian, 283 Frykholm, Steve, 82 f2 design, 141 Fujimoto, Takayoshi, 101 Full Sail Brewing, 22 Futaba, 231 Fy(t)I (For Your Typographic Information), 254

Gagnon, Louis, 137, 233, 234 Gaku, Ohsugi, 76 Galápagos Design Group, 254 Garcia, Dennis, 211 Genemix, 85 Geurts, Koen, 128 Gherman, Mikhail, 173 Giants Chair, 24 Gimeno, Pepe, 139 Giorgio Davanzo Design, 152 Girard Management, 158 Glamour, 262 Glass Half Full, 244 Glauber, Barbara, 176 Gneiding, Daniel, 93

Go, Dennis, 201 Godfrey, Jason, 116 Godfrey Design, 116 Godin, Hélène, 156, 170 Goldberg, Carin, 109 Gould, Annabelle, 98 Gould, Ellen, 212, 223, 245 Gourmet Typography, 254 GQ magazine, 220, 221 Graham, Colin, 191, 192 Grandestypos, 16 Graphiques M&H, 156, 170 Graphis, 20, 22 Great Stuff GmbH, 126 Greenhalgh, Howard, 12 Grendene, Ramon, 61 Grimshaw, Phil, 254 Grzeskowiak, Eric, 100 GSD&M, 22 Guarnieri, David, 137, 234, 236 Guertin-Blanchette, Mariève, 156, 170 Guppe Gut Gestaltung, 108

Haag, Eric, 117 Haband, 254 Habitat for Humanity, 73 Halber, Geoff, 119 Hamburg, German, 42, 258 Hammerpress, 24 Hansen, Caro, 227 Harmsen, Lars, 37 Hauch, Brian, 241 Havana, Cuba, 16 Hawk, Tony, 14 Havashi, Shuzo, 129 HBO, 18 Heal & Son, 145, 177 Hedrich, Jim, 222 Hedrich Blessing, 222 Heiman, Eric, 105 Helfand, Jessica, 119 Hendershott, Kris, 73 Henderson, Hayes, 64, 73, 81 HENDERSONBROMSTEADART, 64, 73, Henredon, 224 Herman Miller, 82 Herold, Jelle, 200

Hesse, Klaus, 140

Hesse Design, 140 Hewlett-Packard Research Laboratories, 258 HfG Offenbach, 140 Hickmann, Fons, 227 Hilburn, Jay, 65, 161 Himmler, Helmut, 204, 215 Hoch, Chris, 122 Hochschule für Künste, Bremen, 96 Hochschule Pforzheim, 37 Hodgson, Michael, 104, 150 Holden, James, 117 Holloway, Tim, 287 Holsten-Brauerei AG, 182 Holzman, Elizabeth Cory, 181 HOME Agentur für Kommunikation, 243 Homemade Baby, 18 Hong Kong, 30 Hong Kong Art Centre, 31 Hook, Clark, 67 Hornall Anderson Design Works, 54, 65, 161 Hörner, Susanne, 51, 124, 127 Houlihan's Restaurants, 24 HOW magazine, 14, 20, 22, 254 Hu, Wen-Hua, 40-41

"I Love Távora," 32
IBM, 6
ICEX, 97
Ichihara, Hiroko, 207
Ichiyama, Dennis. Y., 100
I.D. magazine, 22, 262
IdN, 14
Ikami, Emi, 229
In Style Magazine, 18
incell corp., 63
ING, 208
Ingenioso Hidalgo Don Quijote de la Mancha, El, 274
Inman, Kendra, 117

"Inner Rose, The," 30

Hudson Valley Preservation

Commission, 20

Hyperion, 18

Hugel, Stephanie, 157

Huvart, Lars, 204, 215

Hunt, Randy J., 188

Institut für Kulturaustausch, Tübingen, Germany. 35
Instituto Superior Communicacion
Visual, 16
Instituto Superior Deseño Industial, 16
International House of Fonts, 273
International Typeface Corporation
(ITC), 254, 256, 260
Irrgang, Robb, 121
Israel, David, 176
Israel, Lonny, 130
Issey Miyake Inc., 207
Ito, Akiko, 105

JAGDA, 76

Jakab, Michael, 228

Jamra, Mark, 258-59, 270

Janssen, Daniel, 42-43 Japan, 16 Jazz in Willisau, 144 J.C. Penny, 262 Jerde, Jennifer, 214 Jerez, Iñigo, 274-275 John Anthony Vineyards, 48 John Connelly Presents, 166 Johnson & Johnson, 254 Joy Foundation, The, 55 Joyce, Mike, 14-15, 32, 185, 232, 238 Juchter, Silke, 56 jung und pfeffer: visuelle kommunikation, 86 IWT. 22 JWT London, 58

Kabel, Peter, 43
Kahan, Teri, 260-261, 272
Kahn, Colin, 132
Kalman, Tibor, 18
Kaloff, Constantin, 182
Kang Joong-Gyu, 107
Kansas City, Missouri, 24
Kansas City, Missouri, 24
Karam, David, 41
Keer, Carolyn, 93, 125
Kegler, Richard, 132
Kellys, 22
Ken-Tsai Lee Design Studio, 226
Kent State University, 258

Khoury, Habib N., 288

Kim, Ii-Won, 107 Kim, Yoni, 199 Kimera Type Foundry, 269 KISS, 14 Kitamura, Midori, 207 Klotnia, John, 99, 134 Knight, Robin, 117 Ko, Hong, 189 Koch, Joerg, 30 KOCHAN & PARTNER GmbH, 102 Kodaira, Masayoshi, 229, 235, 237 Koftalki, Oliver, 126 Kono-Noble, Carol, 104, 150 Kornbrust, Sabine, 227 Kosmo Records, 157 Krakowski, Adriane, 285 Kratochvil, Antonin, 174 Krause, David, 195 Kremo, Mosbach, 72 Krol, Mike, 232, 238 Kummer, Karsten, 77 Kunic, Domagoj, 135

Kuon, Julia S., 86

LaBrecque, Eric, 104 Laguna Beach, California, 260 Laricks, Lindsay, 24 Las Vegas, 18 Lawrence, Amanda, 149 Lee, Choong Ho, 87 Lee, Ken-Tsai, 226 Lemieux, Marie-Pierre, 170 Lenscape Studio, The, 85 Lenz, Christian, 72 Lenz/Typografie & Design, 72 Leonard, Nils, 175 Letraset Ltd., 256 Letterspace, 6, 256 Leung, James Wai Mo, 85 Levi Strauss & Co., 22 Lewis Communications, 67 Liang, Julyanne, 59 Library of Congress, 14 Licher, Bruce, 132 Lightstone, John, 117 Lindauer, Armin, 112 Linder, Amanda, 222 Ling, Pazu Lee Ka, 142, 143 Linotype GmbH, 254, 283

Lippa, Domenic, 38-39, 91, 145, 177 Lippa Pearce Design, 39, 91, 145, 153, 177, 180 Little Brown & Co. Inc., 262 Ljubicic, Boris, 131 Lo Celso, Alejandro, 280 Lobe, Sascha, 34-35, 71, 123 London, 12, 20, 22, 38 London International Advertising, 22 Louie, Ron, 99 L2M3 Kommunikationsdesign GmbH, 35, 71, 123 Lubalin, Herb, 254 Luis Filipe Folgado, 159

Lyon, Dave, 149 Ma, Berth, 85 Maag, Bruno, 39 Maak, Ingo, 95 Maclean, Douglas, 92, 160 Magnum, Inc., 235 Maine College of Art, 258 Maley, Kim, 199 Mallonée & Associates, 223, 245 M&Co., 18 Manso, Eduardo, 282 Maritime Hotel, The, 18 Markl, Thomas, 126, 157 Markwald, Nicolas, 239 Markwald und Neusitzer, 239 Maroon 5, 14 Marquardsen, Ankia, 169 Marriott, 22 Martínez Meave, Gabriel, 268-269 Masoura, Eva, 283 Mau, Gary, 83 Mauss, Peter, ESTO, 172 Max, Sonja, 54

Mayes, Erin, 111

Meckes, Oliver, 114 Medford Printing, 93, 125 Meier, Raymond, 75

Meiners, Tracy, 211 Mendez, Jason, 193 Mercer Hotel, The, 18

McCann, Alana, 125 McClaren, Malcolm, 12 McKinney, 22 McVarish, Emily, 136, 138 Murphy, Tim, 171 Murray, Jason, 241 Musée Cantonal de Géologie, Lausanne, 106 Museum Documentation Centre, Croatia, 131 Museum of Fine Arts, Houston (MFAH), The, 111 Museum of Modern Art, 20 Museum of Work, Hamburg, 42 Musicmaker Relief Foundation, 64 Muthesius Academy of Fine Arts (Kunsthochschule), Kiel, 56, 89 MYFonts.com, 204

Merchant, Natalie, 14

Mexico, 16

Mexico, 268

Microsoft, 22

Miller, Jeff, 80

MINETM. 218

Mixer, 203

Money, 262

MGM Grand, 18

Miami Ad School, 62

Mika, Shinozaki, 76

Milligan, Spike, 180

Miriello Grafico, 211

MJM Creative Services, Inc., 6

Mohawk Fine Papers, Inc., 212

Monotype Imaging Corporation, 254

Montalbano, James, 262-63, 274

Mooney, Yann, 110, 194

Morlok, Franziska, 227

MTV, 18; Networks, 14,

Mucca Design, 225

Munich, 20

Müller, Thomas, 178

Muñiz, Roberto, 106

Muller + Company, 80

Miller Brewing, 22, 262

Michael Austin Wines, 164

Nakajima, Hideki, 30-31 Nakajima Design Studio, 31 Nam Seung-Youn, 107 Narges, Iran, 136 Nassau Guardian, 254 NBC, 18 Neese, Jennifer, 100

Neeser, Thomas, 178 Neeser & Müller, 178 Nelson, Sarah, 216, 217 Neue Sammlung Museum, 20 Neumann, Robert, 77 Neusitzer, Nina, 239 New Cat Orange, 113 New School University, 16 New York Art Directors Club; see Art Directors Club New York Magazine, 14 New York Times, The, 262: Style Magazine, 75 New York University, 172 Newspaper Marketing Agency, 175 Nickelodeon, 18 Nicol, Jonathan, 170 Nike, 12, 22 Niklaus Troxler Design, 144 Nill, Nadine, 50

Nissan, 22 Non-Format, 94 Nook Bistro, 150 Norcutt, Mark, 58 Nosal, Alexa, 16-17, 34 Novum (Germany), 22 Number Seventeen, 18

Oberman, Emily, 18-19, 36 O'Brien, Justin, 191 O'Brien, Lee, 244 Oded Ezer Typography, 167 Ogilvy & Mather, 22 Ogilvy & Mather Frankfurt, 204, 215 Oh Dong-Jun, 107 Okumura, Akio, 101 Olson, Dan, 78, 148 One Show, The, 14, 22 100 Days, 205 Oporto Fine Arts School, 32 Opto Design, 99, 134 Ordem does Arquitectos—Secção Regional do Norte, 33

Oregon State Fair, Blue Ribbon, 22 Original Juan's, 117 OroVerde Rainforest Foundation,

Germany, 215 Otsuka, Namiko, 235 Ottawa, Nicole, 114 Otten, Marenthe, 128 Outis, Andy, 196 :output foundation, 86

Palmer, Robert, 211 PampaType Digital Foundry, 280 Pankoke, Betie, 96 Papierfabrik Scheufelen, 120, 127 Paprika, 137, 233, 234 Park Kum-Jun, 107 Parkinson, Jim. 254 Parsons School of Design, 6, 16, 262 Partly Sunny, 151 Pask, Guy, 92, 160 Pasteels, Laurence, 156, 170 Pauls, Jan, 195 Pazu Lee Ka Ling, 142, 143 Pazazz, 166 Peacock, David, 98 Pearce, Harry, 153, 180 Pemrick, Lisa, 148 Penny, Judy, 62 Pentagram Design Inc. (U.S.), 20, 111,

Pepe Gimeno Proyecto Grafico, 139 Pesce, Giorgio, 106 Peterson, David, 224 Petrasch, Verena, 227

Pfeffer, Florin, 86

172, 181

Pfizer, 6 Ph.D, 104, 150 PIE BOOKS, 229 Piercy, Clive, 104, 150 Pigeon, Peter, 156 Pirtle, Woody, 20-21, 38 Pirtle Design, 20 Place, Tiffany, 54

Platinum Design, 14 Plimmer, John, 162 Plunkert, David, 90

Plus 81, 14

Pobojewski, John, 121 Poby, Peter, 113

Podravka d.d., 135 Poirier, Judith, 184, 236

Polcar, Ales, 215 Pop, Iggy, 14

Pop!Tech Conference, 88

Portland, Maine, 258
Portland, Oregon, 20, 22
Portland Advertising Federation,
Advertising Professional of the Year, 22
Poth, Christina, 49
Pratt Institute, 6, 57, 165
Print magazine, 14, 262
Prologue, 83

Provincia Autonoma di Bolzano, 108

Prugger, Uli, 108
PS 158, 6
P22, 132
P22 Records, 132
P22 Type Foundry, 273
Publicis, 22

Publicis Mojo, 162, 173 Pupillo, Rosa, 168

Purdue University, 100 Putzer, Philipp, 108

Quelhas, Vitor, 159 Quinn, Laurence, 58 Quitters Club, 24

Rädeker, Jochen, 51, 120, 124, 127, 169

Ramalho, Lizá Defossez, 32-33

Ramón, Ibán, 97
Rascoe, Kate, 138
ReadyMade, 105
Rebelo, Artur, 32-33
Regej, Byron, 186
Remix Magazine, 162
Requerni, Daniel, 97
RGD Ontario, 254
Rhodes, Silas, 70
Richards, Todd, 82
Richter, Annegret, 182
Rilke, Rainer Maria, 30
River-to-River Festival, 18

Rizzoli, 20, 219

Robbers on High Street, 14

Robert F. Wagner Graduate School of Public Services, New York University,

172

Roberts, Nigel, 115, 175

Robinizer, 242 Robinson, Kevin, 201 Rockport Publishers, 218 Rolling Stone, 14
Rosario, Argentina, 16
Rosman, Jonathan, 156, 170
Royal Academy of Arts, 12
Royal College of Art, 12

Royal Mail, 12

Royal Norwegian Embassy, The,

London, 94 R2 Design, 33 Ruiz, Allison, 166 Ruiz, Danny, 201

Sagmeister, Stefan, 84, 114, 118, 240 Sagmeister Inc., 84, 114, 118, 240 Saito I.M.I. Graduate School, 101 Sakurai, Ken, 78, 148 Sandstrom, Steve, 22-23, 40 Sandstrom Design, 22

Santo Domingo, 16
"Saturday Night Live," 18
Schaffarczyk, Till, 204, 215

Schäffer, Wolfram, 168 Schauspiel Stuttgart, 169

Scher, Paula, 187 Schindler, Heribert, 182

Schmelz, Katja, 102, 154 Schmidt, Matthias, 182

Schnell, Raoul Manuel, 156, 170

Schoberer, Martin, 242 Scholz & Friends, 182

School of Design, Basel, Switzerland,

258

School of Visual Arts, 14, 20, 70, 109, 185, 186, 187, 196, 199, 232, 238;

MFA Design, 79, 188, 197 Schrader, Niels, 200

Schrama, Floris, 128 Schuemann, David, 48 Schultz, Christina, 289 Schuster, Stephen, 83 Schwarm, Christian, 205

Scotch Malt Whiskey Society, The, 153

Scribner, 262 Seagrams, 22 Sebbah, David, 75

Secretos del Diseño Grafico Exitoso,

Los, 16

Sedelmayer, Hana, 89 Seed Media Group, 84 Seliger, Mark, 219 Sensus Design Factory, 53 Seven Exhibition, 30 702 Design Works Inc., 76 Shenzhen Graphic Design Association, 142, 143 Shinnoske, Inc., 52 Shvets, Yri, 54 Siegfried, René, 56 Siegler, Bonnie, 18 Sieka, Paul, 216 Silver Pictures, 83 Simmons, Christopher, 218 Simmons, John, 153 Simon, Brad, 99, 134 Sinclair, Alan, 130 Singer, Beth, 122 Sister Love, 200 601bisang, 107 Skeesuck, Justin, 211 Skerm, Paul, 145, 177 Skidmore Owings & Merrill LLP, 130 Slimbach, Robert, 284 Smith, Buck, 55 Smith, Howard, 122 Smith, Justin, 68

Smith, Paul, 12 Snavely, Pat, 151 Snidvongs, Sucha, 122 Society for the Advancement of Architecture, Engineering and Design (AED), 179 Solomon, Martin, 16 Sony Pictures, 22 Sousa, Miguel, 281 South America, 6 Spiekermann, Erik, 254, 270 Spiranni, Ariane, 118 Spoljar, Kristina, 53 Spoljar, Nedjeljko, 53 Spur. 90 Staatstheater Stuttgart, 169

Stanescu, Traian, 114 Stefanidis, Dimitrios, 165 Stein, Jens, 182 STEP Inside, 254

Stepp, Shelley, 190, 191, 192, 193 Steppenwolf Theatre, 22 Stereotype Design, 14

Stertzig, Alex, 168

Stichting Pleinmuseum, Amsterdam, 200

Stigler, Bruce, 161

Stöhrmann Fotografie, Hamburg, 72

Stone, Sumner, 254 Stora Enso, 146 Stout, DJ, 111

Strategy Design & Advertising, 92, 160

strichpunkt, 51, 74, 120, 124, 127, 169

Strizver, Ilene, 250-251, 256

Strokes, The, 14 Studio International, 131 Studio 't Brandt Weer, 128 Suben/Dougherty, 172 Sugisaki, Shinnoske, 52

Suma+, 16 Sumatra, 270

Summ, Martin, 102, 154

Sung, Jae-Hyouk, 190, 191, 192, 193

SW20, 87 Synaesthesia, 40

TAFE SA. 163 Takechi, Jun, 63 Takechi, Kozue, 231 Takimoto, Mikiya, 229, 237

Tam, Helena, 85 Target, 60

Távora, Fernando, 32

Tazo Tea, 22 T-B A21, 103 TBWA/ChiatDay, 22

TDC: officers, 322-23; membership,

324-27

TDC3 - 1956, 290-321

TDC² 2006, 246-89: chairman's statement, 250-51; judges, 252-63; judges' choices and designers' statements, 264-75; entries selected for excellence

in type design, 276-89

TDC52, 6-245: Chairman's statement, 6-7; judges, 8-25; judges' choices and designers' statements, 26-43; entries

selected for typographic excellence,

44-245 Tee, James, 54 Teknion, 222 Templin, Joel, 164 Templin Brink Design, 164 Terminal Design, Inc., 262

Texas, 36

Textaxis.com, 275

Thames and Hudson, 12

Thares, Scott, 60, 69, 155, 158

The, Richard, 118, 240 Theatre Project, 90

Thedens, Ina, 204

Theodosion, Sallyanne, 39

Thirst, 121

Thomas, Brad, 130

Thorp, Mick, 68

Throm, Michael, 37

Thymes, 78, 148

Ting, Oliva, 166

tipoGráfica, 6, 16

Topic, Marin, 135

Toyota Motor Corporation, USA, 260

"Trans-Sensing/Seeing Music," 40

Trantham, Andy, 244

Trollbäck, Jakob, 88

Trollbäck + Company, 88

Trommer, Klaus, 243

Troxler, Annik, 227

Troxler, Niklaus, 144

Trudeau, Julia, 184

"26," 153

2K, 14

Tyler, Jo, 156 TypeCulture, 258

Type Directors Club (TDC), 6, 14, 22,

256, 258, 262, 272; Annual, 32, 256;

competition, 34; newsletter

Letterspace, 6, 256

Type Rules!: The Designer's Guide to Professional Typography, 250, 251,

254, 256

Type Studio, The, 254

Typographic Circle, The, 38-39, 91

Typography 25, 6

Typography 22, 256

Uebele, Andreas, 179

University of Applied Sciences

Hamburg, 43

University of Oregon School of

Architecture and Allied Arts, Board of

Visitors, 22

University of Washington, 98

University Teaching Award, 16 Upper & Lowercase (U&lc), 254, 256,

URW Software & Type GmbH, 258 U.S. Government Printing Office, 16 U.S. National Park Service, 262

Vainesman, Diego, 6, 256

Valicenti, Rick, 121

Vanderbyl, Michael, 41, 210, 212, 222,

223, 224, 245

Vanderbyl Design, 210, 212, 222, 223,

224, 245

van der Hoeven, Mark, 173

Vandeventer, Nick, 100

Vanity Fair, 262

Veljovic, Jovica, 43

Venice Biennale, German Pavilion, 95

Verein Neue Musik Rümlingen, 178

Veryeri, Emre, 88

Vest, Brady, 24-25, 42

VGS, 172

Victoria & Albert Museum, 20

Vieceli-Garza, Gina, 121

Virgin Mobile, 22

Virgin Records, 12

Virginia Museum of Fine Art, 20

Visual Information Design Association

of Korea (VIDAK), 107

Voelker, Ulysses, 183

Vogue, 262

Voice, 163

Volume, Inc., 105

von Geramb, Wolfgang, 242

von Rohden, Philipp, 49, 103

Wachowiak, Dirk, 176

Wachtel Lipton Rosen & Katz, 20

Wacker, Susanne, 168

Wahler, Adam S., 109

Wahler, Carol, 323

Waller, Garry, 88

Walter Pfisterer Fotografie, 242

Warner Bros., 83

Wayne, Rodney, 173

Werner, Sharon, 216, 217

Werner Design Werks, Inc., 216, 217

Westerweel, Fréderiek, 209

White Dot Inc., 149

Why Not Associates, 12 Wichmann, Marcus, 168 Widmaier, Felix, 51, 124, 127 Widmer Brothers Brewery, 161 Wieden-Kennedy, 22 Wierinck, Saskia, 209 Wildass Vineyards, 210 Wilde, Richard, 109 "Will & Grace," 18 William Stafford Center, The, 20 Wimboprasetyo, Agung, 190 Wink, 60, 69, 155, 158 Winterhouse Institute, 119 Winterhouse Studio, 119 Wired, 262 Witsche, Julia, 182 Woehler, Philipp, 182 Wolf, Kerstin, 183 Wood Type Manufacture Hamburg: History and Future, 42-43 Woodward, Fred, 219, 220, 221 Workshop 3000, 171 Worthington, Nick, 162, 173 Wright, Joe, 88 Wu, Hsin-Yi, 57 Württembergischer Kunstverein Stuttgart, Germany, 123 www.fonts.com, 254 www.itcfonts.com, 254 www.kosiuhong.com, 189 www.terikahandesign.com, 260 www.terminaldesign.com, 262 www.touch-me-there.com, 227 www.ydt-fonts.com, 256

032c (Germany), 30
Zietz, Florian, 286
Zinic, Nikola, 135
Zitromat, 49, 103
Zurich Poster Museum, 20

Zehender, Stephanie, 120

Yale School of Art, 176, 181, 228
Yale University Graduate Design
Program, 18
ydtfonts, 256
Yeo, Jeehwan, 185
Yeh, Patricia, 130
Yoshinaga, Yasuaki, 207
You, Na-Won, 107
Young, Gordon, 12
Young & Rubicam, 22
Young Guns show, 14
Yount, Danny, 83

Andrew Kner DESIGNER

Michele L. Trombley ASSOCIATE DESIGNER

Andrew Kner was born in Hungary, where his family has been involved in design and publishing since the 18th century. He came to the United States in 1940 at the age of 5, and received both his BA (1957) and his MFA (1959) from Yale University.

He worked in promotion design for Time, Inc., Esquire, and Look magazine before joining The New York Times as Art Director for the Sunday Book Review. In 1970 he became Executive Art Director at The New York Times Promotion Department, a position be beld until 1984 when he left to join Backer & Spielvogel as Senior Vice President, Creative Director for Sales Promotion. In 1990 he left to join RC Publications as Creative Director and Art Director of Print and Scenario magazines (he art directed Print on a freelance basis from 1963 to 1990). He left RC Publications in April of 2000 to freelance.

He has won over 150 awards for design and art direction. Posters be has designed are part of the poster collections of MoMA, the Smithsonian and the Louvre.

He teaches Communication Design at Parsons School of Design and the Fashion Institute of Technology. He served as President of the New York Art Directors Club from 1983 until 1985.

Upon receiving ber BFA in Graphic Design from the University of Michigan, Michele Trombley began ber career as associate art director at Print magazine. She also served as associate art director of Scenario: The Magazine of Screenwriting Art. Michele later worked as an art director for retailers J. Crew and The Limited Stores. Michele then returned to publishing and served as art director of Grid magazine, a commercial real estate publication. She is currently the Creative Director of ARRAY. Her freelance clients include: Archirecture magazine, Barnes & Noble Publishing, The New York Art Directors Club, The Society of Illustrators, and The U.S. Department of Housing and Urban Development.

		e.	
		*	